THE ART OF
DEATH
STRANDING

Titan Books would like to thank the following people for their help and support in producing this book: Special thanks to Hideo Kojima, Shinji Hirano, Taro Yamashita, Yoji Shinkawa, and Ken Mendoza Hashimoto at KOJIMA PRODUCTIONS. Thanks also to all the artists whose work is featured in these pages; and to James Vance and Ashley Anne Gauer at KOJIMA PRODUCTIONS; and to Stephanie Fradue, Melanie Kwan, Tomoyo Kimura, Ryuhei Katami, Gerardo Riba, and David Bull at Sony Interactive Entertainment.

THE ART OF DEATH STRANDING
ISBN: 9781789091564
Limited Edition ISBN: 9781789093629
Ultra-Limited Edition ISBN: 9781789093636

Published by
Titan Books
A division of Titan Publishing Group Ltd
144 Southwark St
London
SE1 0UP

www.titanbooks.com

First edition: January 2020
10 9 8

Did you enjoy this book? We love to hear from our readers. Please e-mail us at: readerfeedback@titanemail.com or write to Reader Feedback at the address on the left.

To receive advance information, news, competitions, and exclusive offers online, please sign up for the Titan newsletter on our website: www.titanbooks.com

THE ART OF
DEATH
STRANDING

TITAN BOOKS

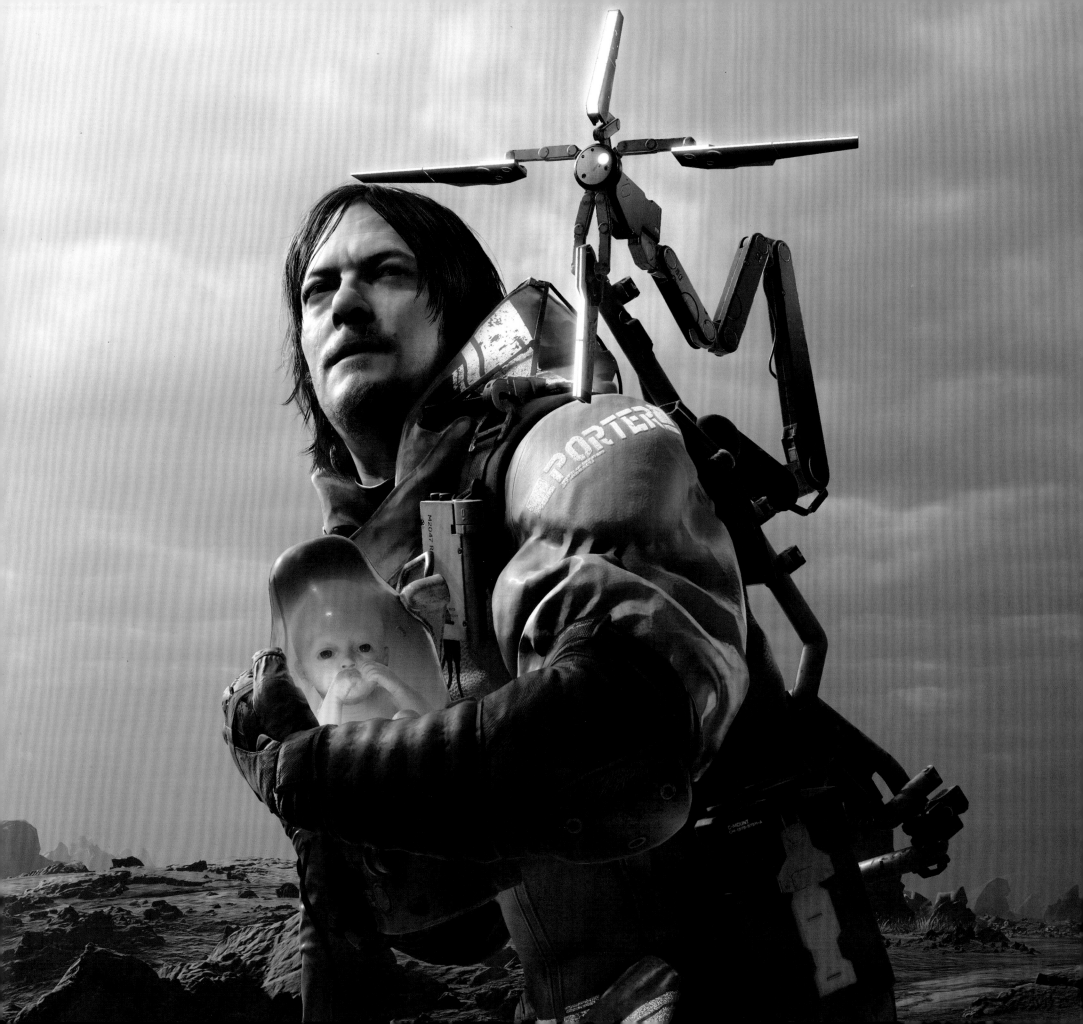

CONTENTS

THE ART OF DEATH STRANDING

CHARACTERS

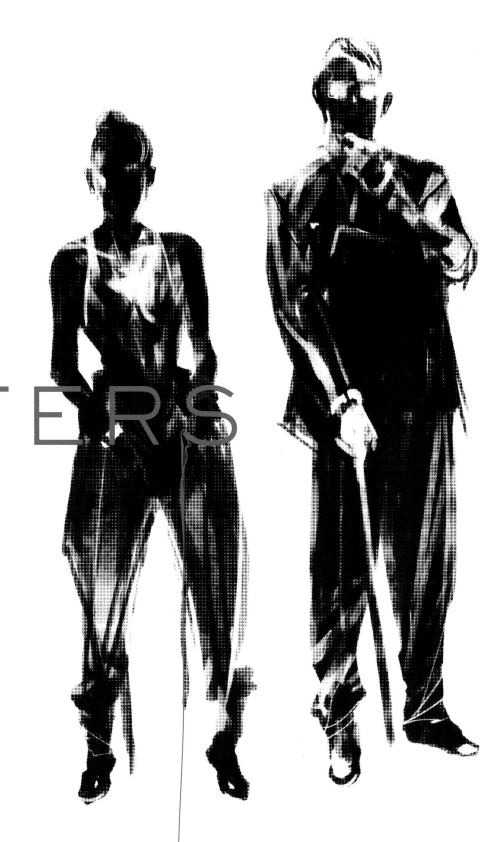

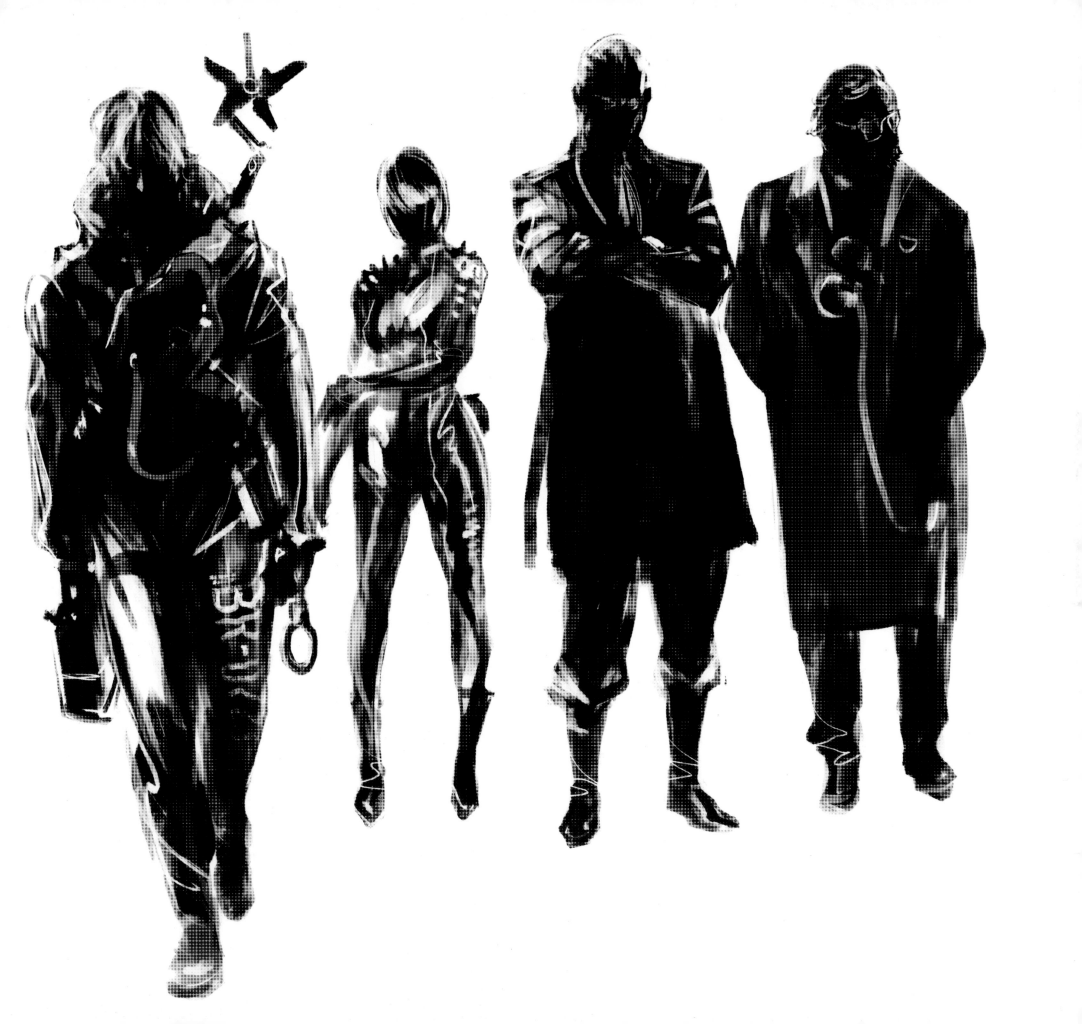

SAM BRIDGES

THIS SPREAD / Early concepts for Sam's suit. At this stage, the concept was slightly more futuristic than the final.

CHARACTERS

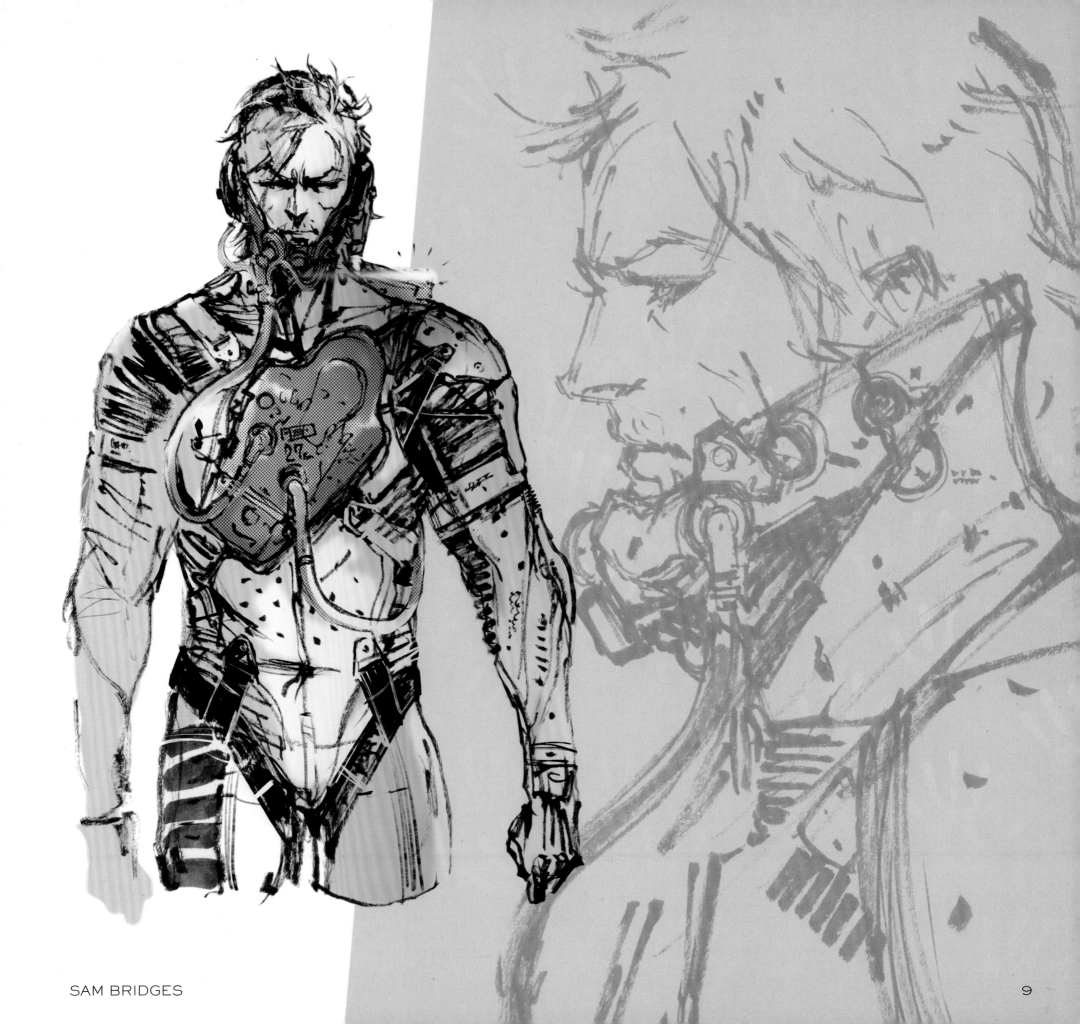

SAM BRIDGES

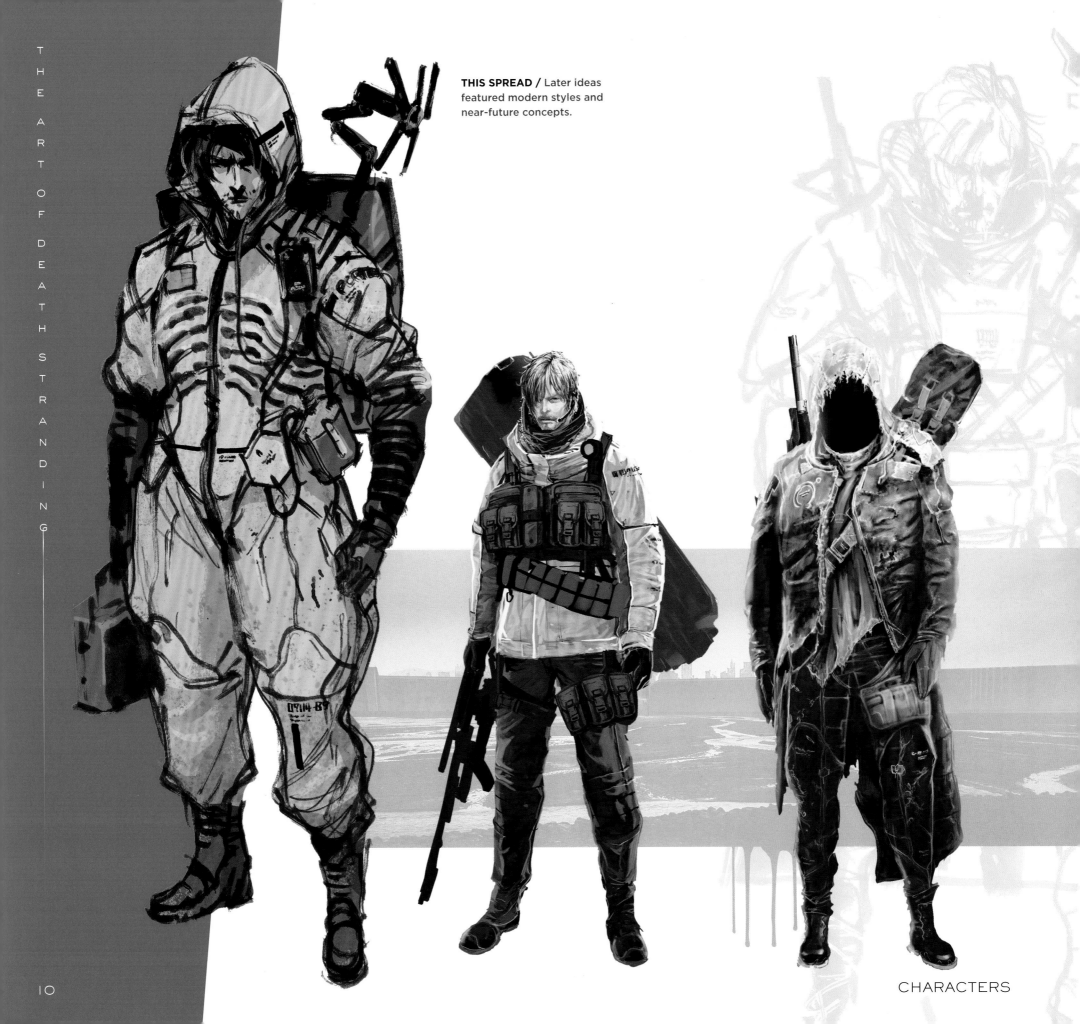

THIS SPREAD / Later ideas featured modern styles and near-future concepts.

CHARACTERS

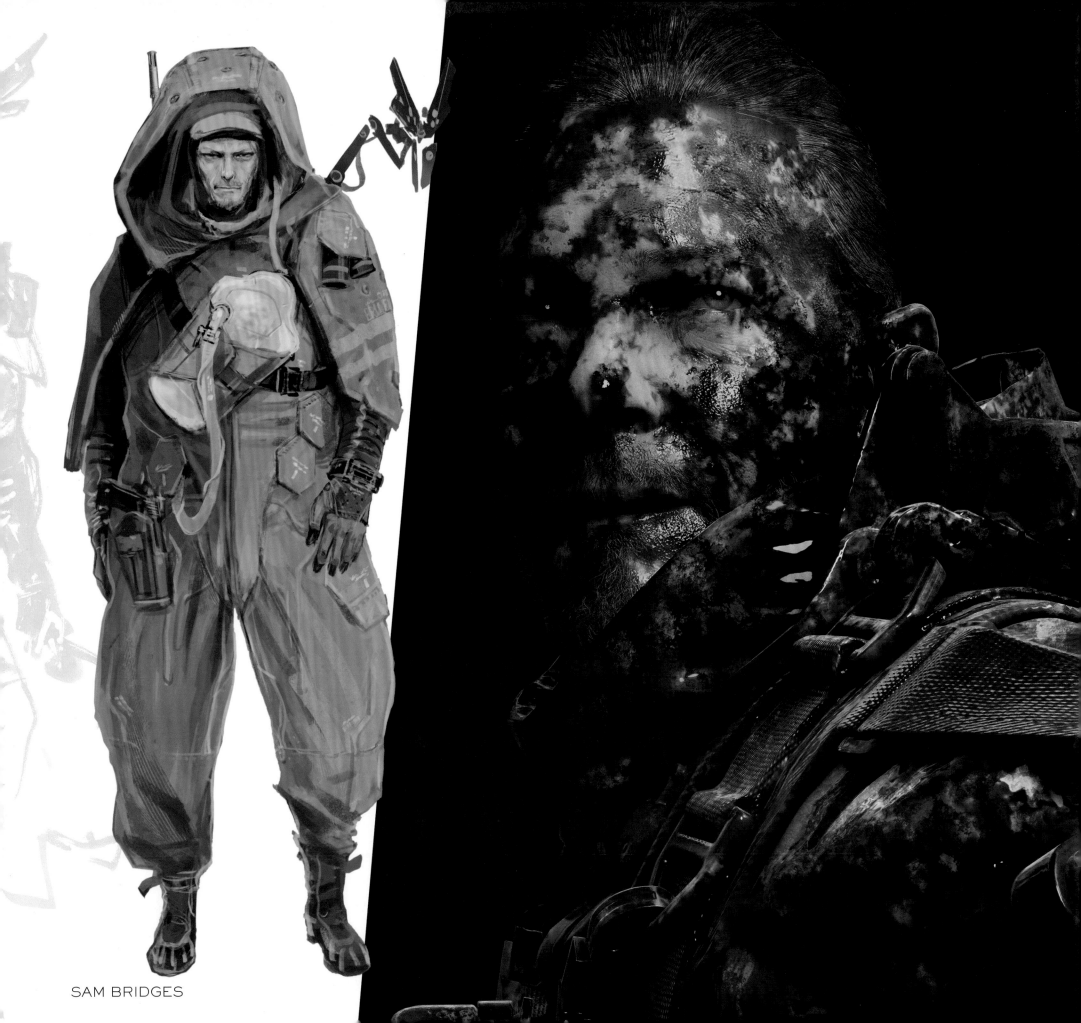

SAM BRIDGES

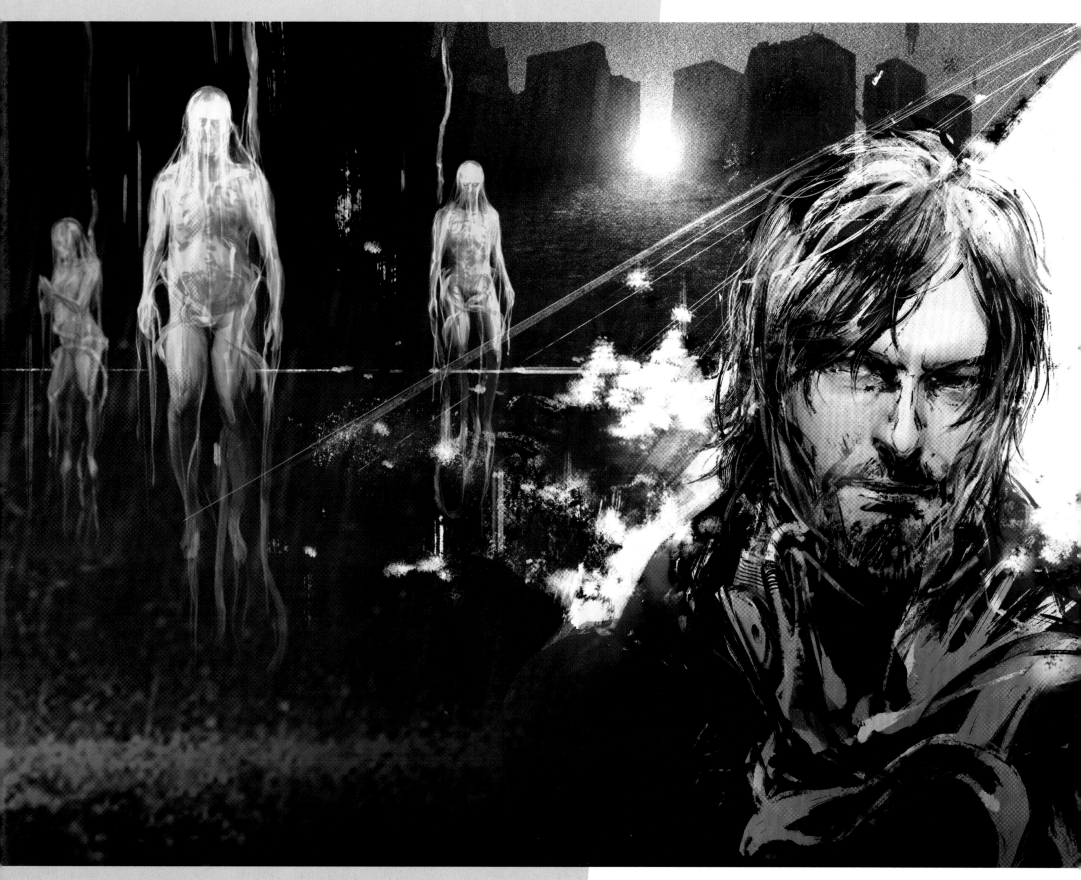

ABOVE / The concepts for Sam and his suit evolved along with the vision for the world of the game.

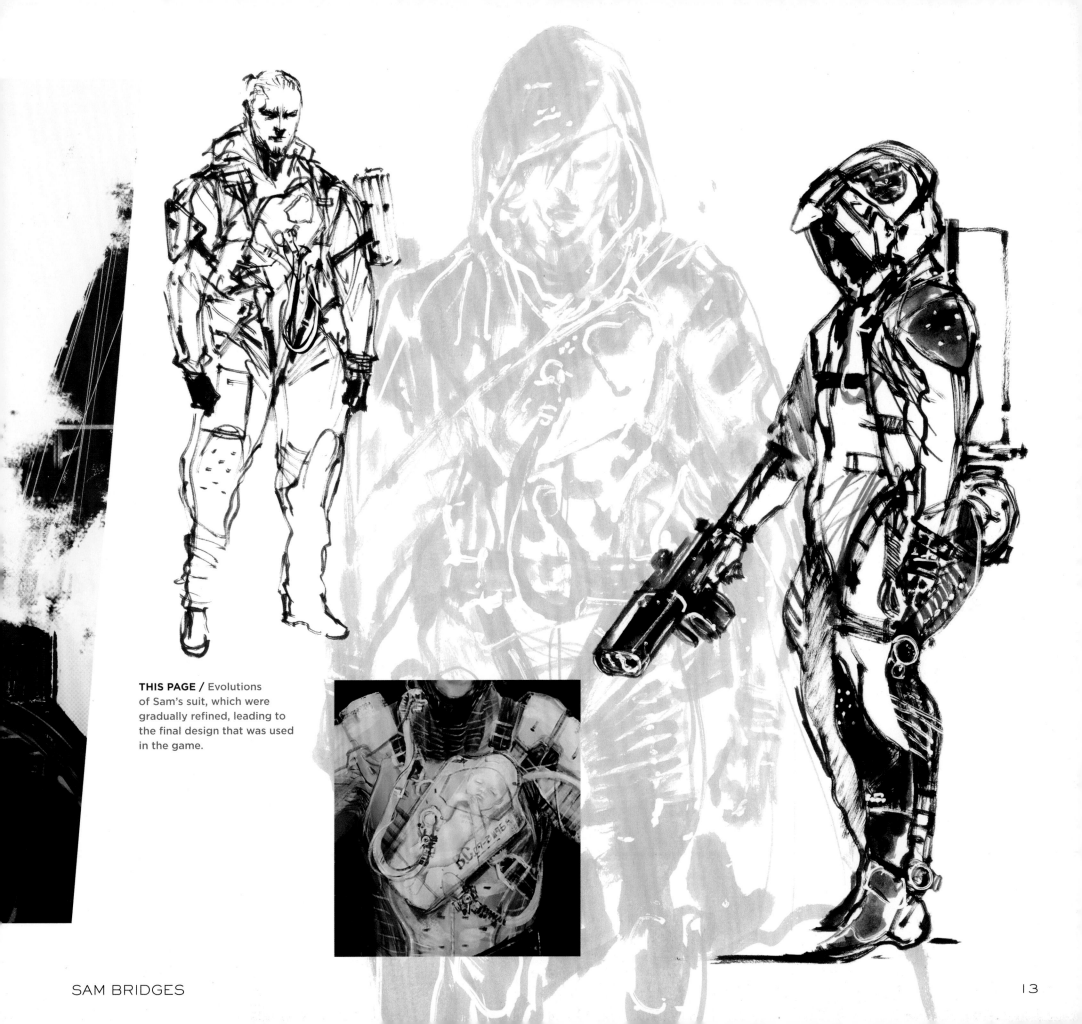

THIS PAGE / Evolutions of Sam's suit, which were gradually refined, leading to the final design that was used in the game.

SAM BRIDGES

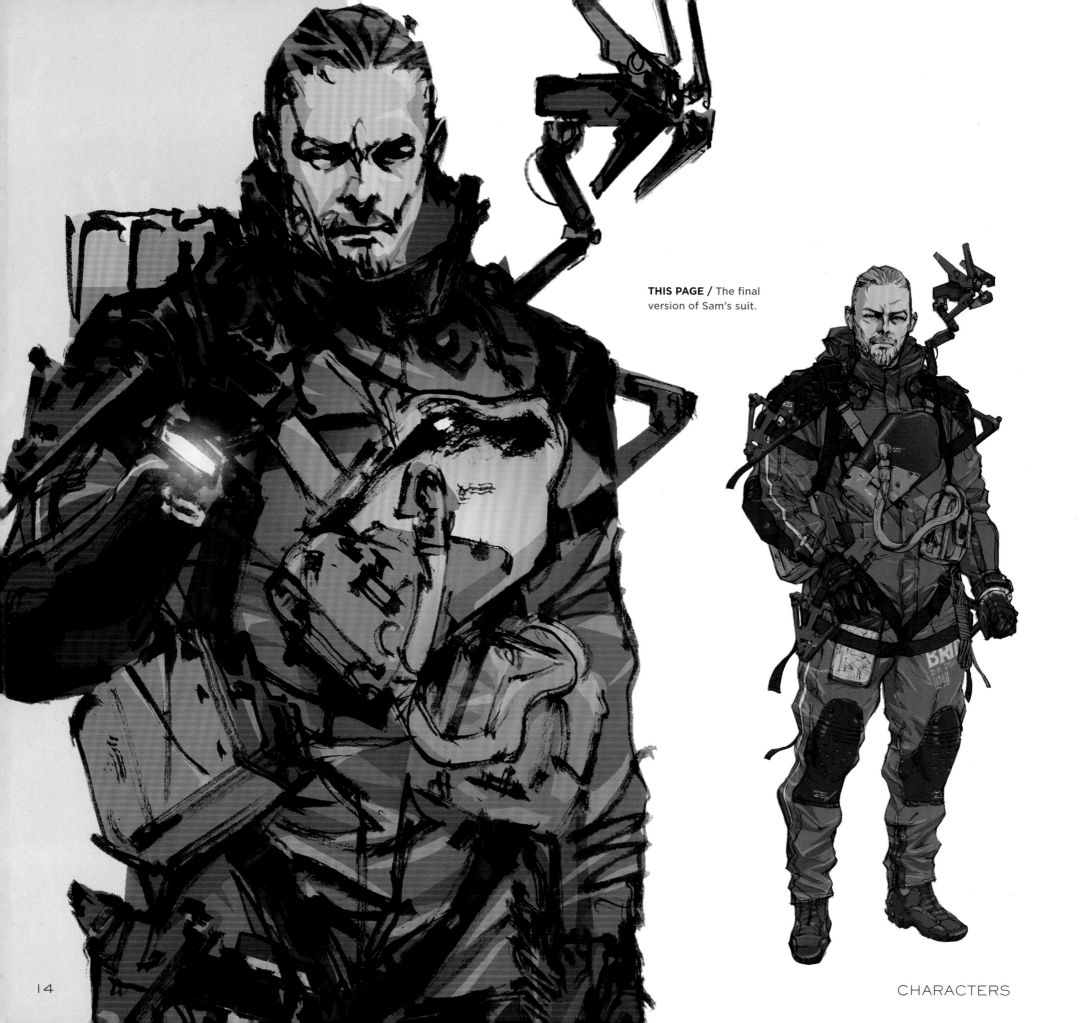

THIS PAGE / The final version of Sam's suit.

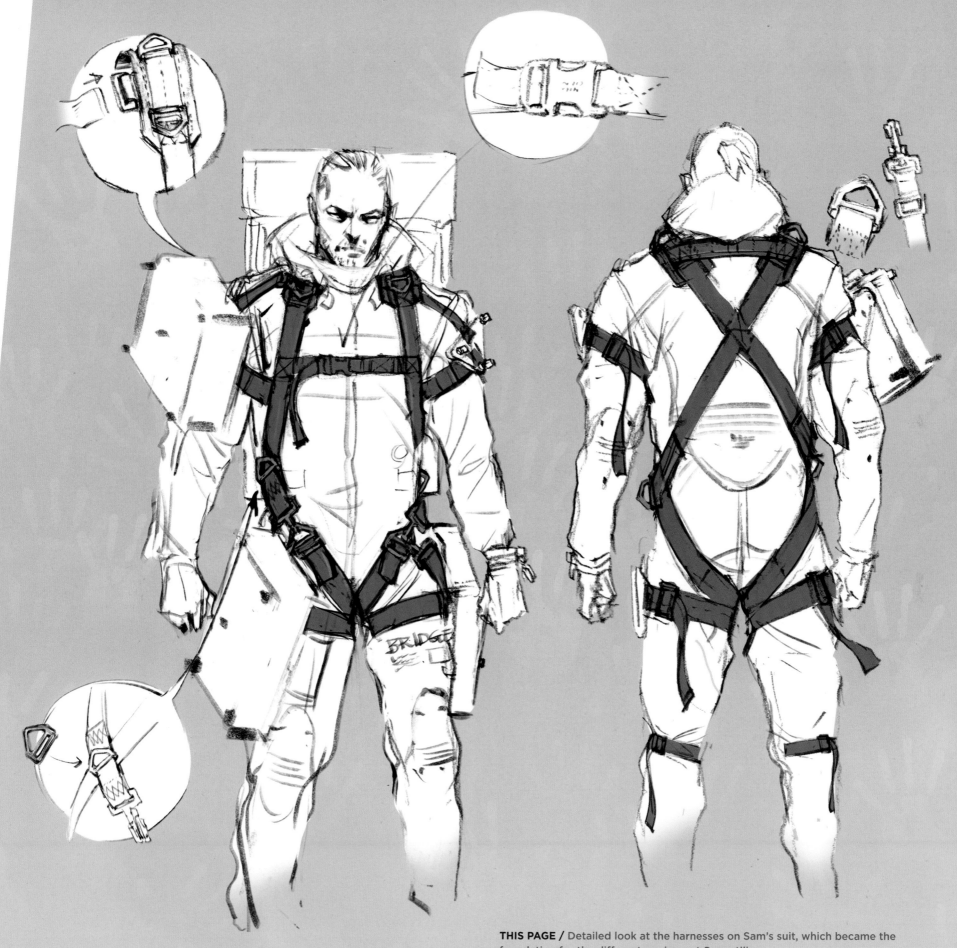

THIS PAGE / Detailed look at the harnesses on Sam's suit, which became the foundation for the different equipment Sam utilizes.

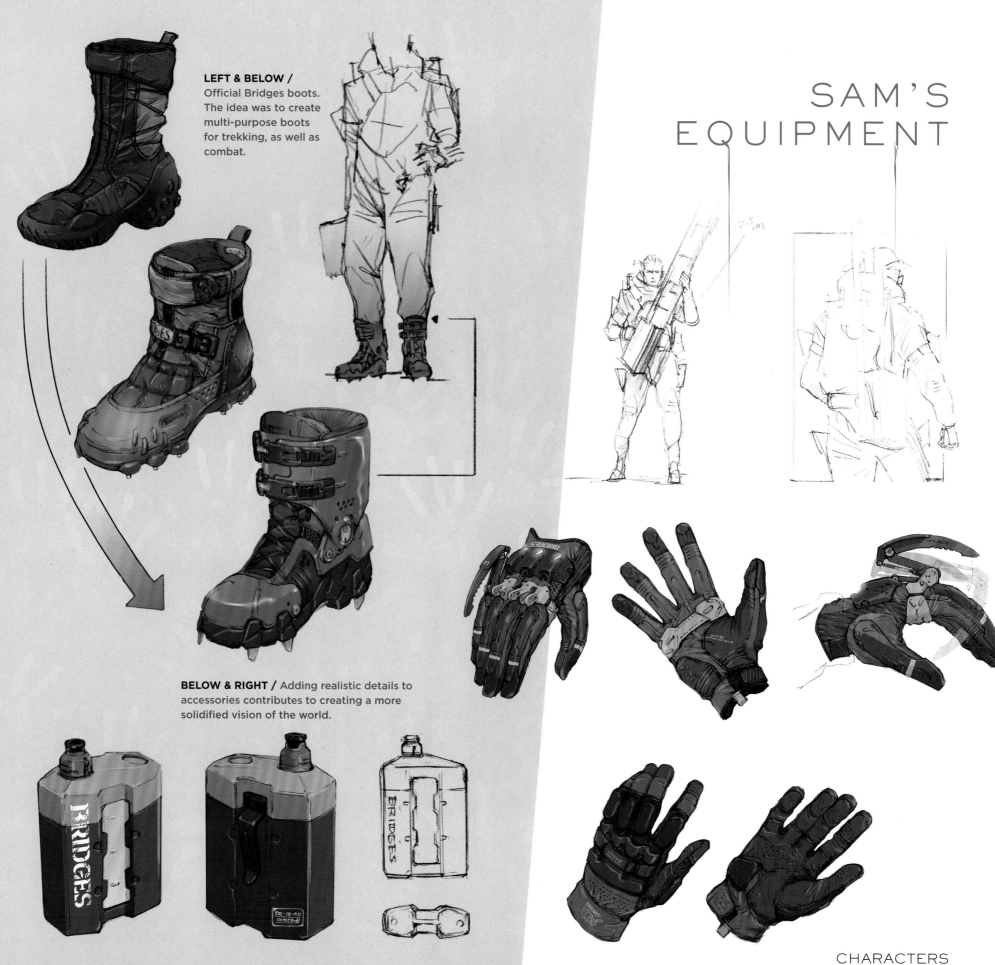

LEFT & BELOW /
Official Bridges boots.
The idea was to create
multi-purpose boots
for trekking, as well as
combat.

BELOW & RIGHT / Adding realistic details to
accessories contributes to creating a more
solidified vision of the world.

SAM'S EQUIPMENT

BELOW / A visor for timefall, which automatically extends with the hood.

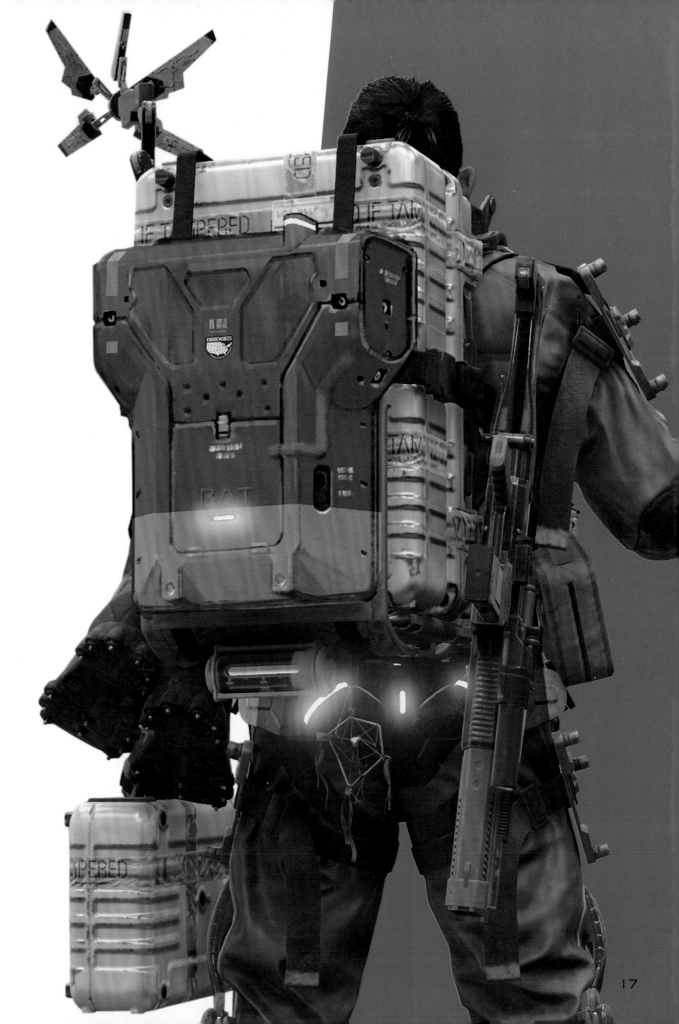

SAM'S EQUIPMENT

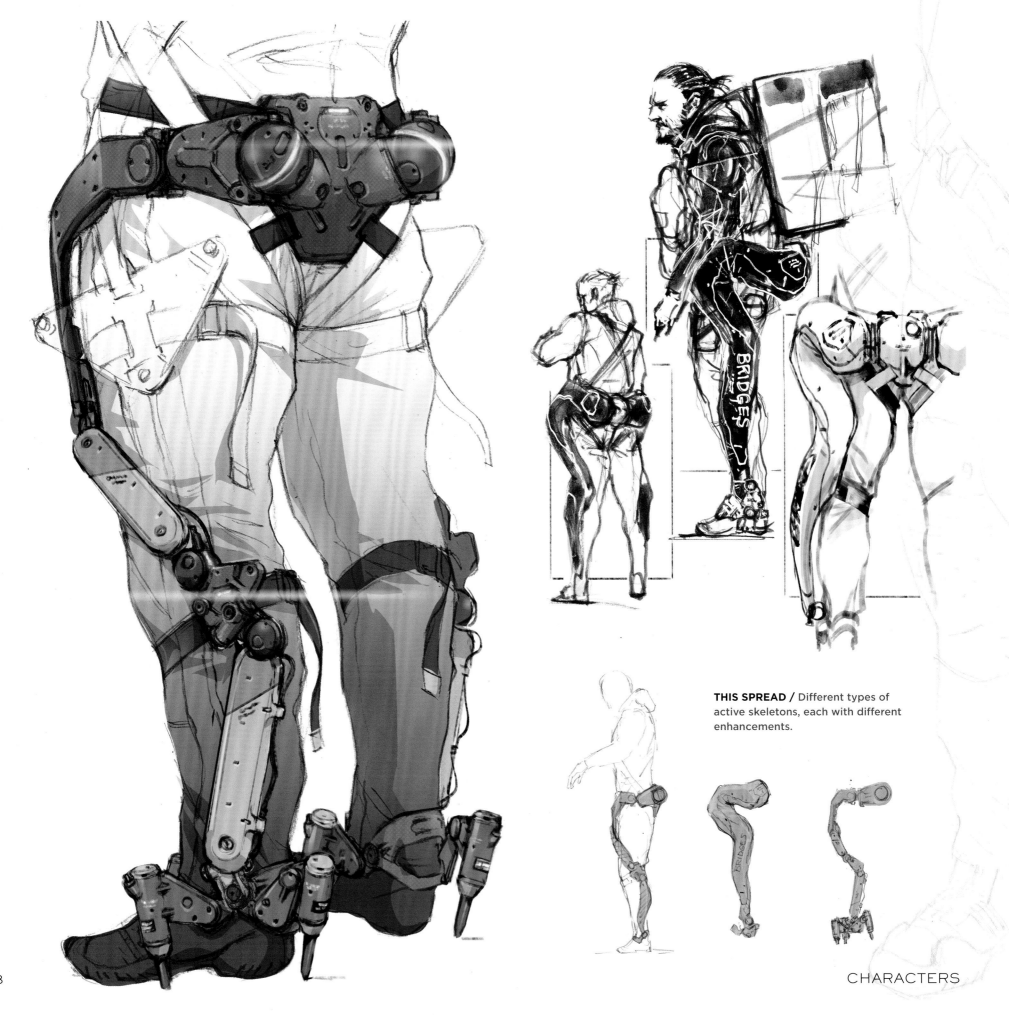

THIS SPREAD / Different types of active skeletons, each with different enhancements.

CHARACTERS

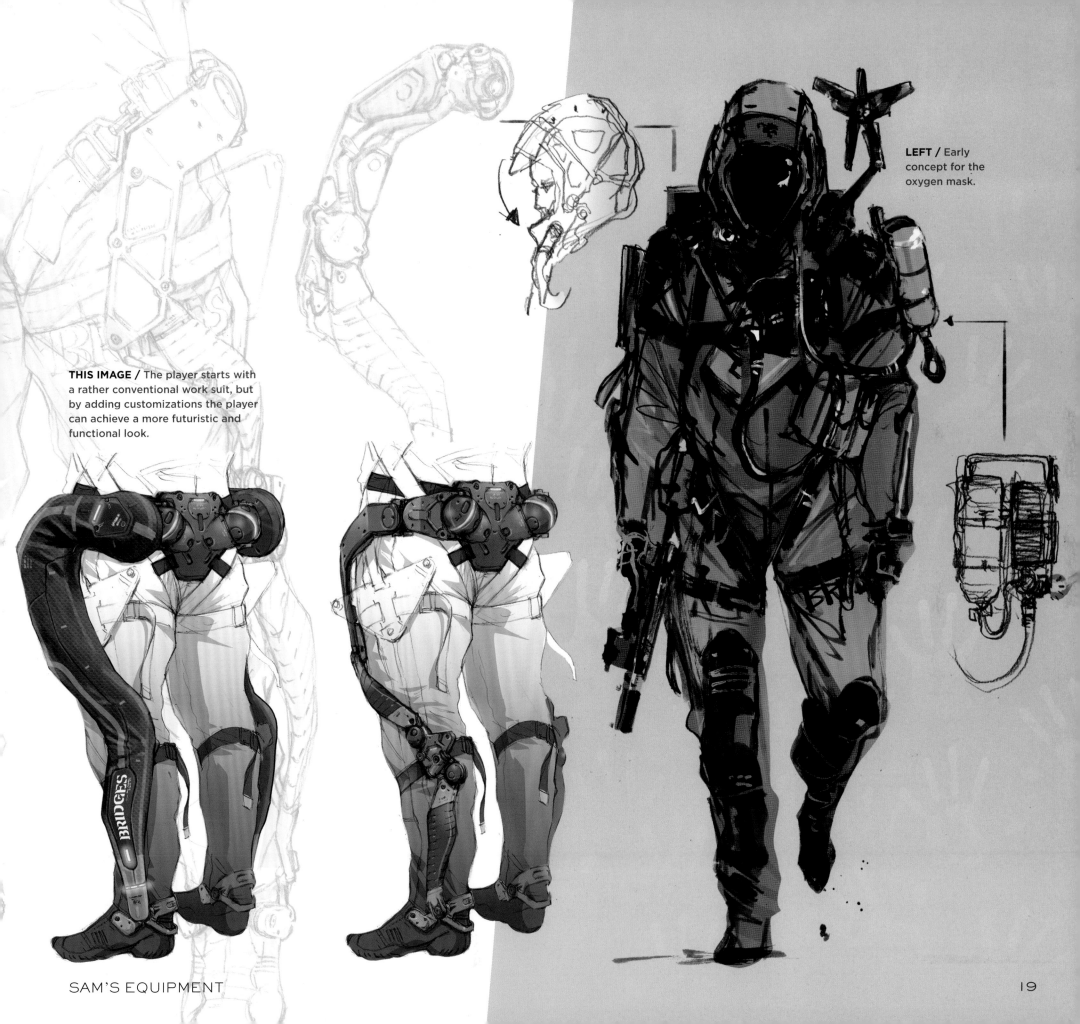

LEFT / Early concept for the oxygen mask.

THIS IMAGE / The player starts with a rather conventional work suit, but by adding customizations the player can achieve a more futuristic and functional look.

SAM'S EQUIPMENT

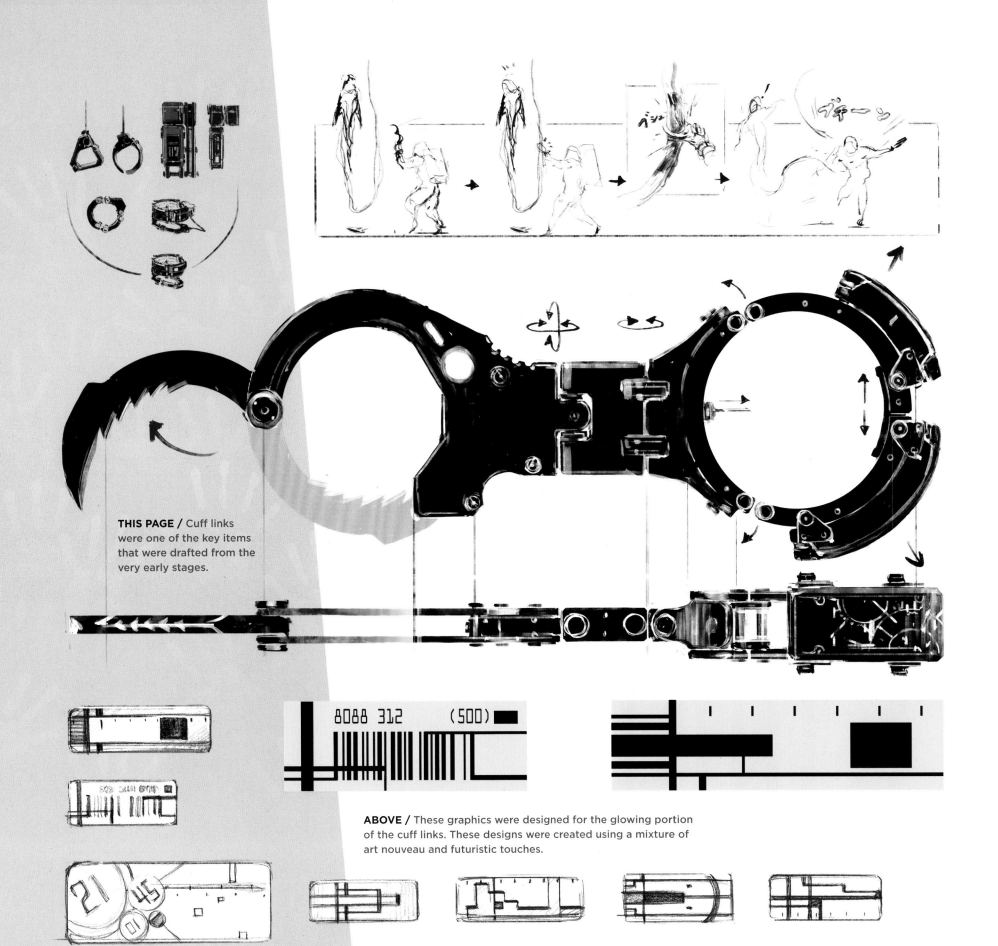

THIS PAGE / Cuff links were one of the key items that were drafted from the very early stages.

8088 312 (500)

ABOVE / These graphics were designed for the glowing portion of the cuff links. These designs were created using a mixture of art nouveau and futuristic touches.

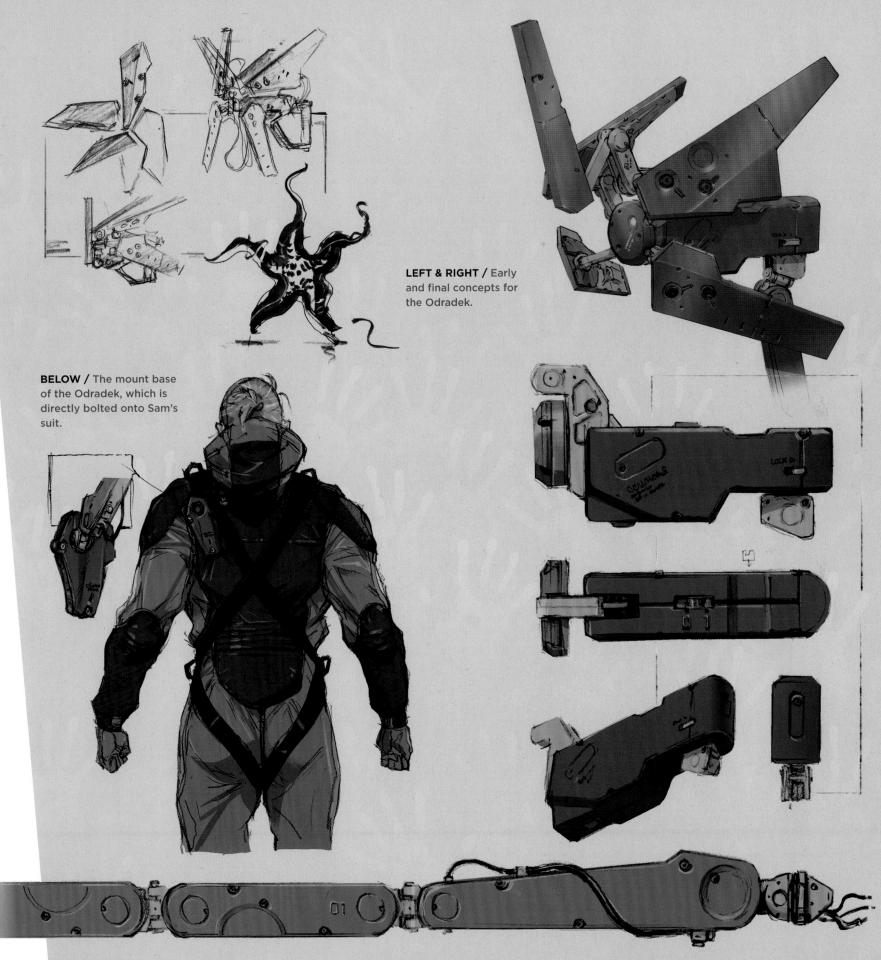

LEFT & RIGHT / Early and final concepts for the Odradek.

BELOW / The mount base of the Odradek, which is directly bolted onto Sam's suit.

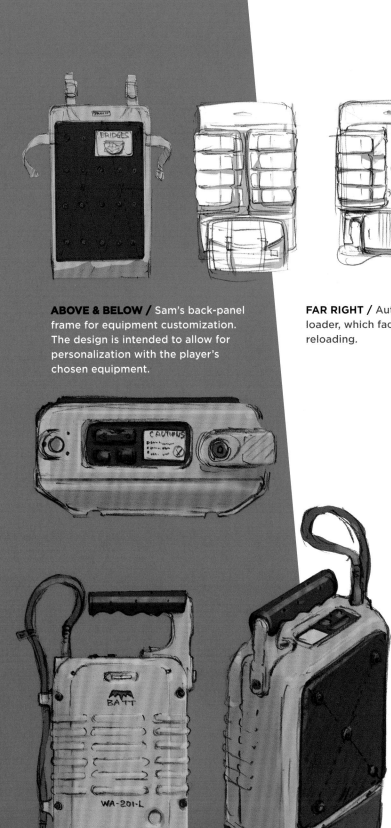

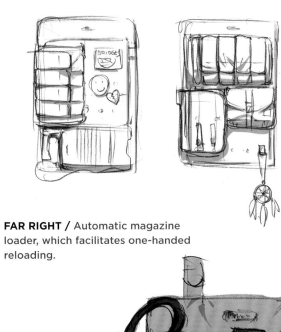

ABOVE & BELOW / Sam's back-panel frame for equipment customization. The design is intended to allow for personalization with the player's chosen equipment.

FAR RIGHT / Automatic magazine loader, which facilitates one-handed reloading.

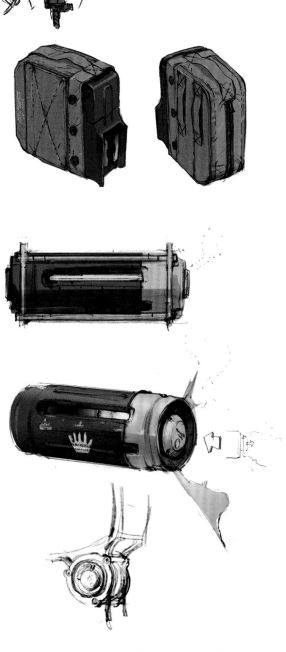

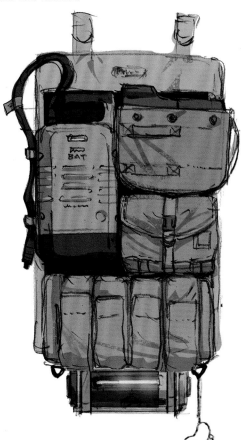

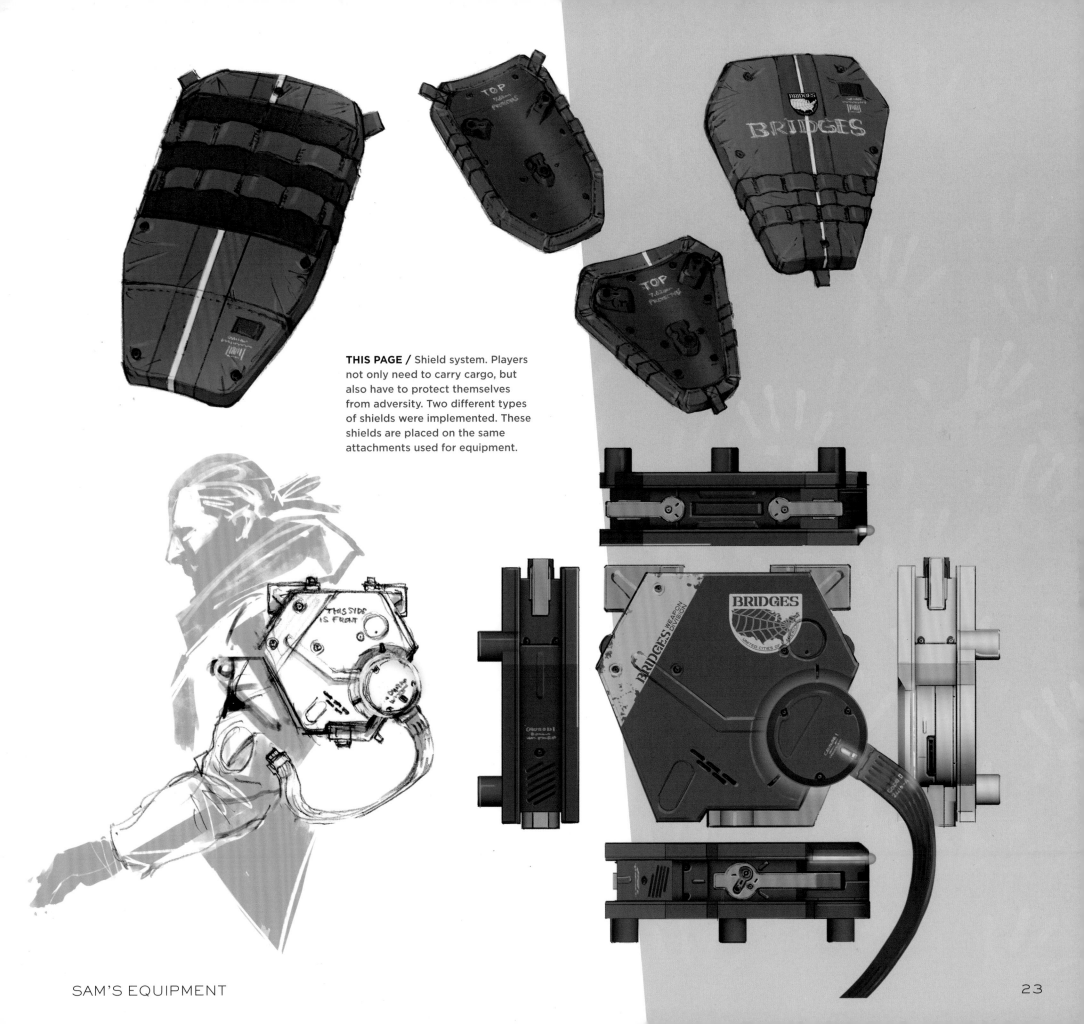

THIS PAGE / Shield system. Players not only need to carry cargo, but also have to protect themselves from adversity. Two different types of shields were implemented. These shields are placed on the same attachments used for equipment.

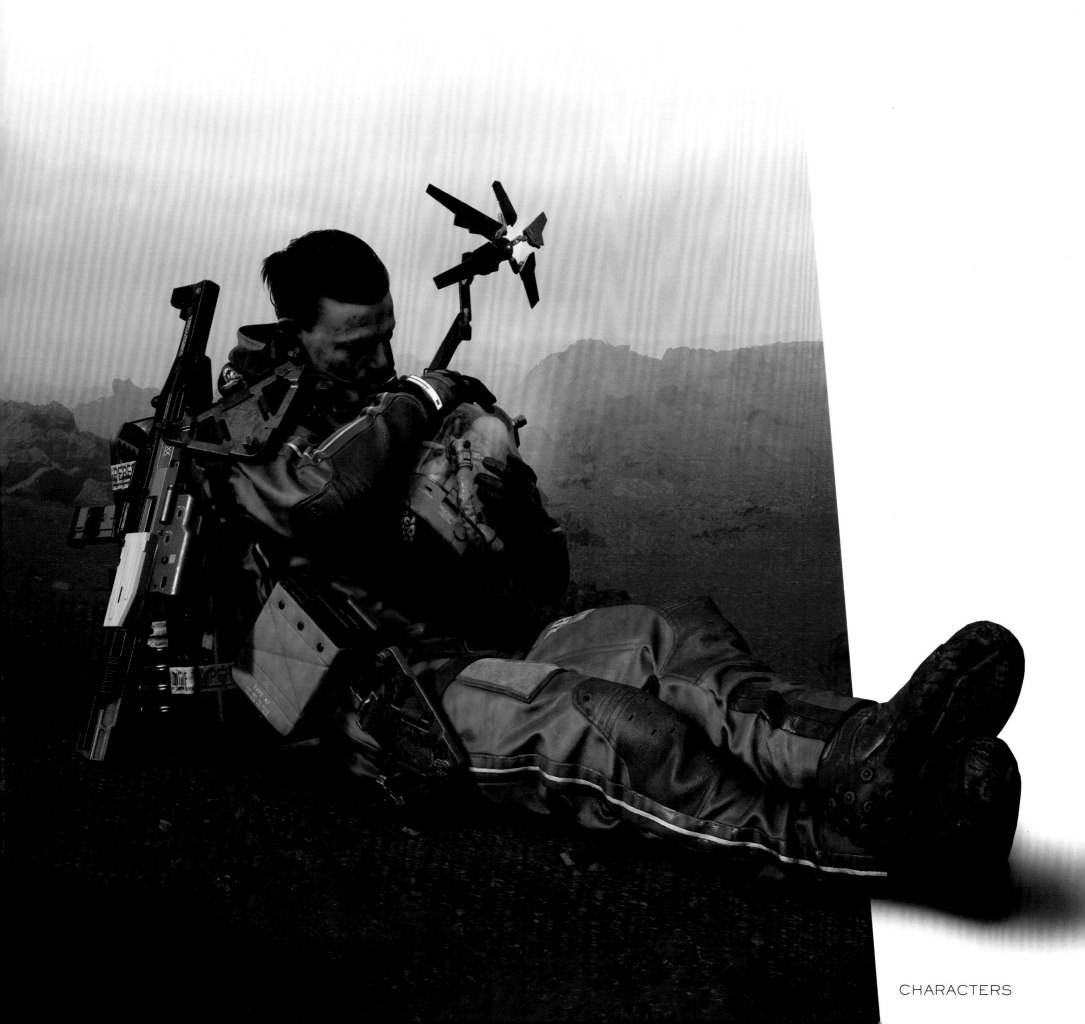

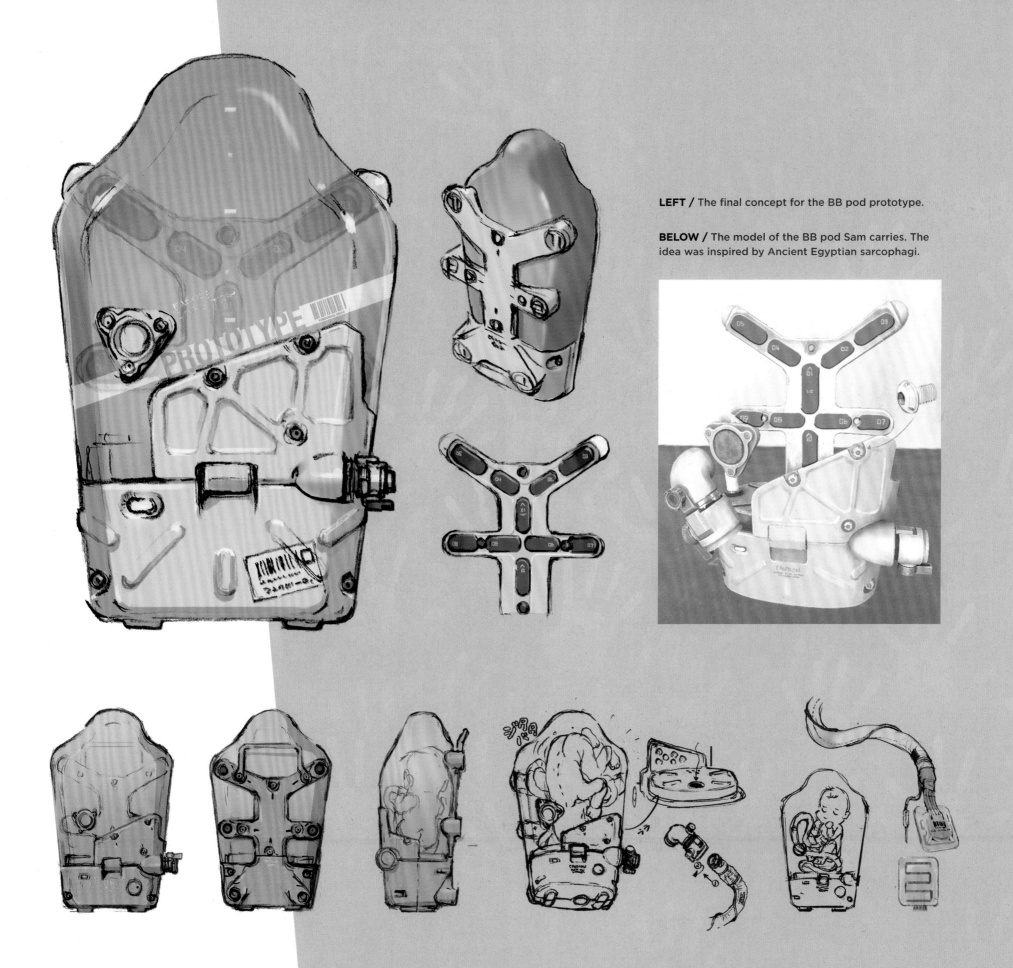

LEFT / The final concept for the BB pod prototype.

BELOW / The model of the BB pod Sam carries. The idea was inspired by Ancient Egyptian sarcophagi.

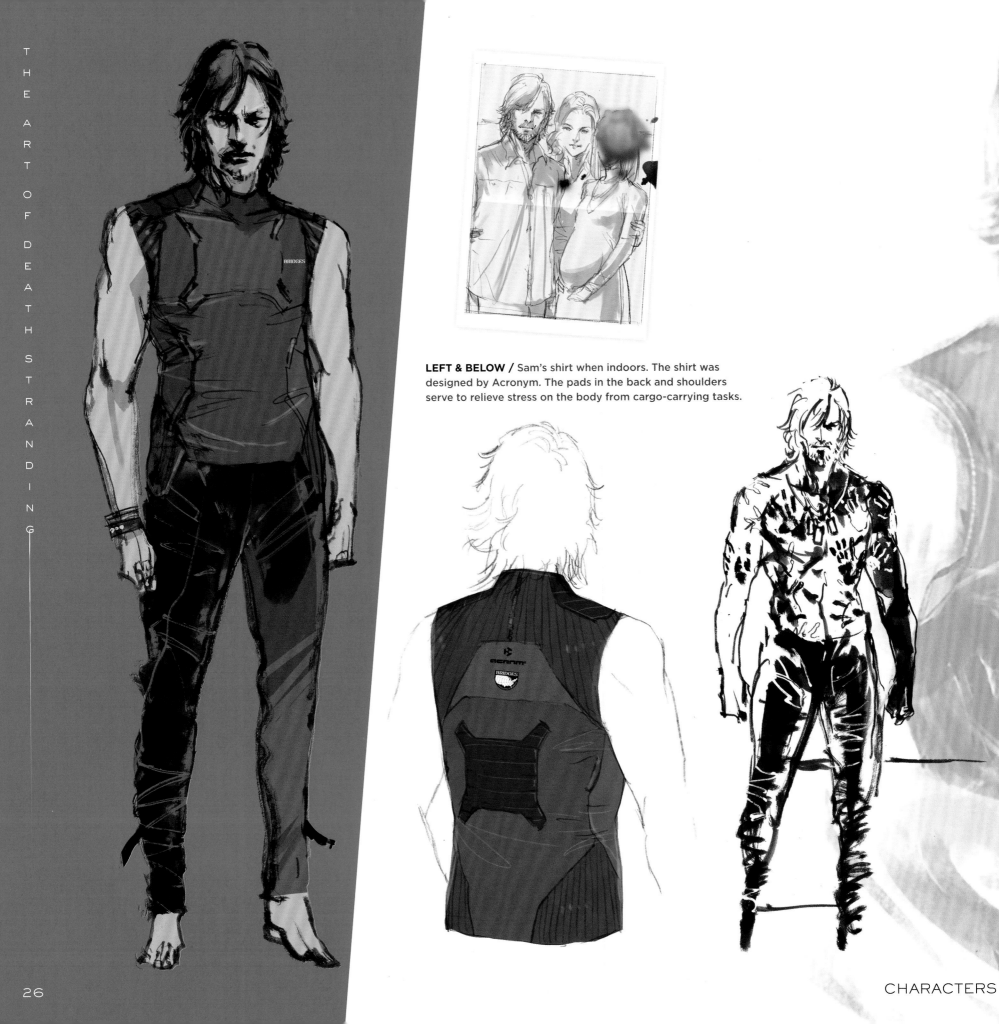

LEFT & BELOW / Sam's shirt when indoors. The shirt was designed by Acronym. The pads in the back and shoulders serve to relieve stress on the body from cargo-carrying tasks.

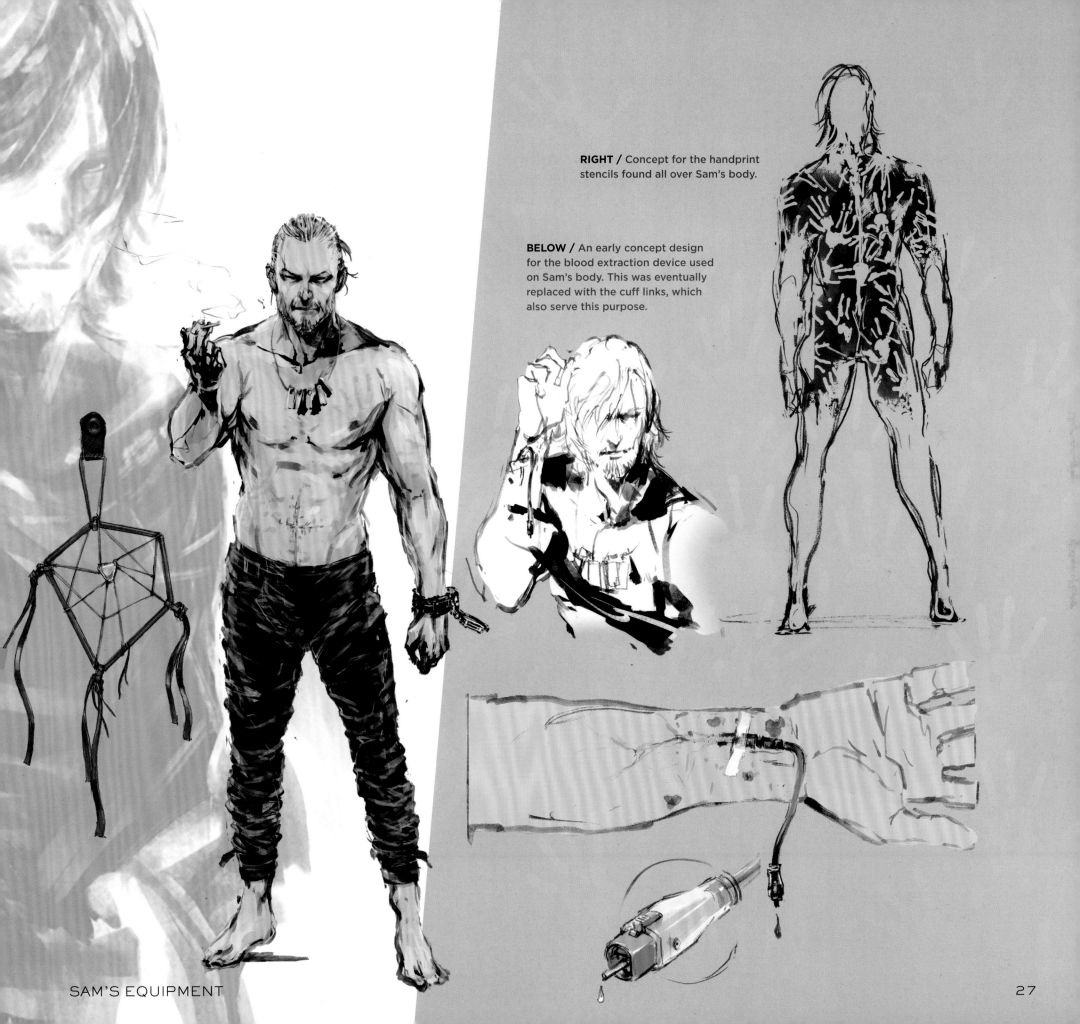

RIGHT / Concept for the handprint stencils found all over Sam's body.

BELOW / An early concept design for the blood extraction device used on Sam's body. This was eventually replaced with the cuff links, which also serve this purpose.

SAM'S EQUIPMENT

BRIDGET STRAND

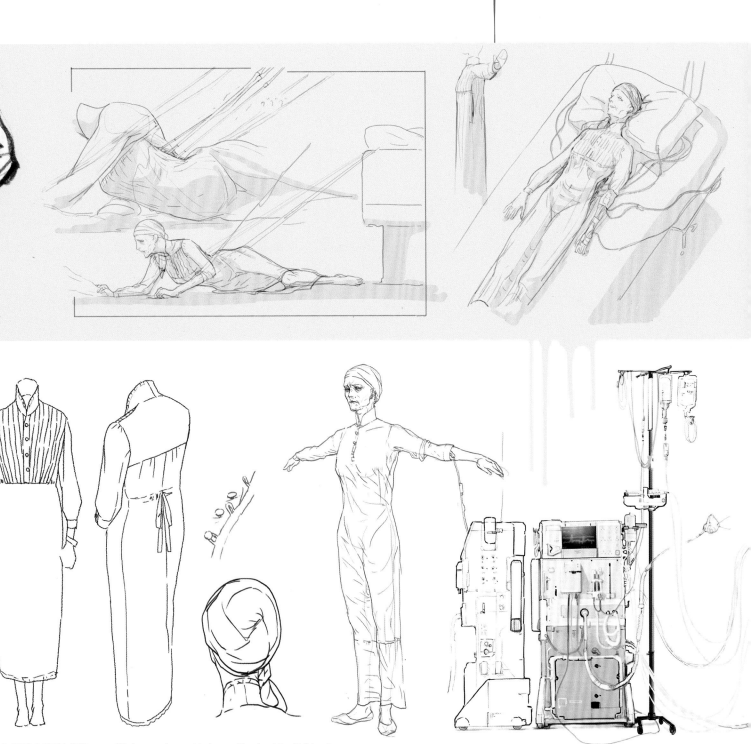

ABOVE & OPPOSITE / The multiple cords and tubes attached to Bridget in her hospital bed reference some of the critical concepts in DEATH STRANDING such as strands and connections.

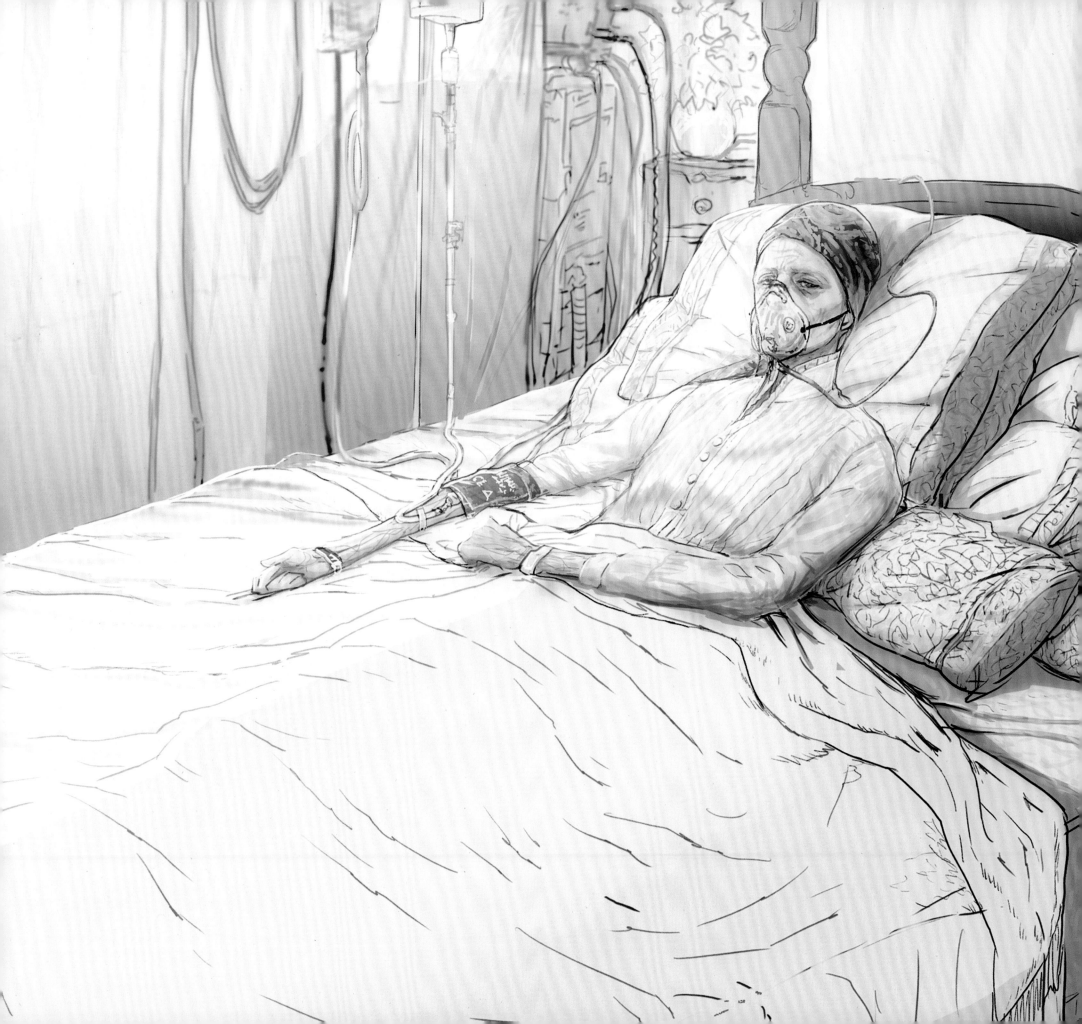

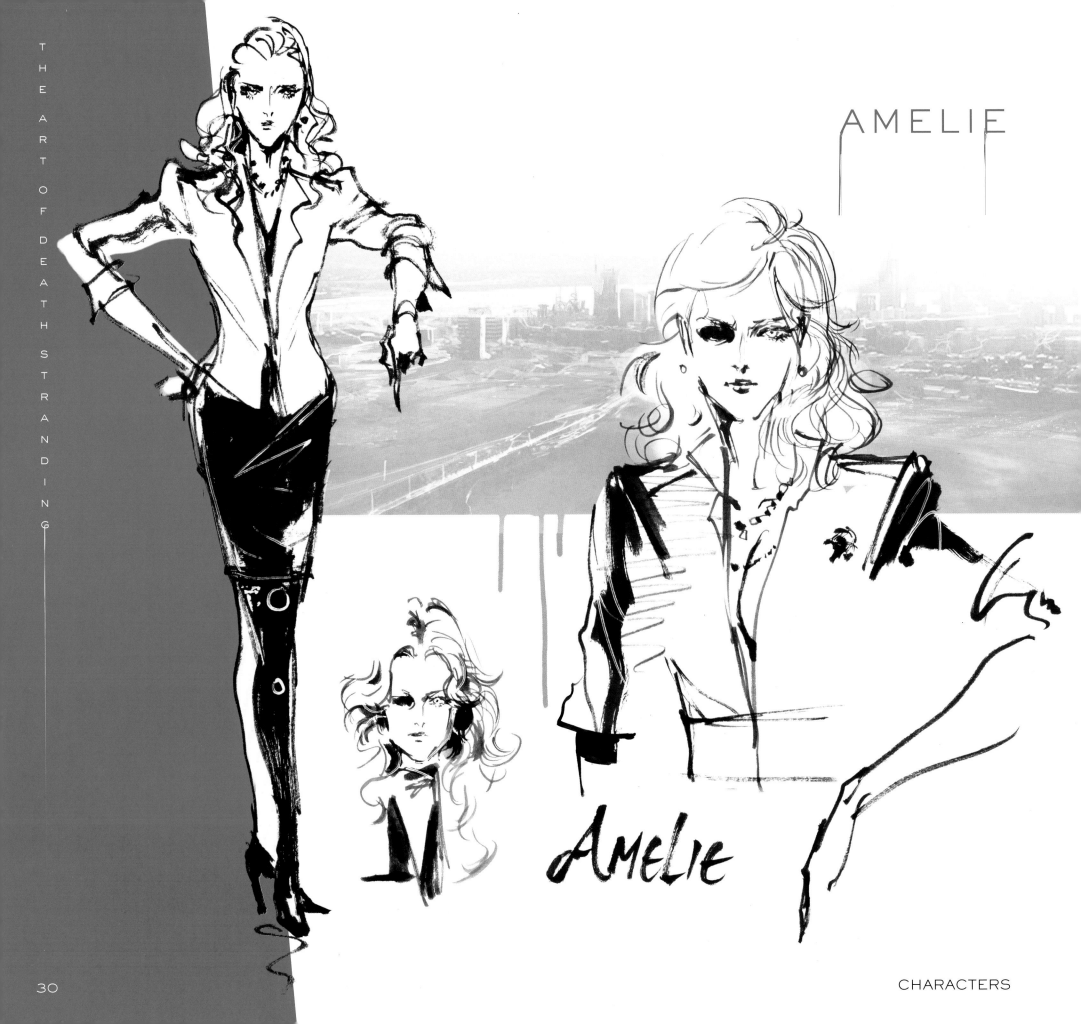

THE ART OF DEATH STRANDING

Amelie

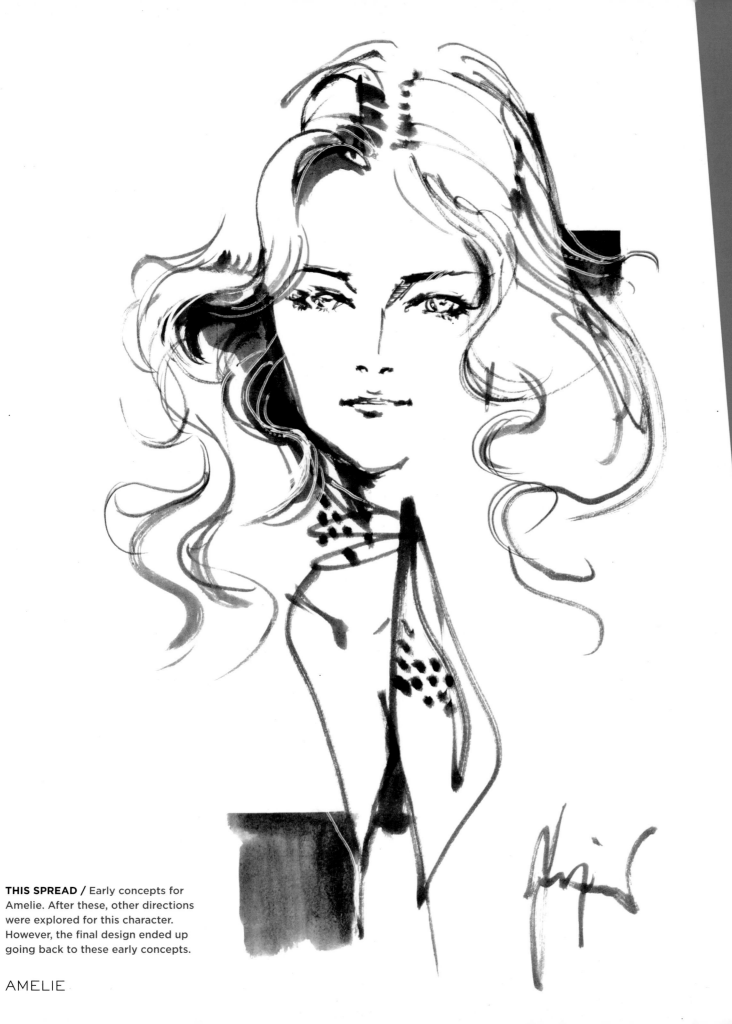

THIS SPREAD / Early concepts for Amelie. After these, other directions were explored for this character. However, the final design ended up going back to these early concepts.

AMELIE

31

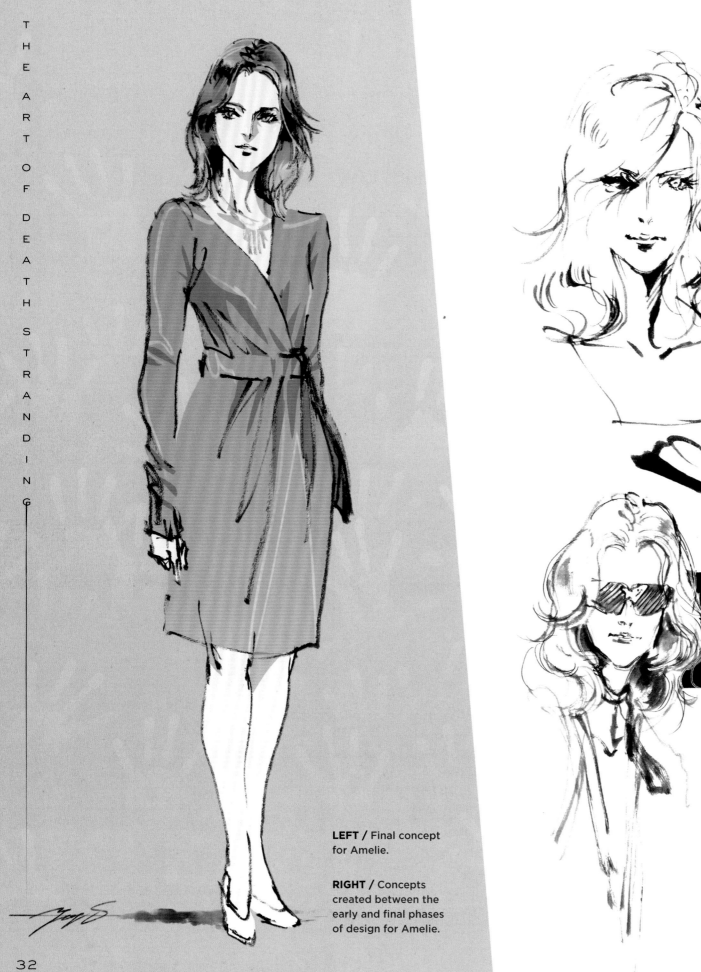

LEFT / Final concept for Amelie.

RIGHT / Concepts created between the early and final phases of design for Amelie.

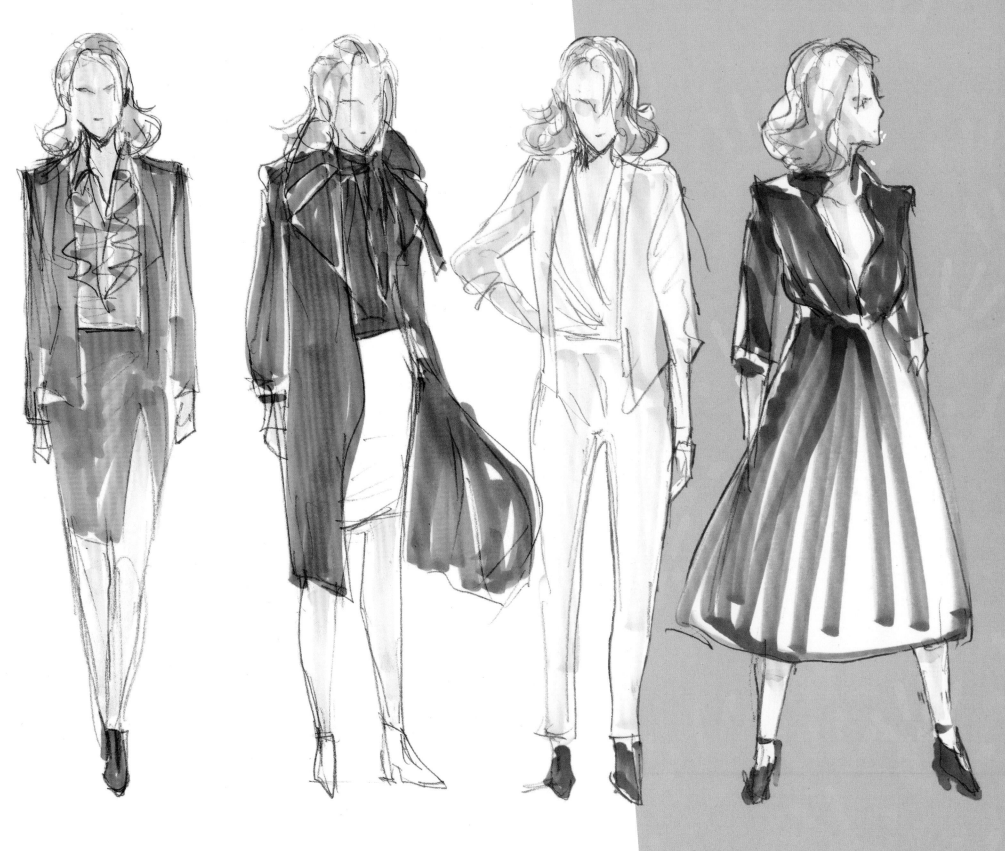

THIS PAGE / Tests were drafted to determine the color palette for Amelie's character.

AMELIE

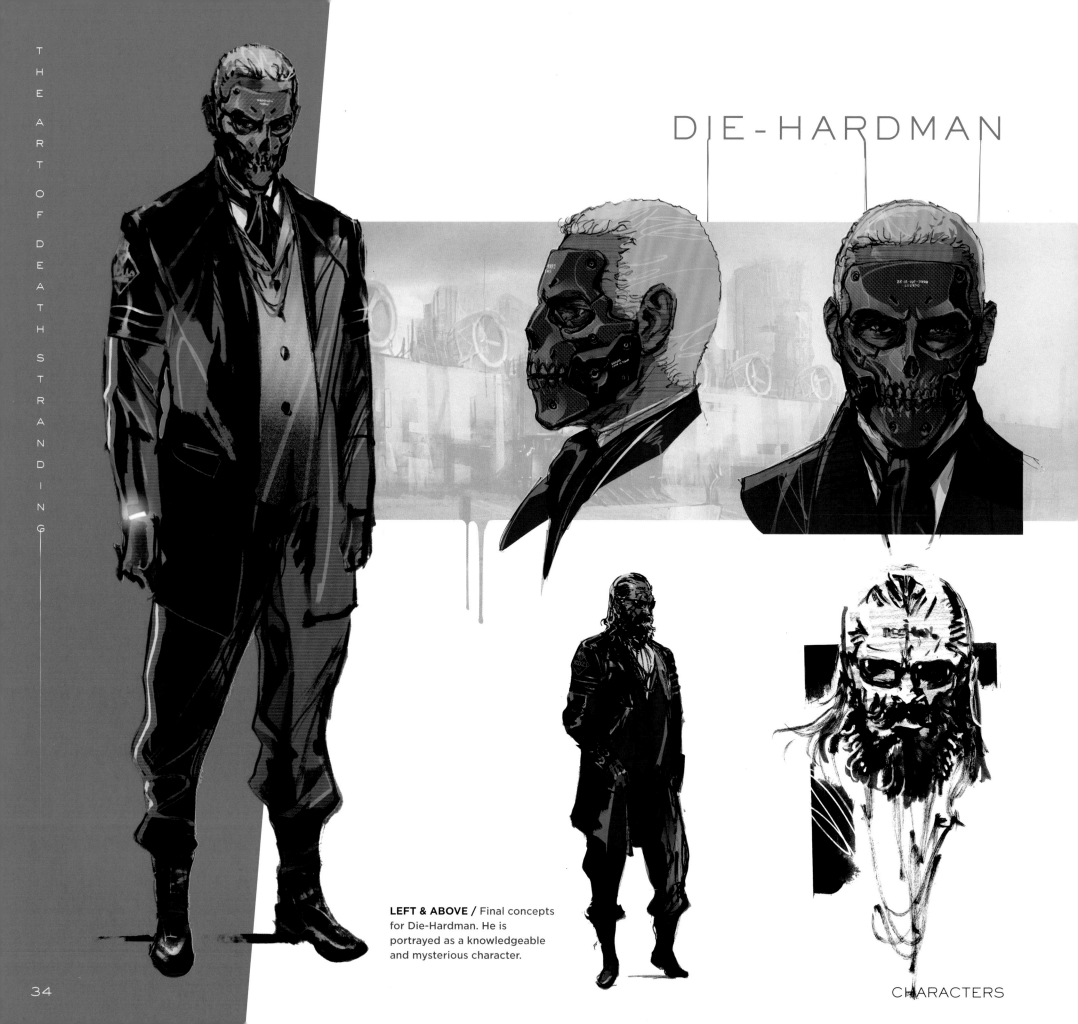

DIE-HARDMAN

LEFT & ABOVE / Final concepts for Die-Hardman. He is portrayed as a knowledgeable and mysterious character.

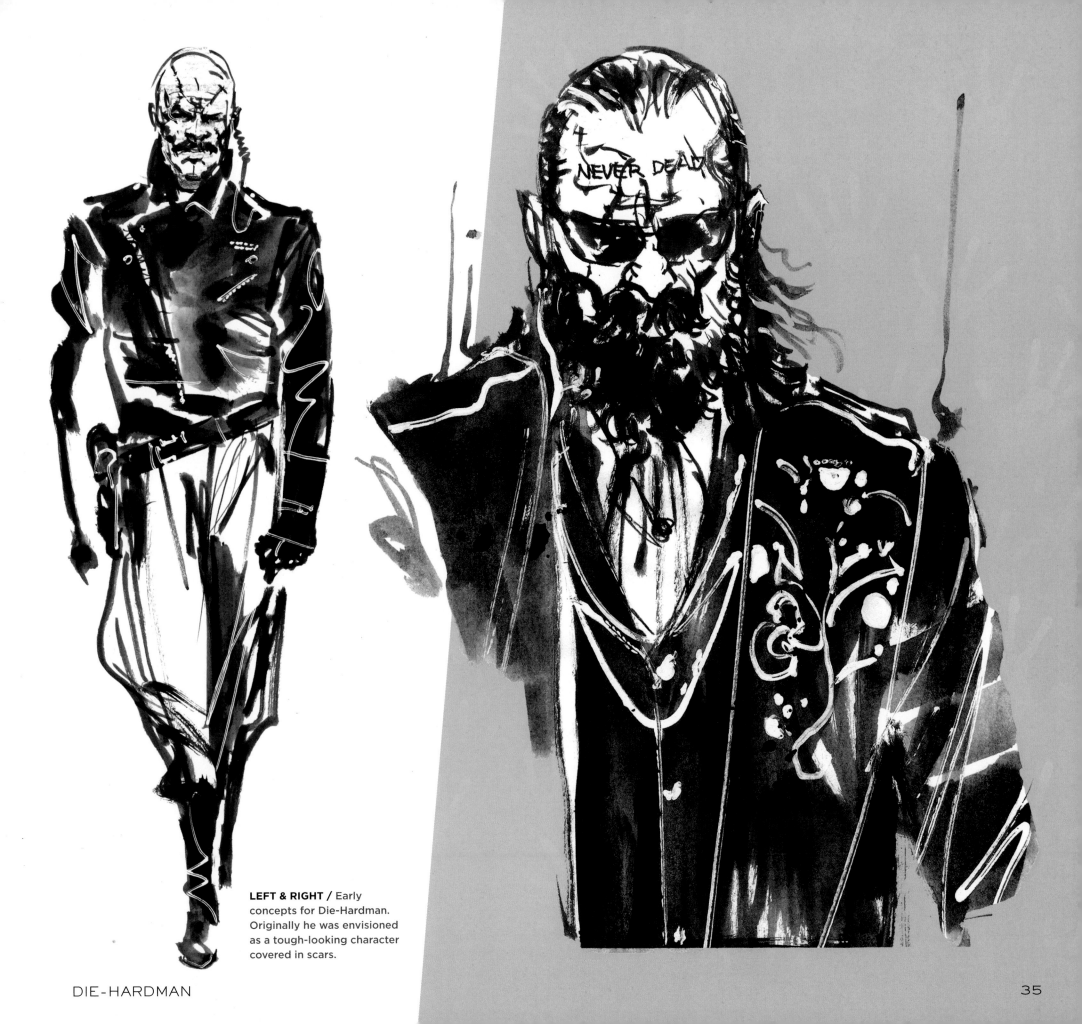

LEFT & RIGHT / Early concepts for Die-Hardman. Originally he was envisioned as a tough-looking character covered in scars.

DIE-HARDMAN

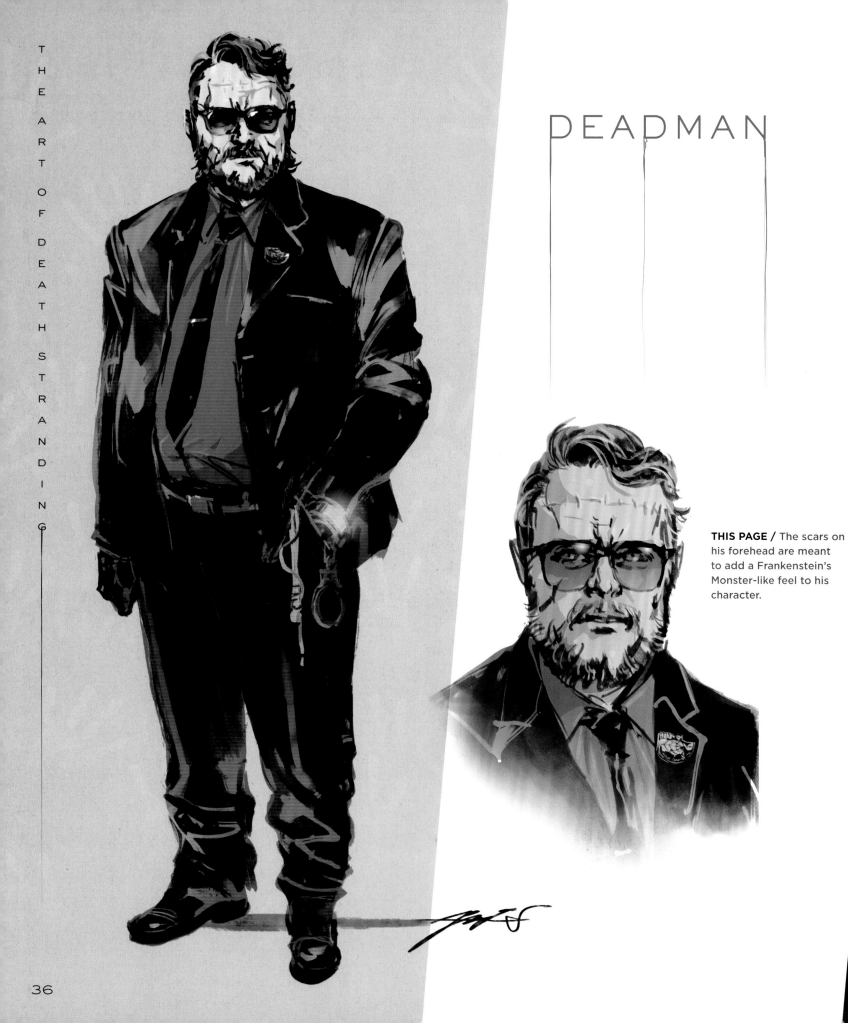

DEADMAN

THIS PAGE / The scars on his forehead are meant to add a Frankenstein's Monster-like feel to his character.

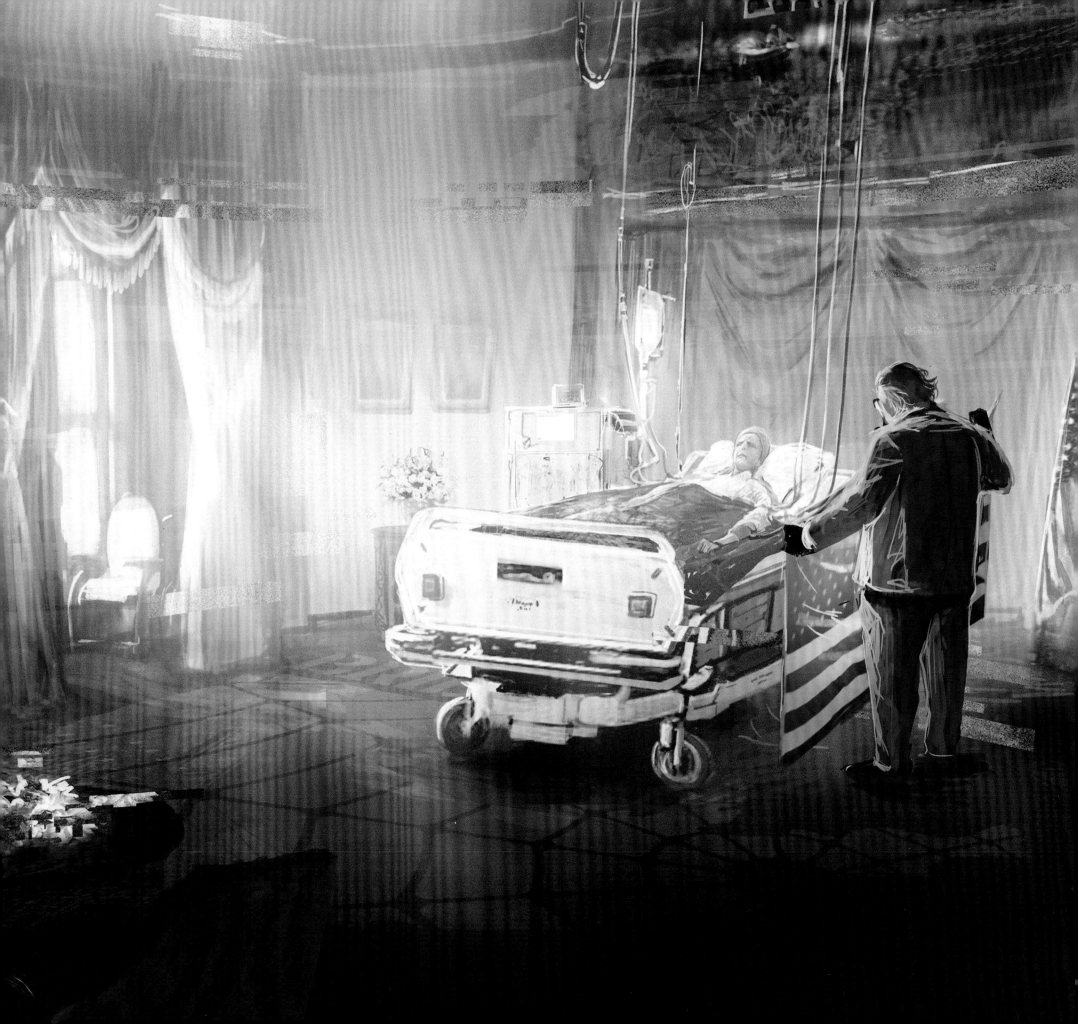

HEARTMAN

THIS SPREAD / Conceptualizing Heartman, as with some other characters, required starting from the uniqueness of an actual person and expanding from there to create the concept for the character, which proved to be a remarkably interesting task.

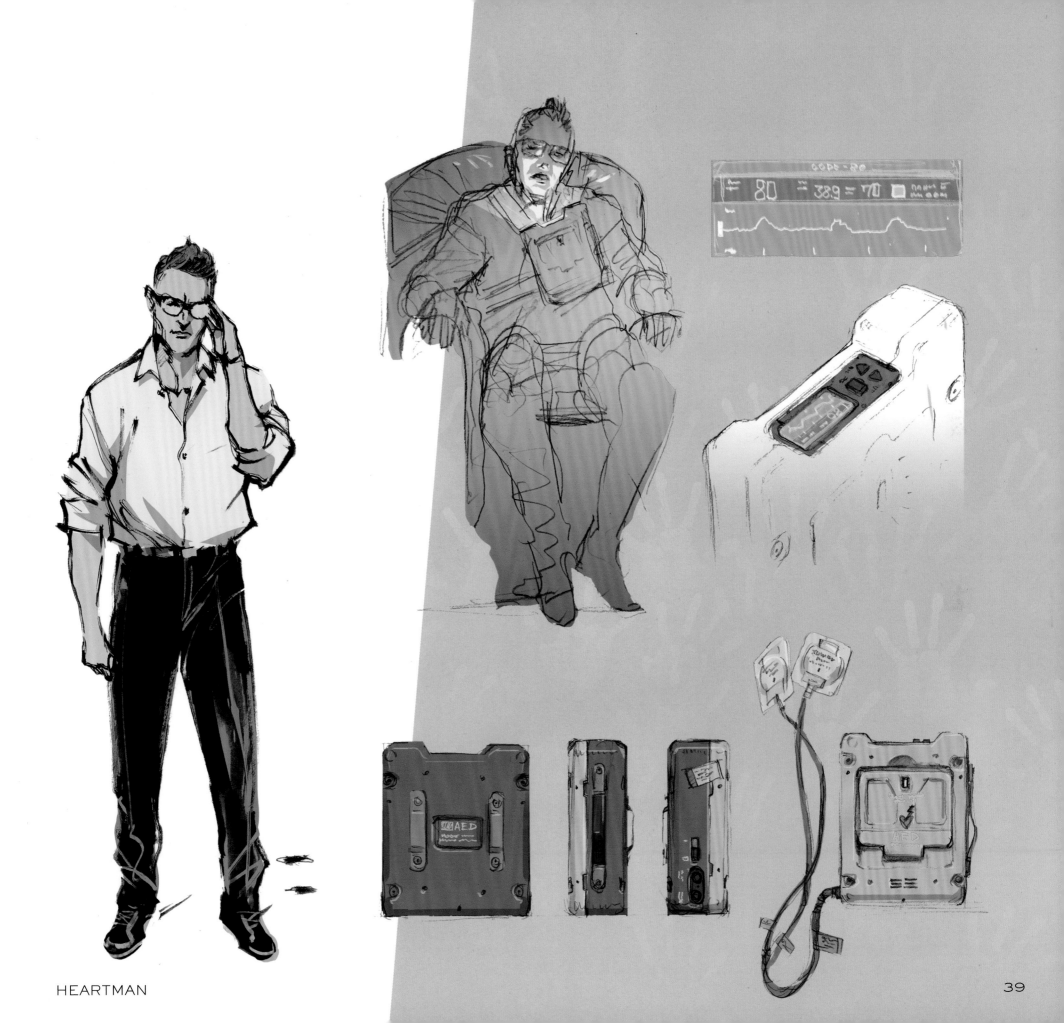

HEARTMAN

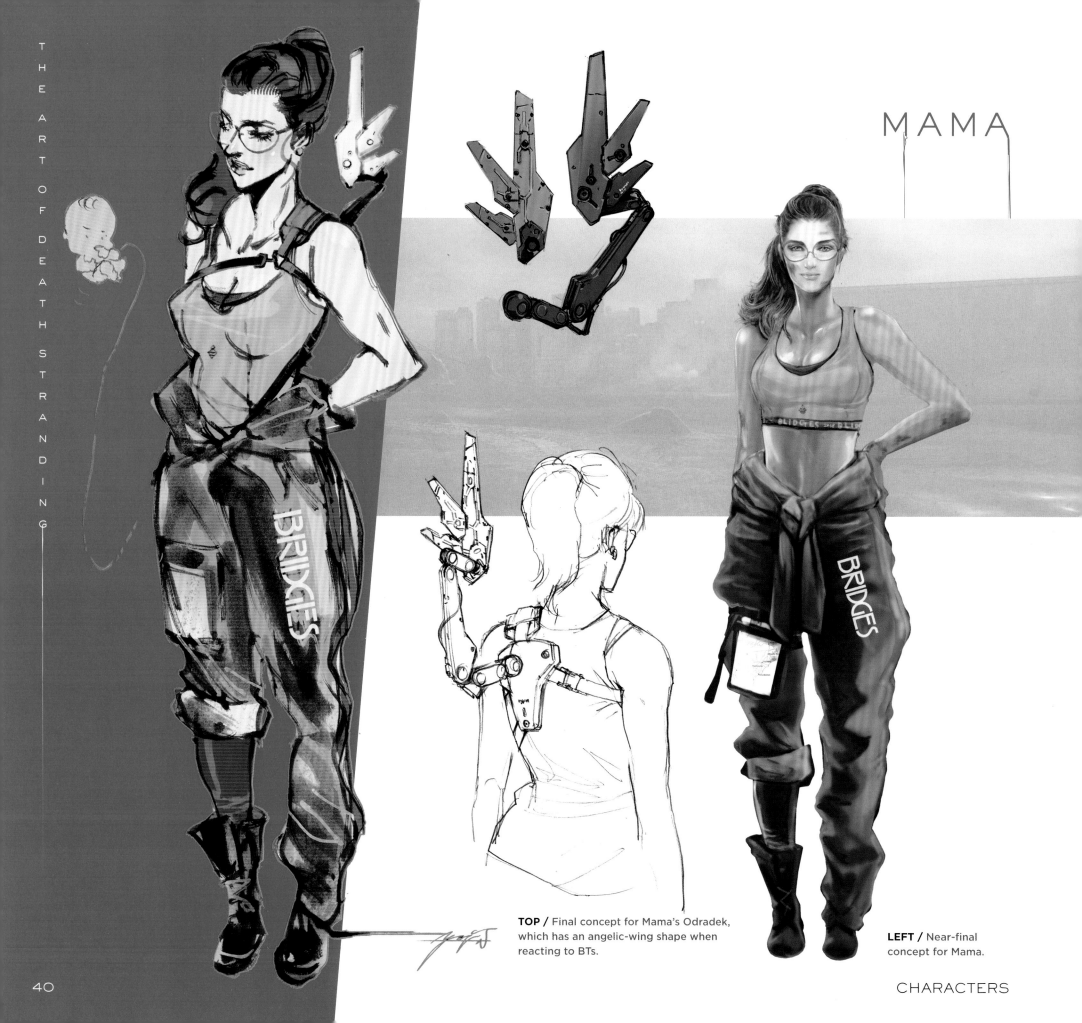

MAMA

TOP / Final concept for Mama's Odradek, which has an angelic-wing shape when reacting to BTs.

LEFT / Near-final concept for Mama.

CHARACTERS

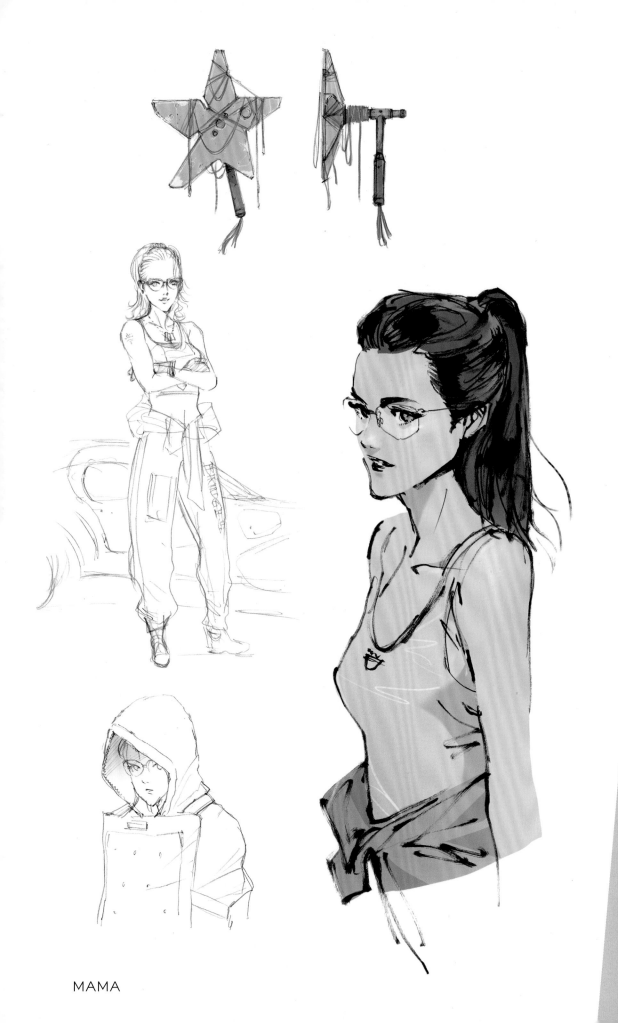

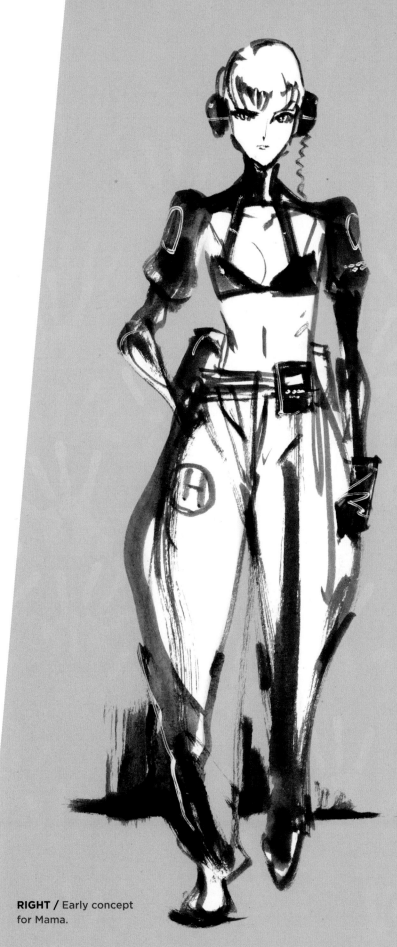

RIGHT / Early concept for Mama.

LOCKNE

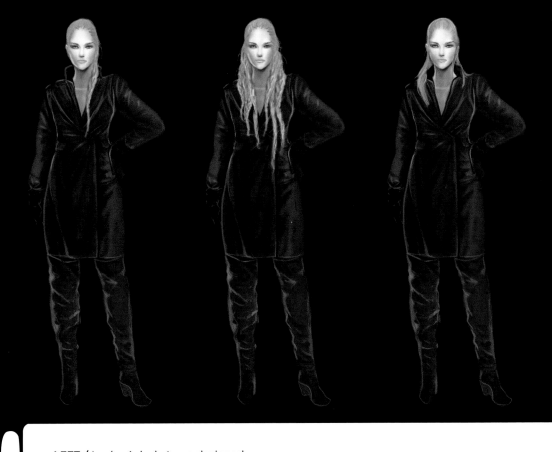

LEFT / Lockne's jacket was designed by Acronym. Acronym's futuristic and highly functional design concepts proved to be a great fit in the world of DEATH STRANDING.

ABOVE / The logo was custom-designed and includes Acronym's logo. It was created for Lockne's jacket.

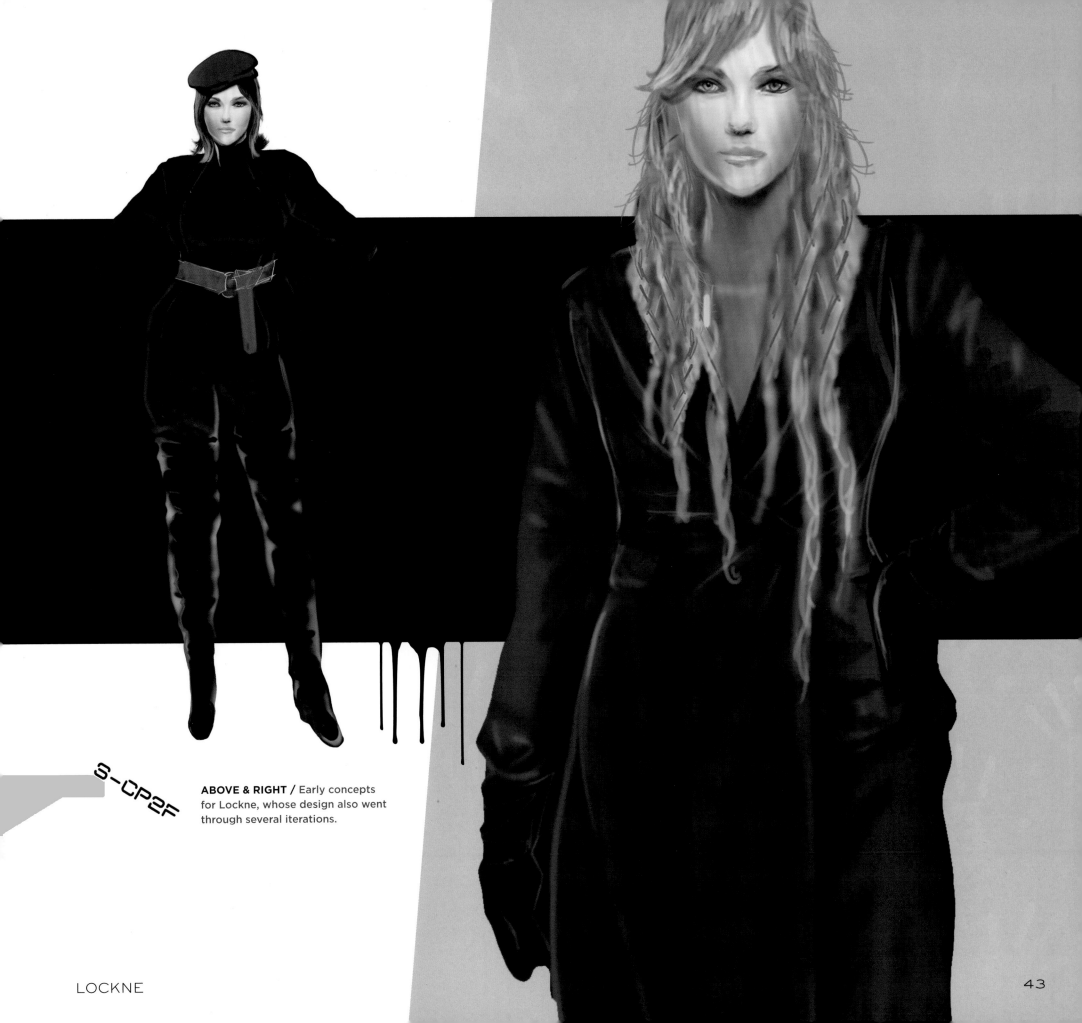

S-CP2F

ABOVE & RIGHT / Early concepts for Lockne, whose design also went through several iterations.

LOCKNE

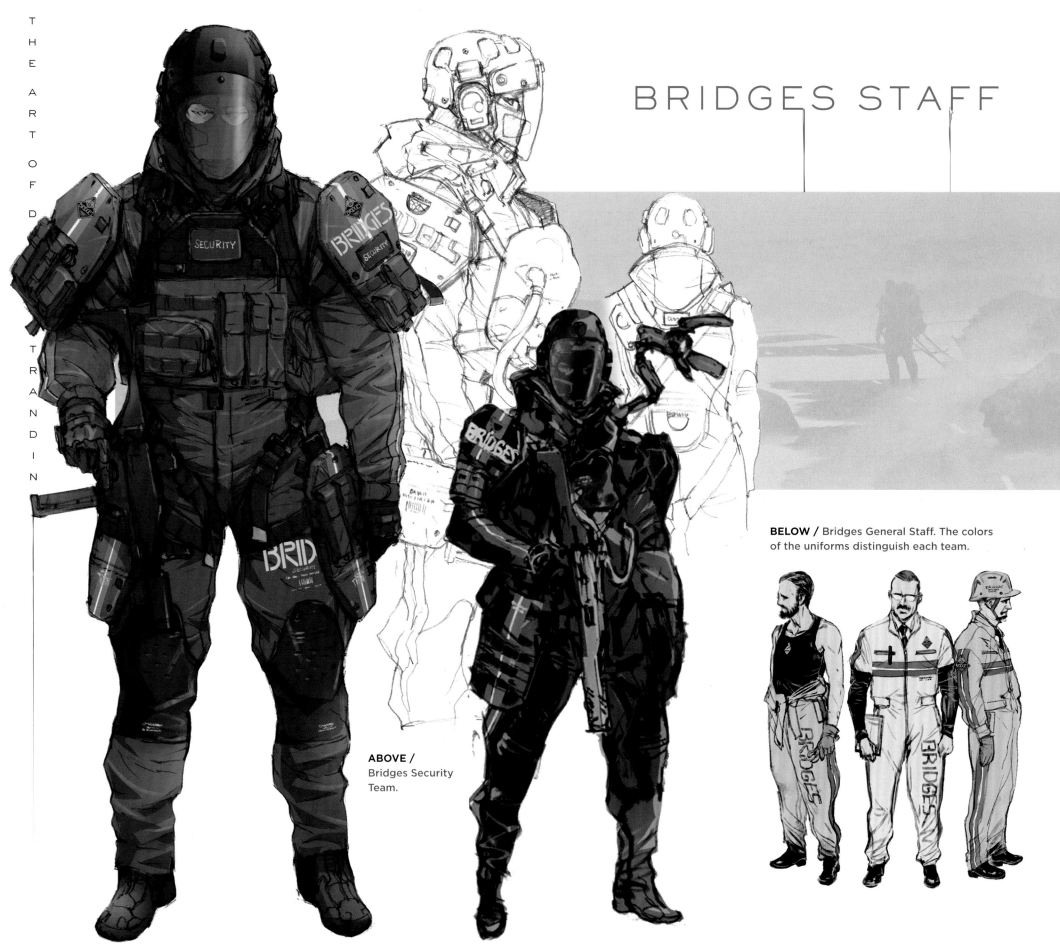

BRIDGES STAFF

BELOW / Bridges General Staff. The colors of the uniforms distinguish each team.

ABOVE /
Bridges Security Team.

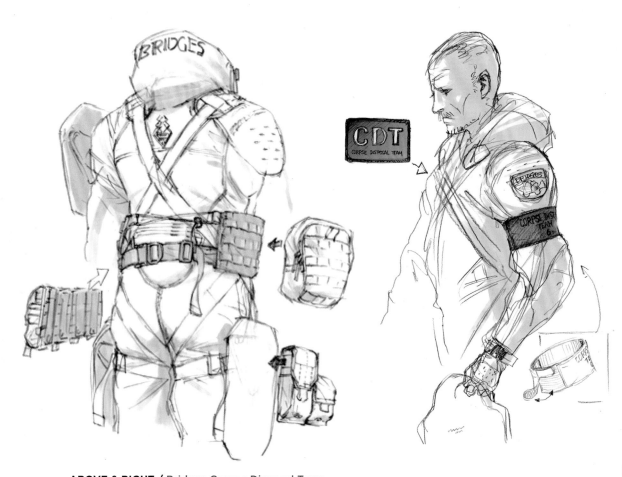

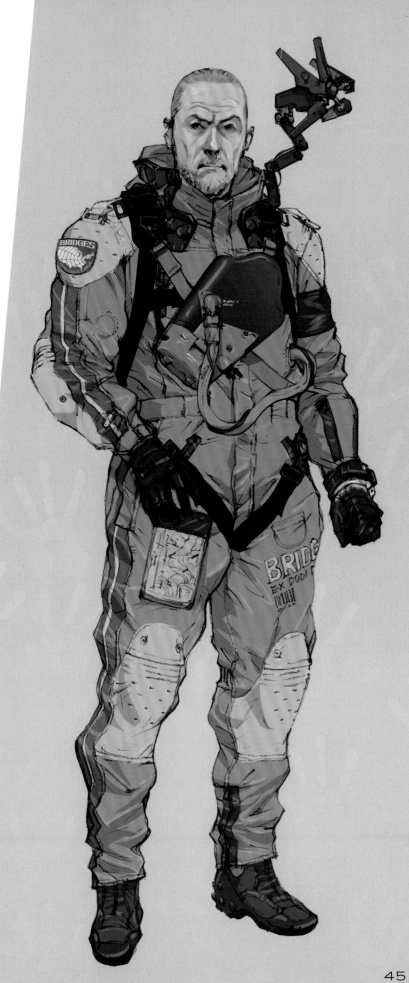

ABOVE & RIGHT / Bridges Corpse Disposal Team.

BELOW / Bridges Delivery Team.

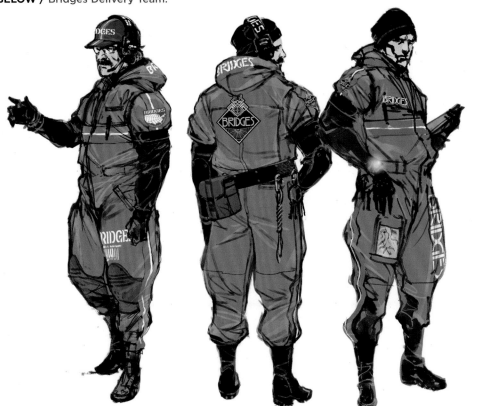

BRIDGES STAFF

FRAGILE

FRAGILE EXPRESS
HANDLED WITH LOVE
★

FRAGILE EXPRESS
FRAGILE EXPRESS
HANDLED WITH LOVE

LEFT / Final concept for Fragile.

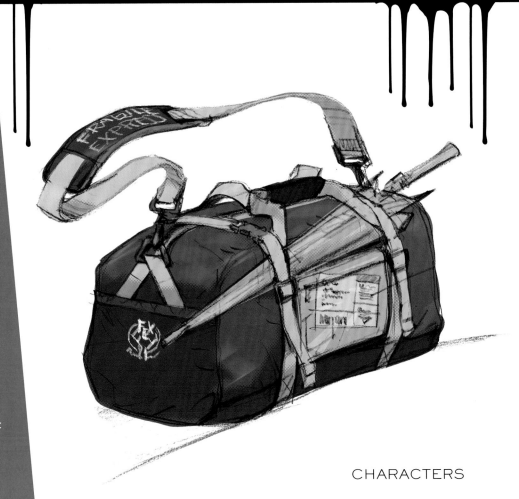

CHARACTERS

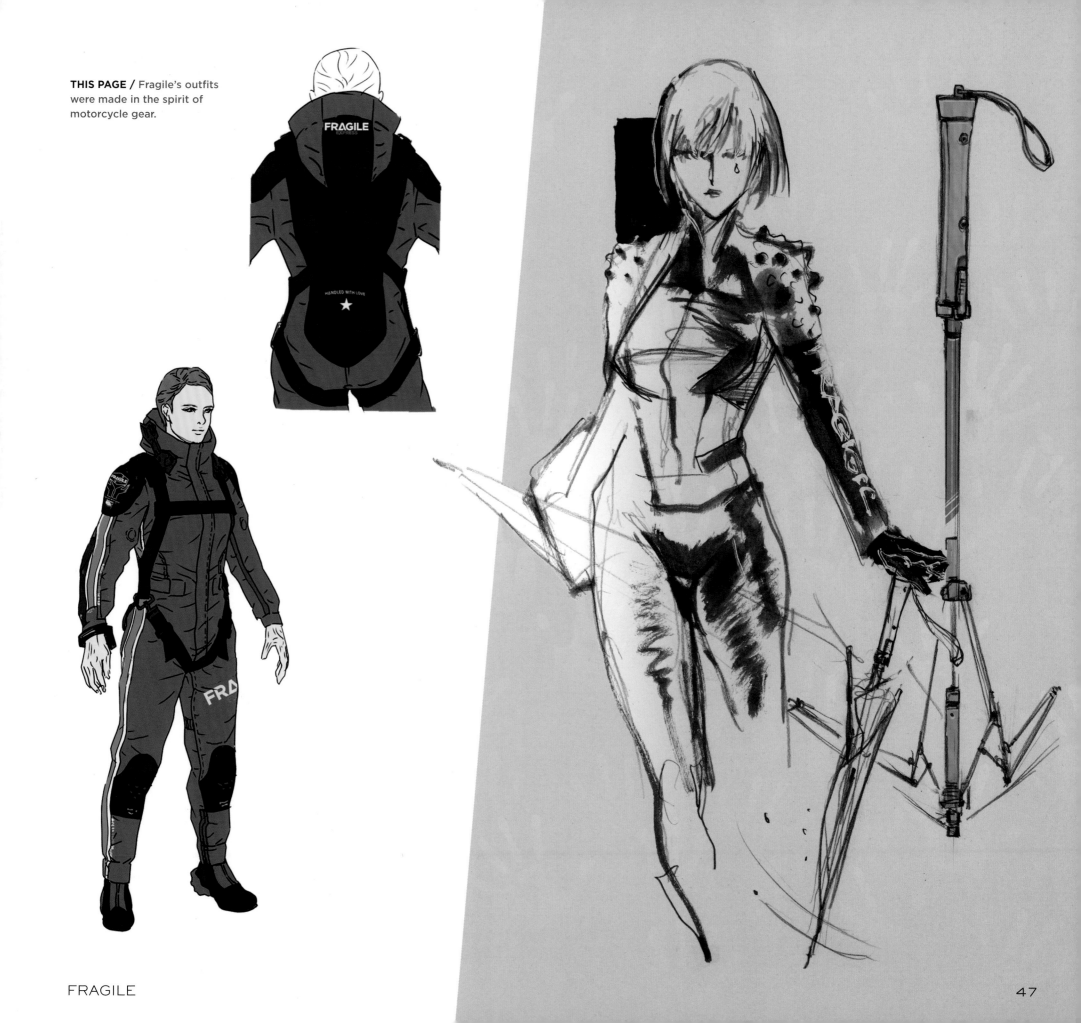

THIS PAGE / Fragile's outfits were made in the spirit of motorcycle gear.

FRAGILE

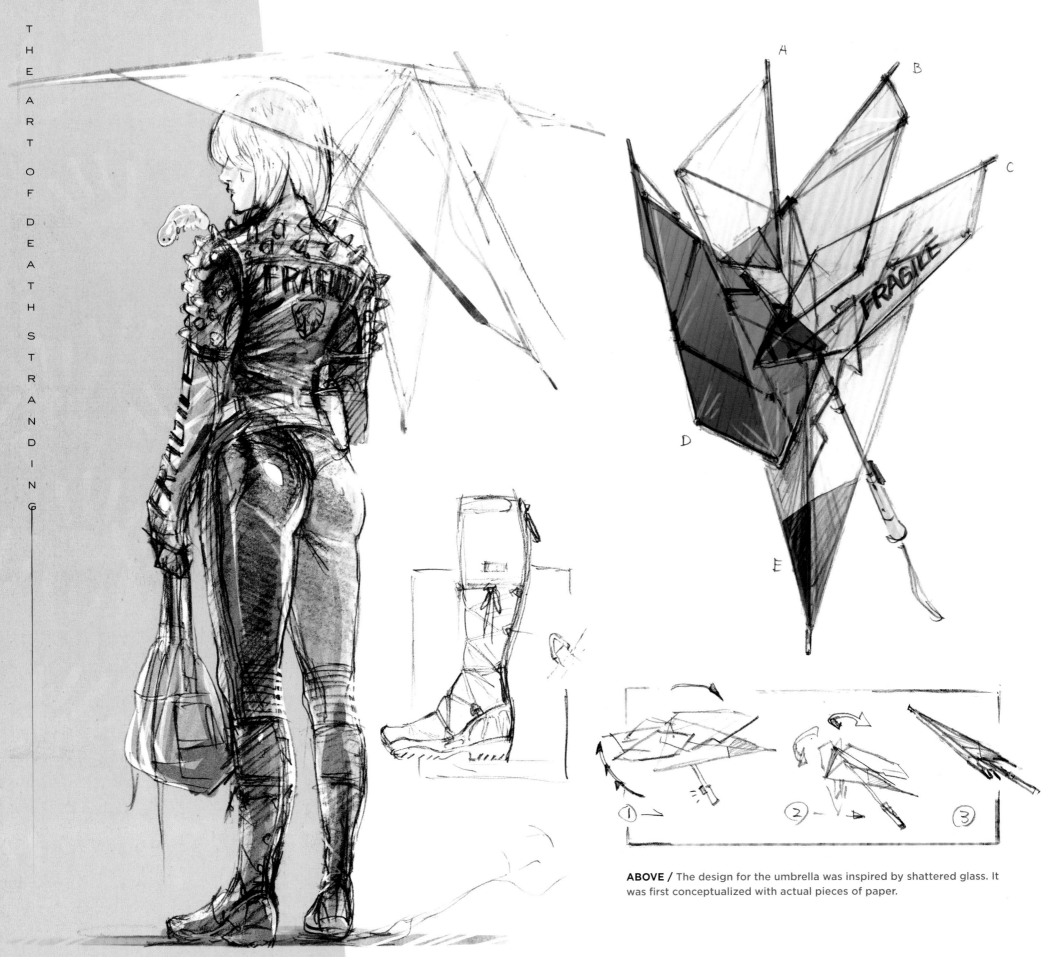

A

B

C

D

E

FRAGILE

FRAGILE

① → ② → ③

ABOVE / The design for the umbrella was inspired by shattered glass. It was first conceptualized with actual pieces of paper.

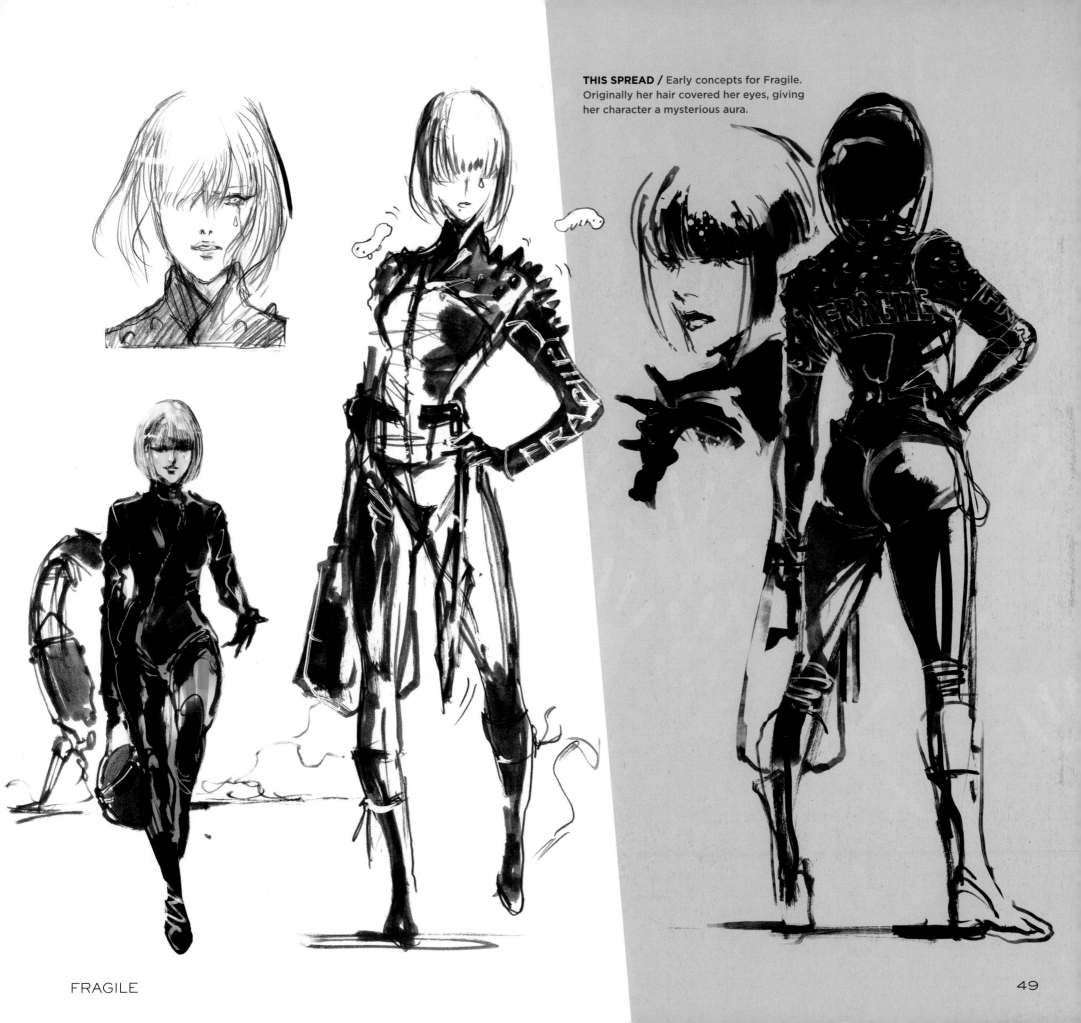

THIS SPREAD / Early concepts for Fragile. Originally her hair covered her eyes, giving her character a mysterious aura.

FRAGILE

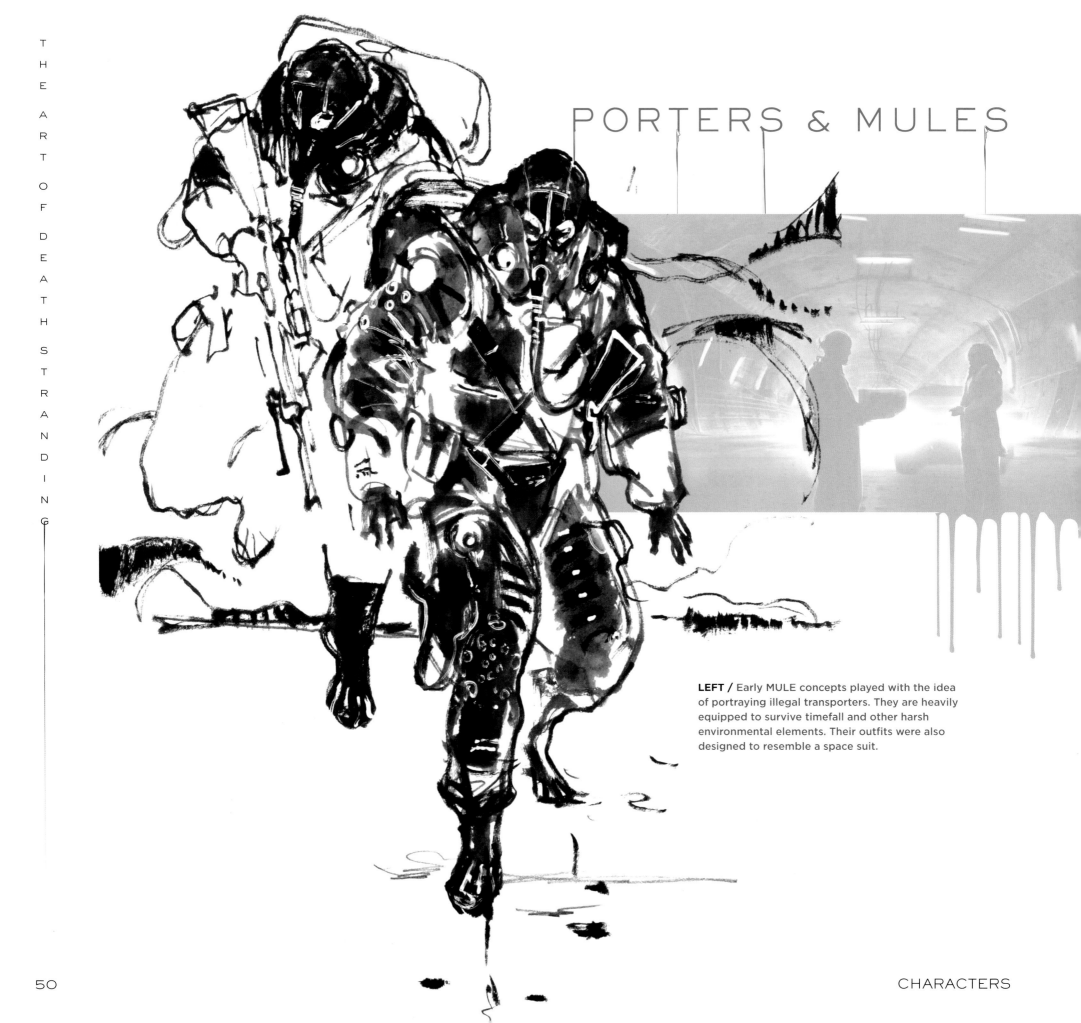

PORTERS & MULES

LEFT / Early MULE concepts played with the idea of portraying illegal transporters. They are heavily equipped to survive timefall and other harsh environmental elements. Their outfits were also designed to resemble a space suit.

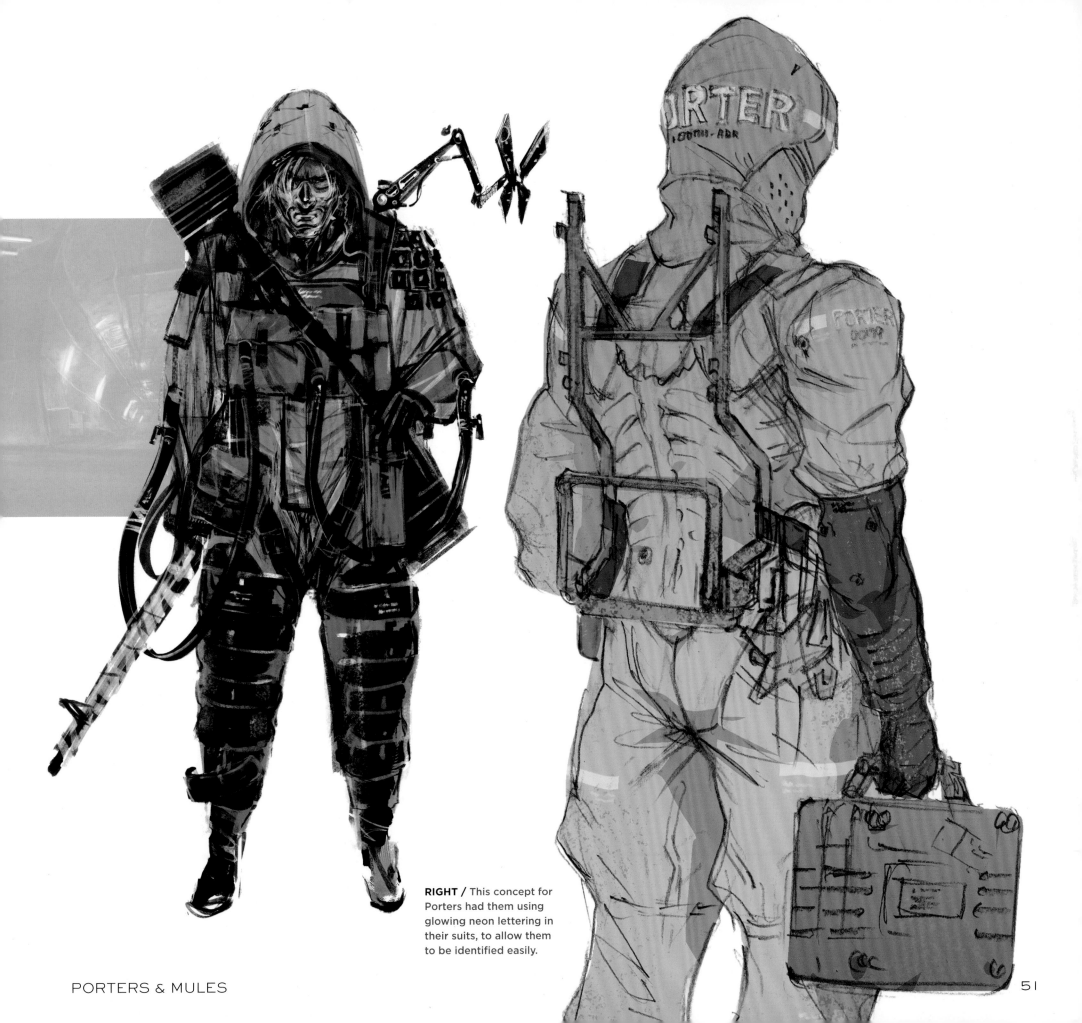

RIGHT / This concept for Porters had them using glowing neon lettering in their suits, to allow them to be identified easily.

PORTERS & MULES

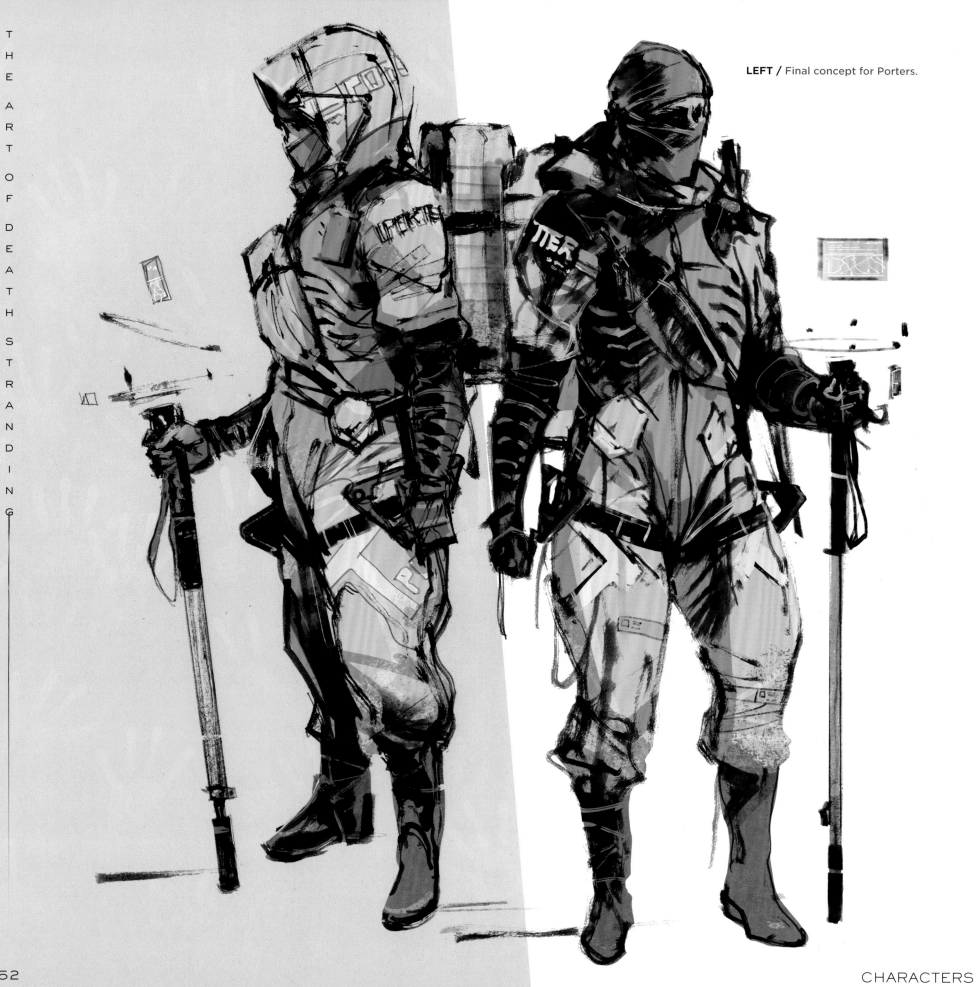

LEFT / Final concept for Porters.

CHARACTERS

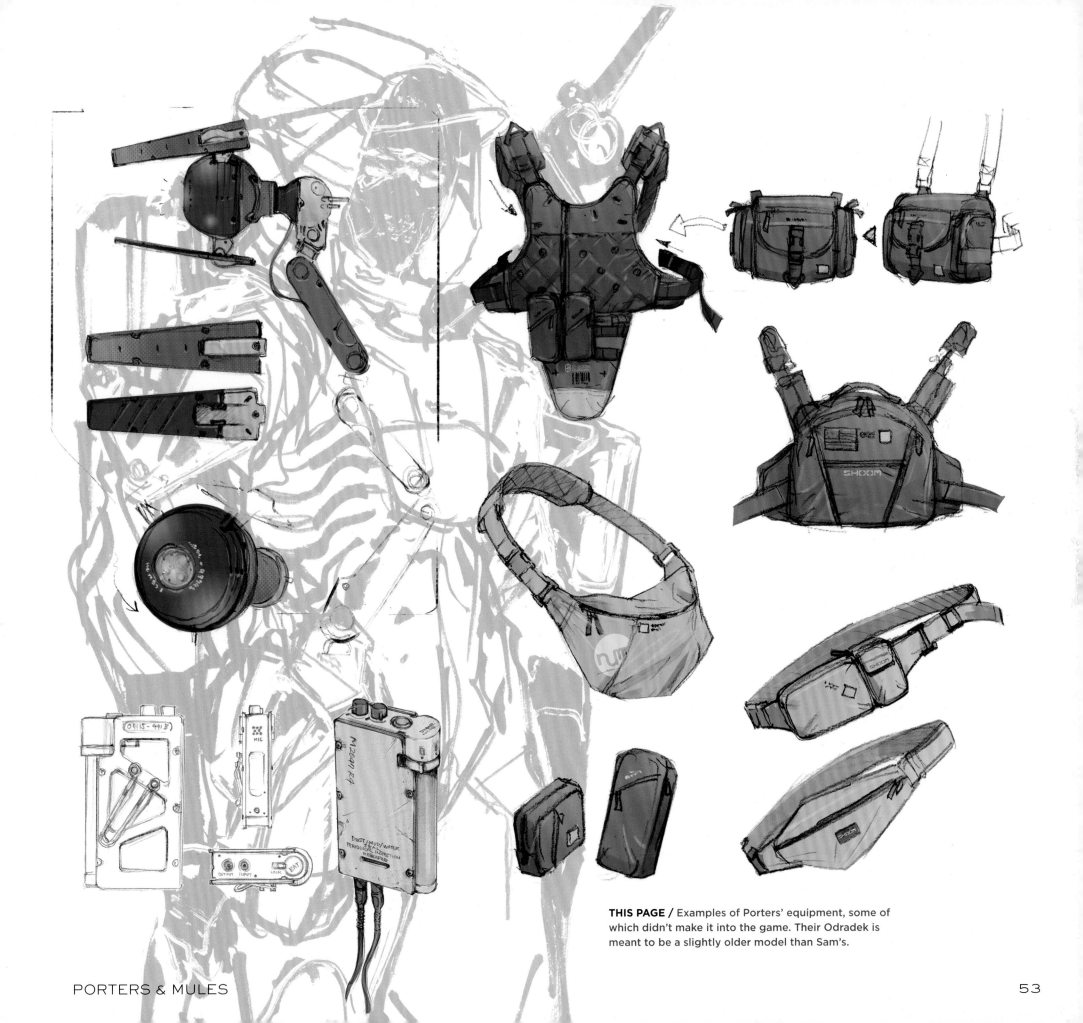

THIS PAGE / Examples of Porters' equipment, some of which didn't make it into the game. Their Odradek is meant to be a slightly older model than Sam's.

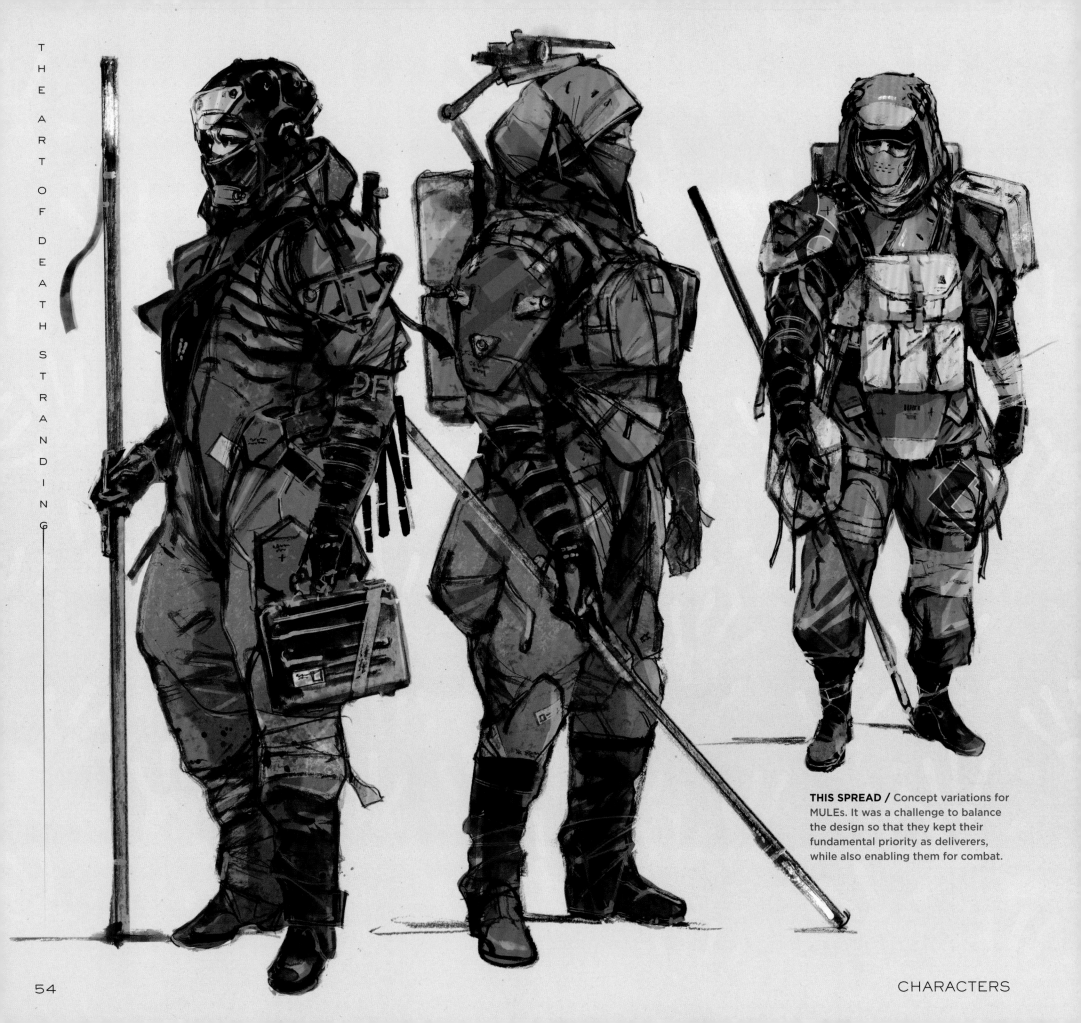

THIS SPREAD / Concept variations for MULEs. It was a challenge to balance the design so that they kept their fundamental priority as deliverers, while also enabling them for combat.

CHARACTERS

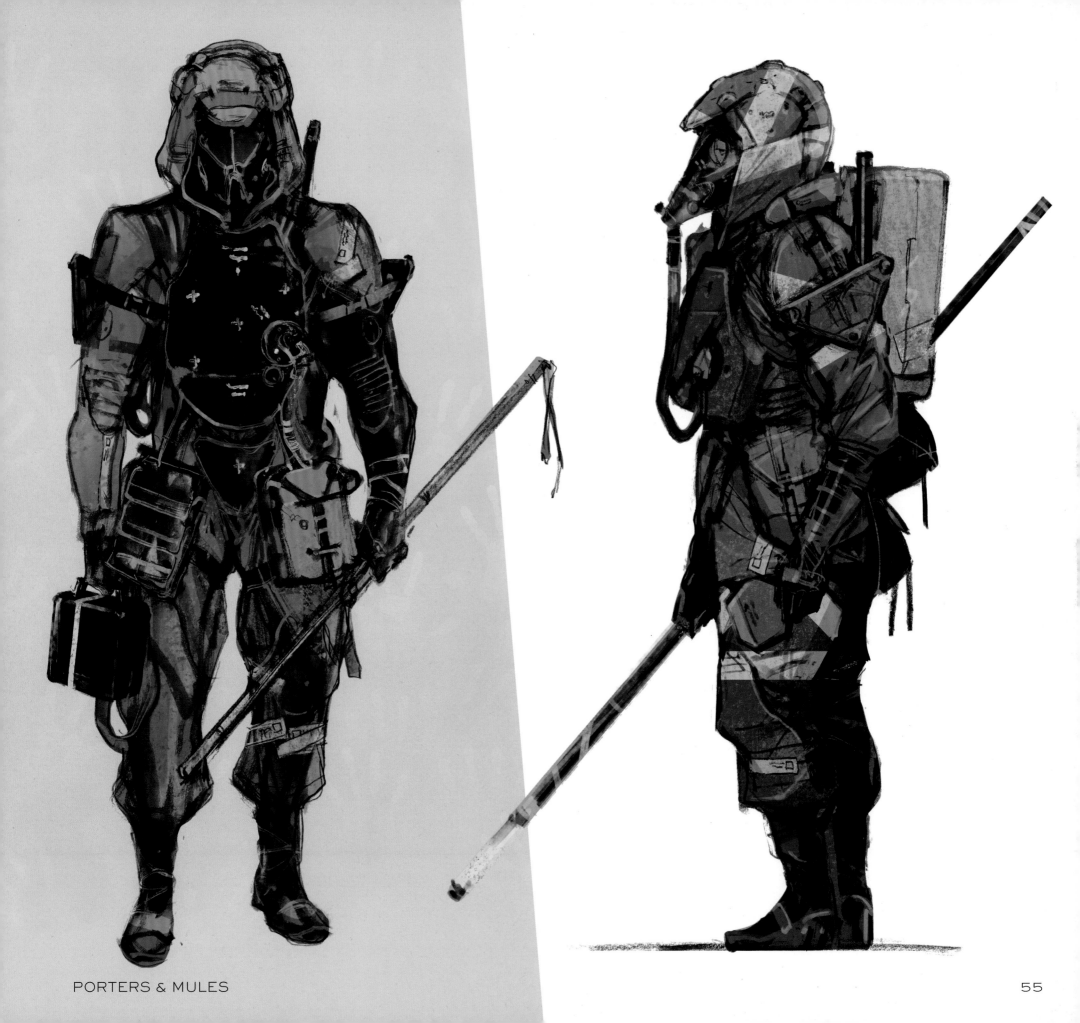

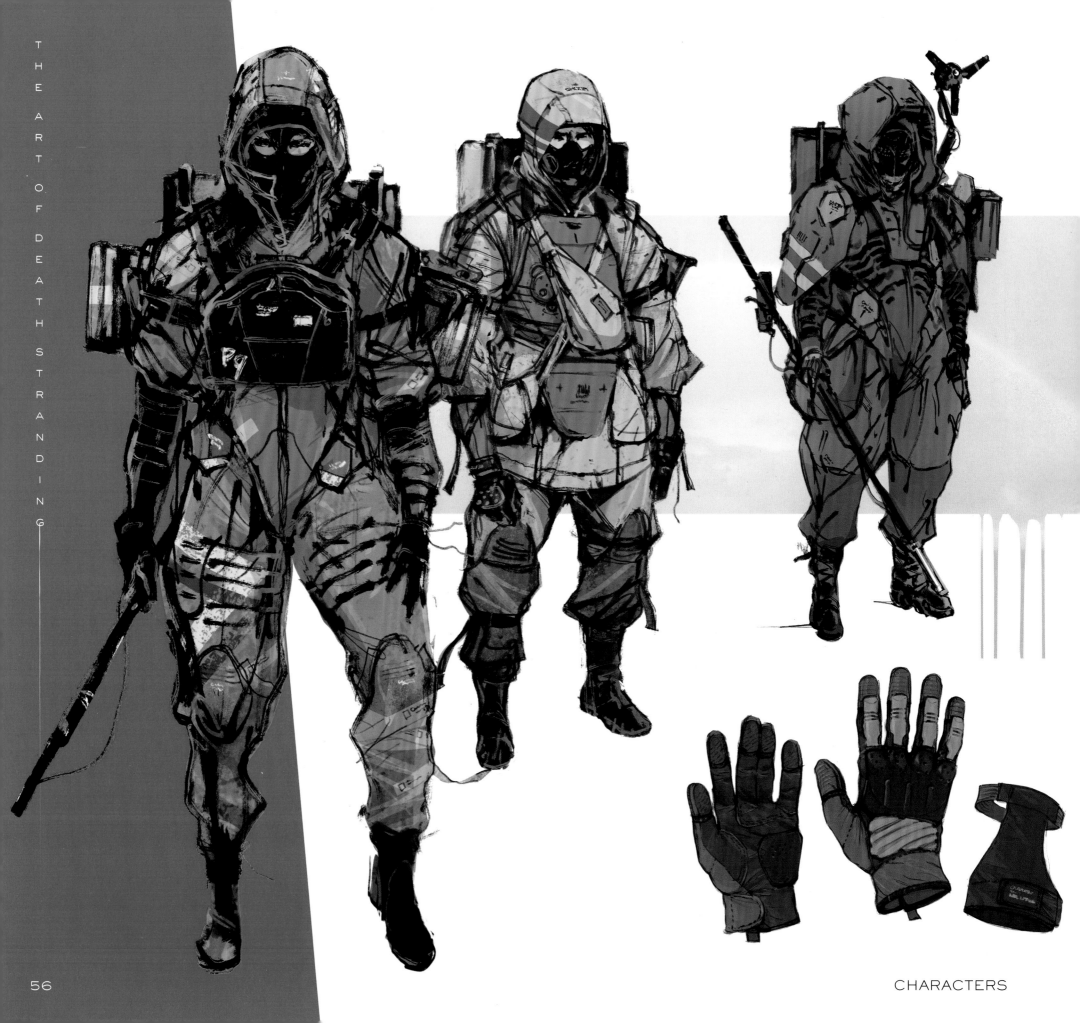

CHARACTERS

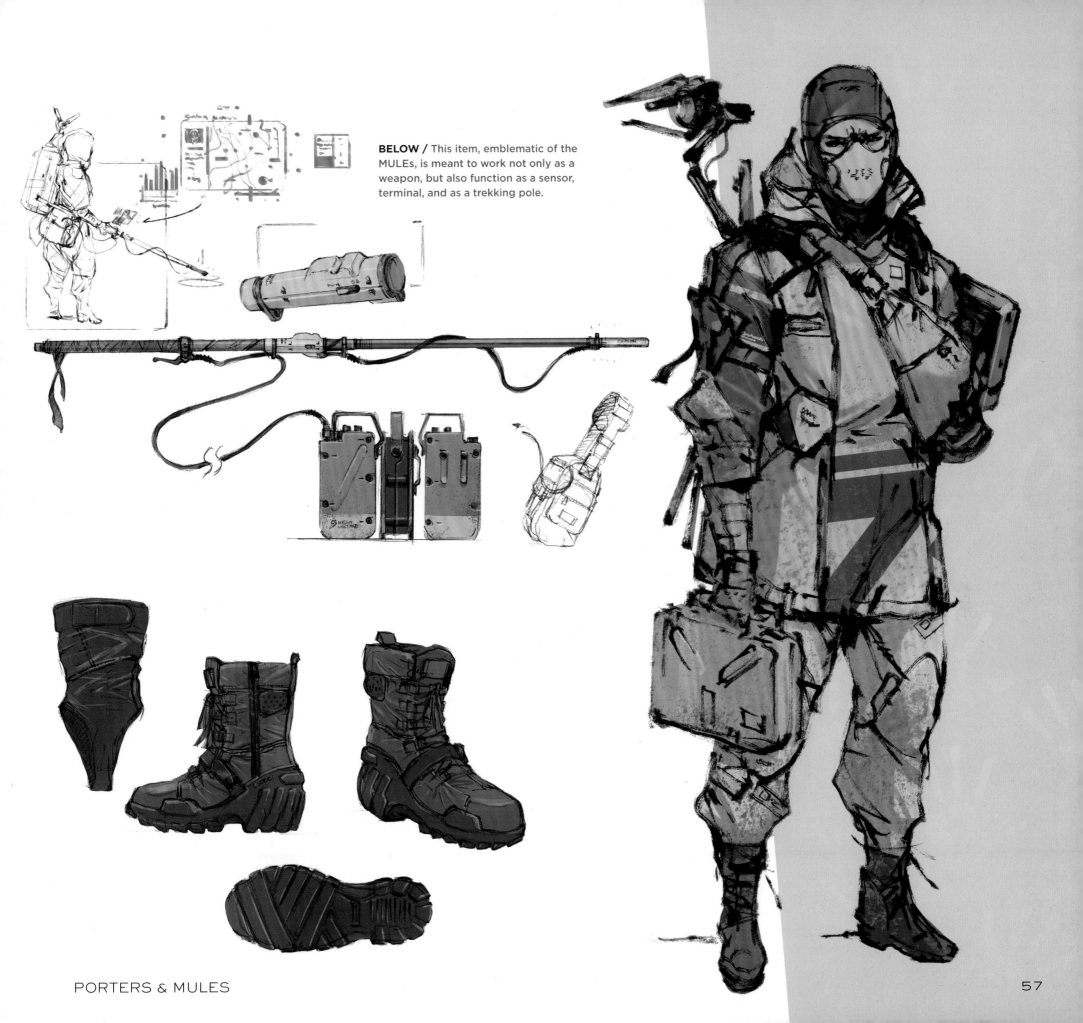

BELOW / This item, emblematic of the MULEs, is meant to work not only as a weapon, but also function as a sensor, terminal, and as a trekking pole.

PORTERS & MULES

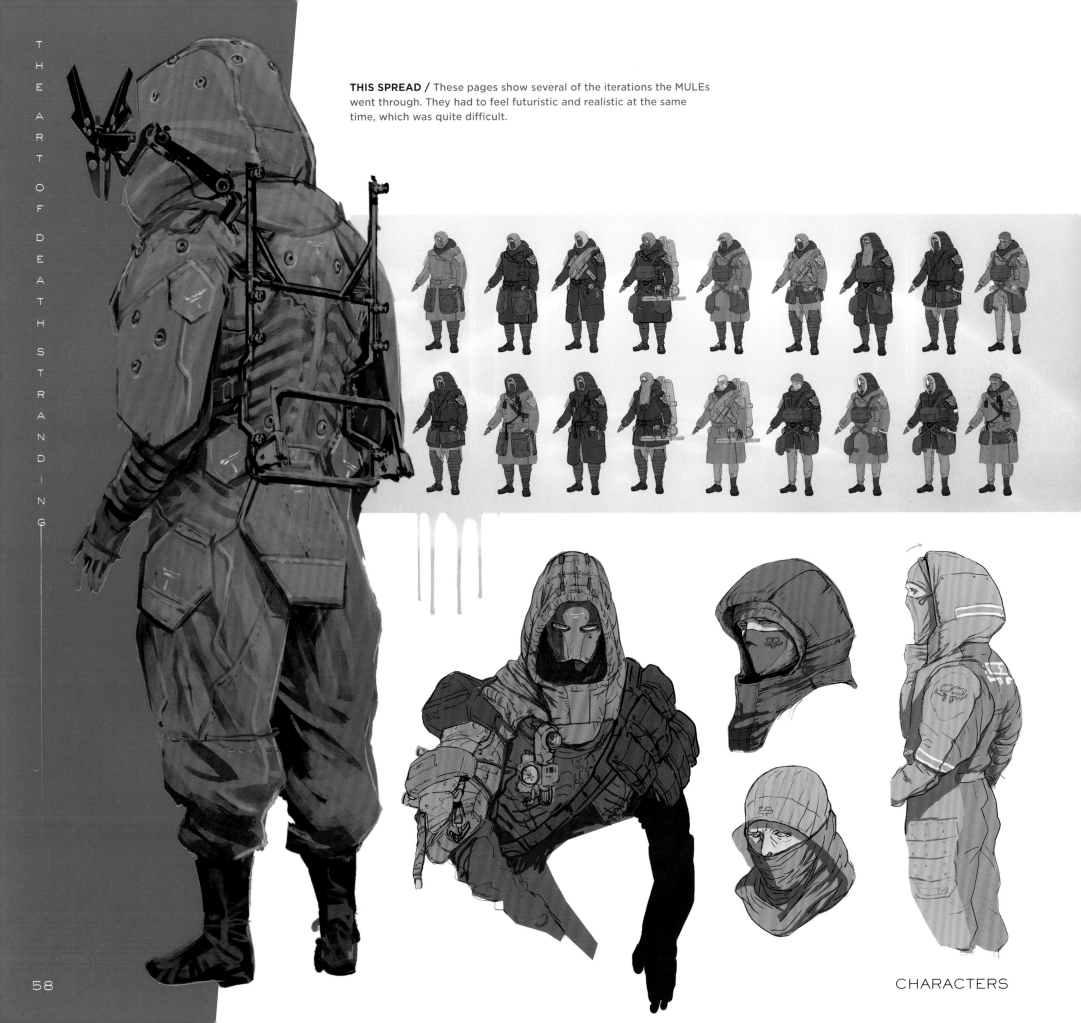

THIS SPREAD / These pages show several of the iterations the MULEs went through. They had to feel futuristic and realistic at the same time, which was quite difficult.

CHARACTERS

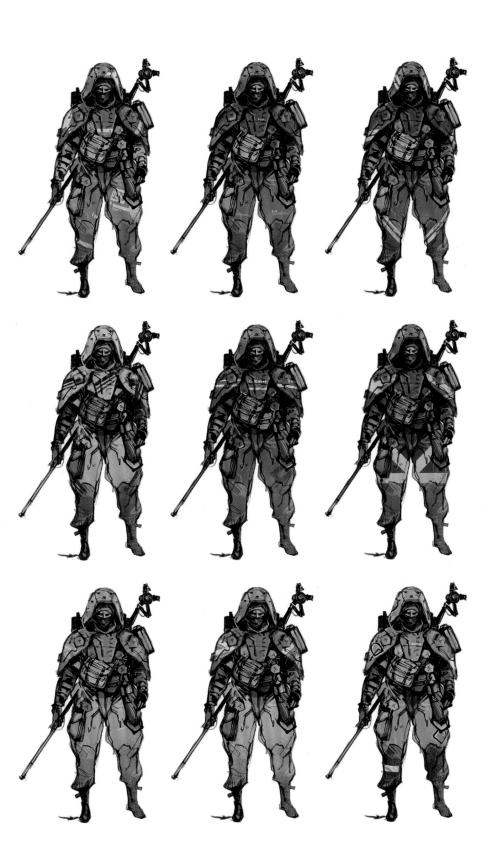

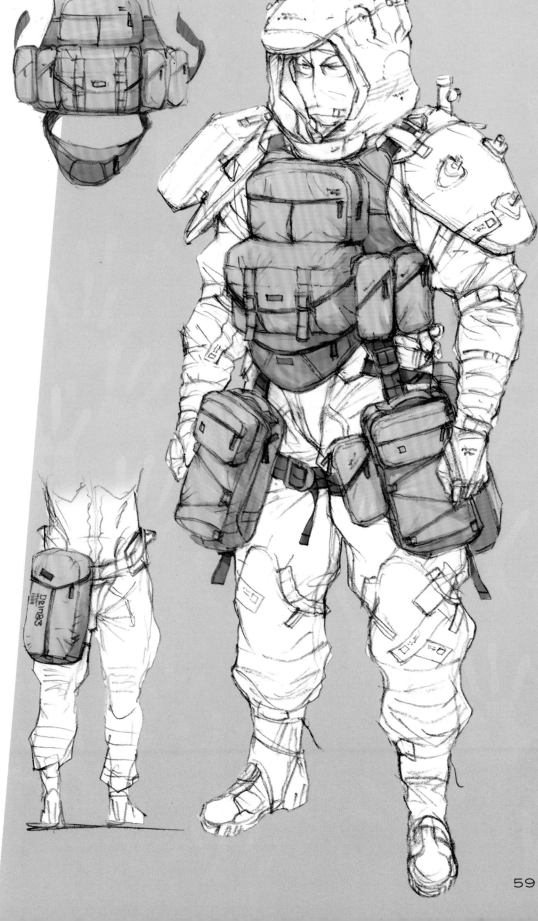

ABOVE / Color variation concepts.

RIGHT / Unused concepts for equipment variations.

PORTERS & MULES

THIS SPREAD / Concept variations for MULEs.

CHARACTERS

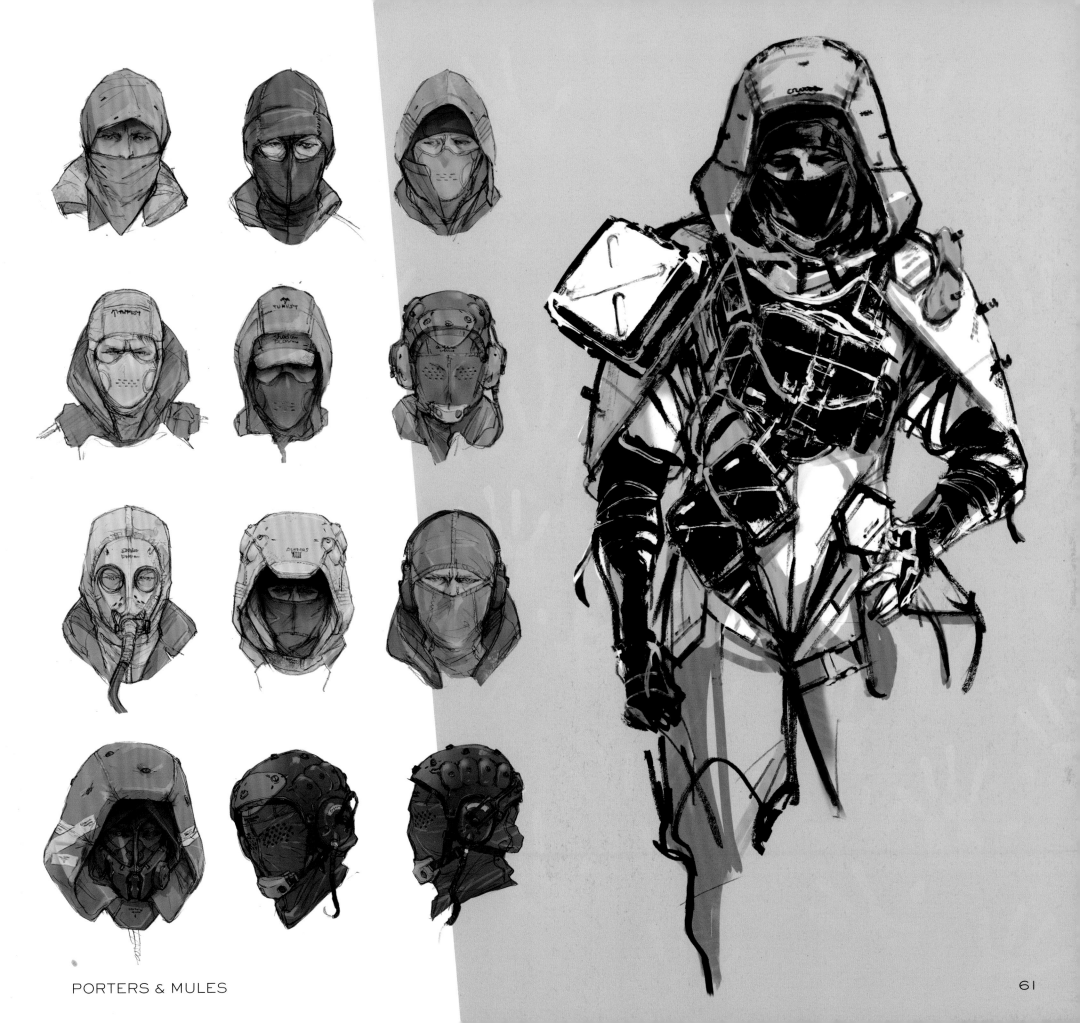

PORTERS & MULES

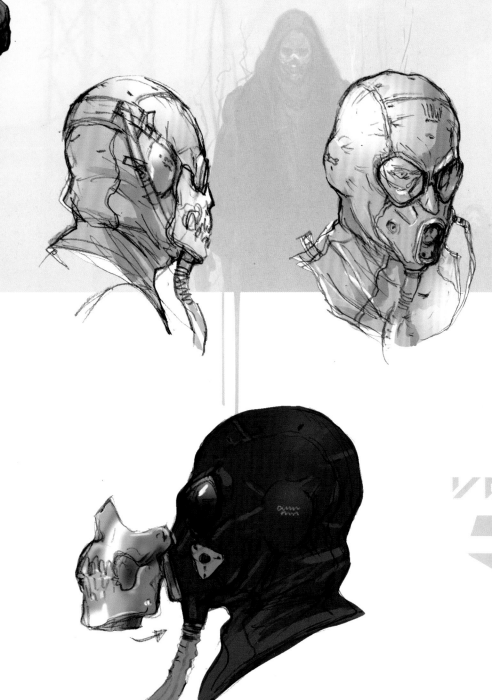

HIGGS

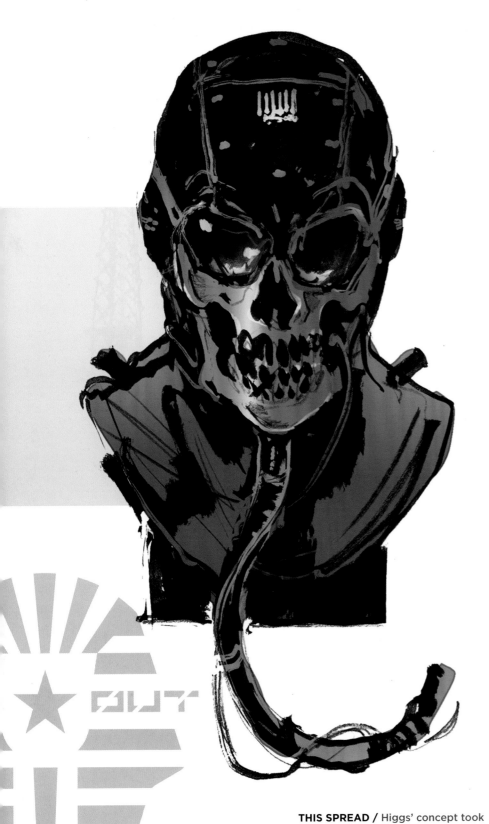

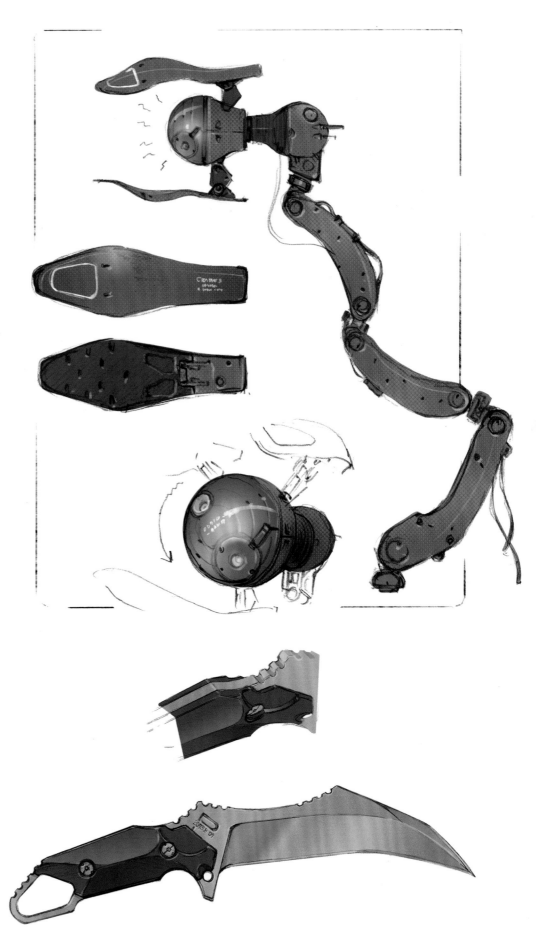

THIS SPREAD / Higgs' concept took some inspirations from Ancient Egyptian culture. His Odradek has a more organic design than Sam's. The colors associated with Higgs are mainly black and gold.

ABOVE / Concepts for Higgs' mask.

BELOW / Concepts for cutscenes.

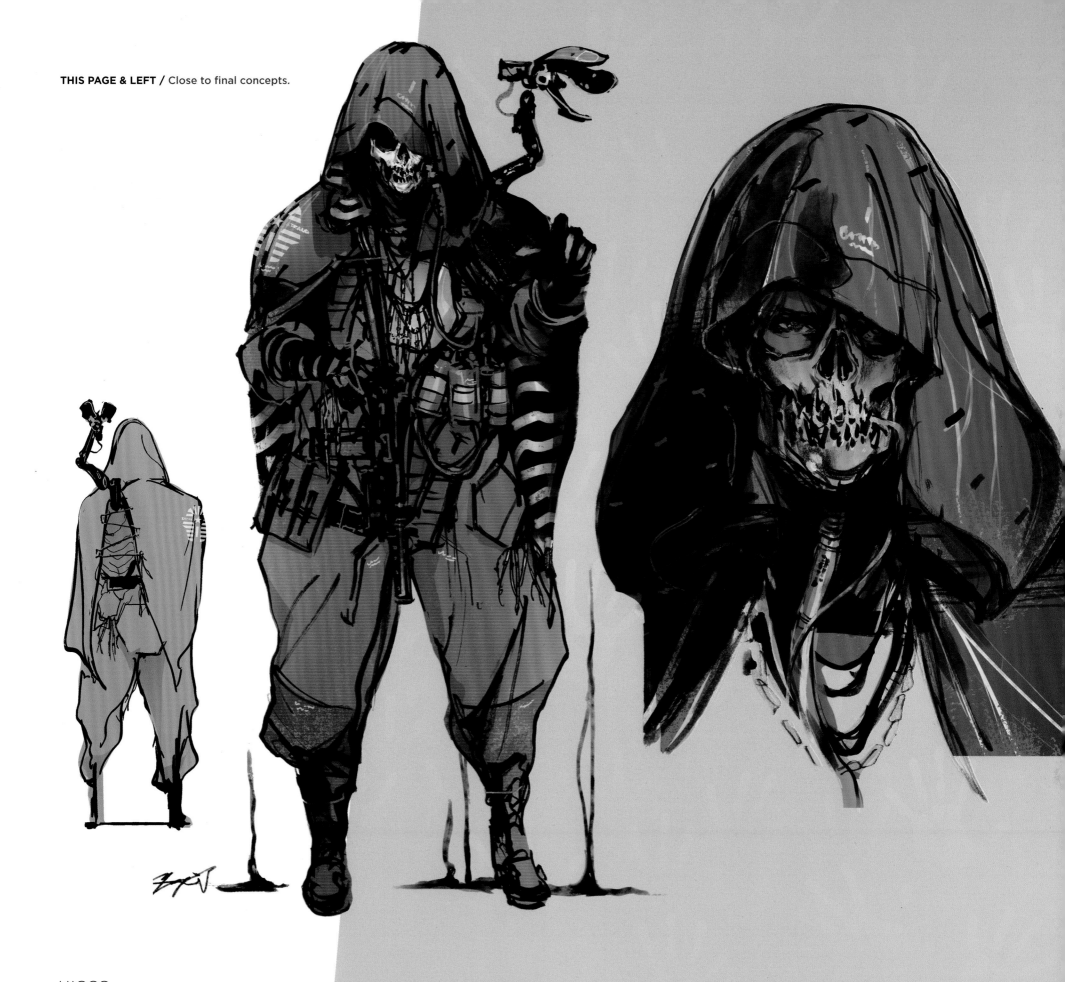

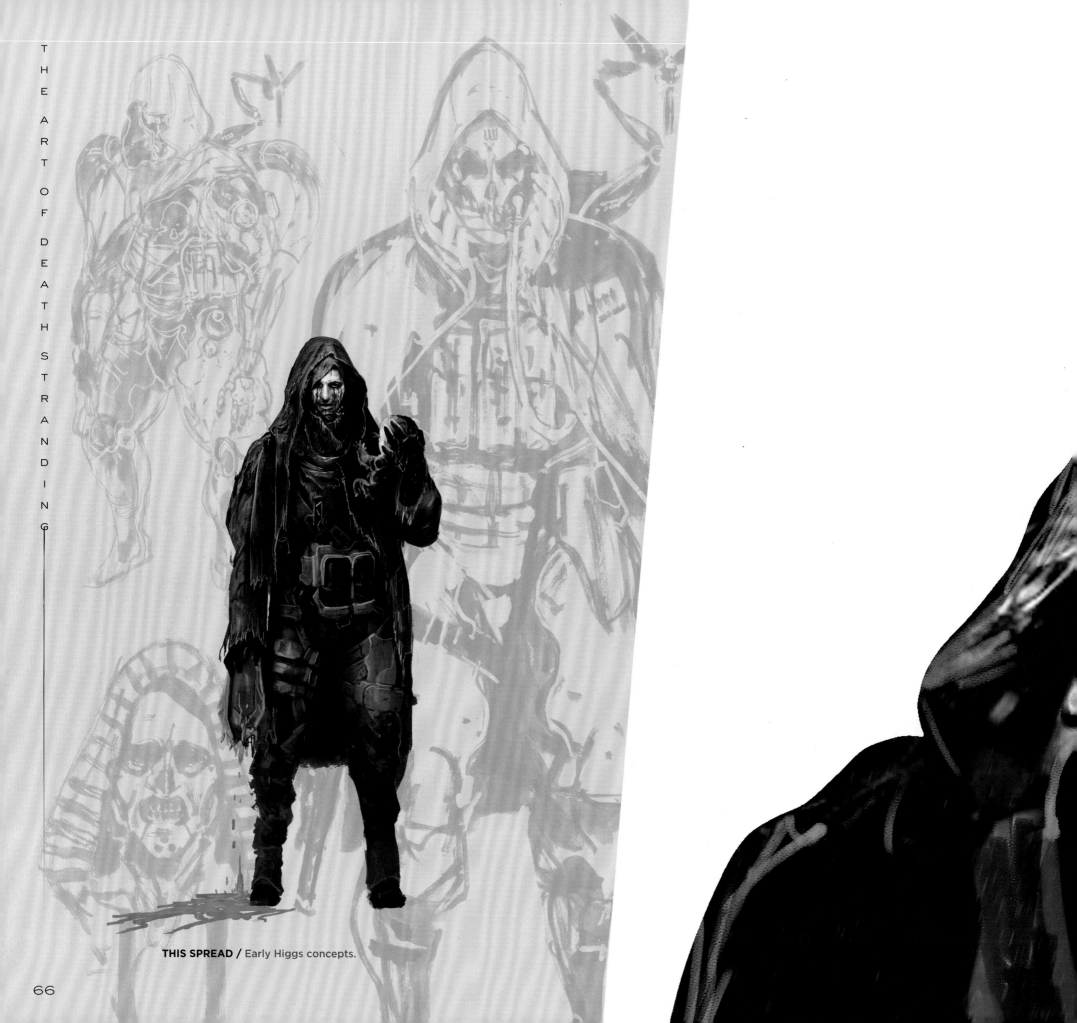

THIS SPREAD / Early Higgs concepts.

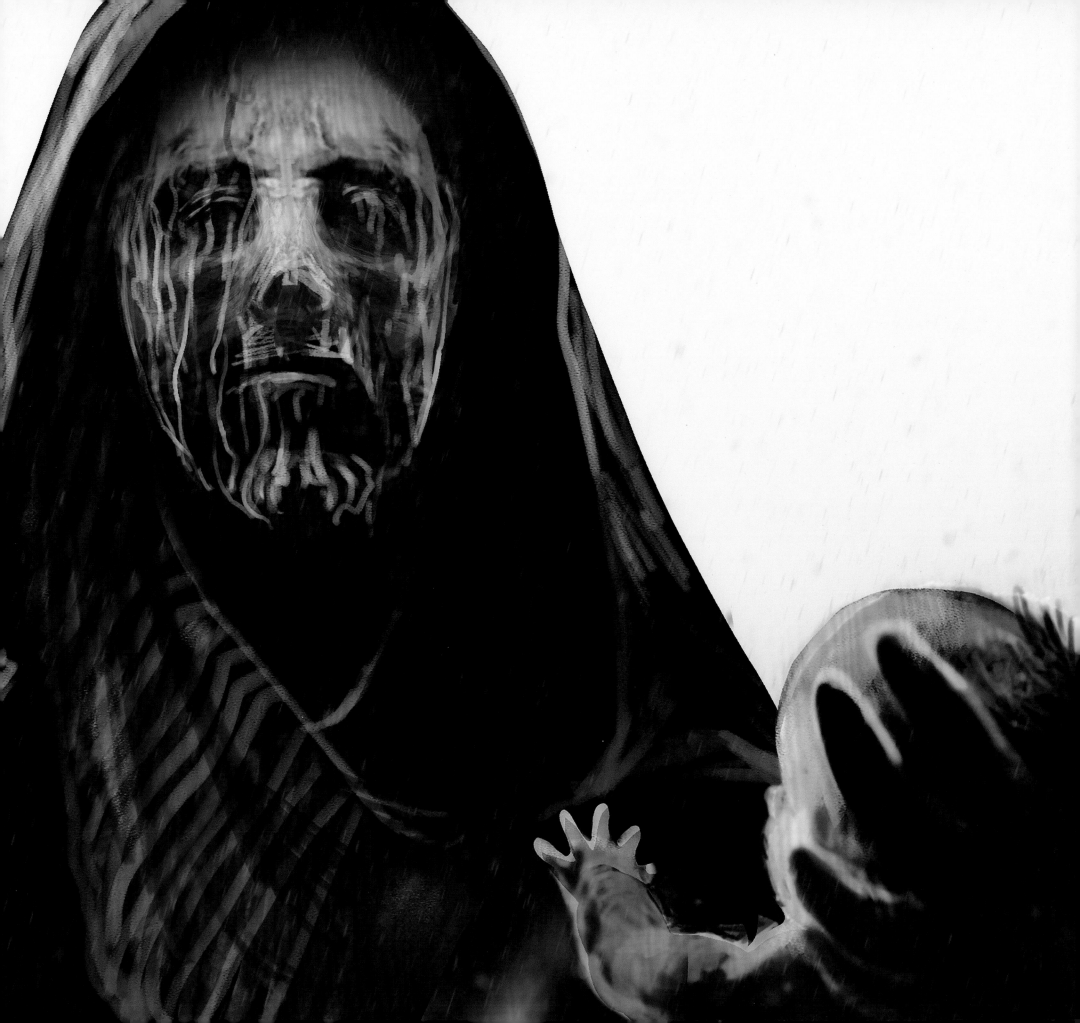

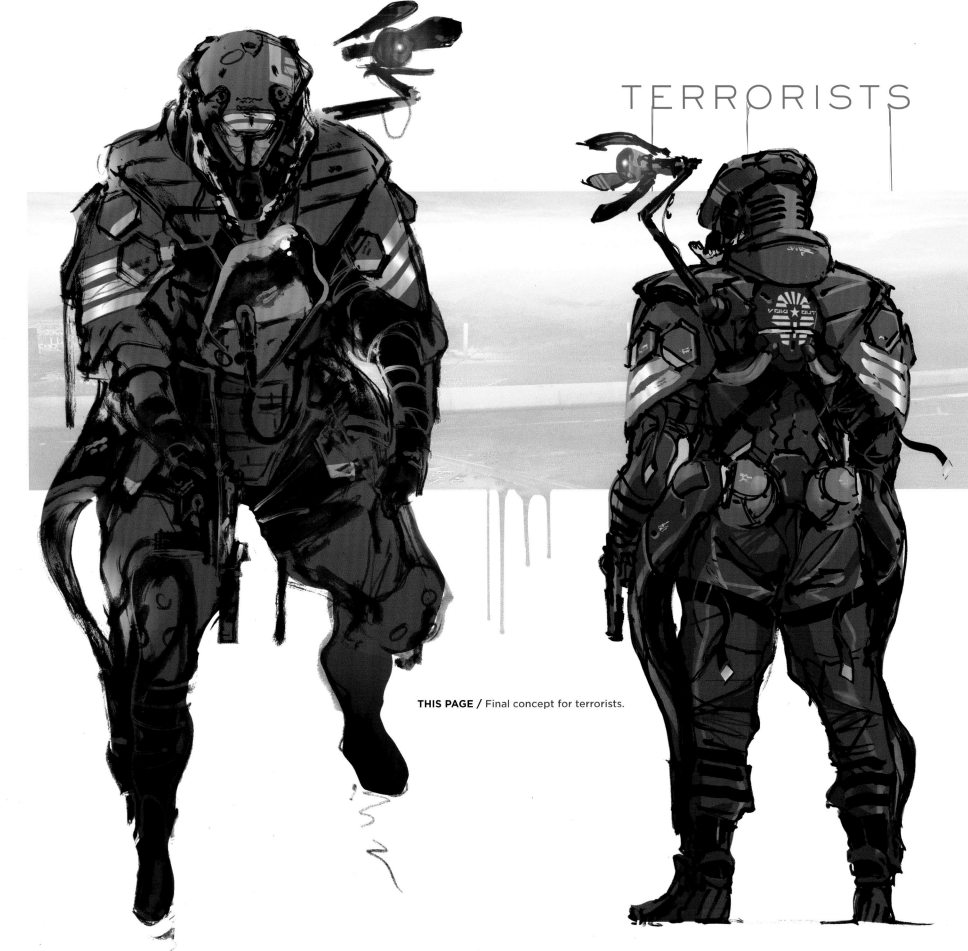

TERRORISTS

THIS PAGE / Final concept for terrorists.

CHARACTERS

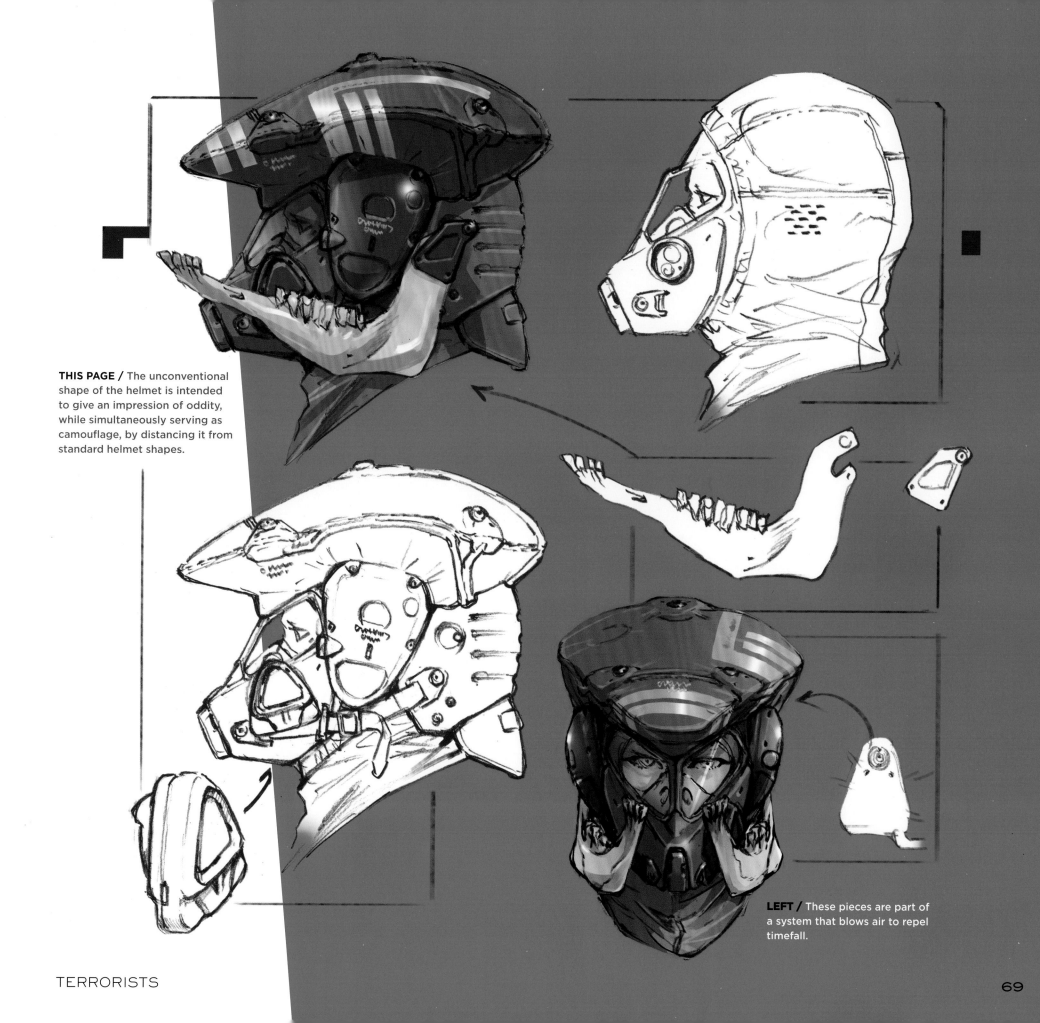

THIS PAGE / The unconventional shape of the helmet is intended to give an impression of oddity, while simultaneously serving as camouflage, by distancing it from standard helmet shapes.

LEFT / These pieces are part of a system that blows air to repel timefall.

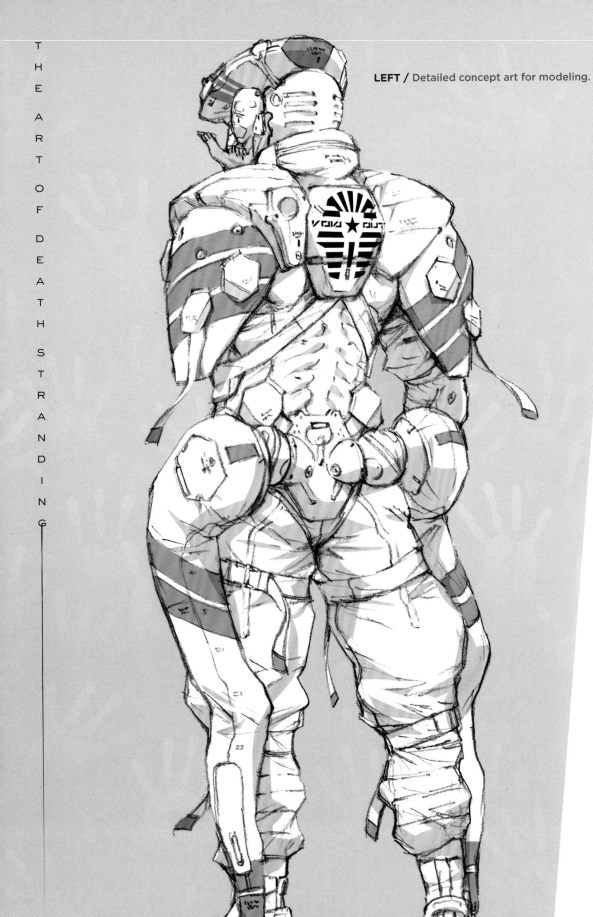

LEFT / Detailed concept art for modeling.

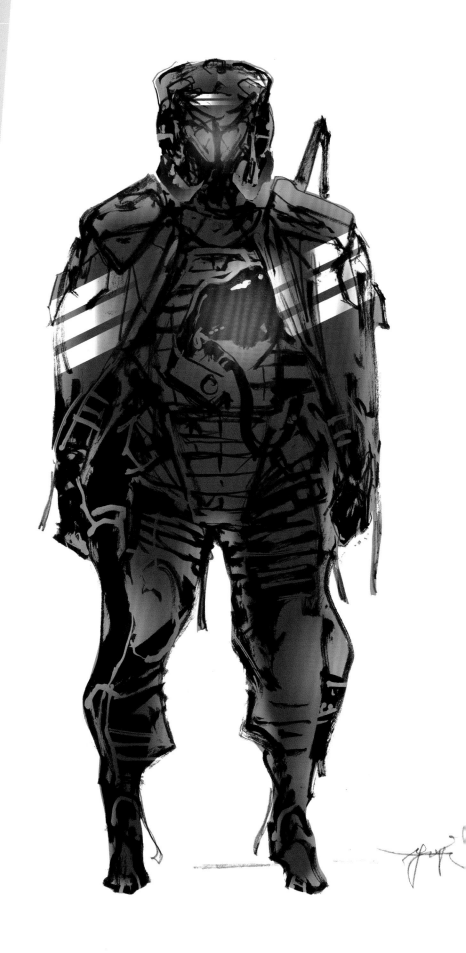

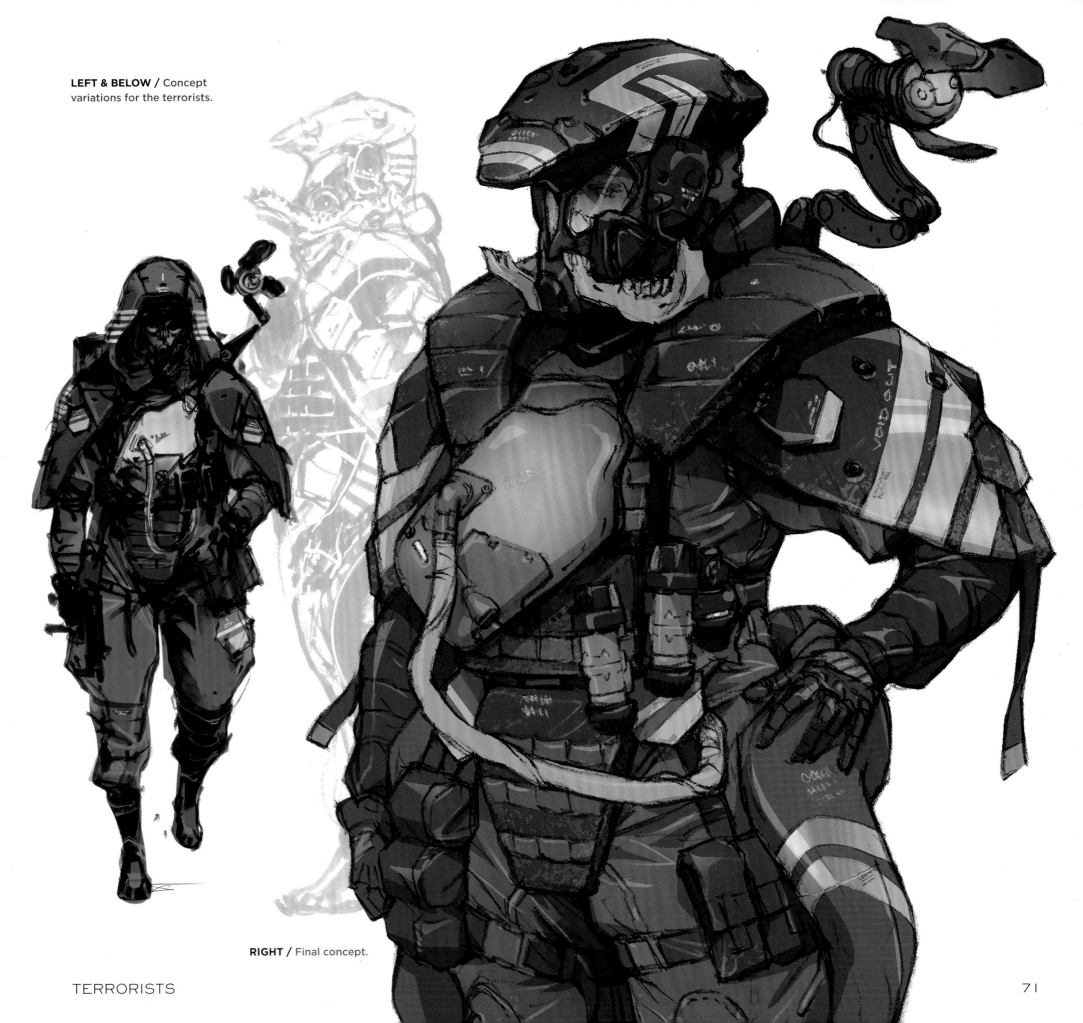

LEFT & BELOW / Concept variations for the terrorists.

RIGHT / Final concept.

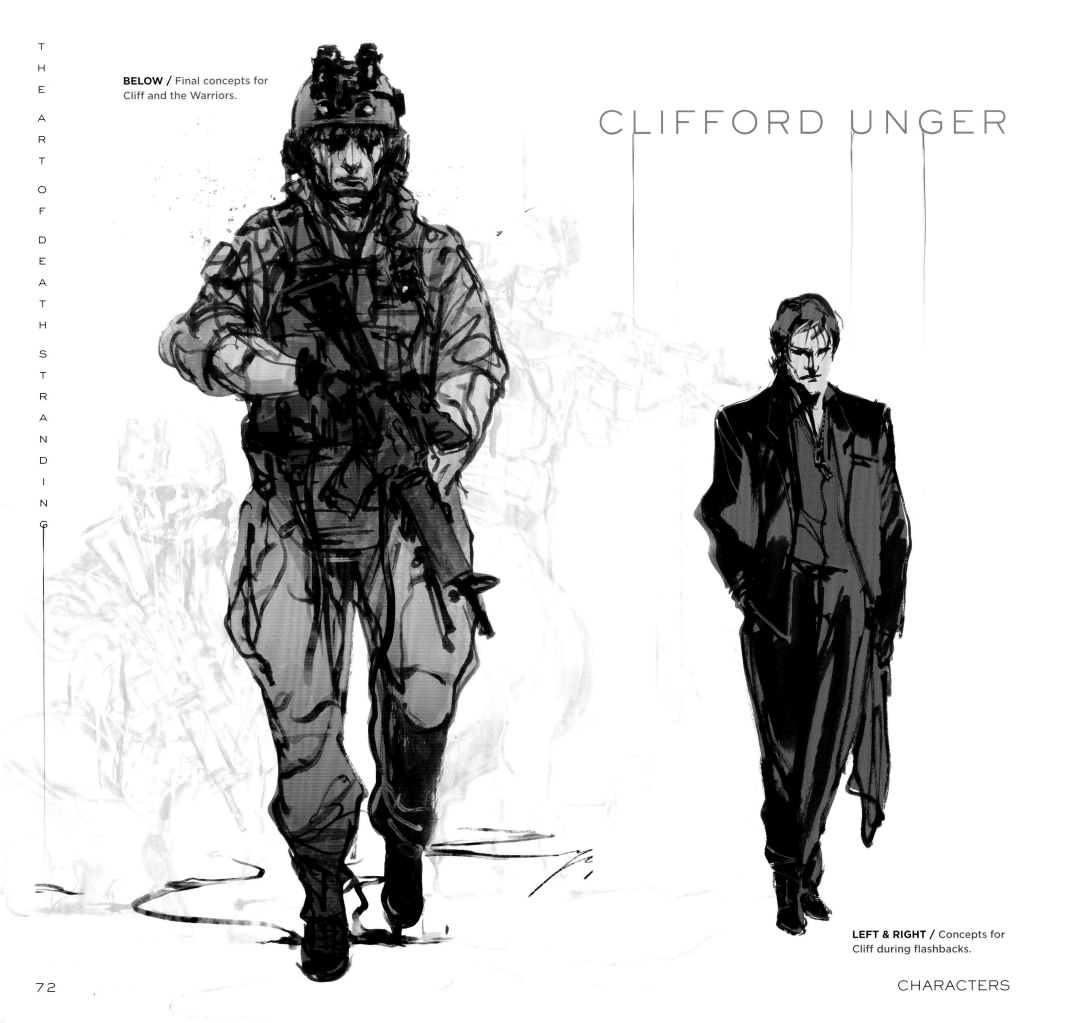

BELOW / Final concepts for Cliff and the Warriors.

CLIFFORD UNGER

LEFT & RIGHT / Concepts for Cliff during flashbacks.

CHARACTERS

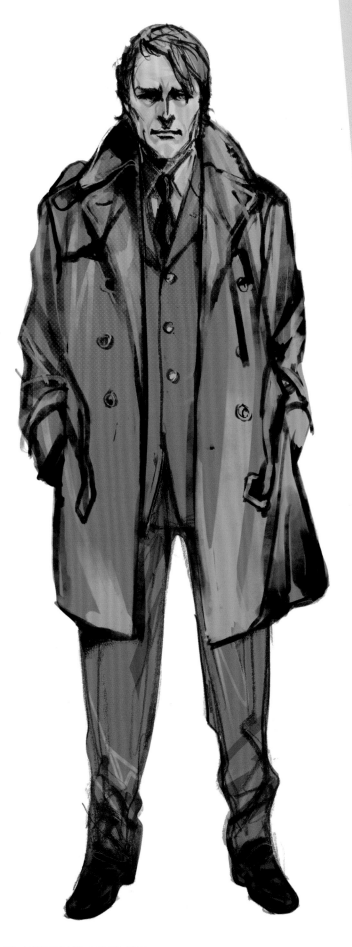

CLIFFORD UNGER

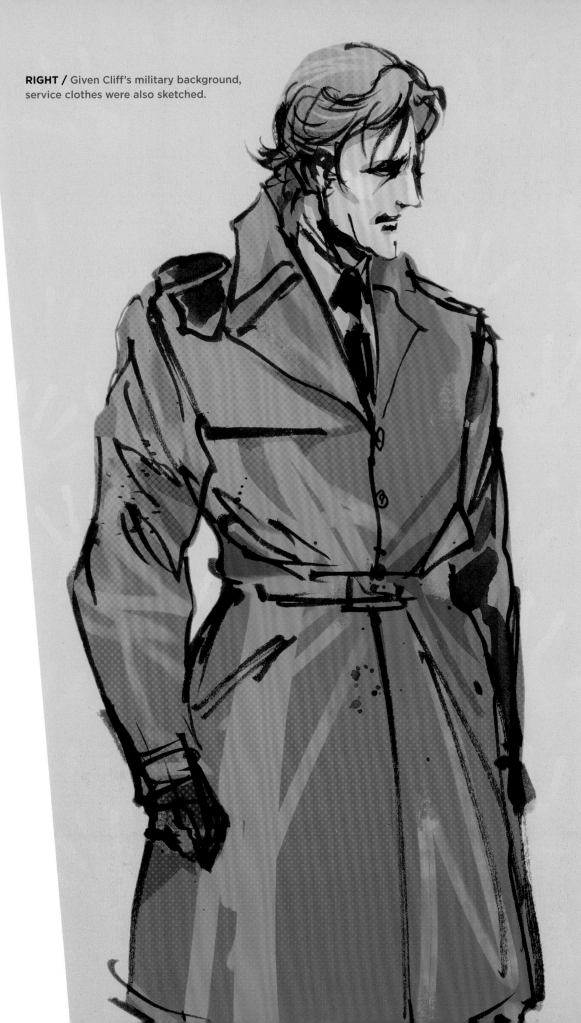

73

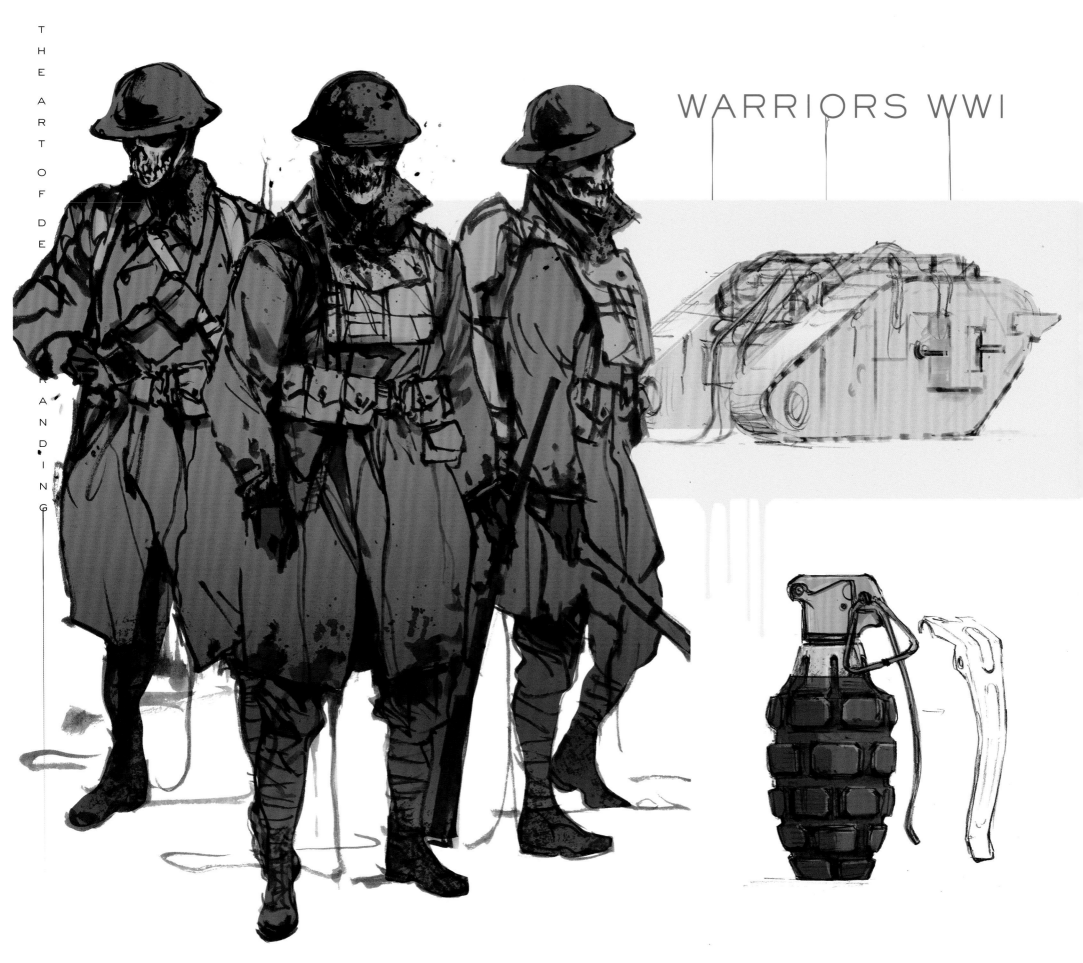

THE ART OF DEATH STRANDING

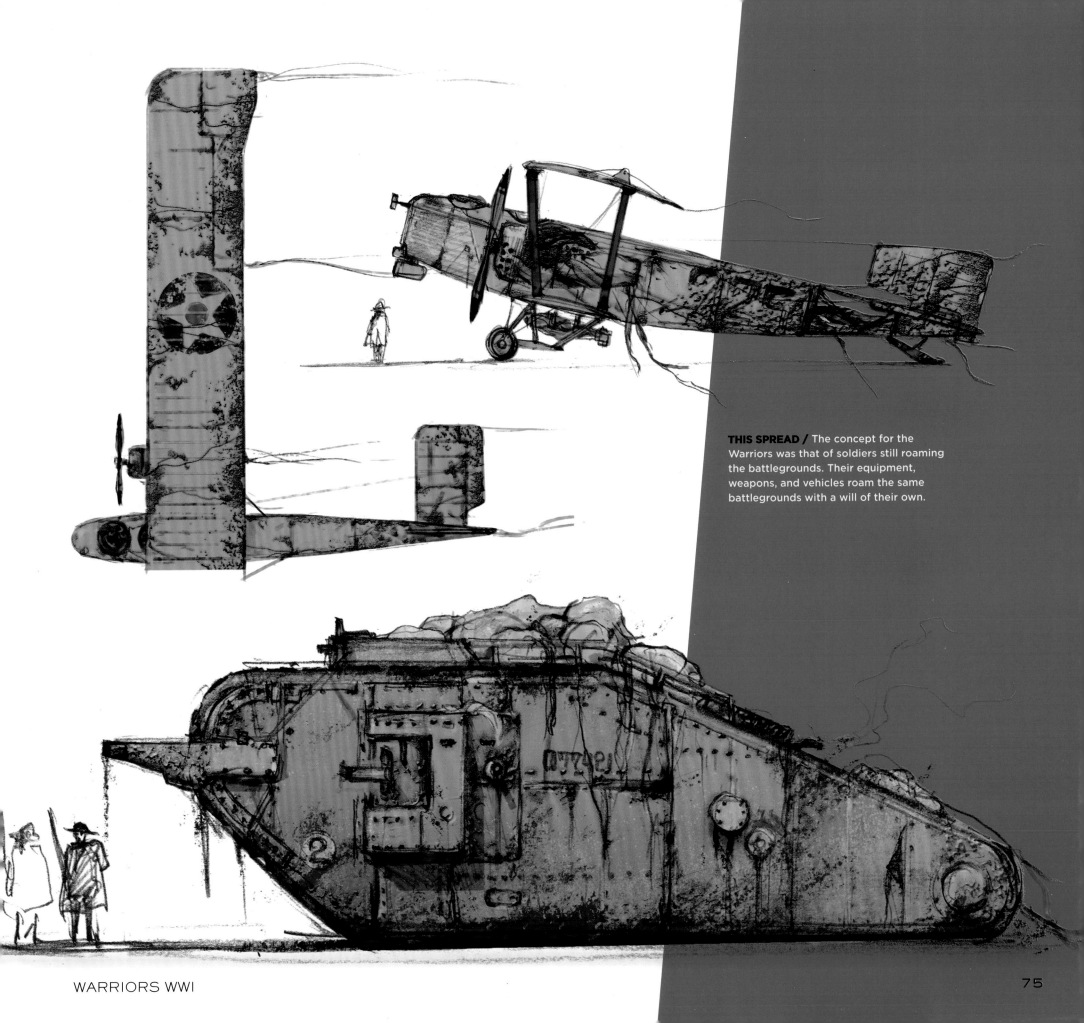

THIS SPREAD / The concept for the Warriors was that of soldiers still roaming the battlegrounds. Their equipment, weapons, and vehicles roam the same battlegrounds with a will of their own.

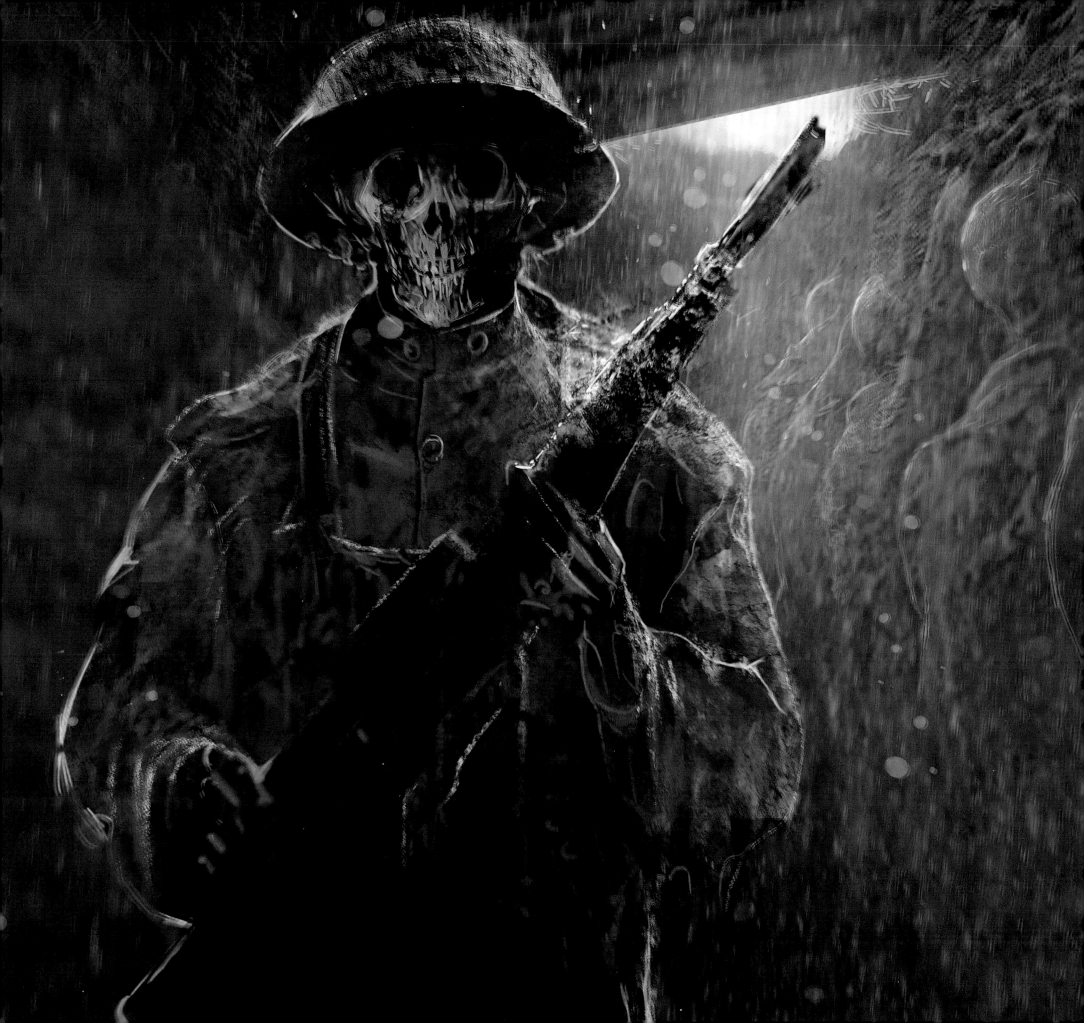

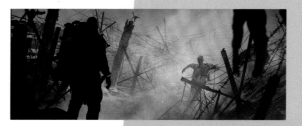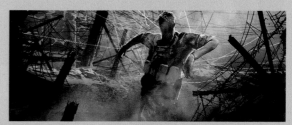

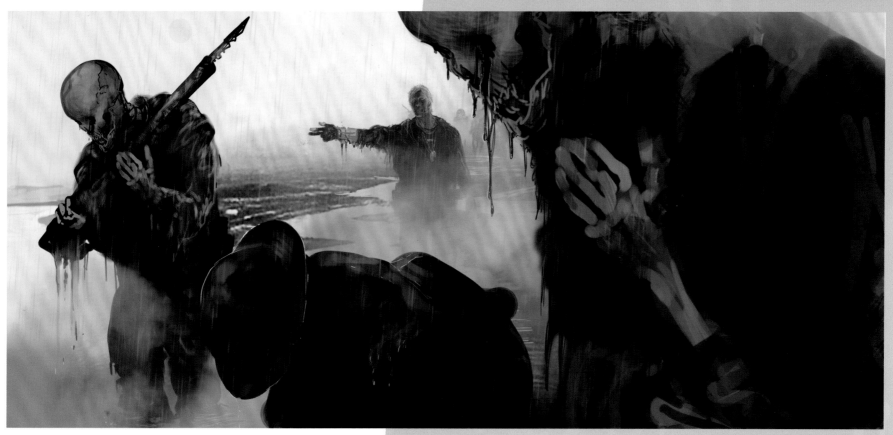

THIS SPREAD / The battles from WWI take place in the emblematic trenches.

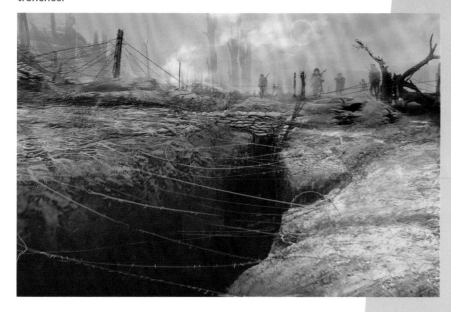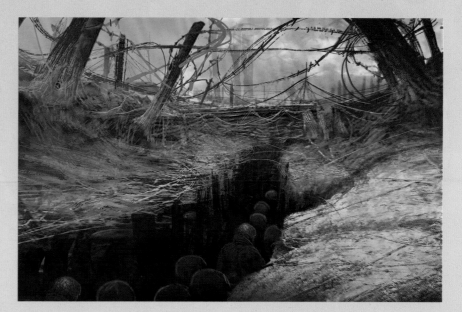

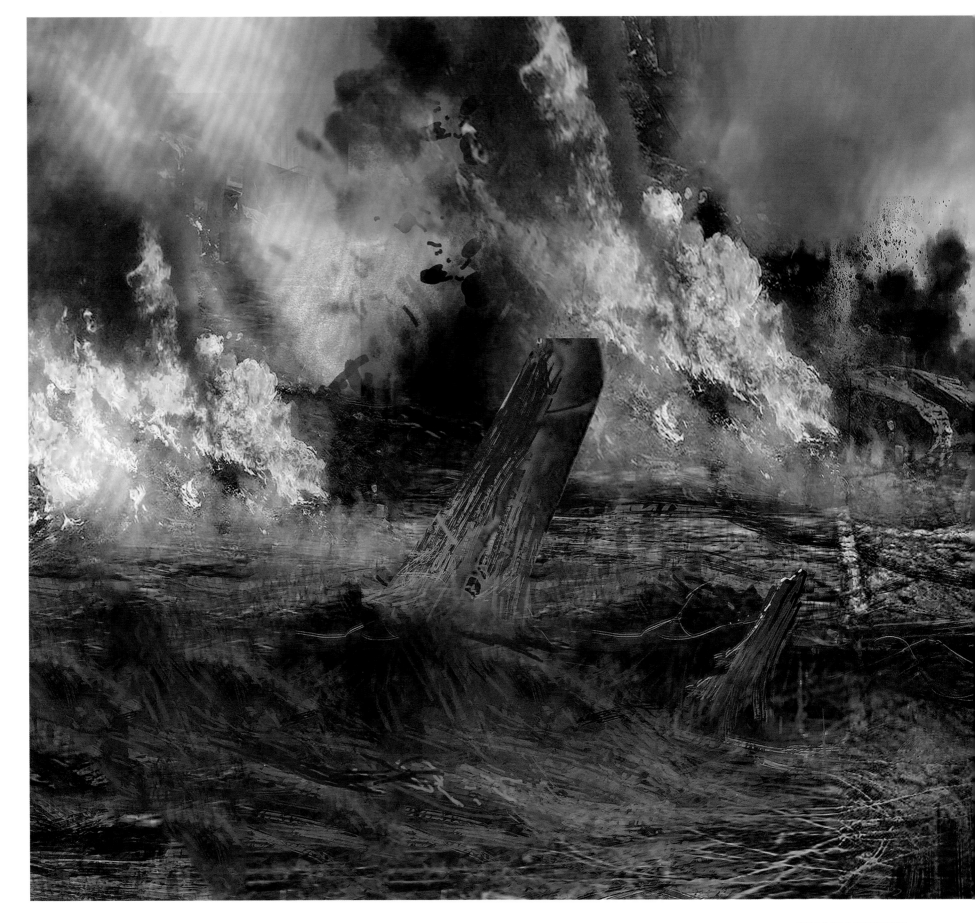

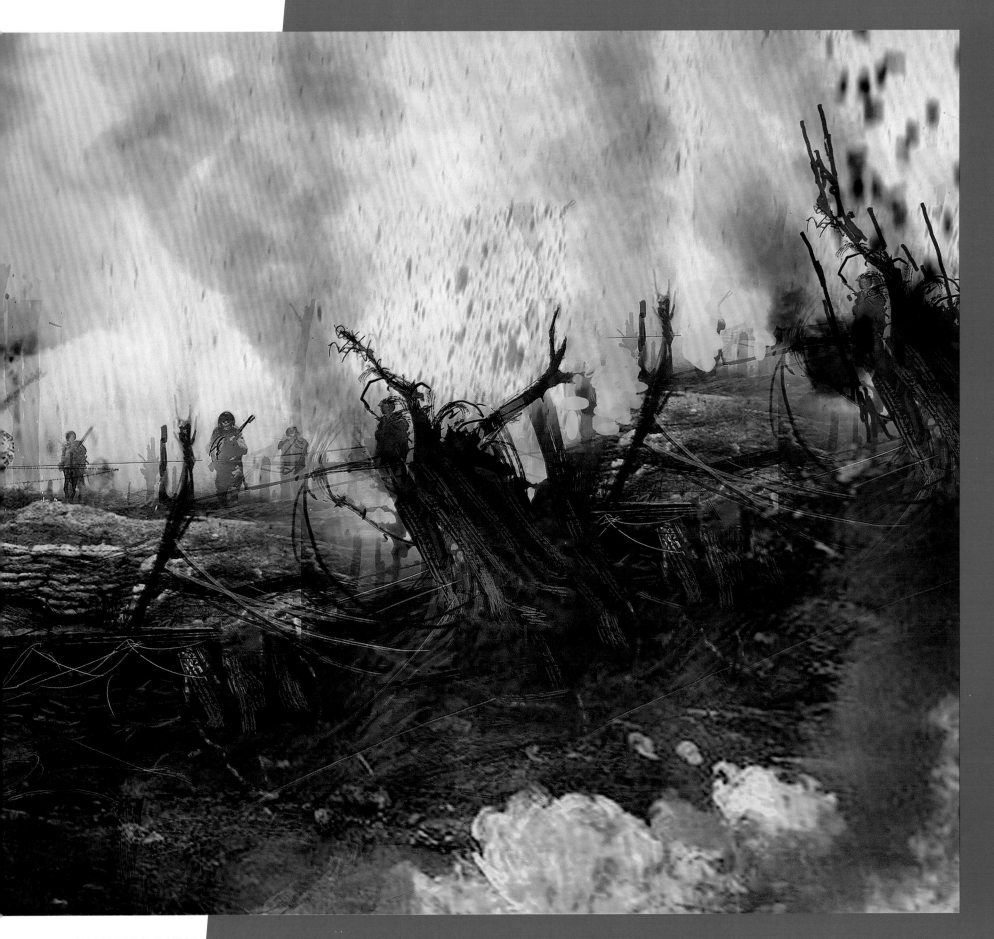

WARRIORS WWII

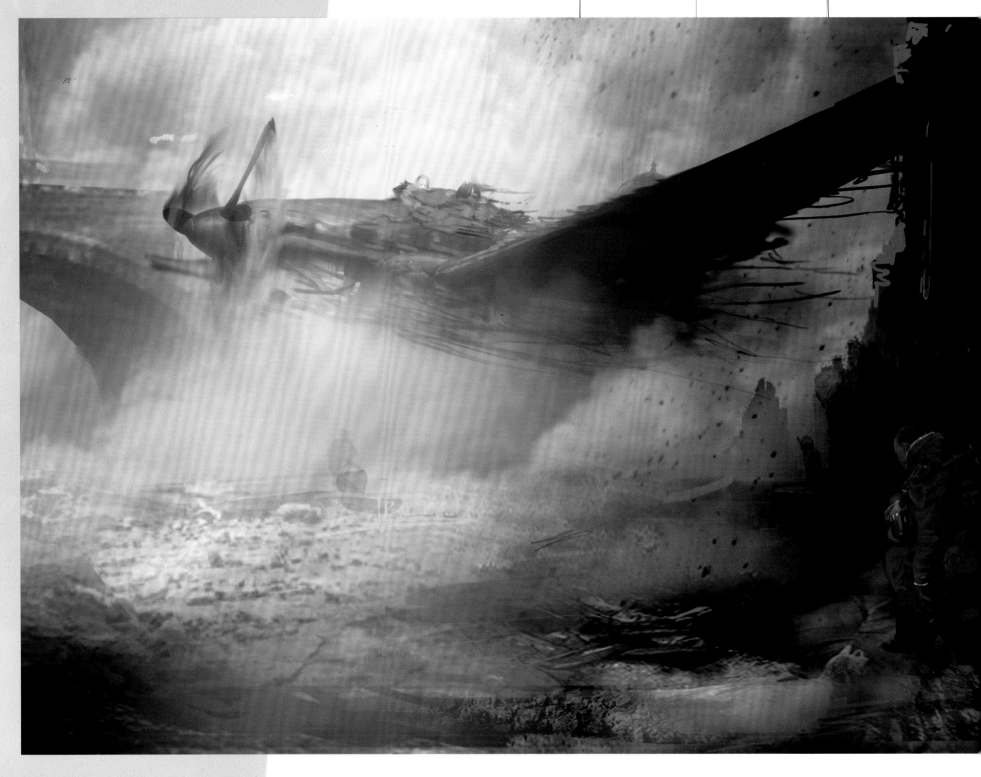

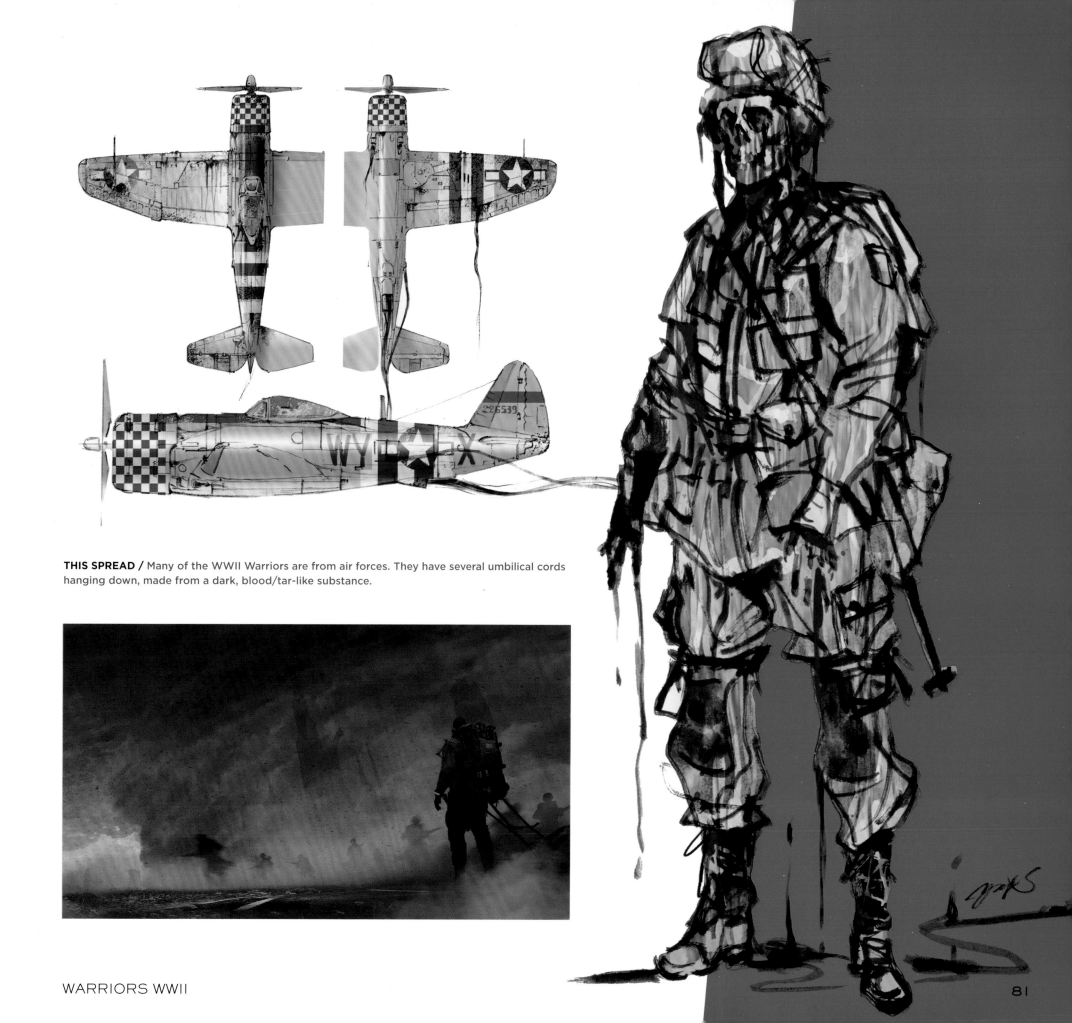

THIS SPREAD / Many of the WWII Warriors are from air forces. They have several umbilical cords hanging down, made from a dark, blood/tar-like substance.

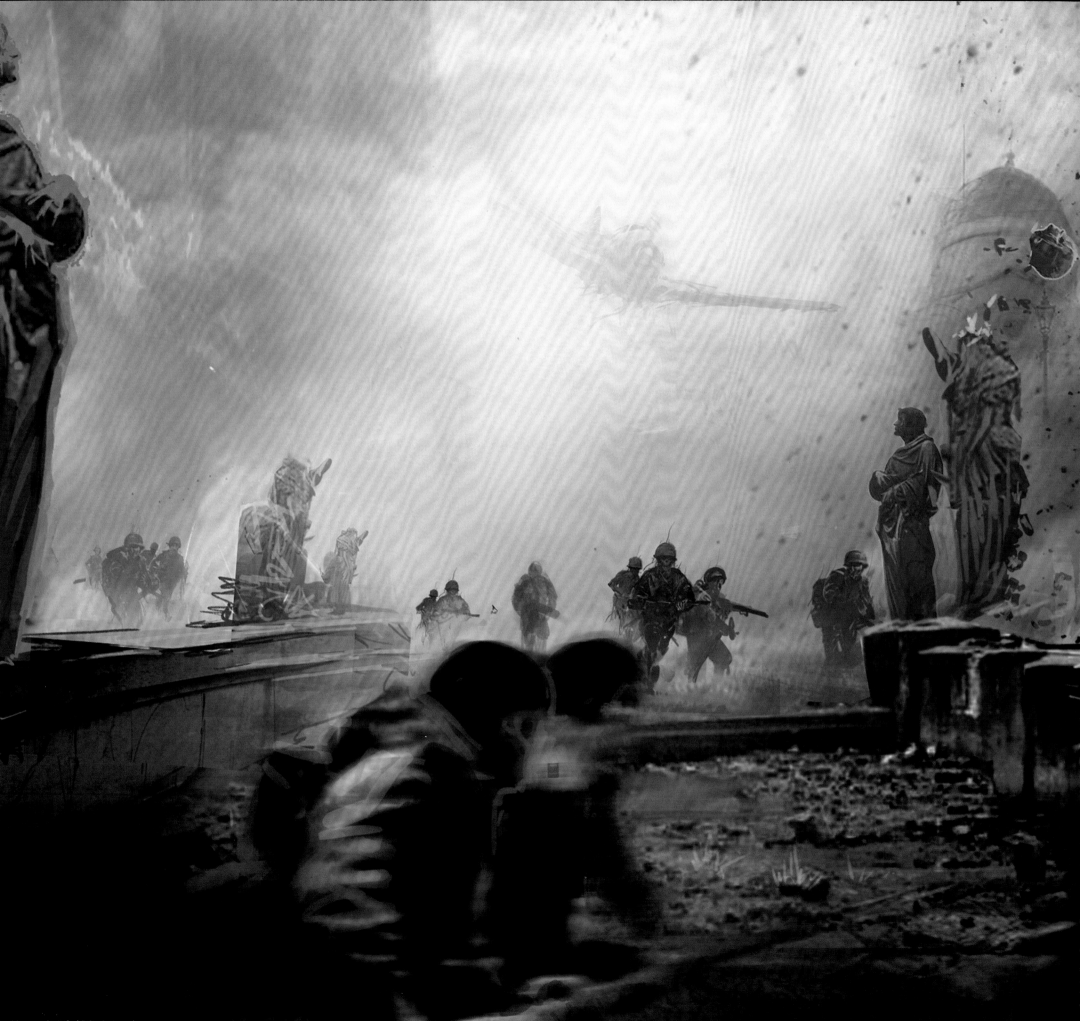

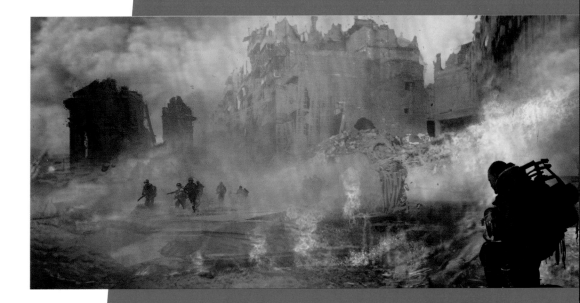

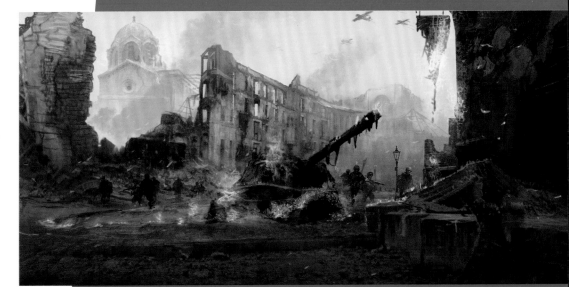

THIS SPREAD / The WWII areas are representative of urban warfare from that time.

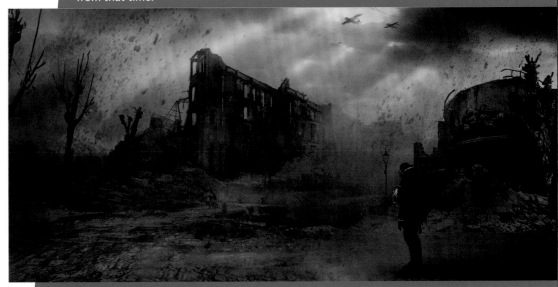

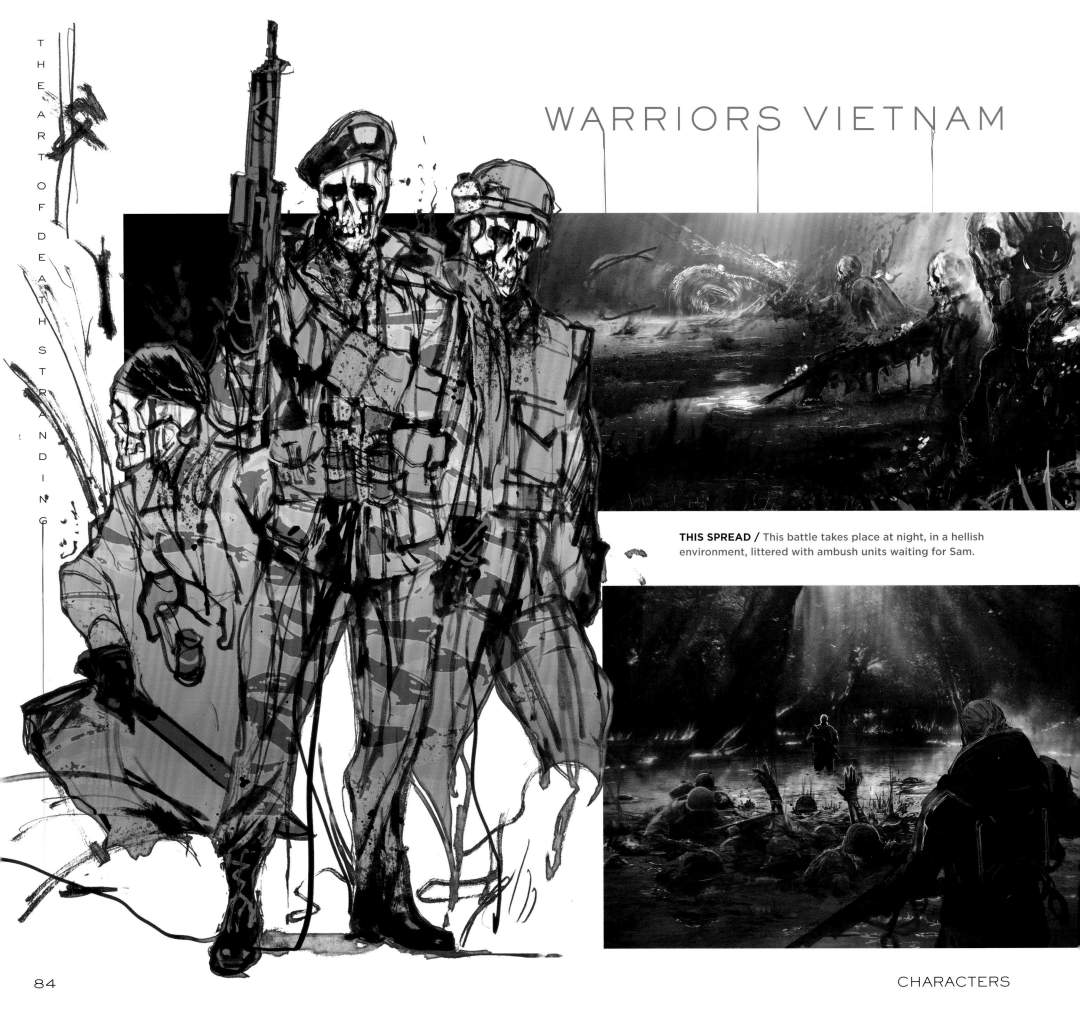

WARRIORS VIETNAM

THIS SPREAD / This battle takes place at night, in a hellish environment, littered with ambush units waiting for Sam.

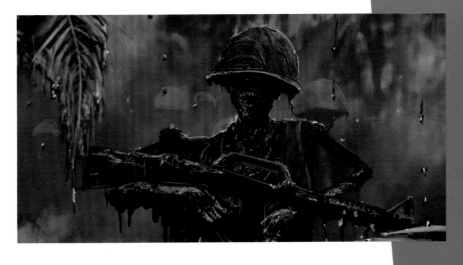
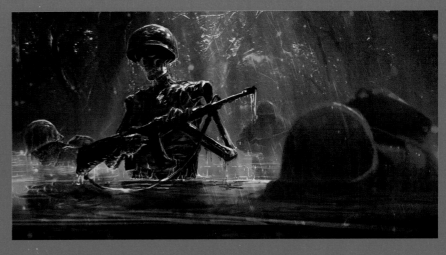
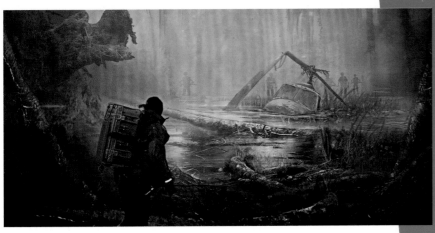
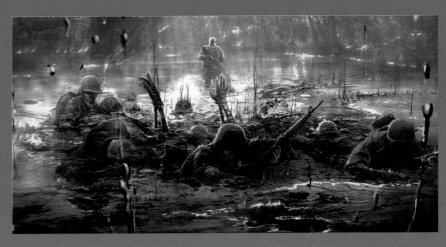
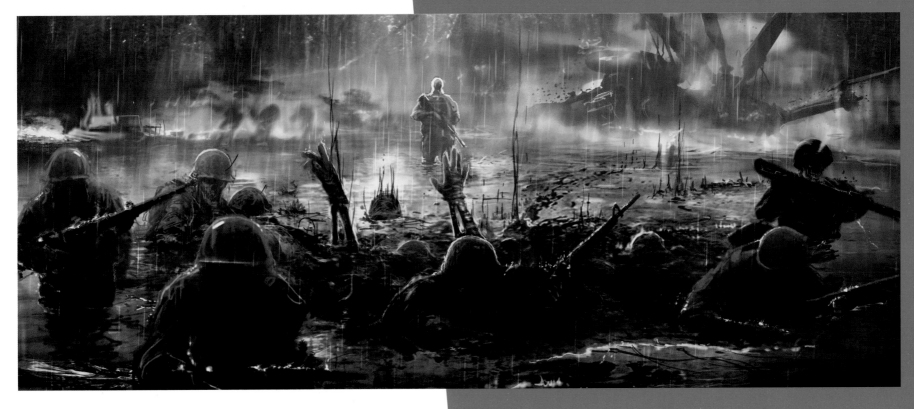

WARRIORS VIETNAM

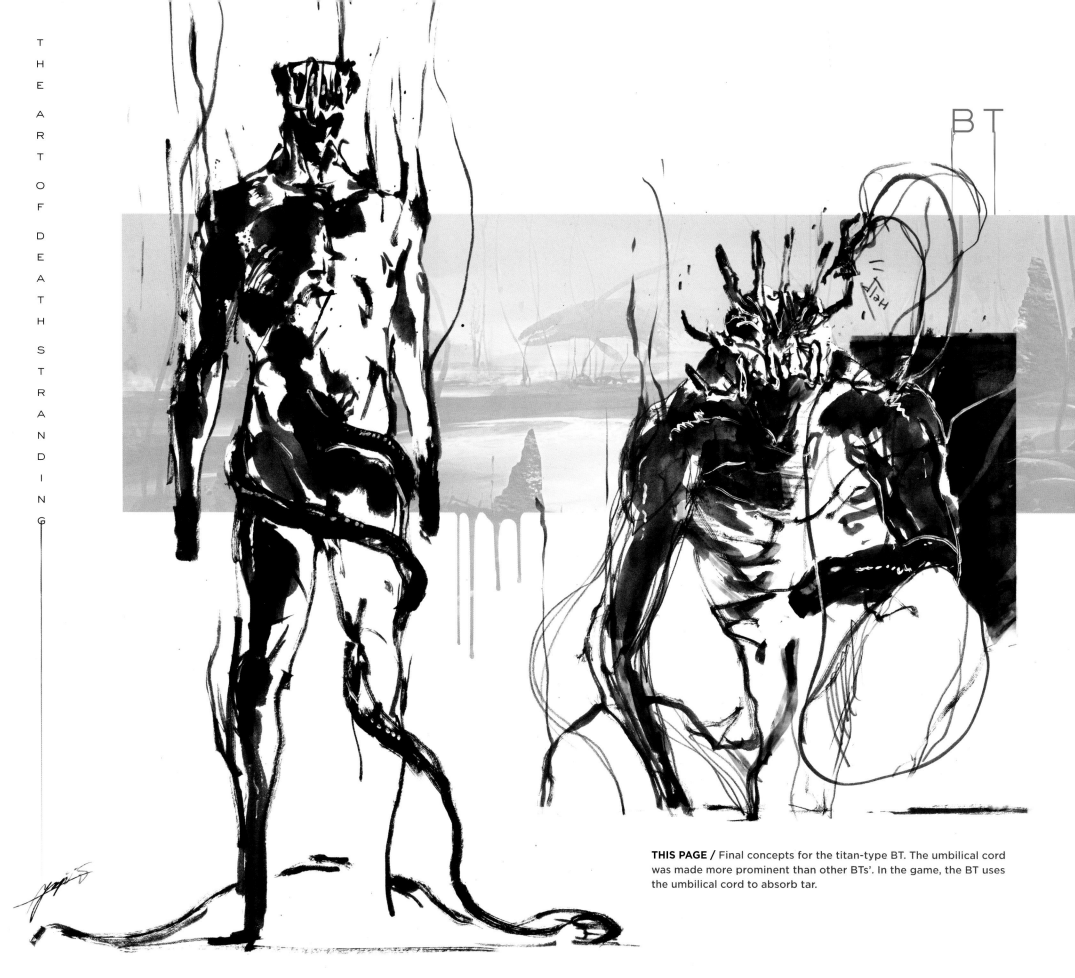

BT

THIS PAGE / Final concepts for the titan-type BT. The umbilical cord was made more prominent than other BTs'. In the game, the BT uses the umbilical cord to absorb tar.

CHARACTERS

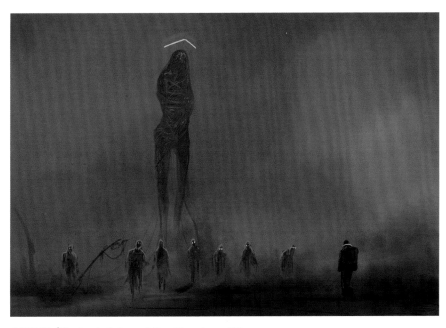

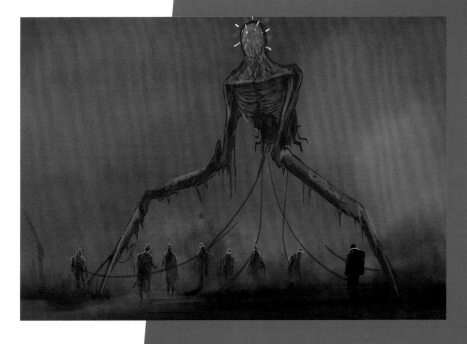

ABOVE / Early sketches of the titan-type BT.

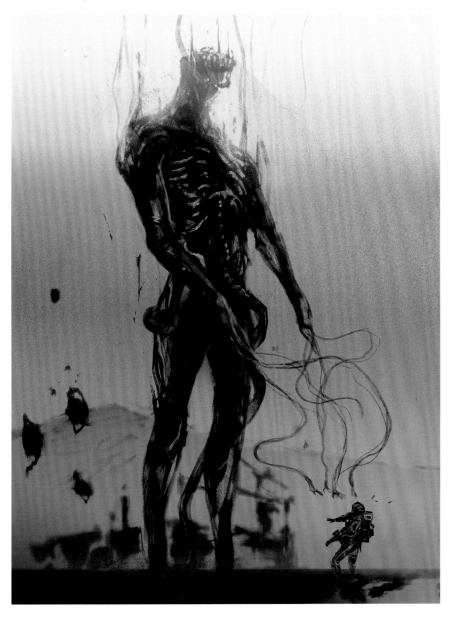

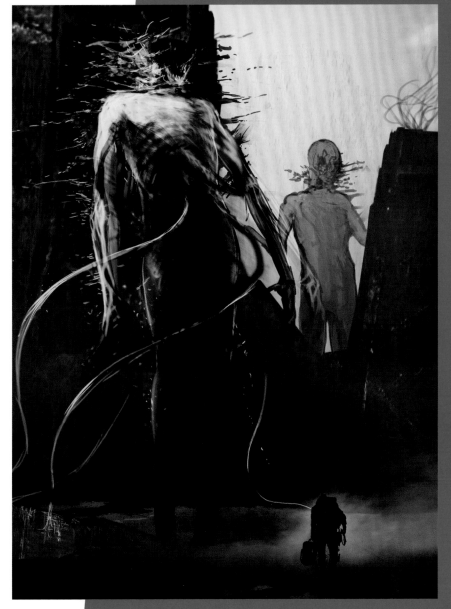

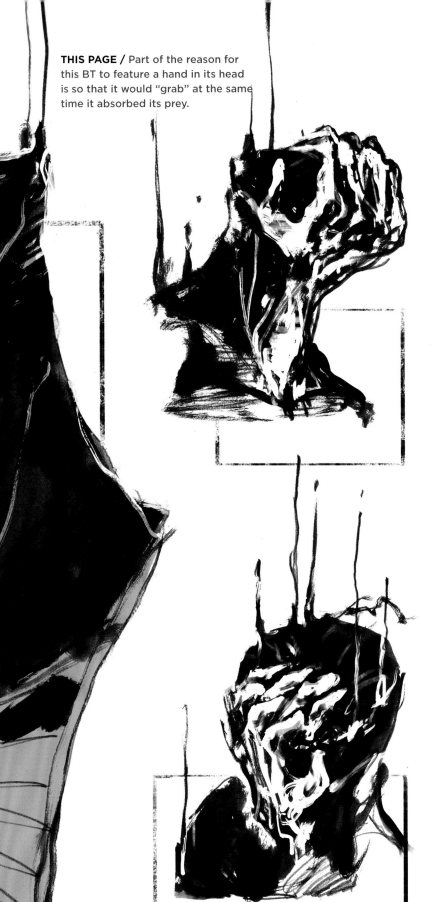

THIS PAGE / Part of the reason for this BT to feature a hand in its head is so that it would "grab" at the same time it absorbed its prey.

CHARACTERS

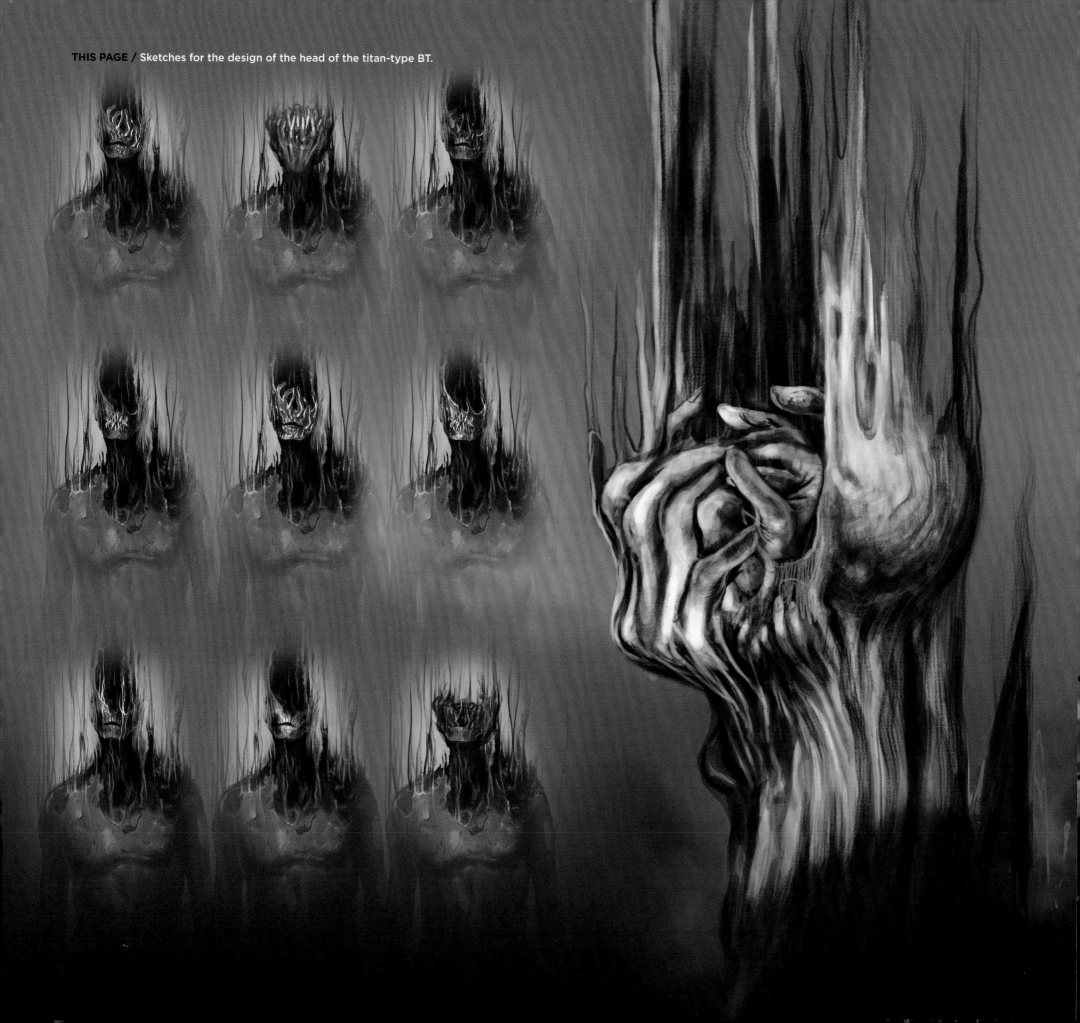

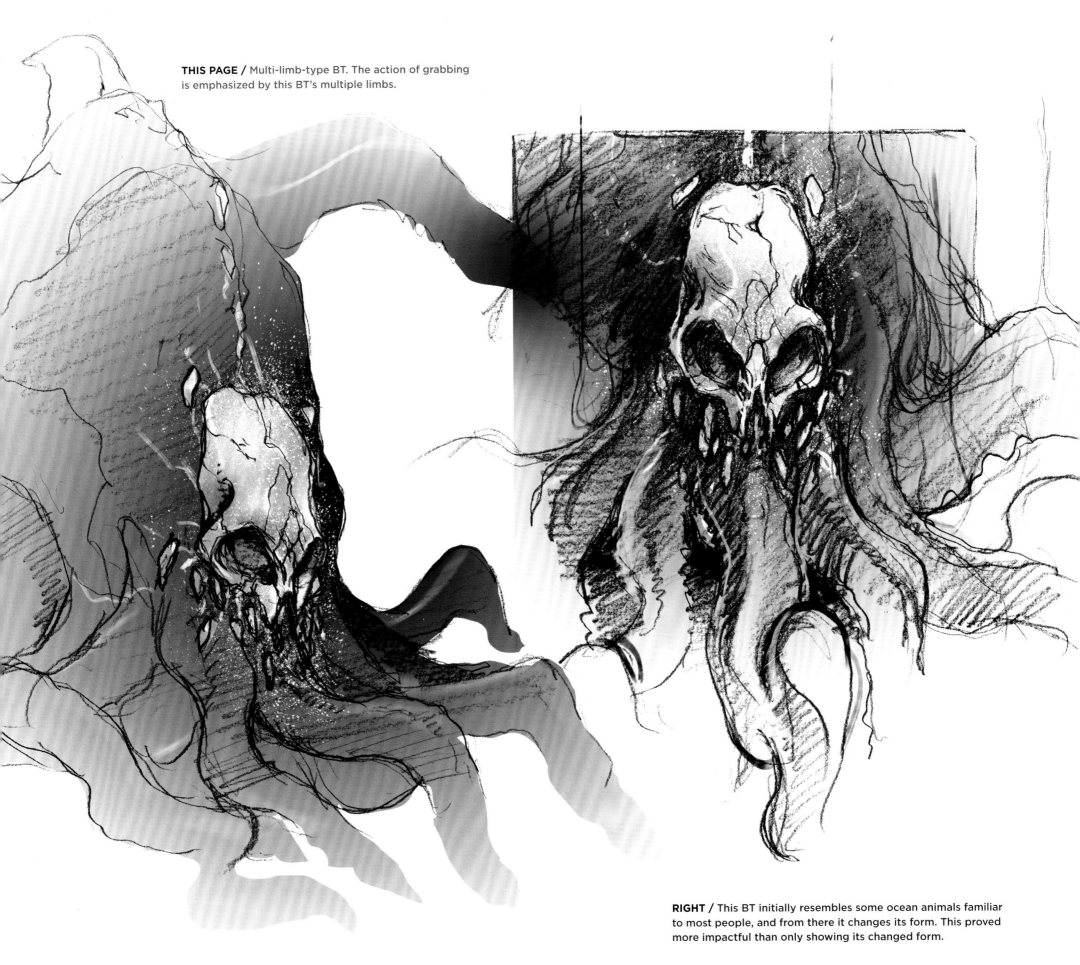

THIS PAGE / Multi-limb-type BT. The action of grabbing is emphasized by this BT's multiple limbs.

RIGHT / This BT initially resembles some ocean animals familiar to most people, and from there it changes its form. This proved more impactful than only showing its changed form.

CHARACTERS

RIGHT / The interior of the mouth of the whale-type BT.

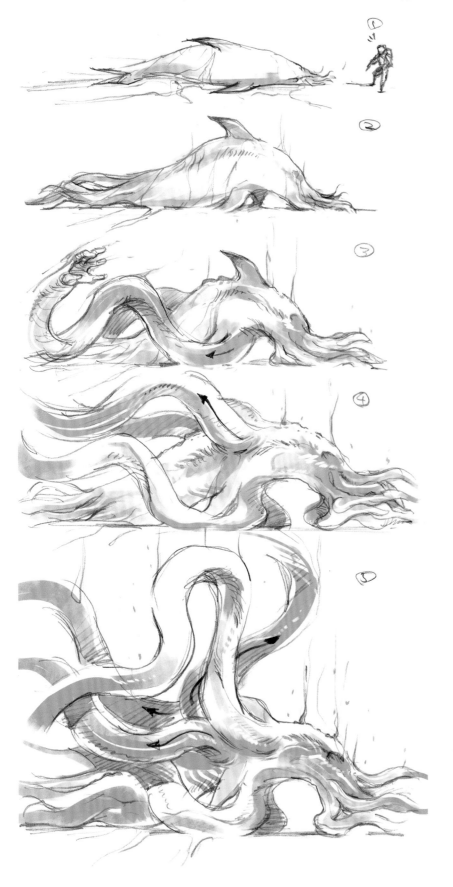

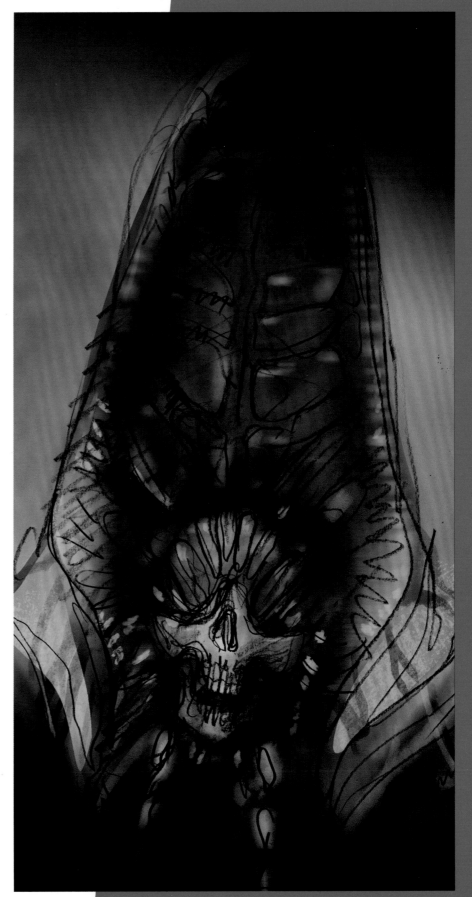

BT

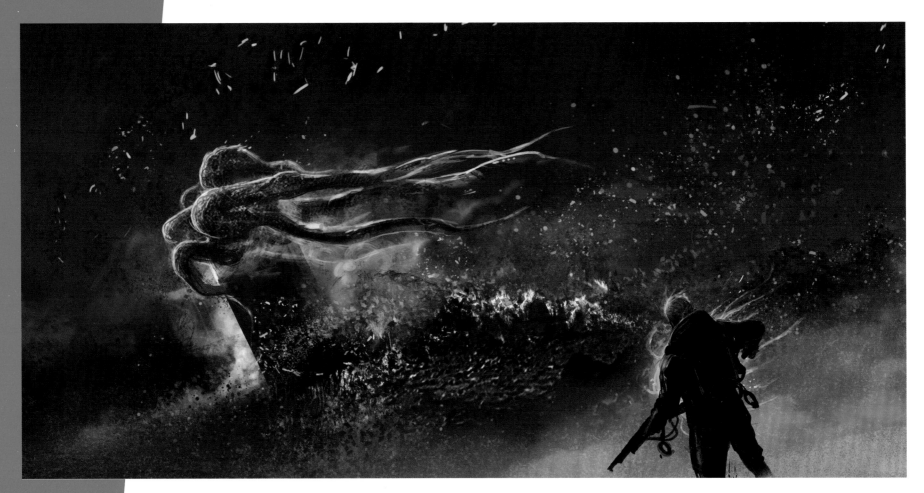

THIS SPREAD / Concepts for battles with multi-limb-type BTs.

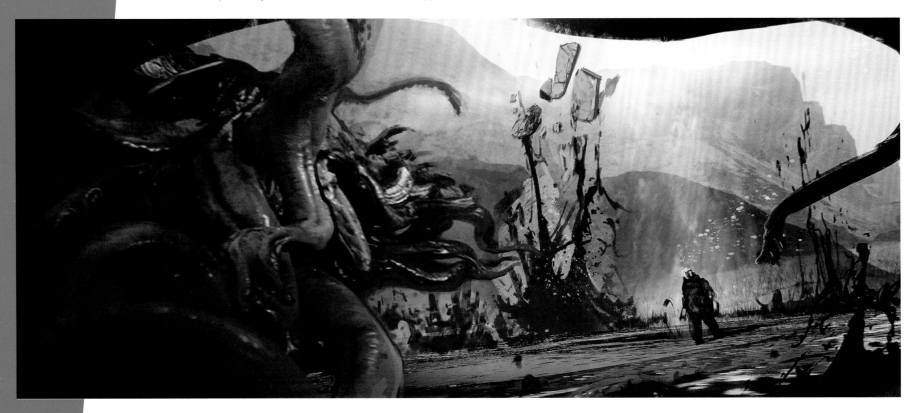

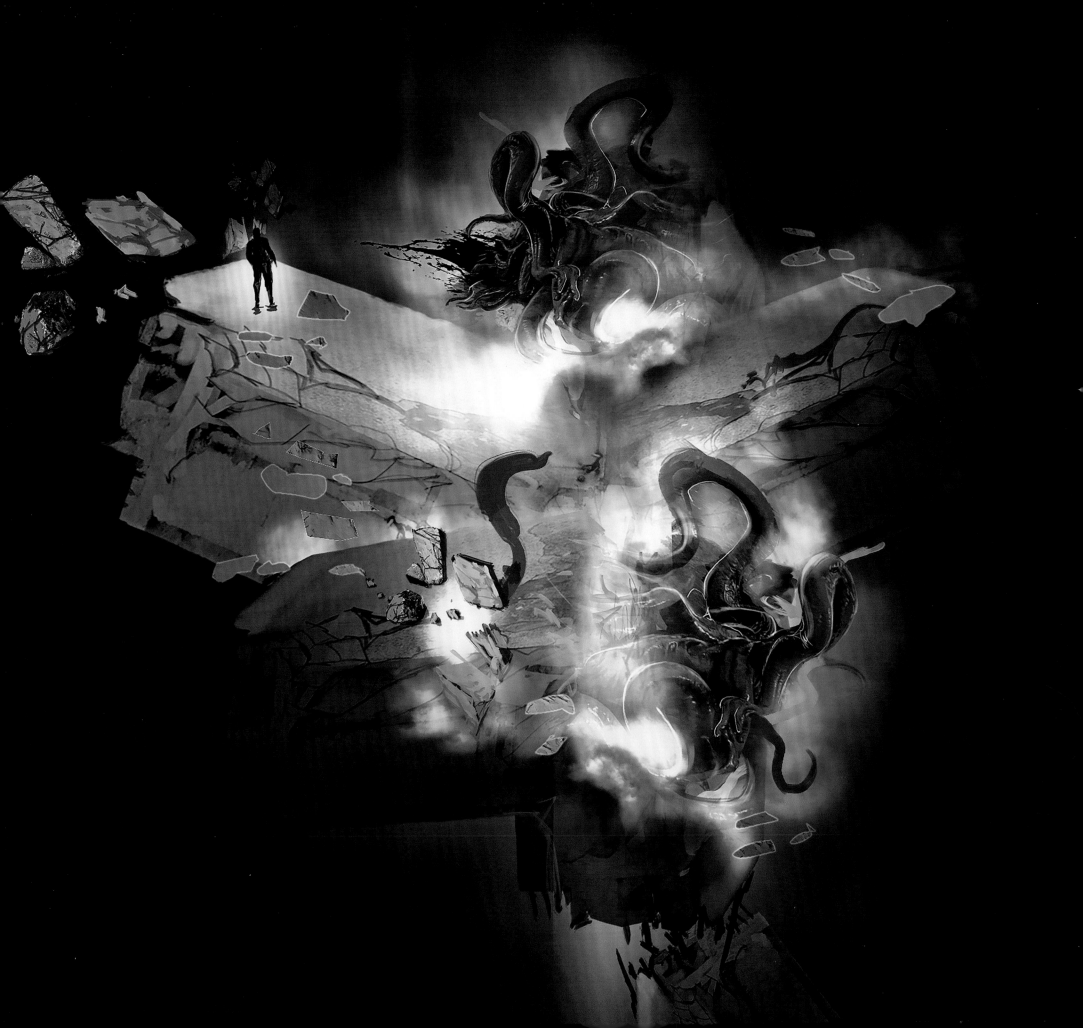

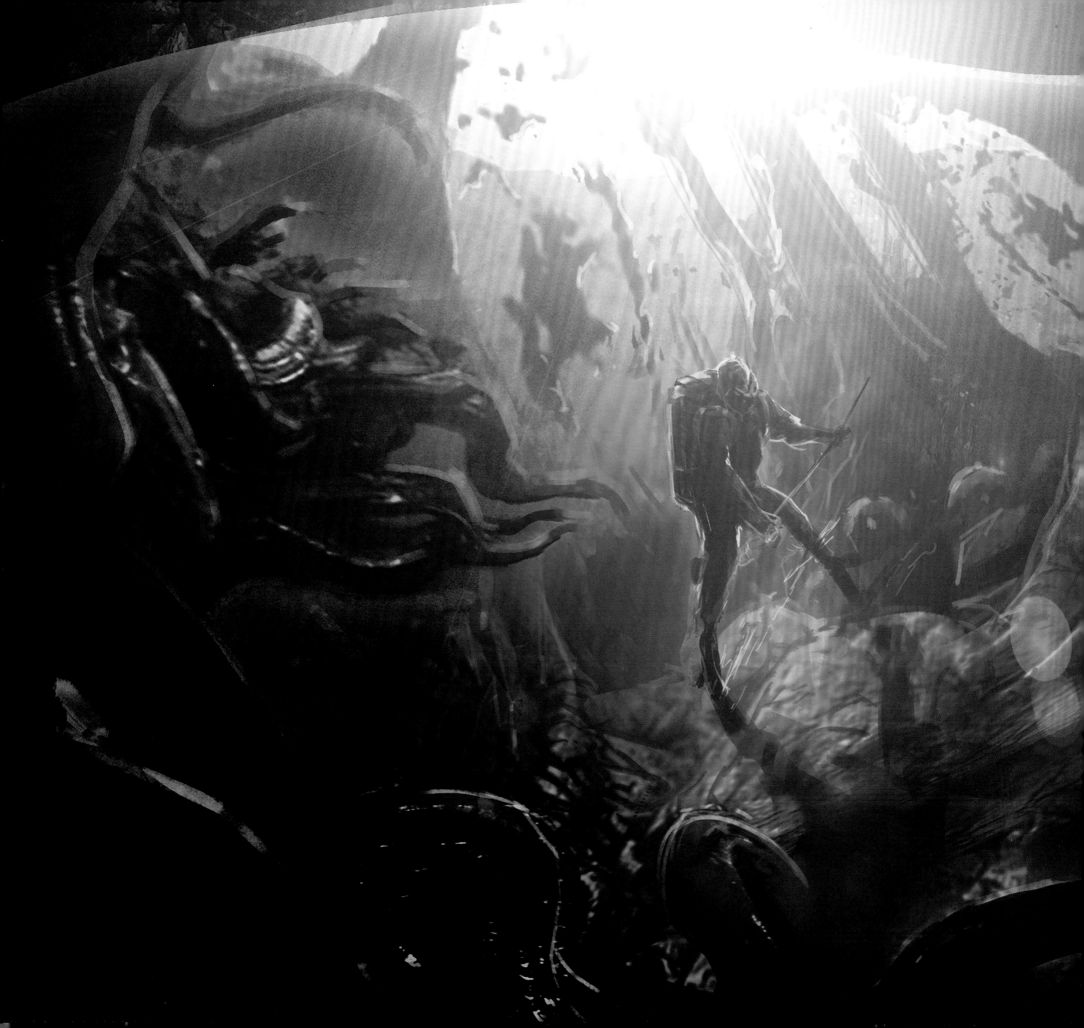

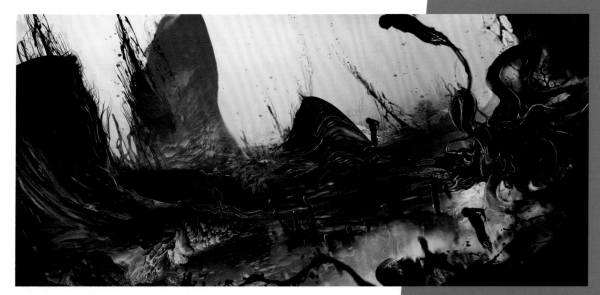

THIS SPREAD / Early concepts for how BTs would appear.

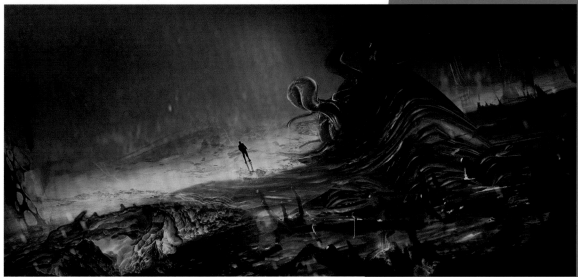

BELOW / Early concept for how BTs would appear. The idea for this concept was for BTs to be "born" from the sky.

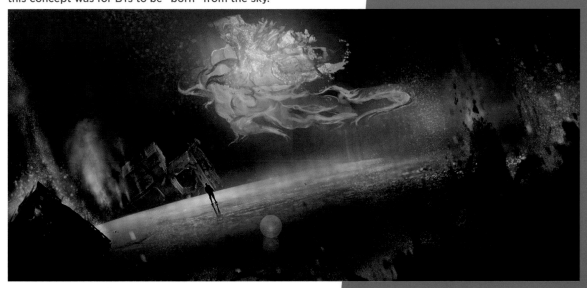

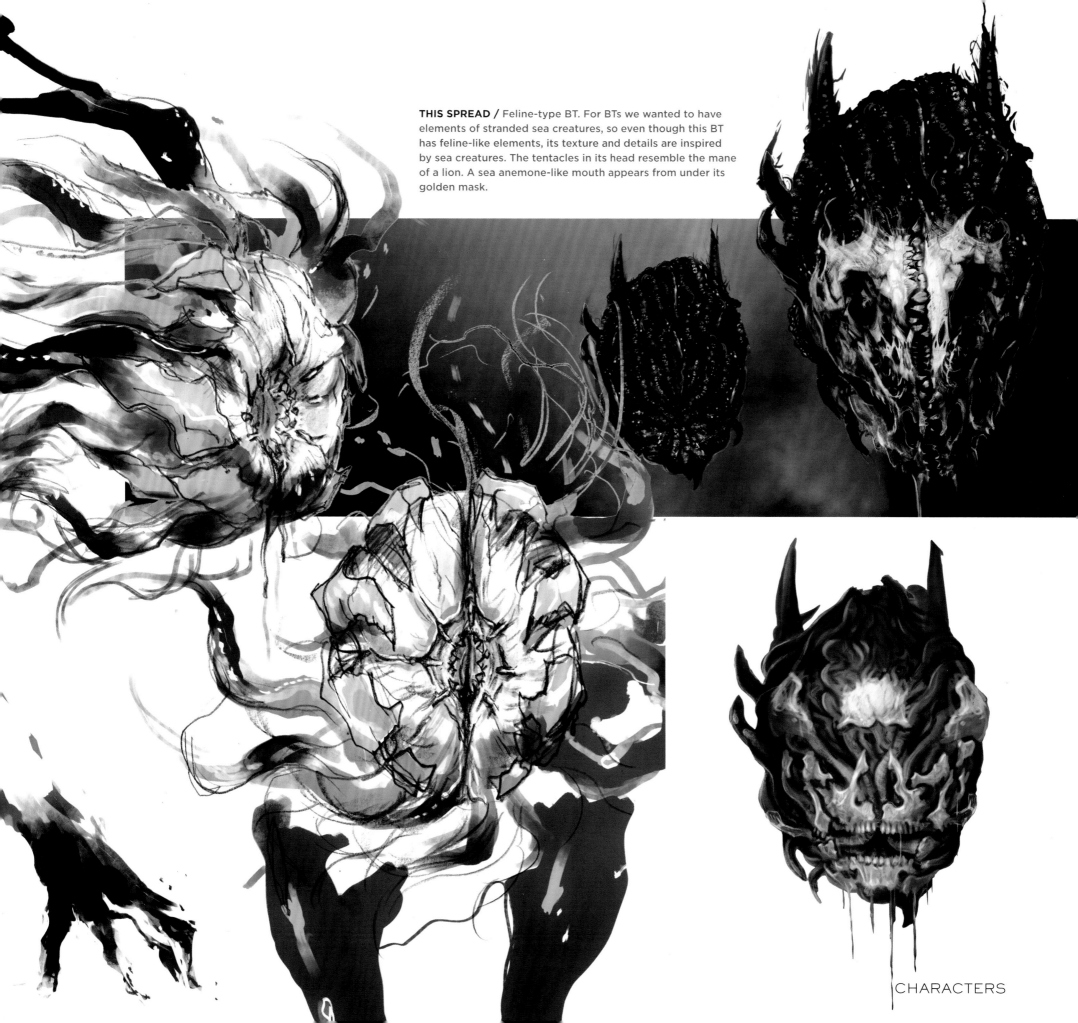

THIS SPREAD / Feline-type BT. For BTs we wanted to have elements of stranded sea creatures, so even though this BT has feline-like elements, its texture and details are inspired by sea creatures. The tentacles in its head resemble the mane of a lion. A sea anemone-like mouth appears from under its golden mask.

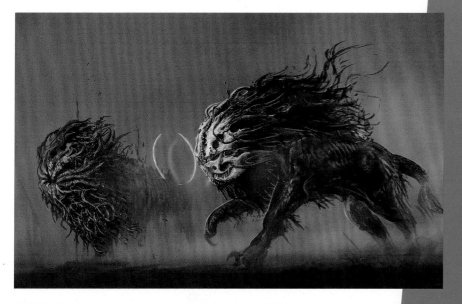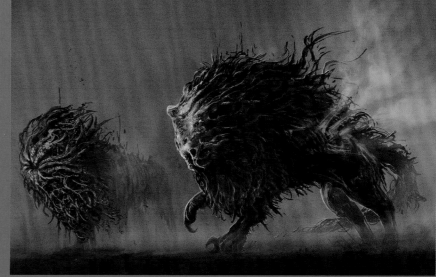

ABOVE / Different concepts for the feline-type BT's head.

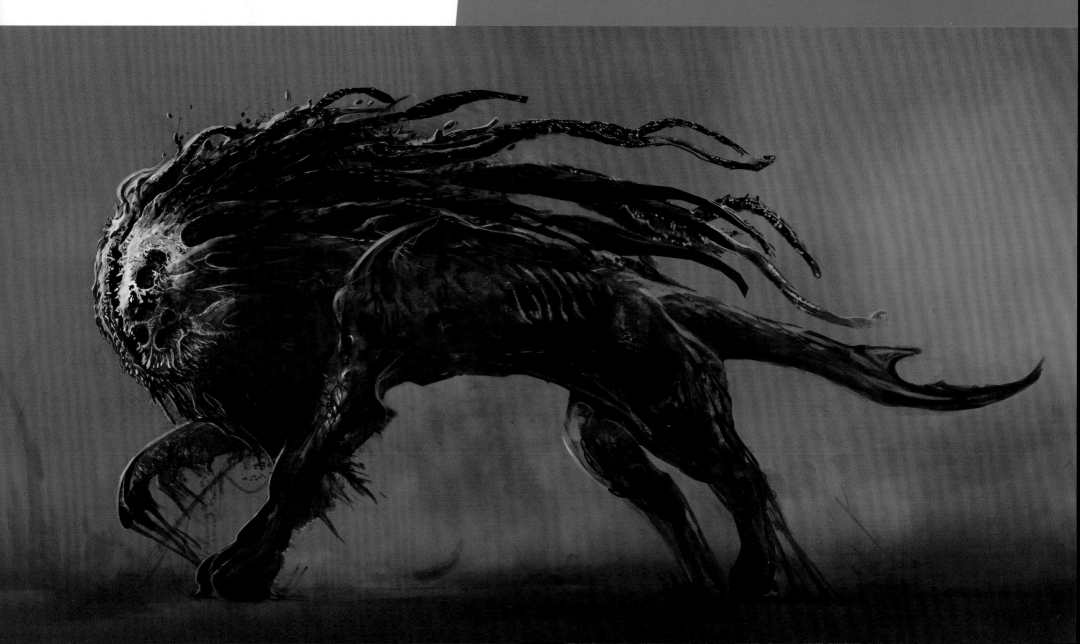

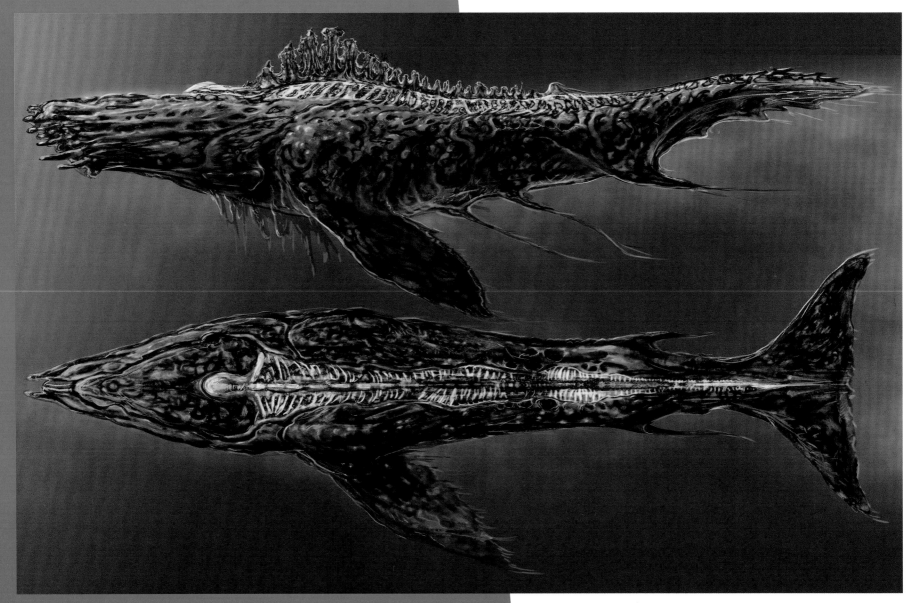

THIS PAGE / Final concepts for the whale-type BT. Its exposed spine gives the impression of a human.

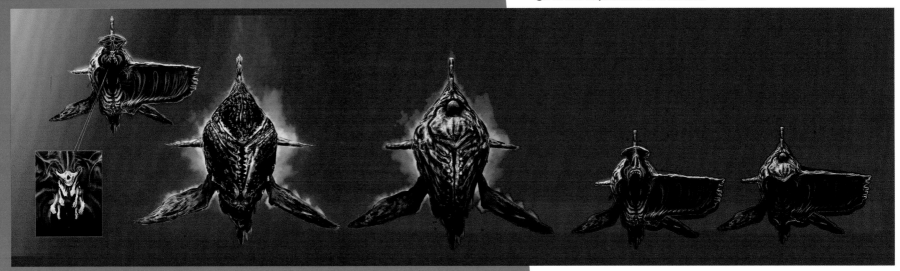

CHARACTERS

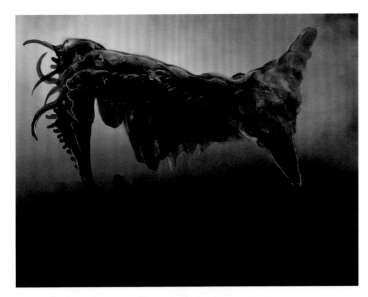

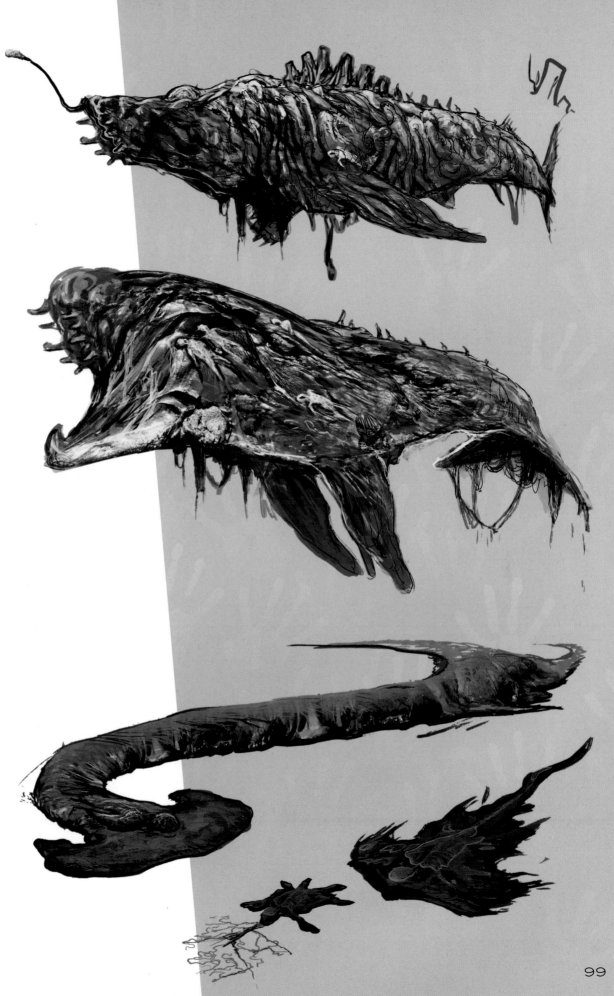

THIS PAGE / Early sketches of the whale-type BT.

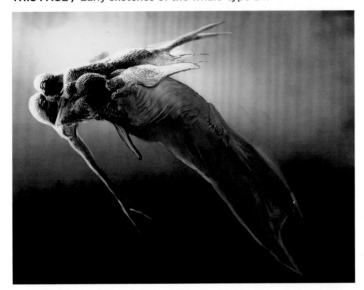

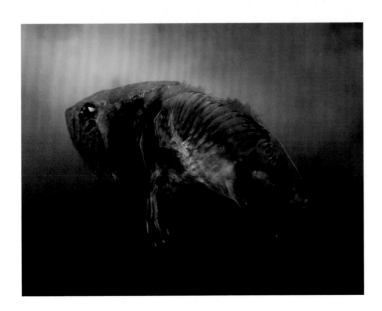

BT

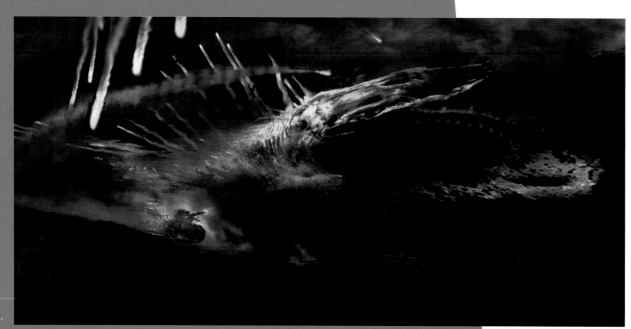

THIS SPREAD / Concepts for various BT battles.

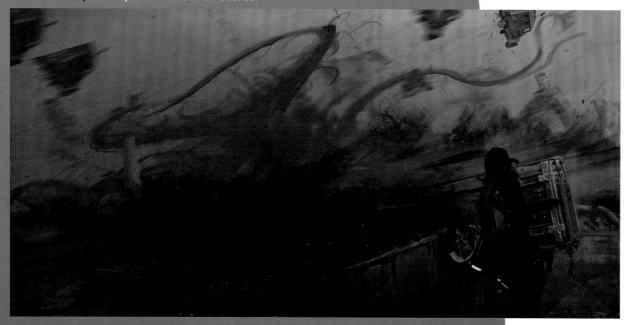

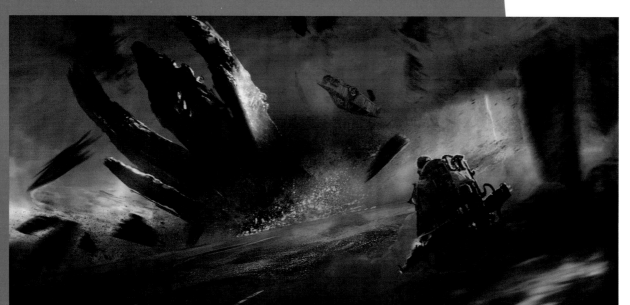

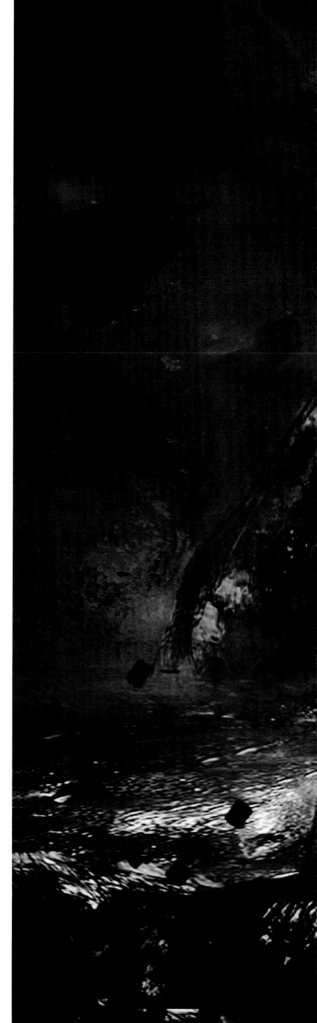

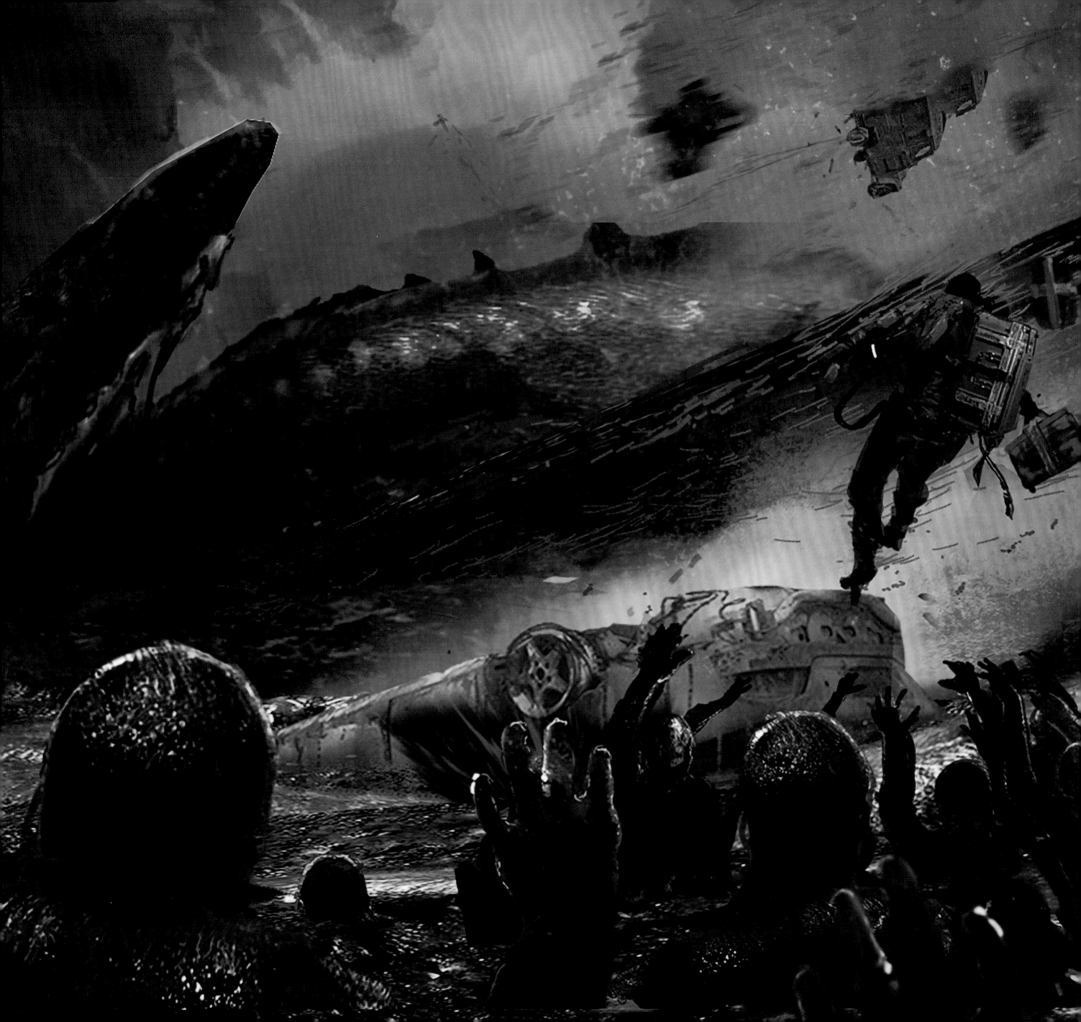

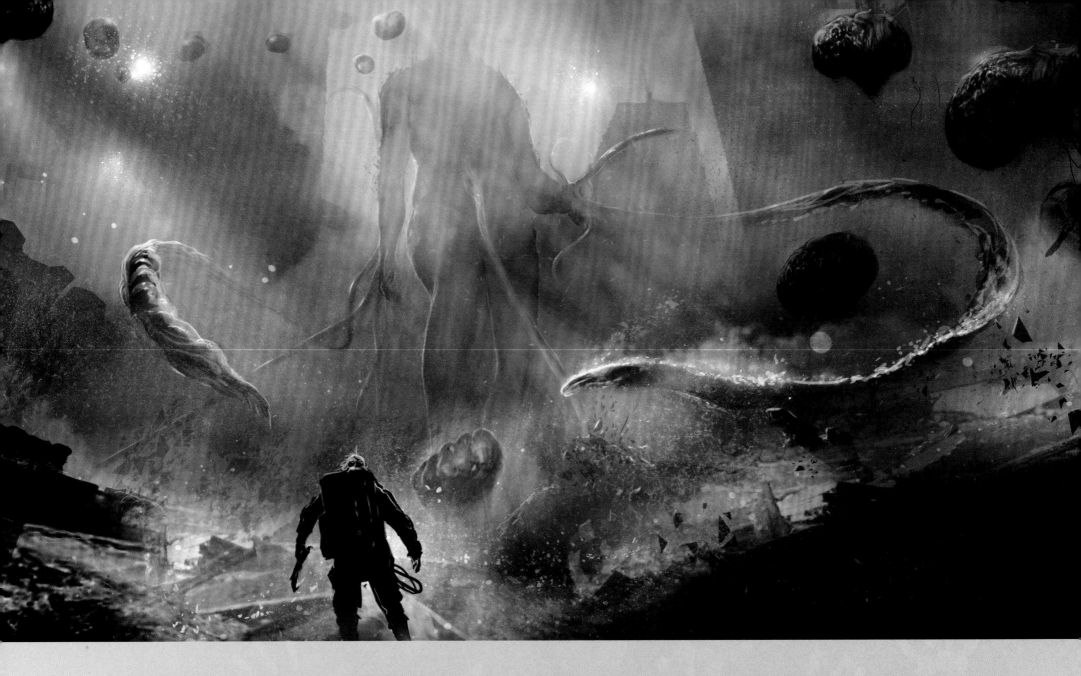

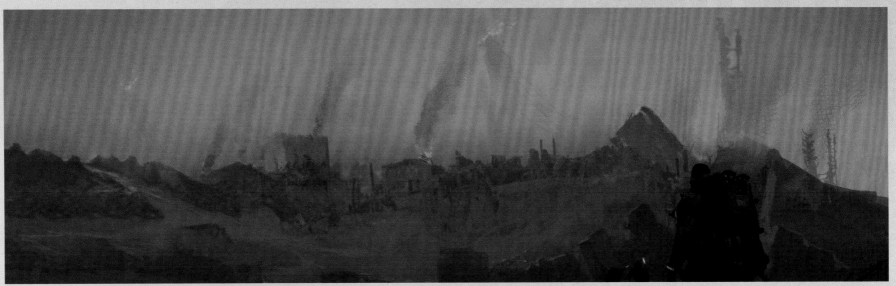

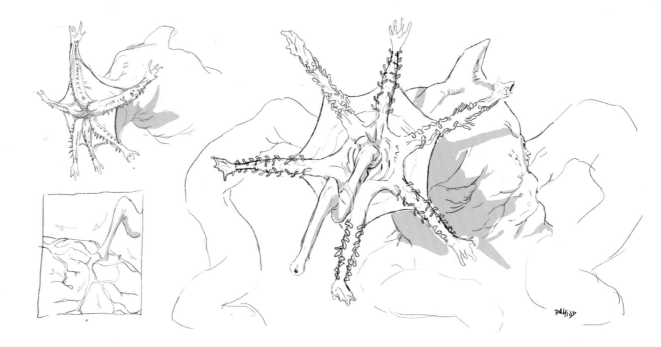

THIS SPREAD / In parallel with conceiving the BTs themselves, ideas for how their attacks would look were also conceptualized.

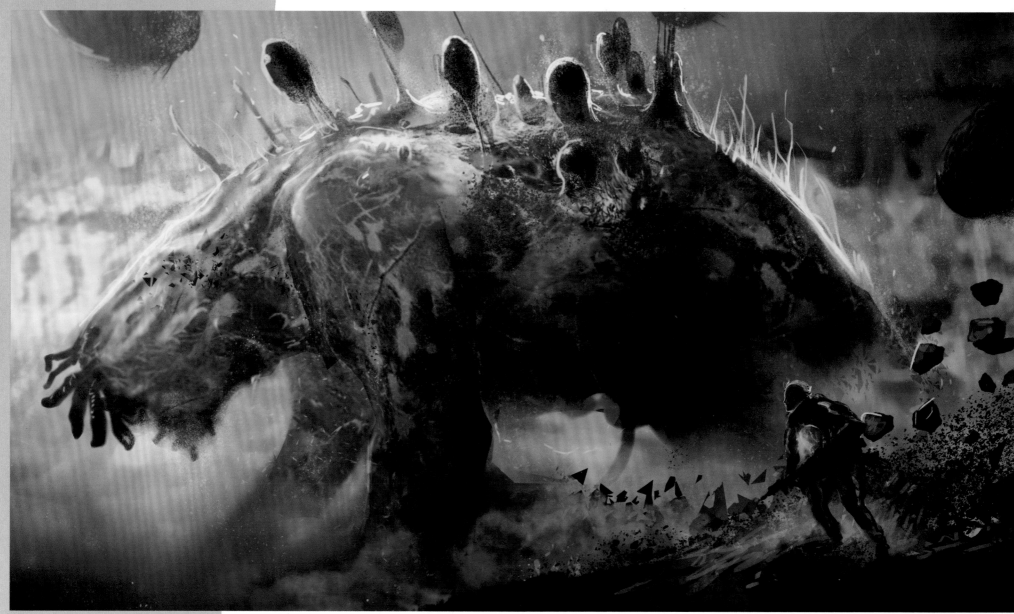

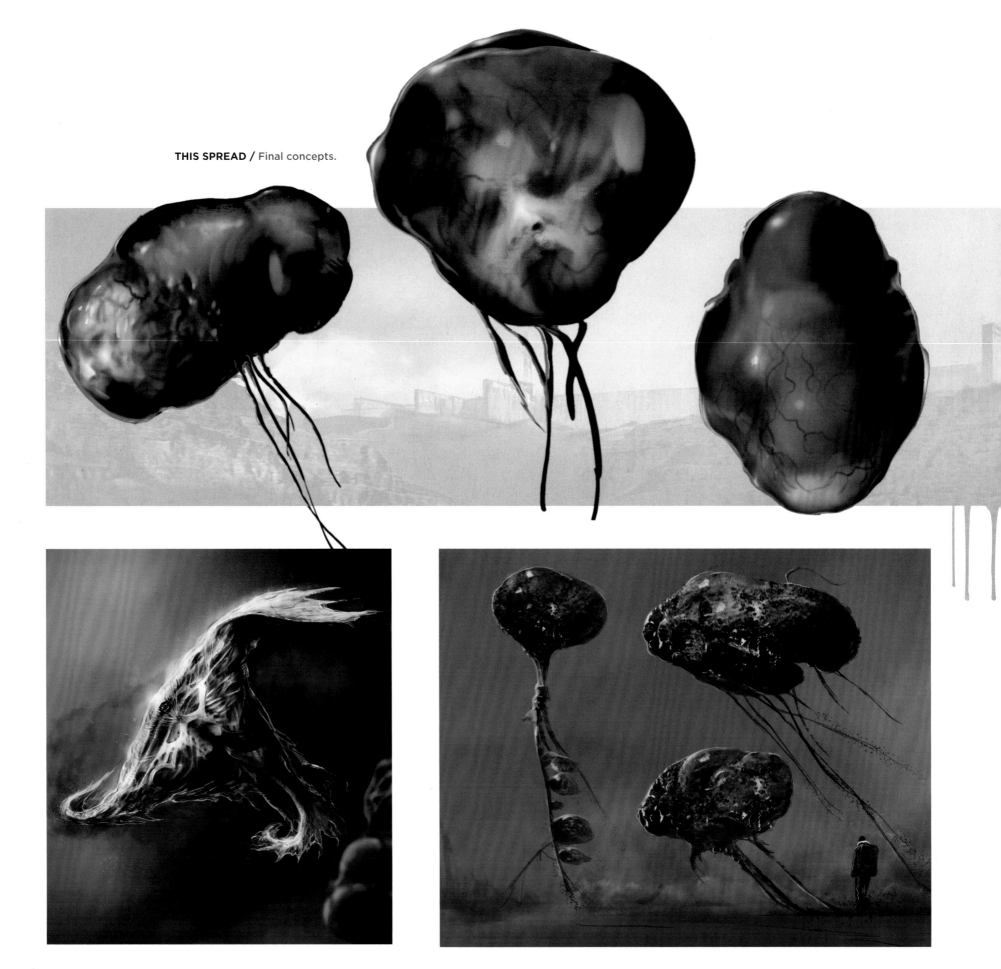

THIS SPREAD / Final concepts.

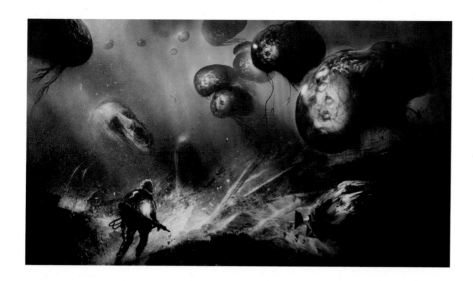
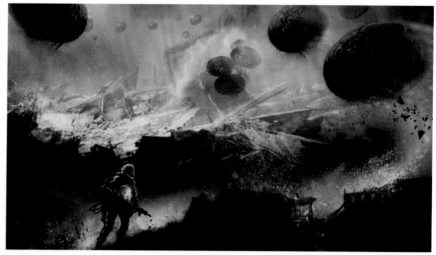
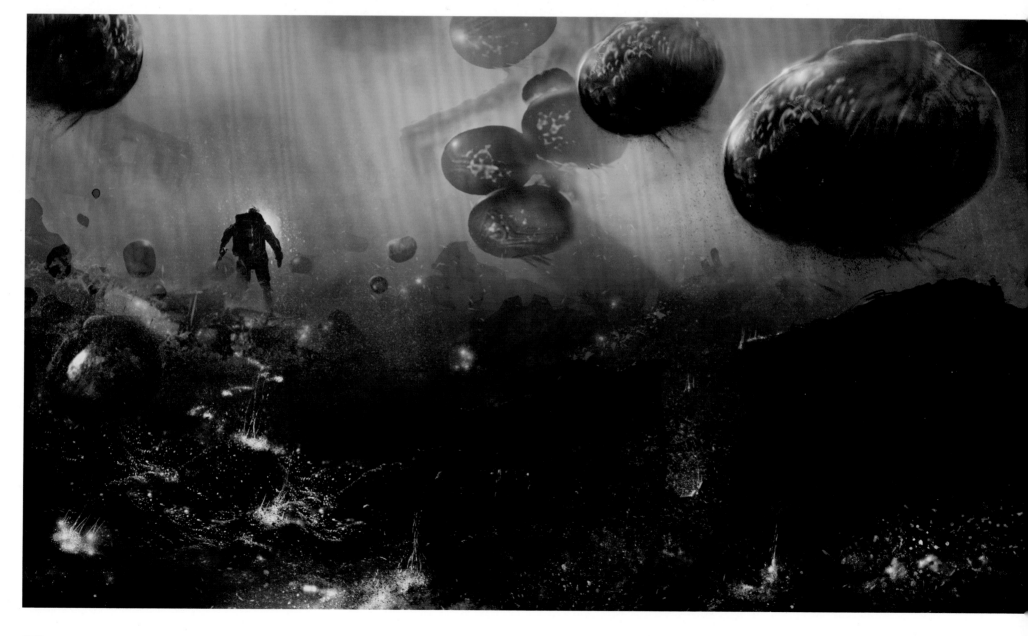

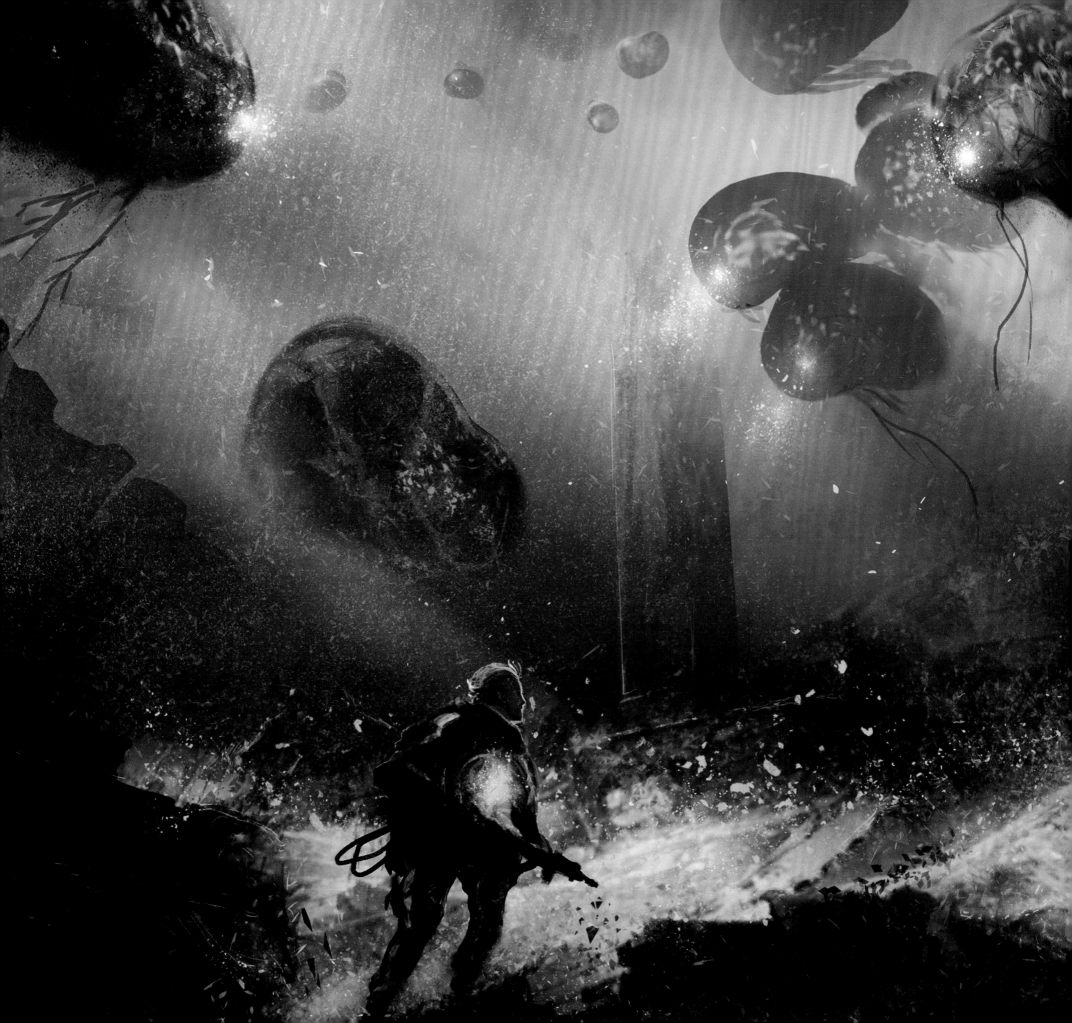

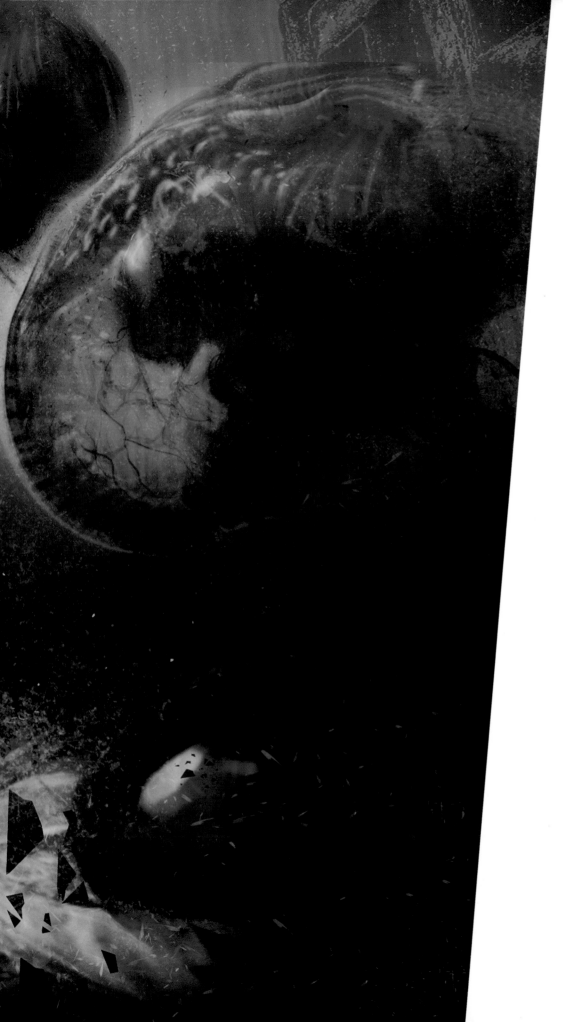
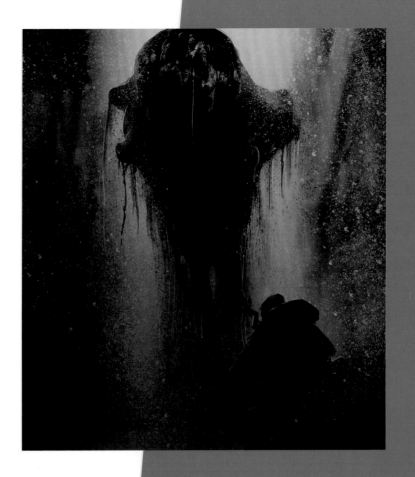
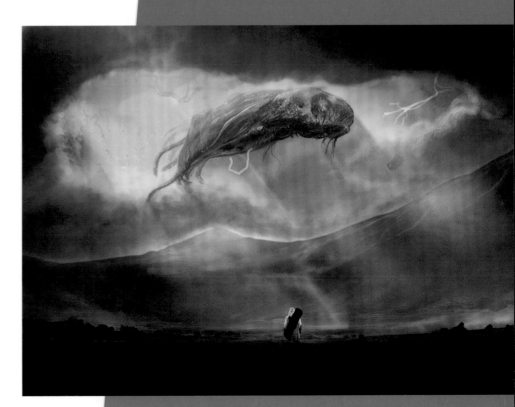

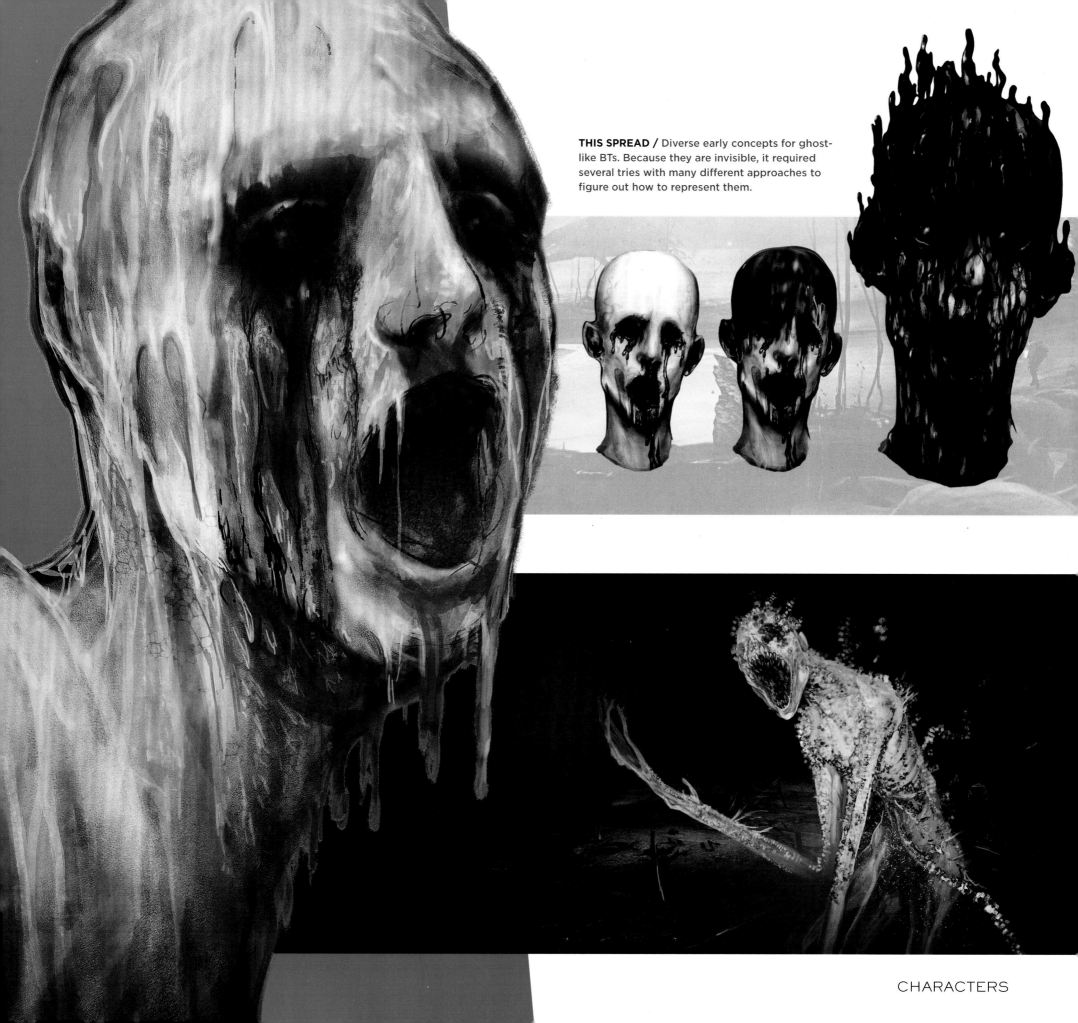

CHARACTERS

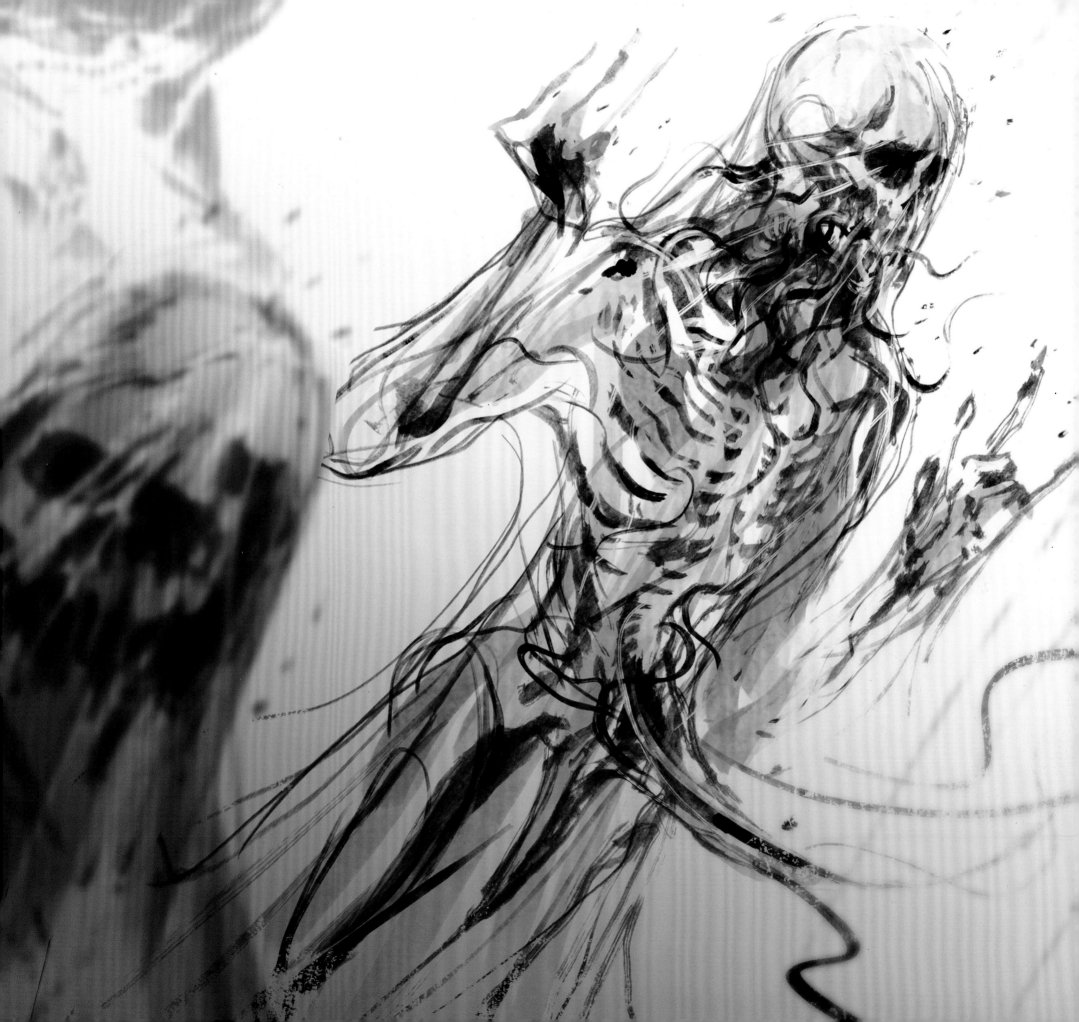

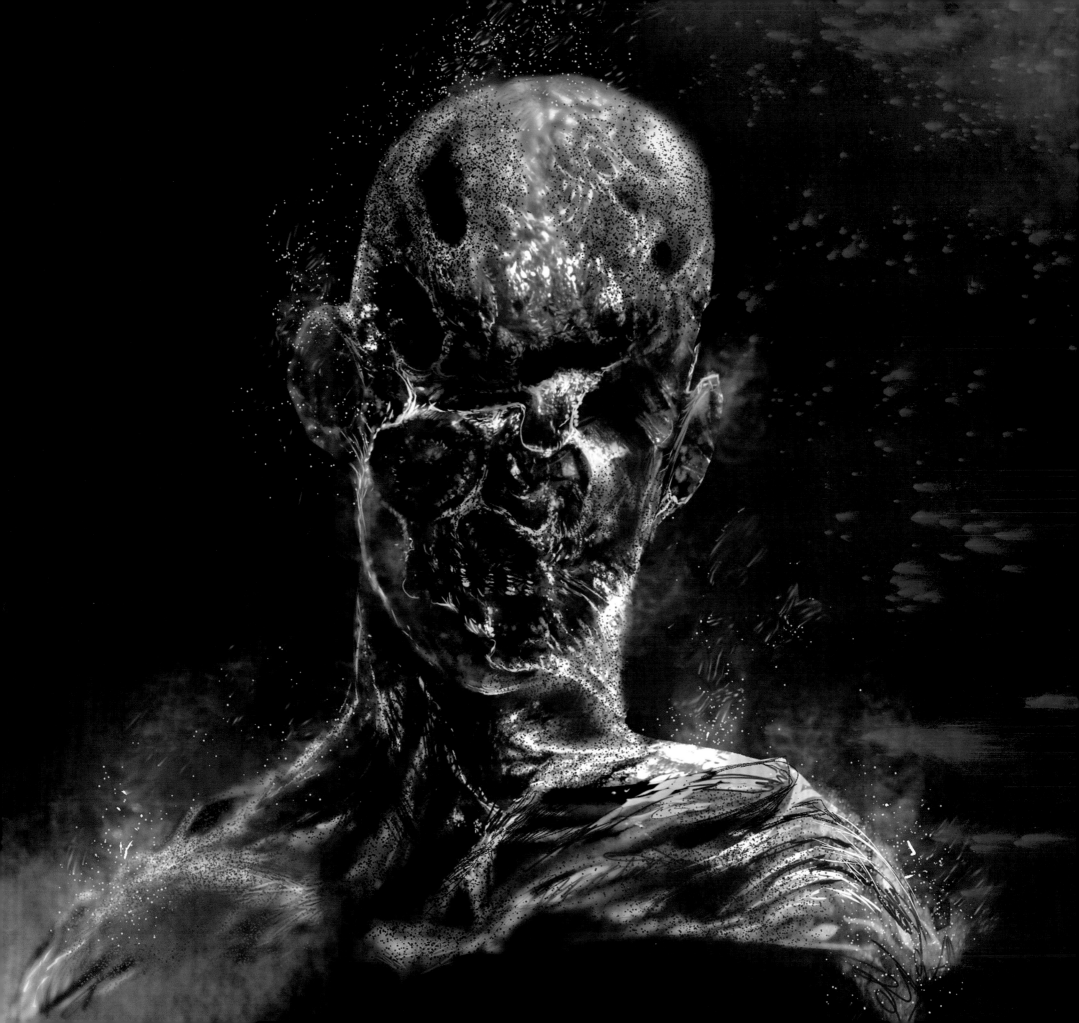

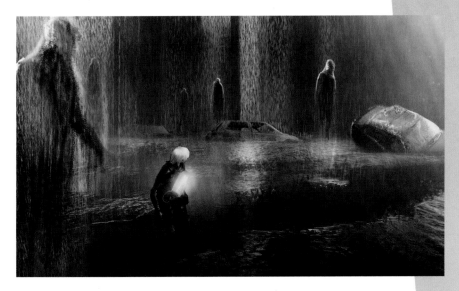

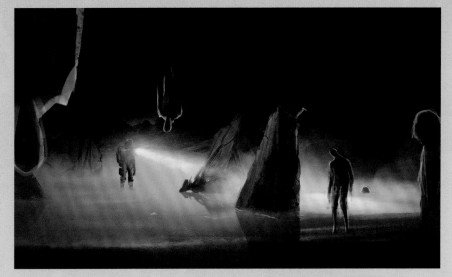

THIS SPREAD / Different concepts for how to represent invisible BTs.

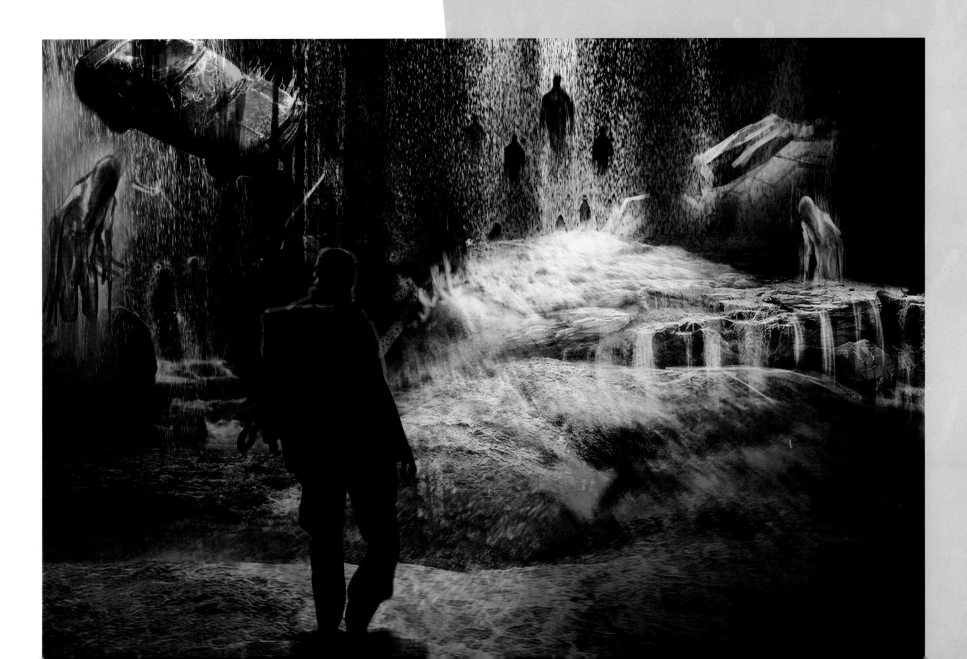

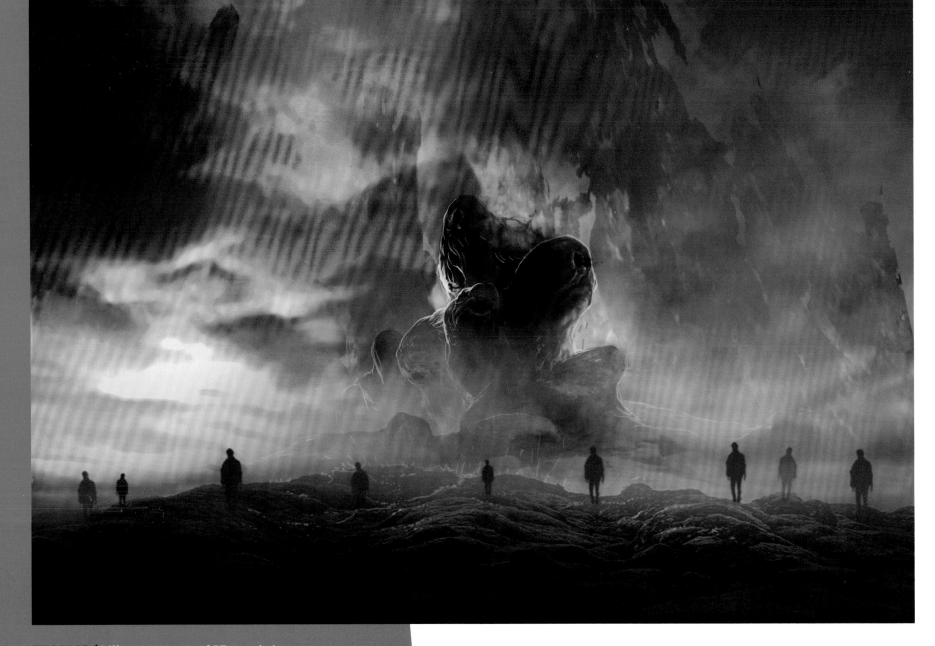

THIS PAGE / Different concepts of BTs wandering.

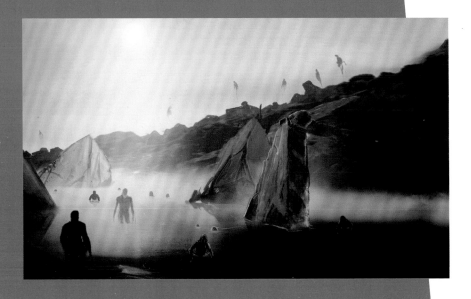

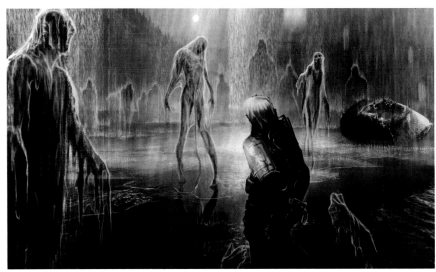

CHARACTERS

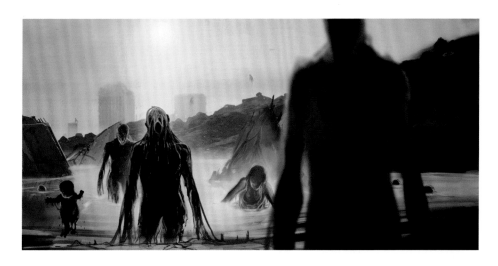

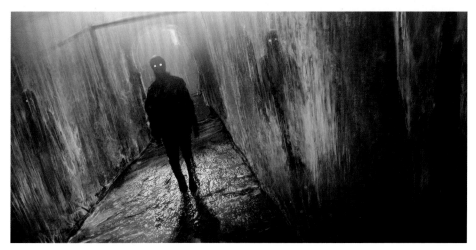

BELOW & RIGHT / Detailed concepts for how to represent invisible BTs.

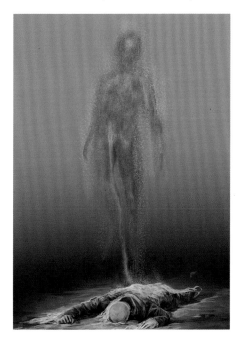

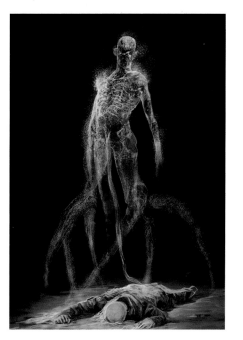

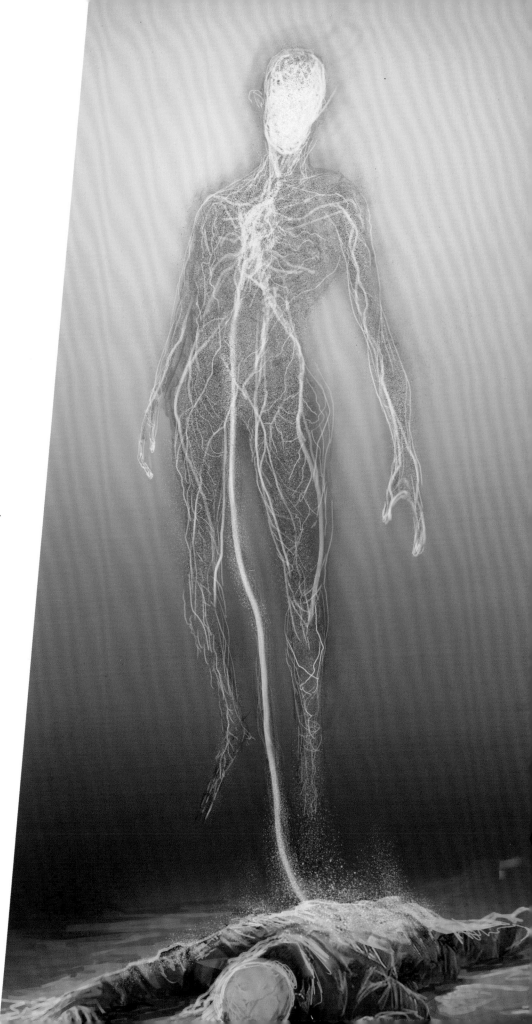

BT

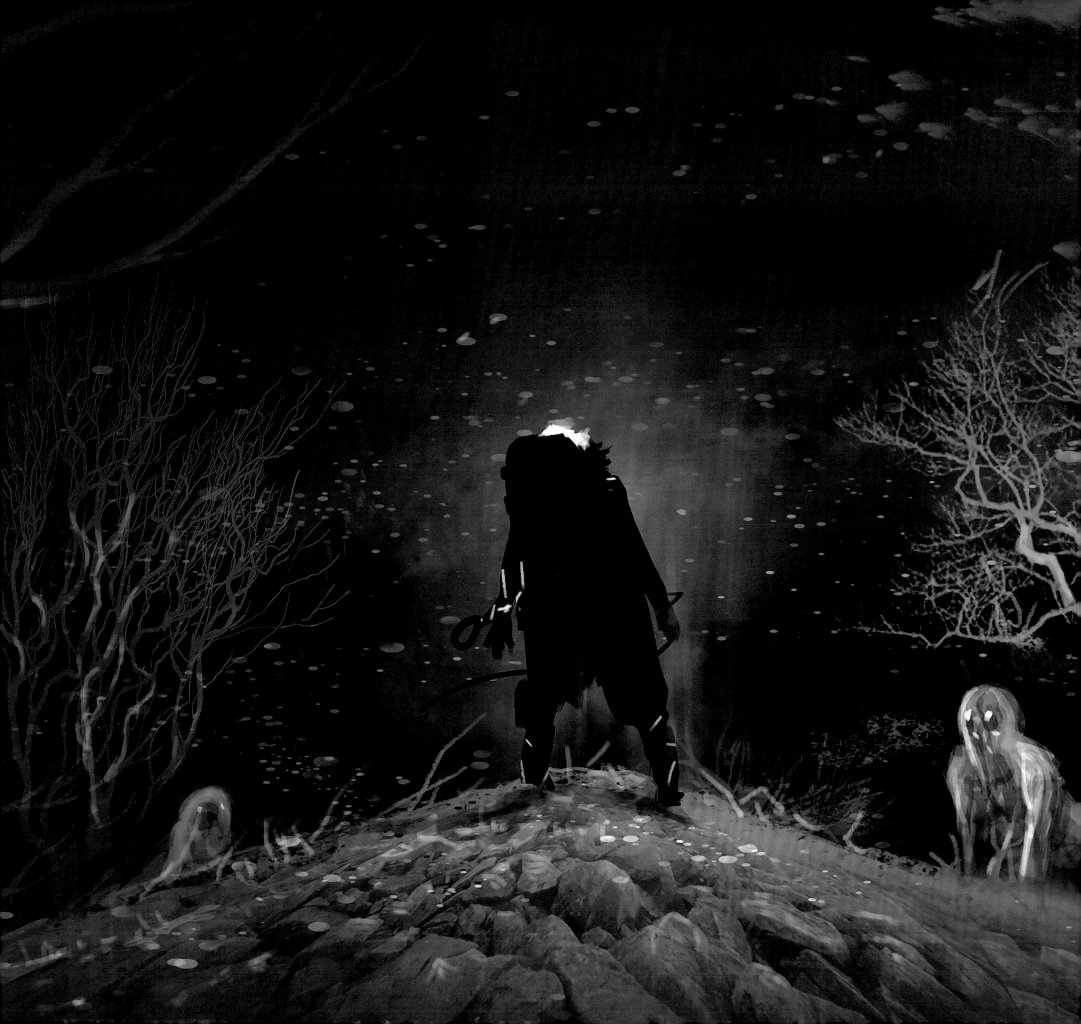

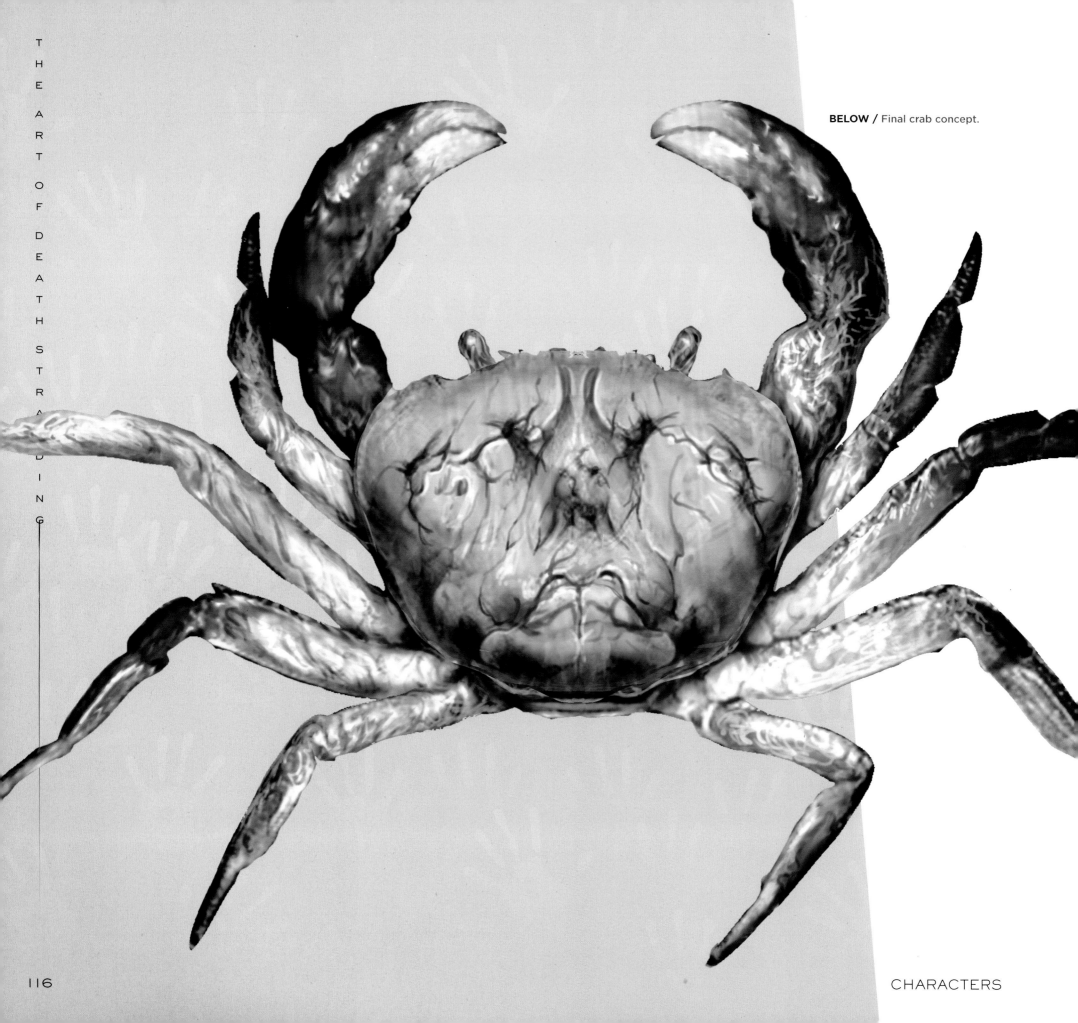

BELOW / Final crab concept.

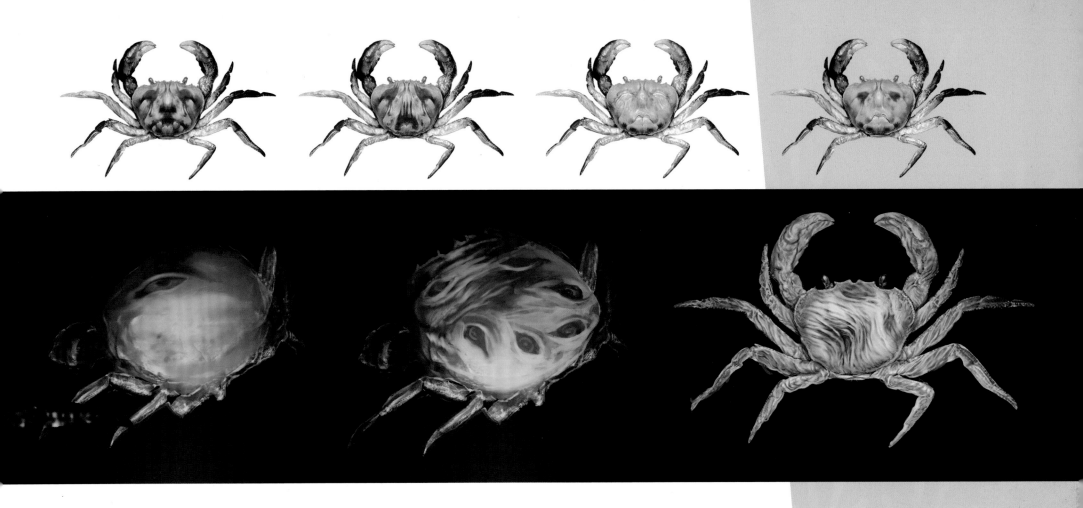

THIS SPREAD / Stranded crabs, which also required several concept iterations before being finalized. The final concept favors representing something familiar that when looked at closely reveals something bizarre.

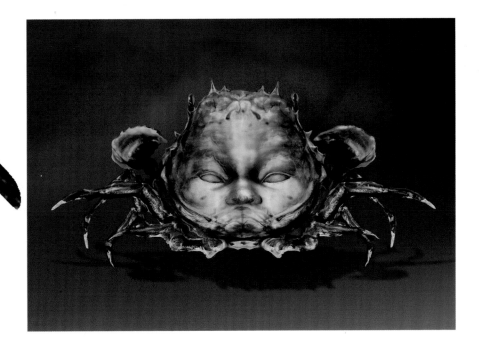

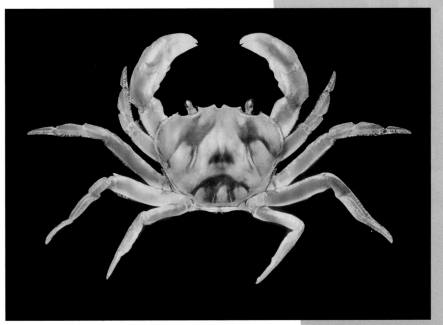

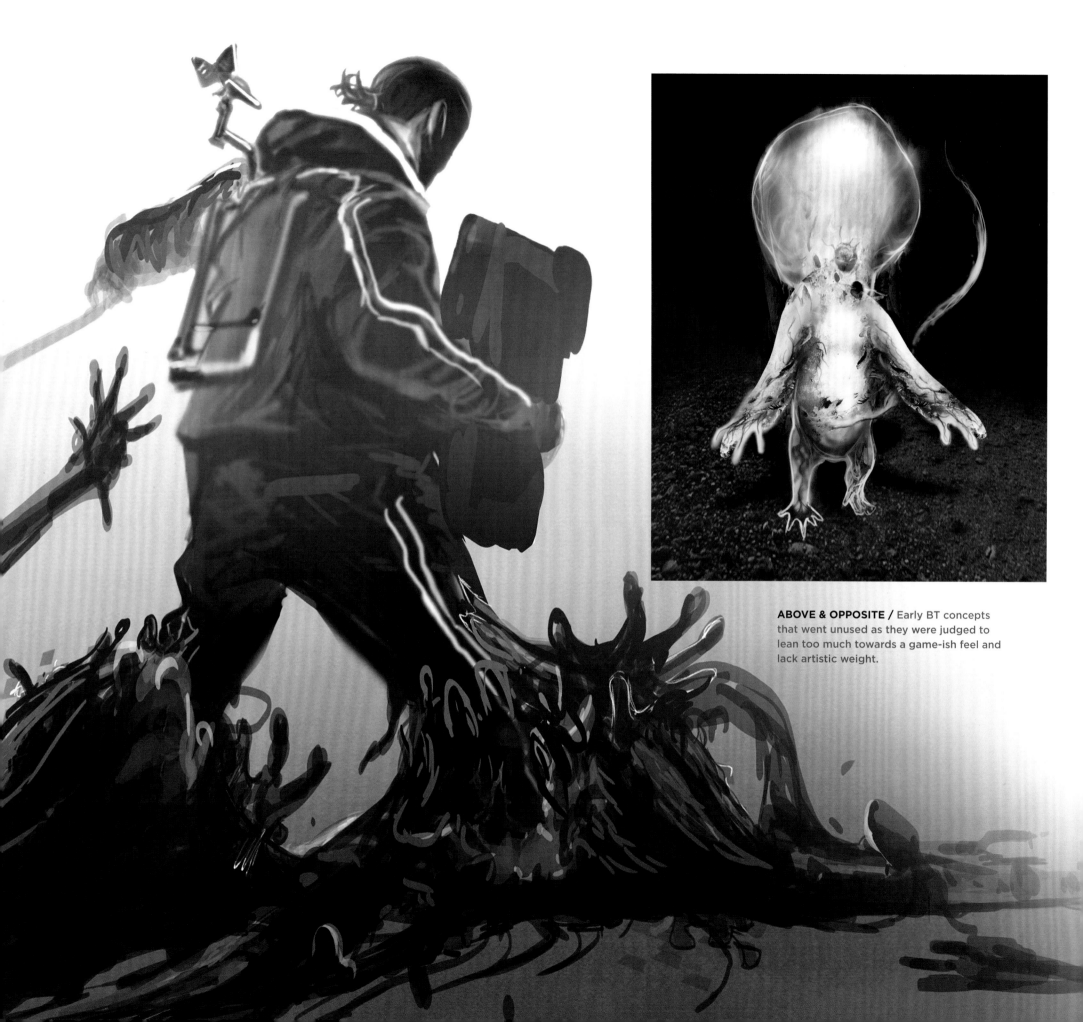

ABOVE & OPPOSITE / Early BT concepts that went unused as they were judged to lean too much towards a game-ish feel and lack artistic weight.

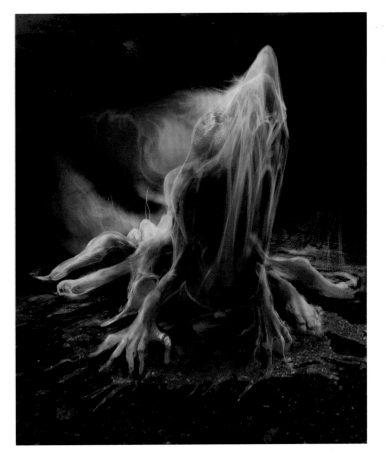

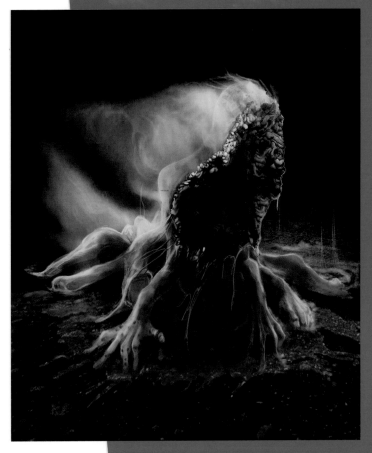

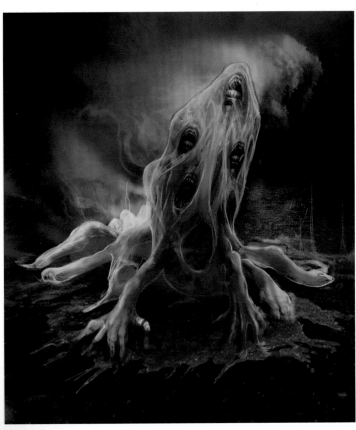

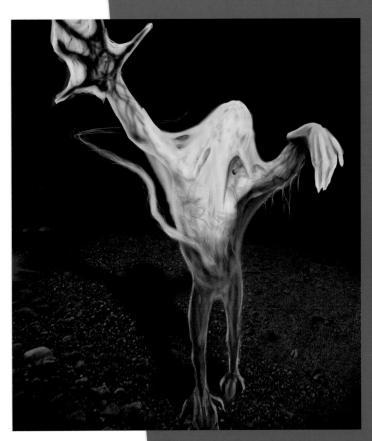

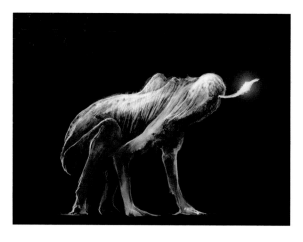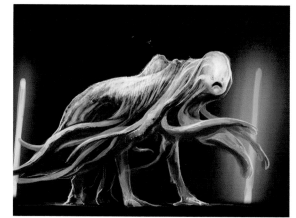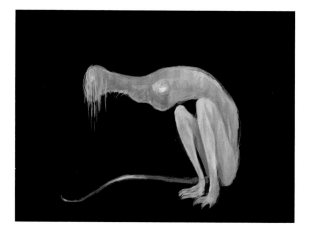

ABOVE & OPPOSITE TOP / Unused BT concepts.

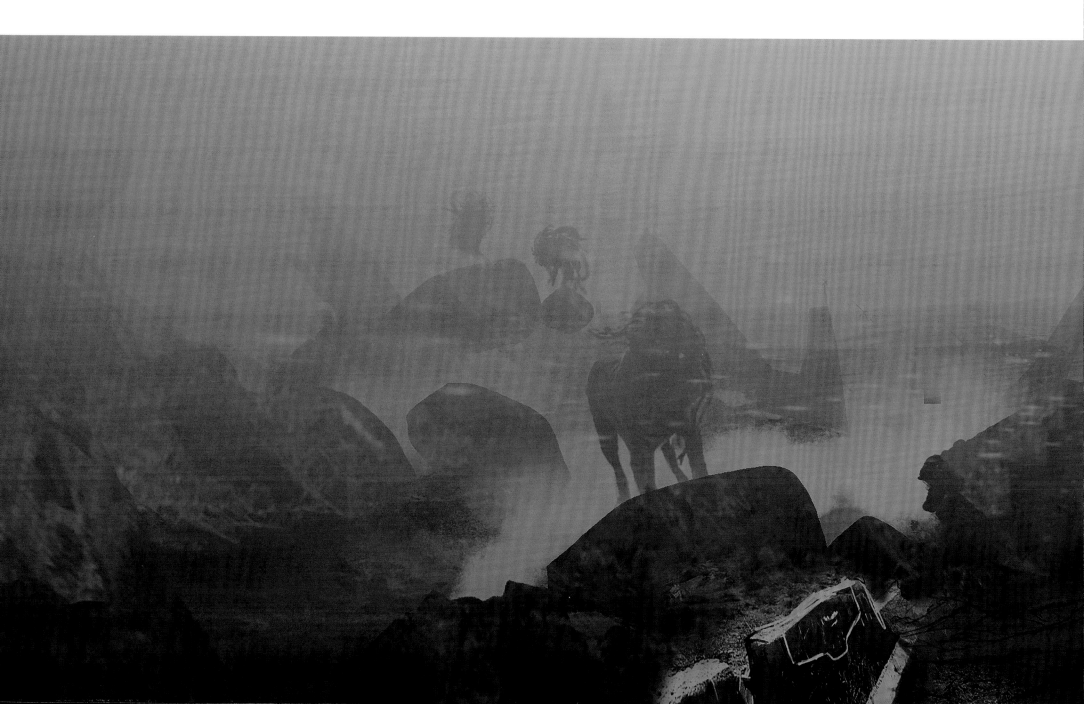

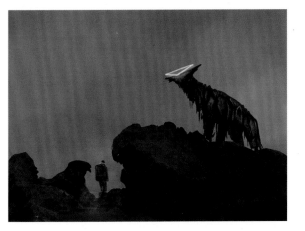
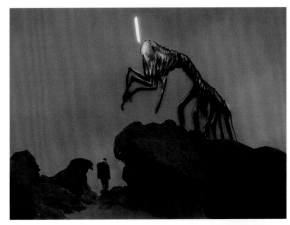
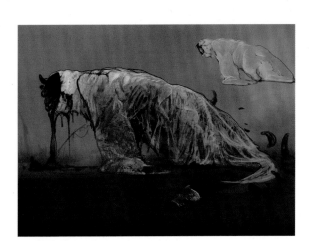

BELOW / Concept for battle with feline-type BTs.

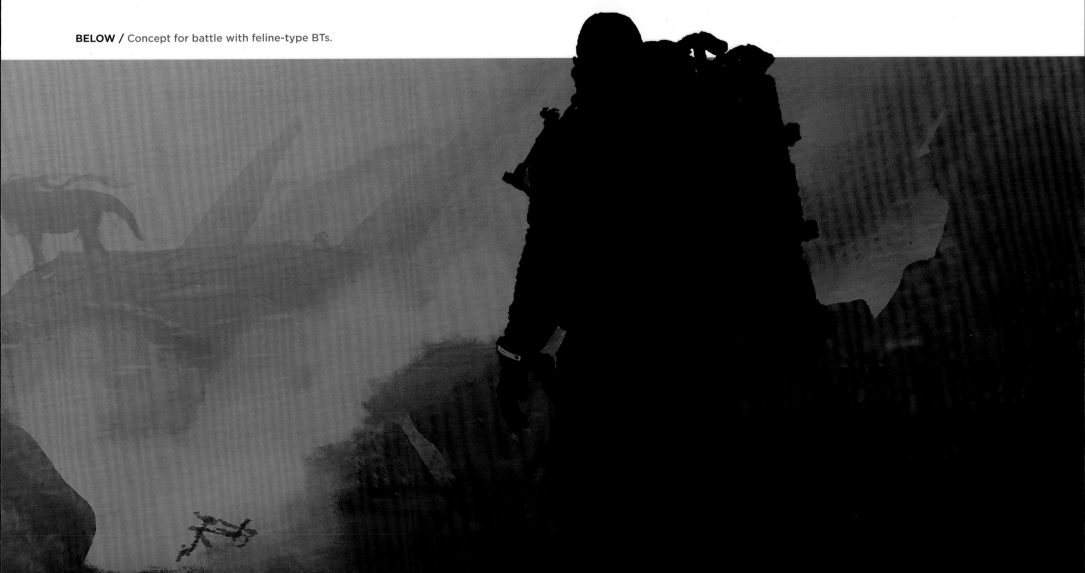

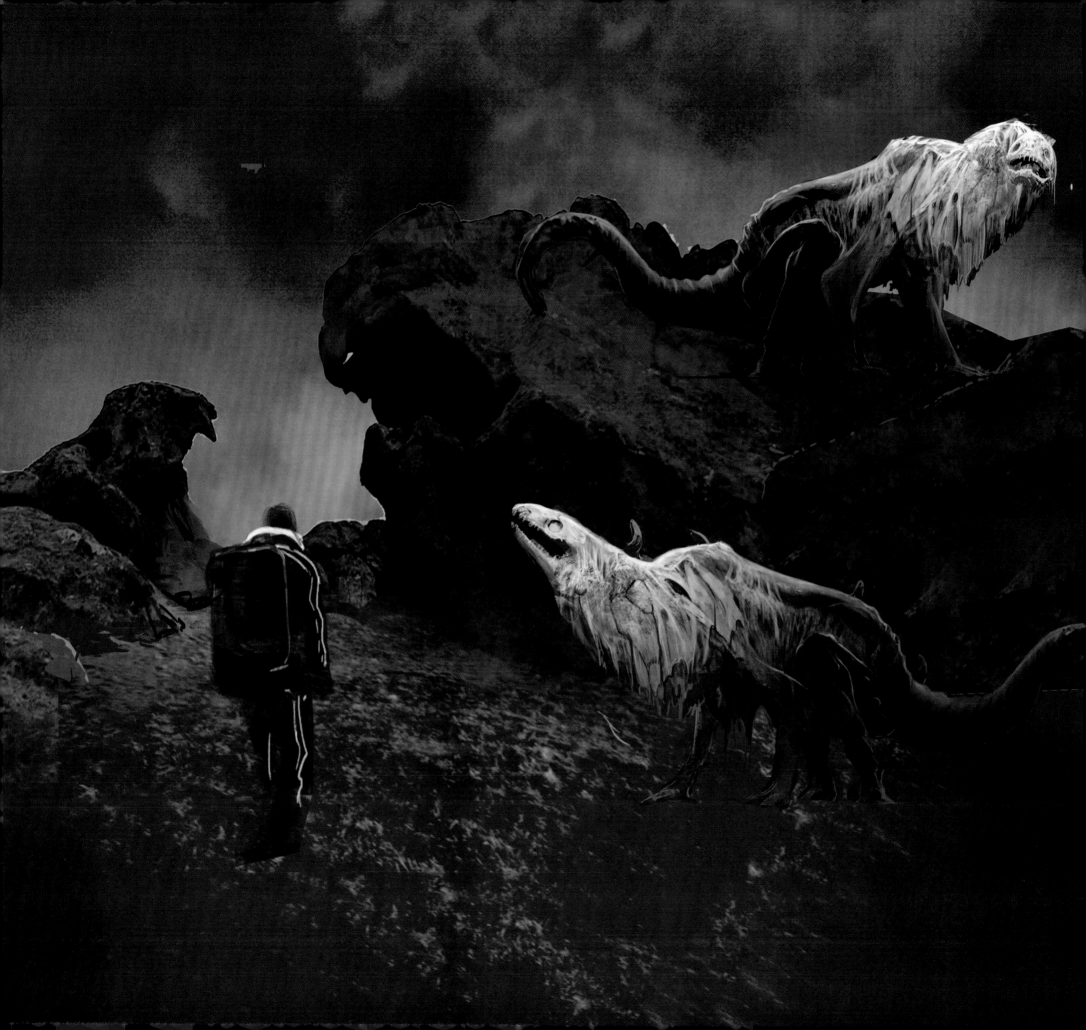

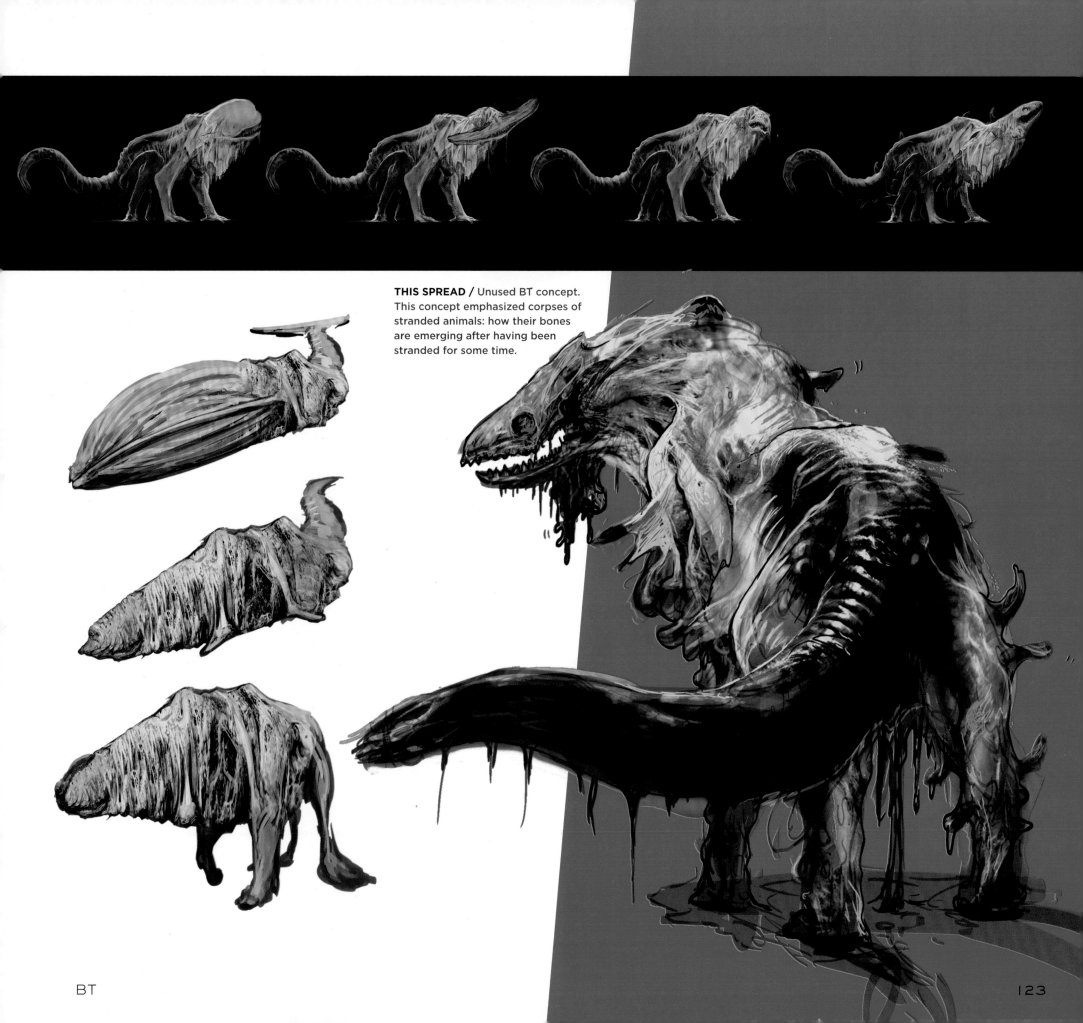

THIS SPREAD / Unused BT concept. This concept emphasized corpses of stranded animals: how their bones are emerging after having been stranded for some time.

BT

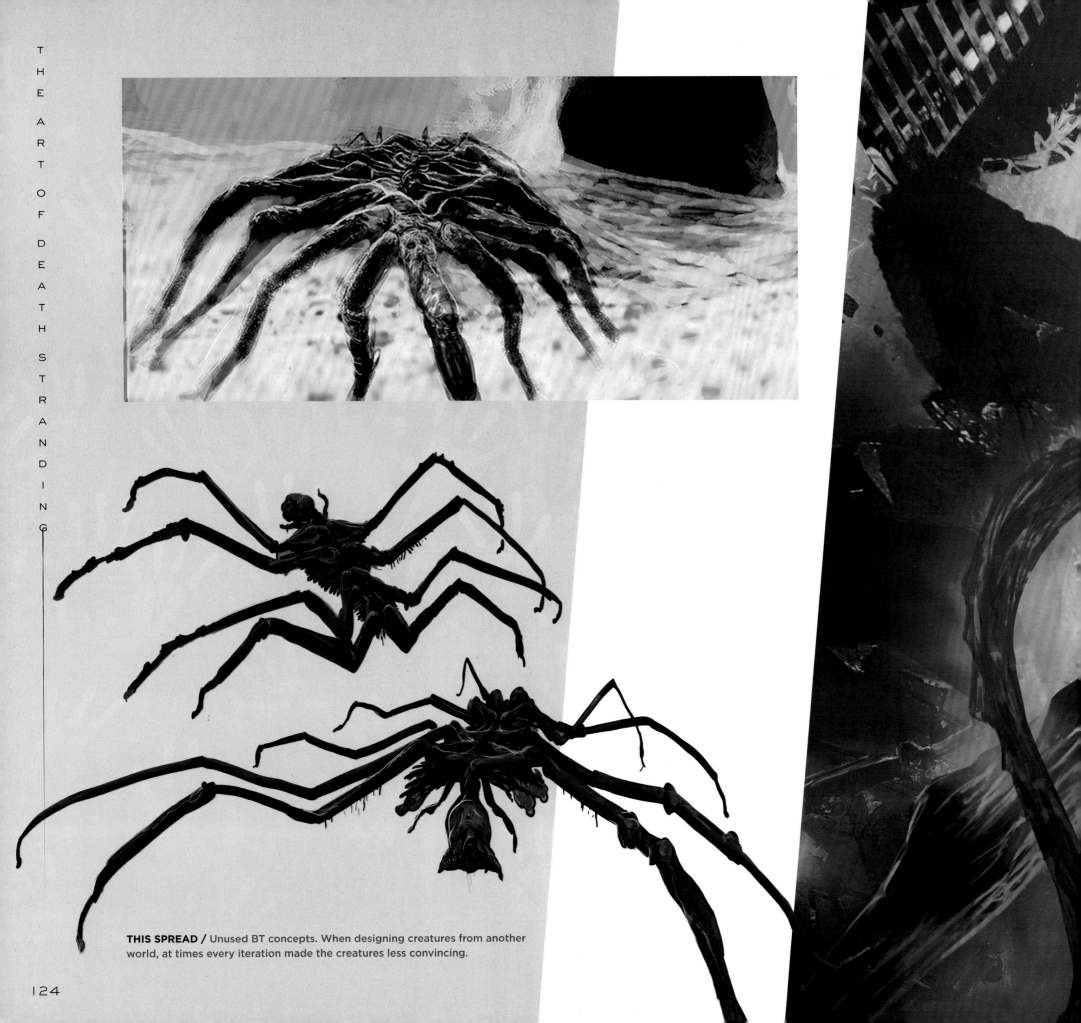

THIS SPREAD / Unused BT concepts. When designing creatures from another world, at times every iteration made the creatures less convincing.

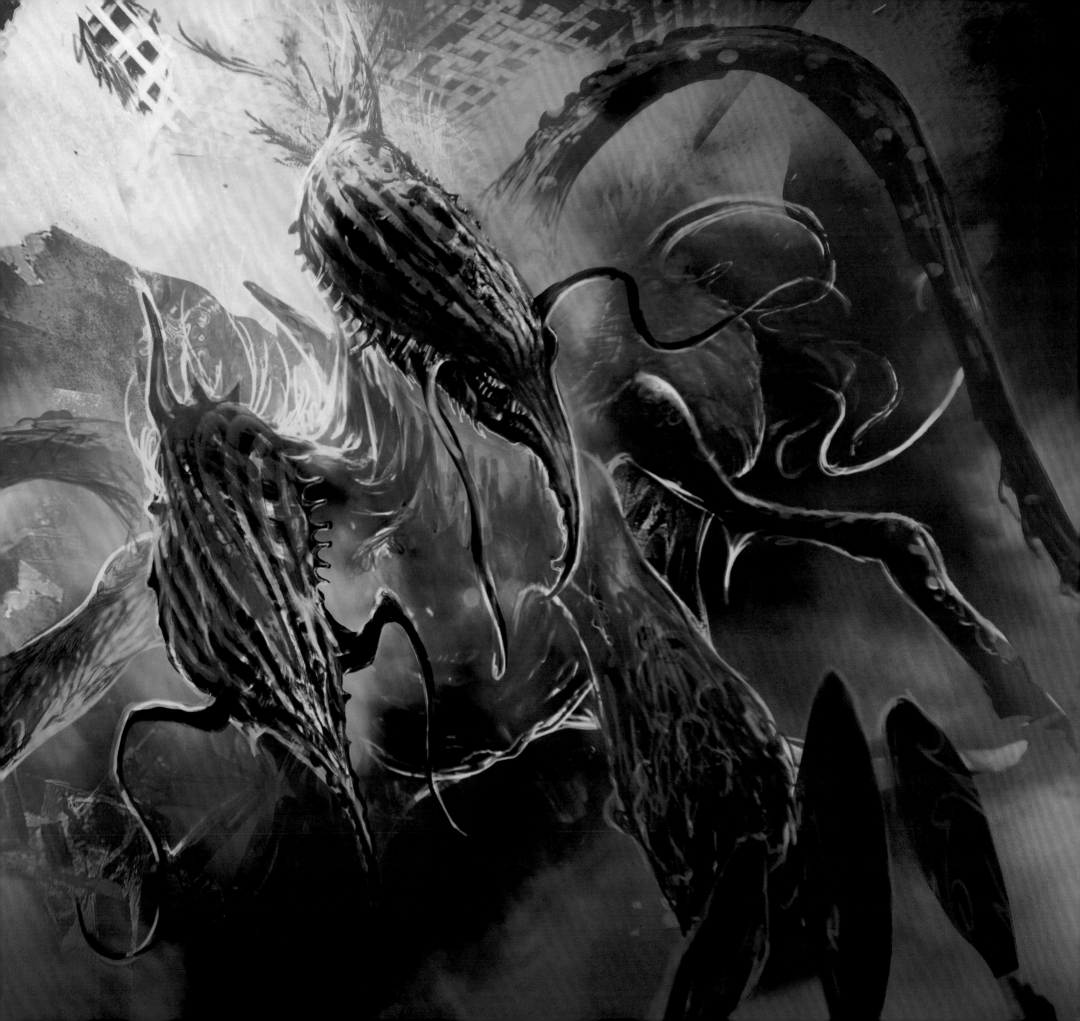

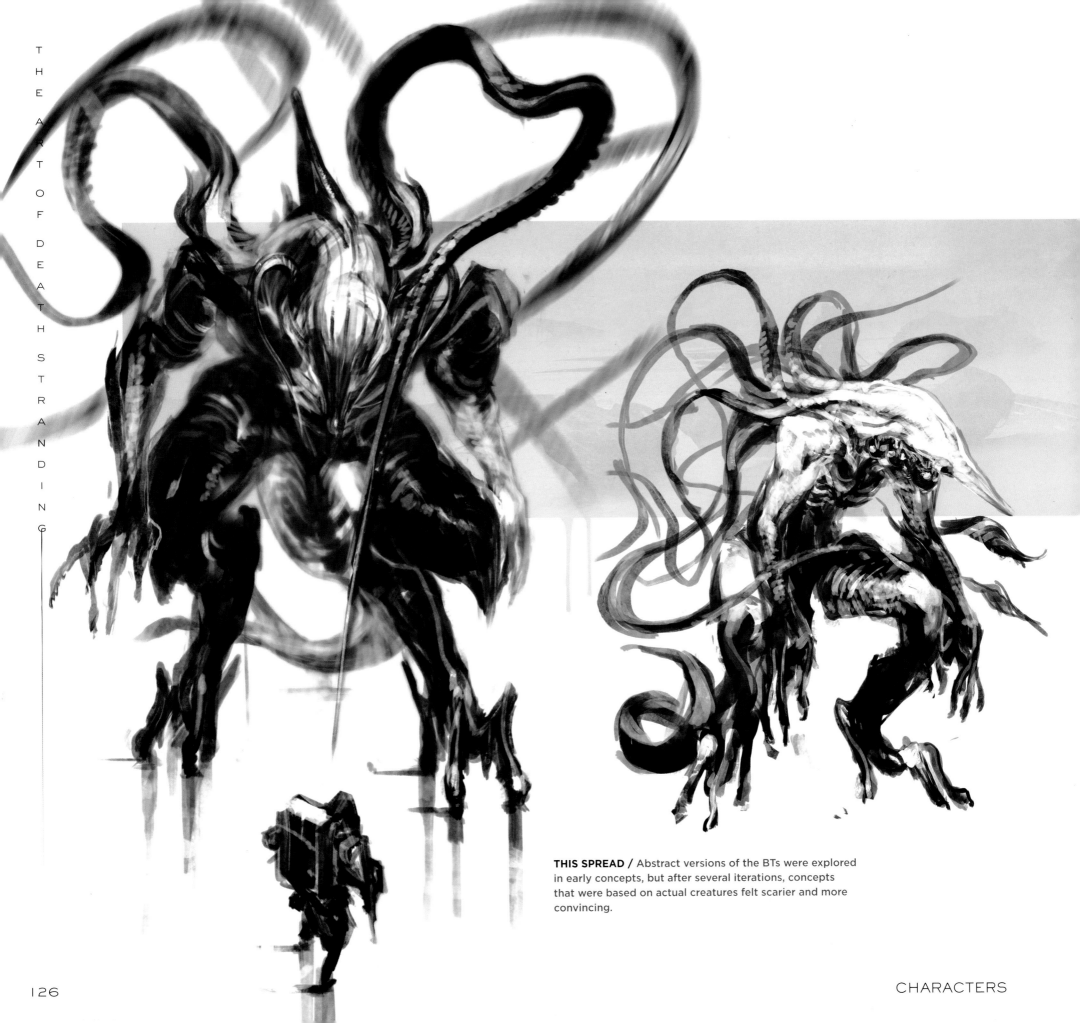

THIS SPREAD / Abstract versions of the BTs were explored in early concepts, but after several iterations, concepts that were based on actual creatures felt scarier and more convincing.

CHARACTERS

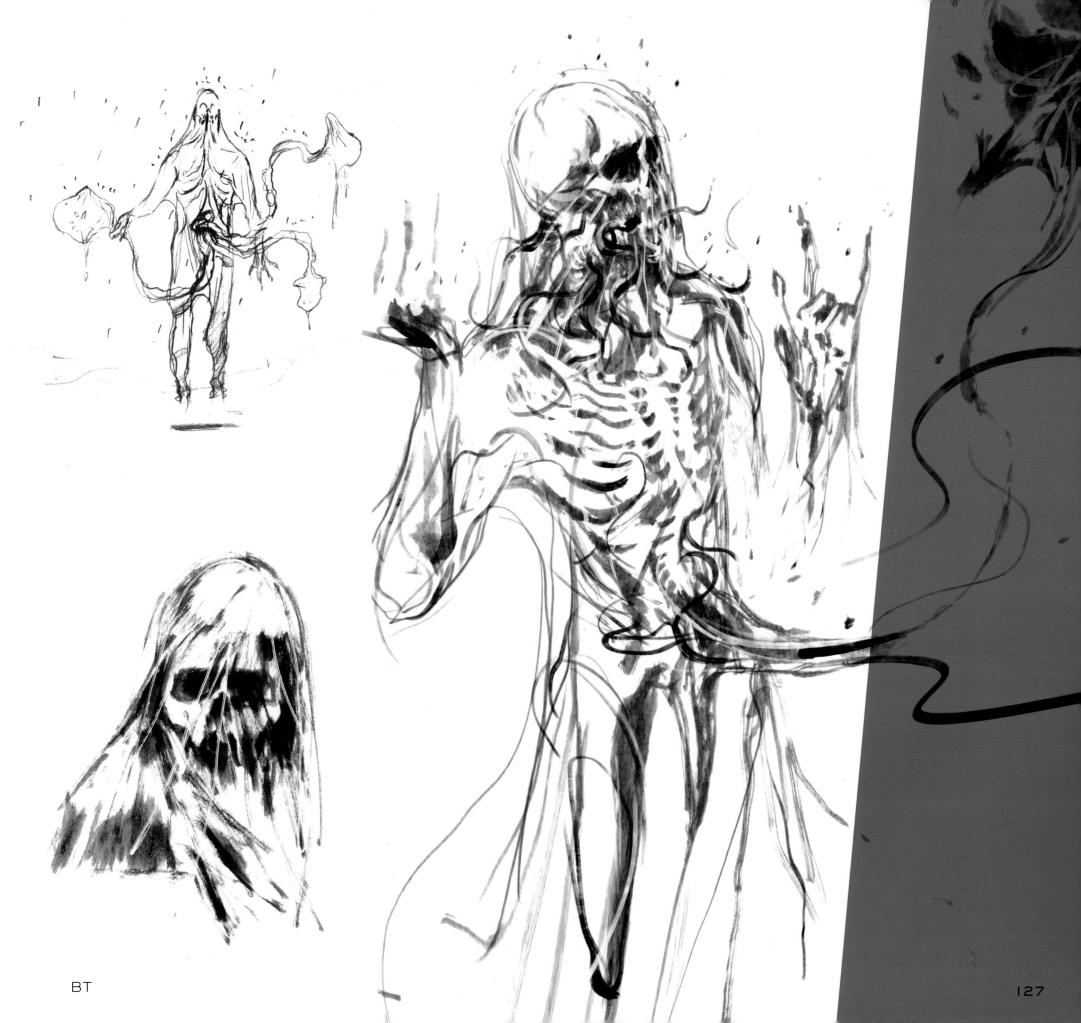

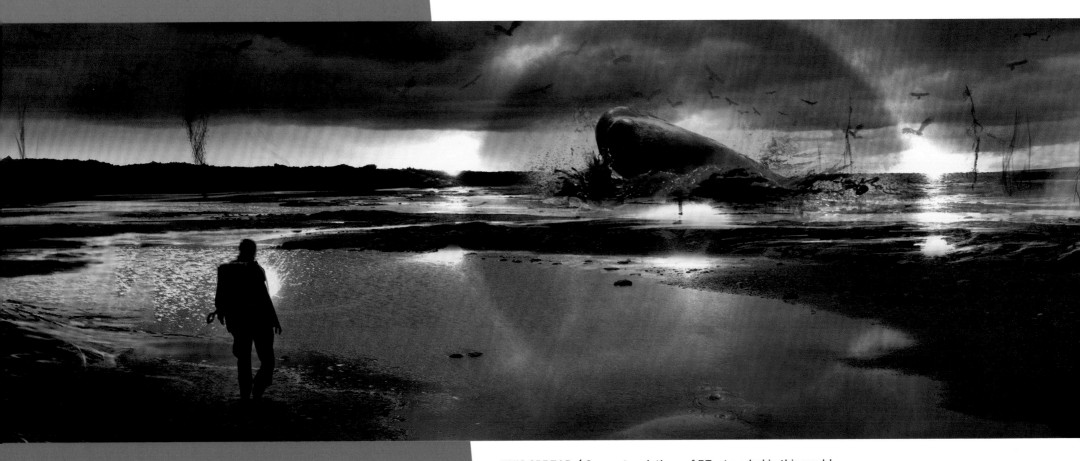

THIS SPREAD / Concept variations of BTs stranded in this world.

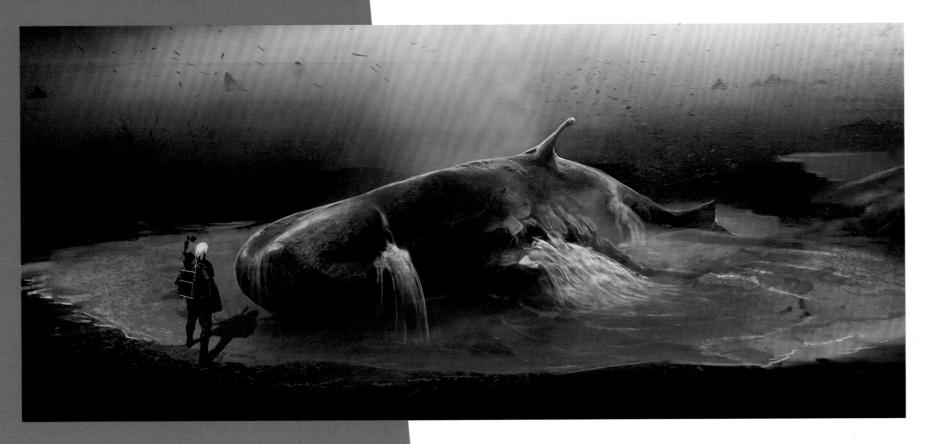

CHARACTERS

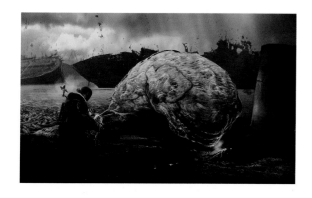

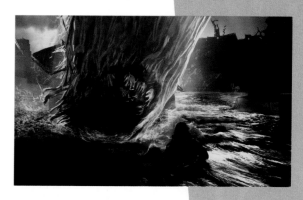

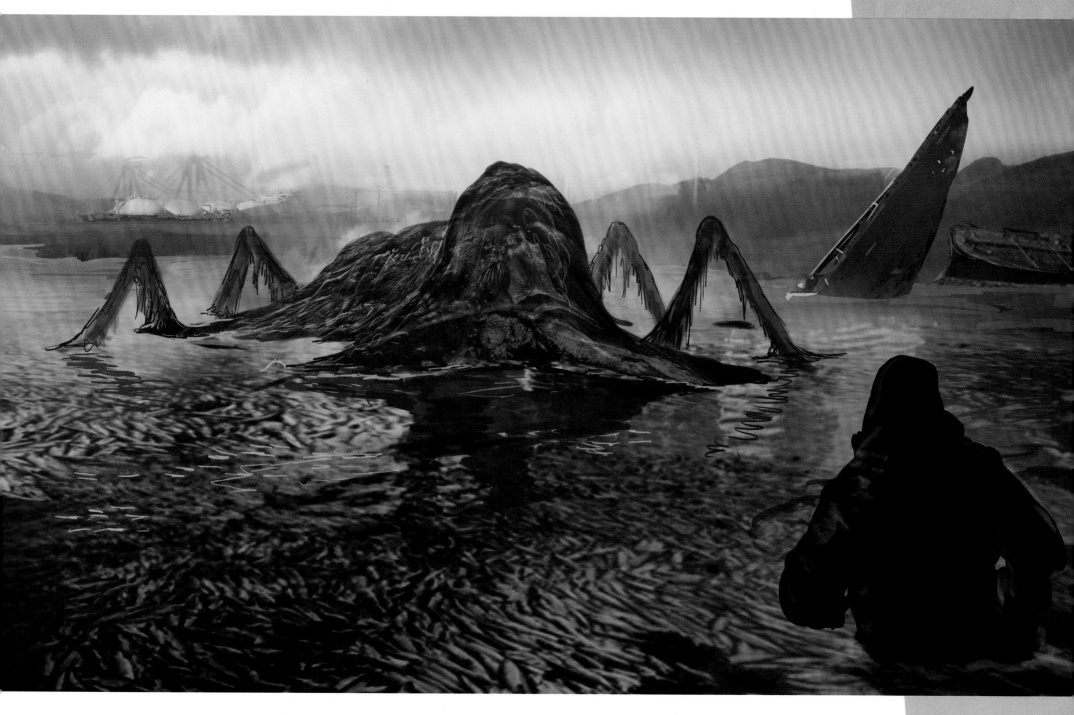

BT

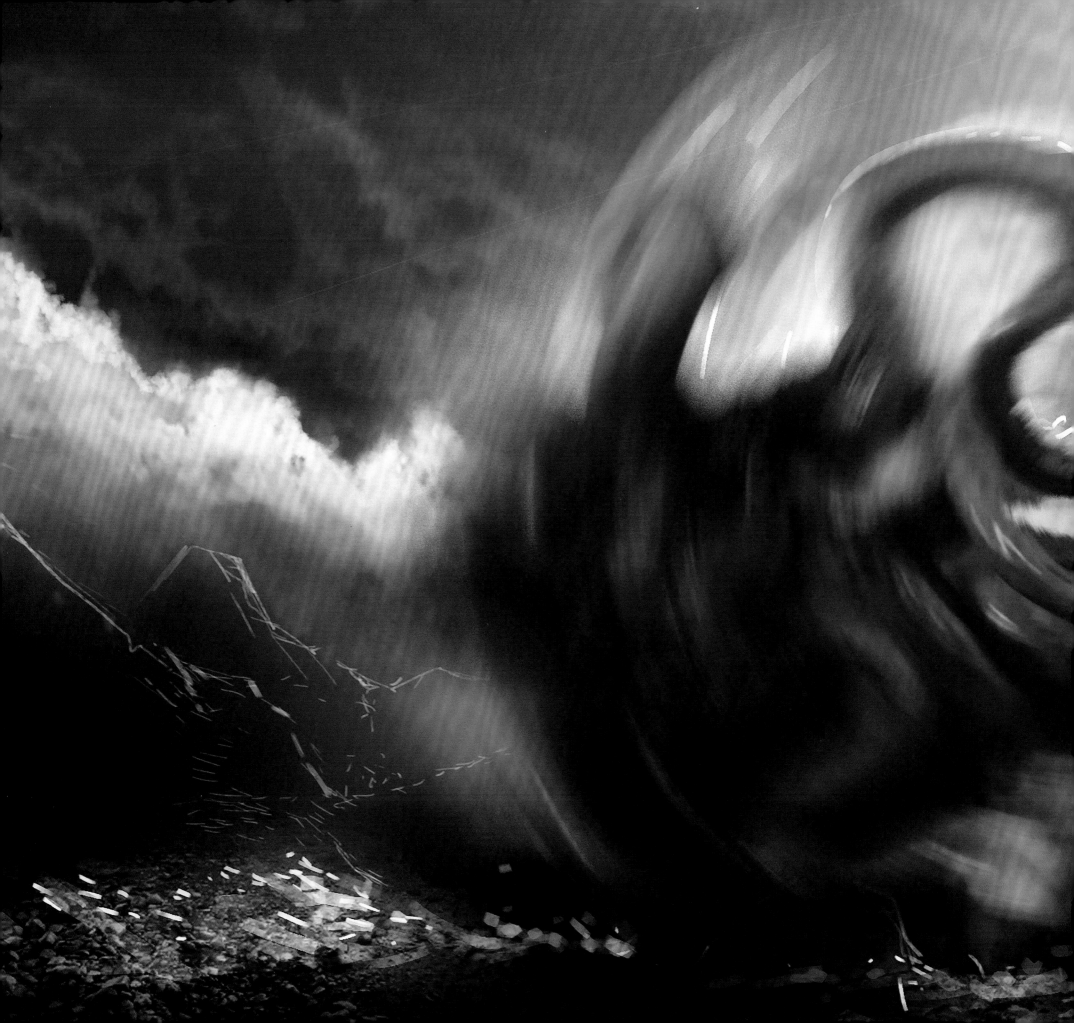

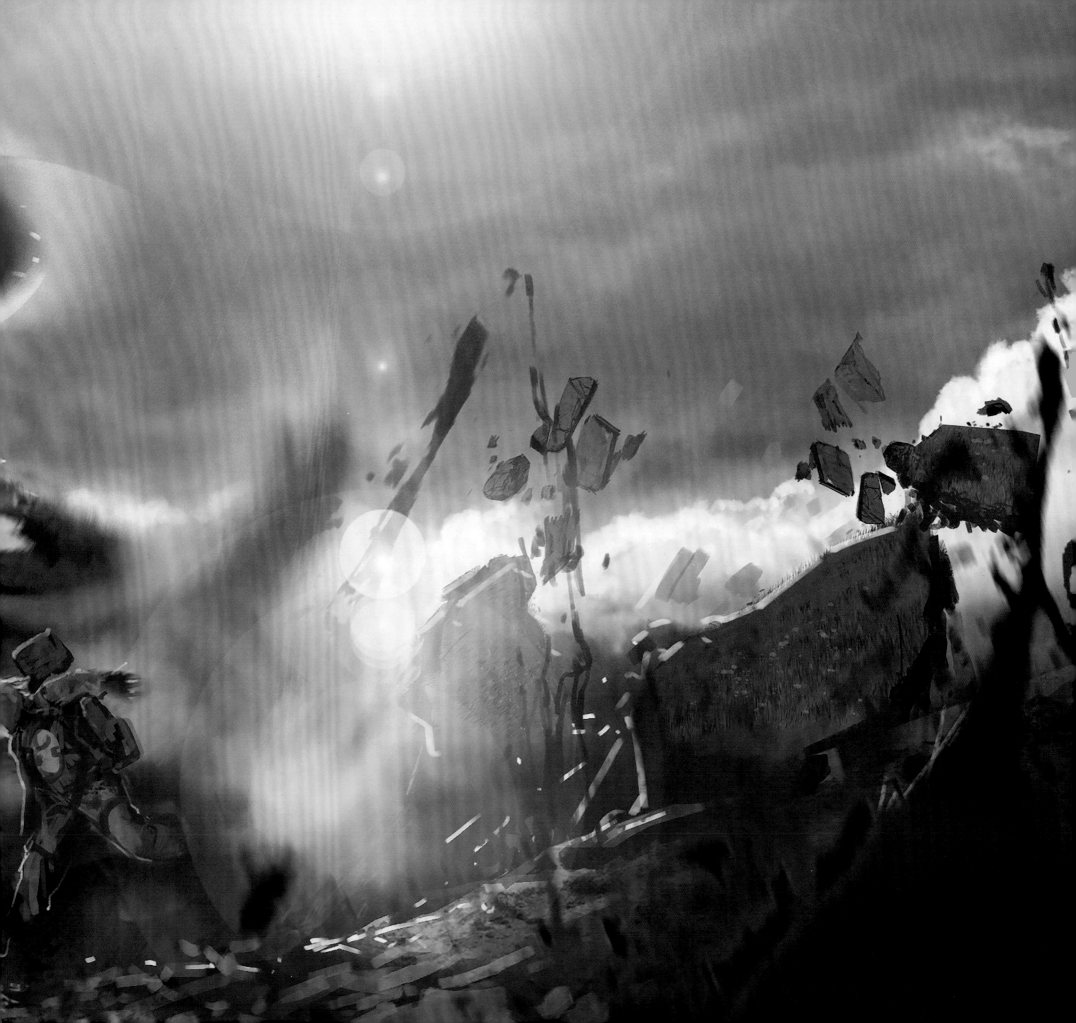

VEHICLES

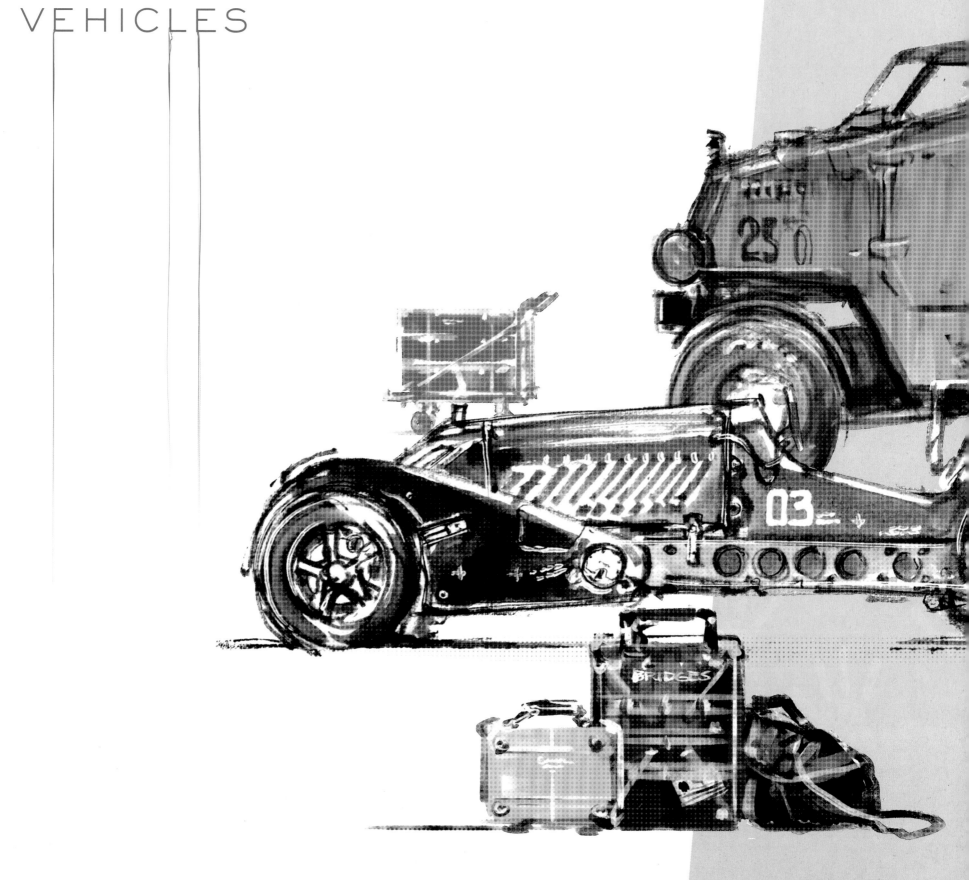

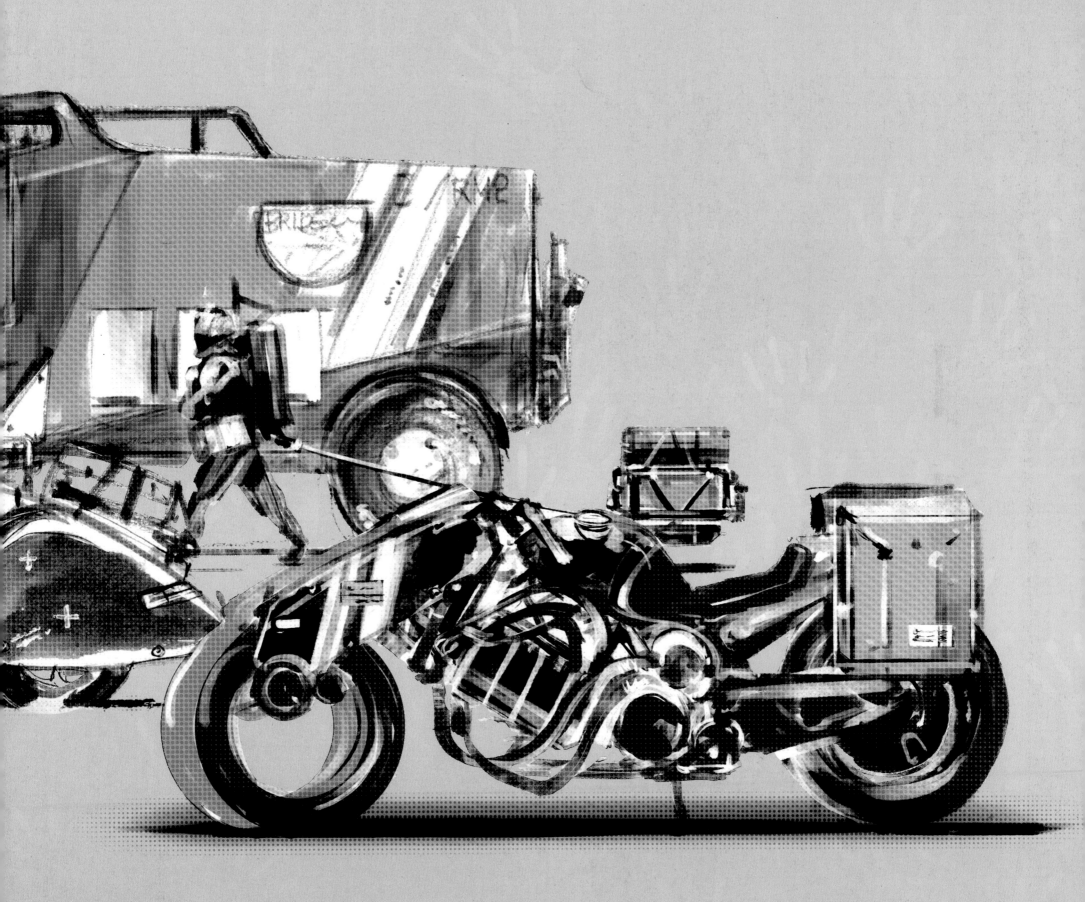

THIS PAGE / Final concepts for the reverse trike.

TRISKELION
MC 600v

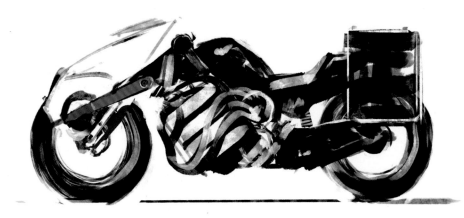
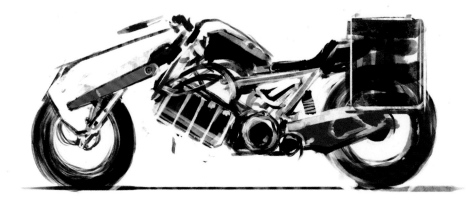

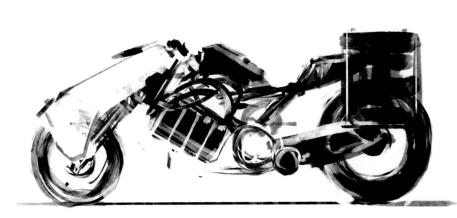
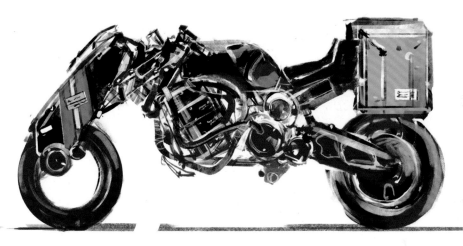

ABOVE / Early trike concepts.

BELOW / Vehicle pack concepts.

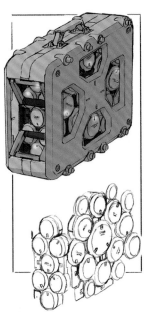
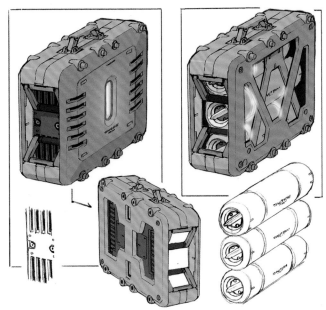

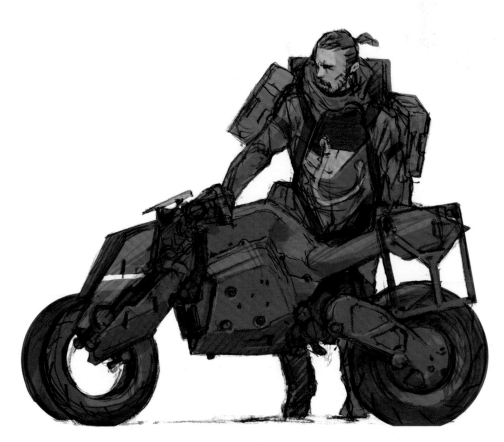

VEHICLES

THIS SPREAD / Unused vehicle concept. The design was for a vehicle with a classic hot rod touch performing in the future.

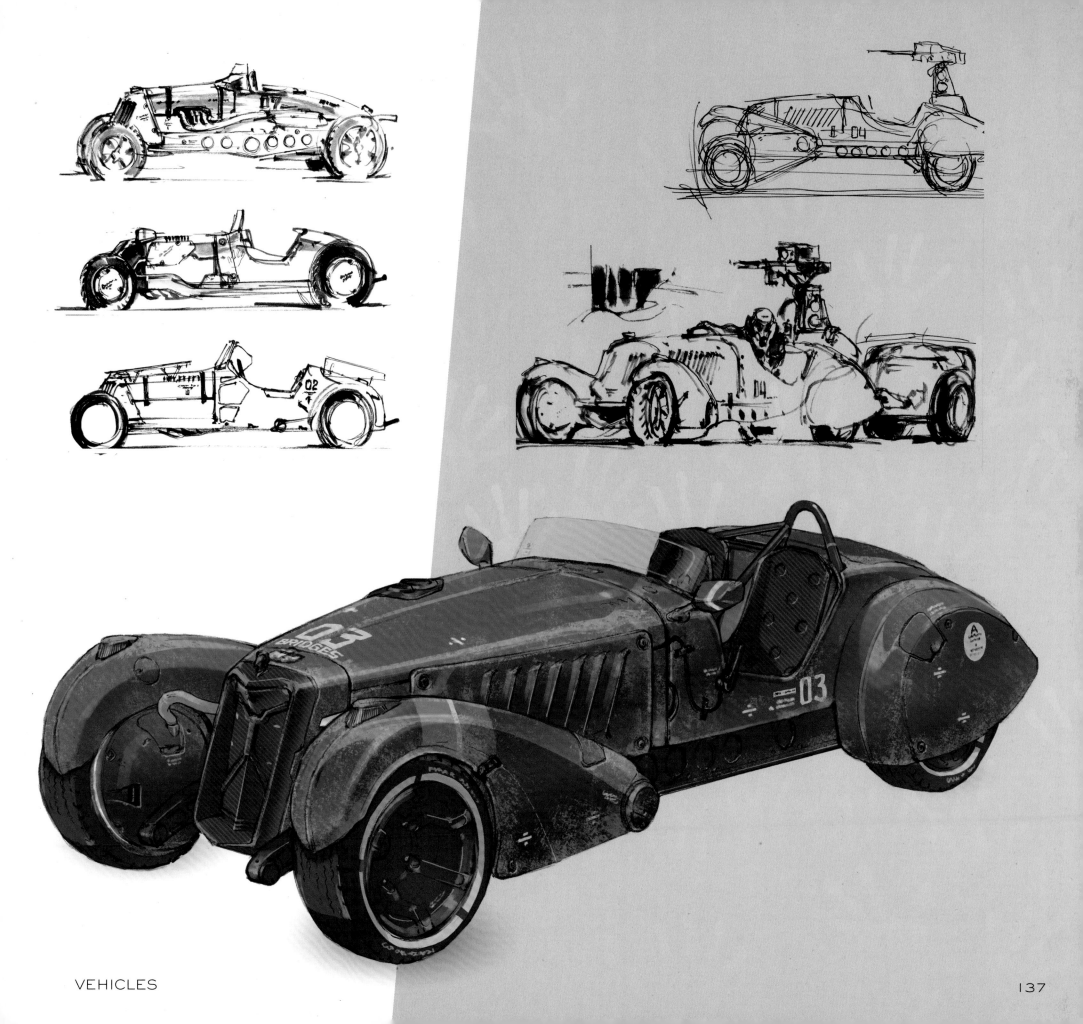

VEHICLES

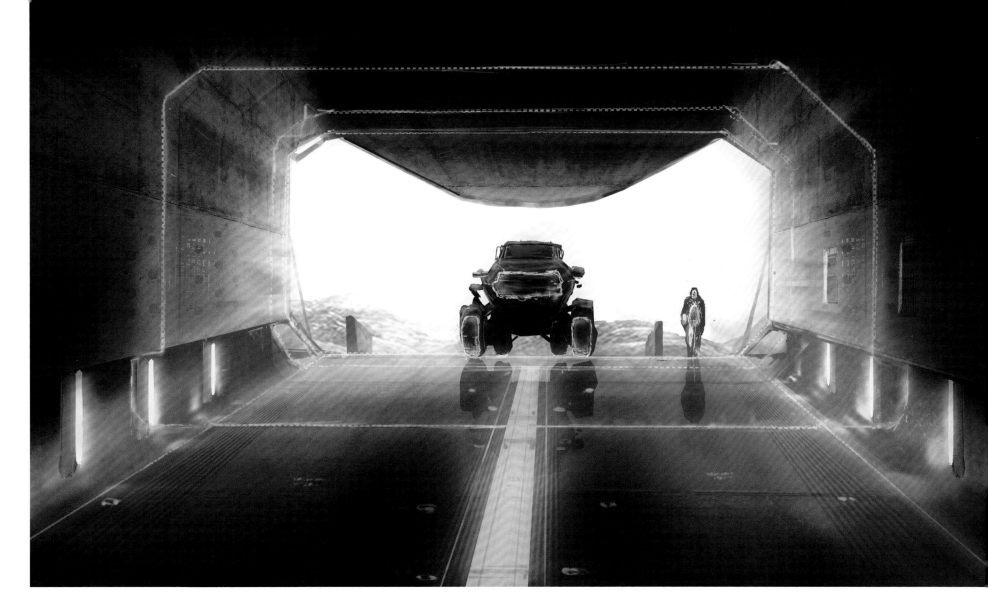

THIS SPREAD / Pickup-type exploration vehicle used by BRIDGES I.
It appears very briefly during a cutscene in the game.

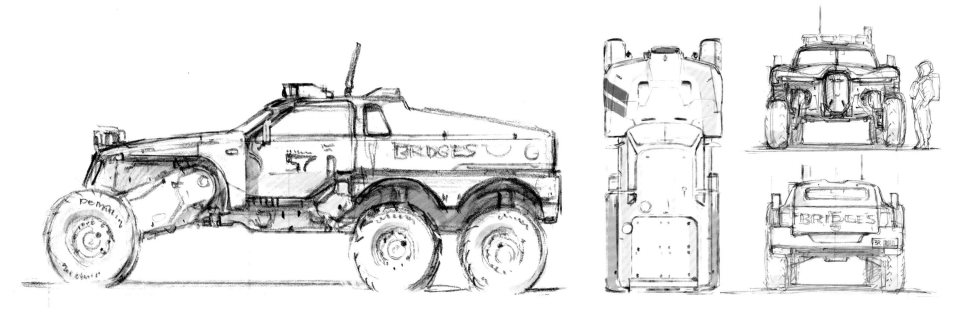

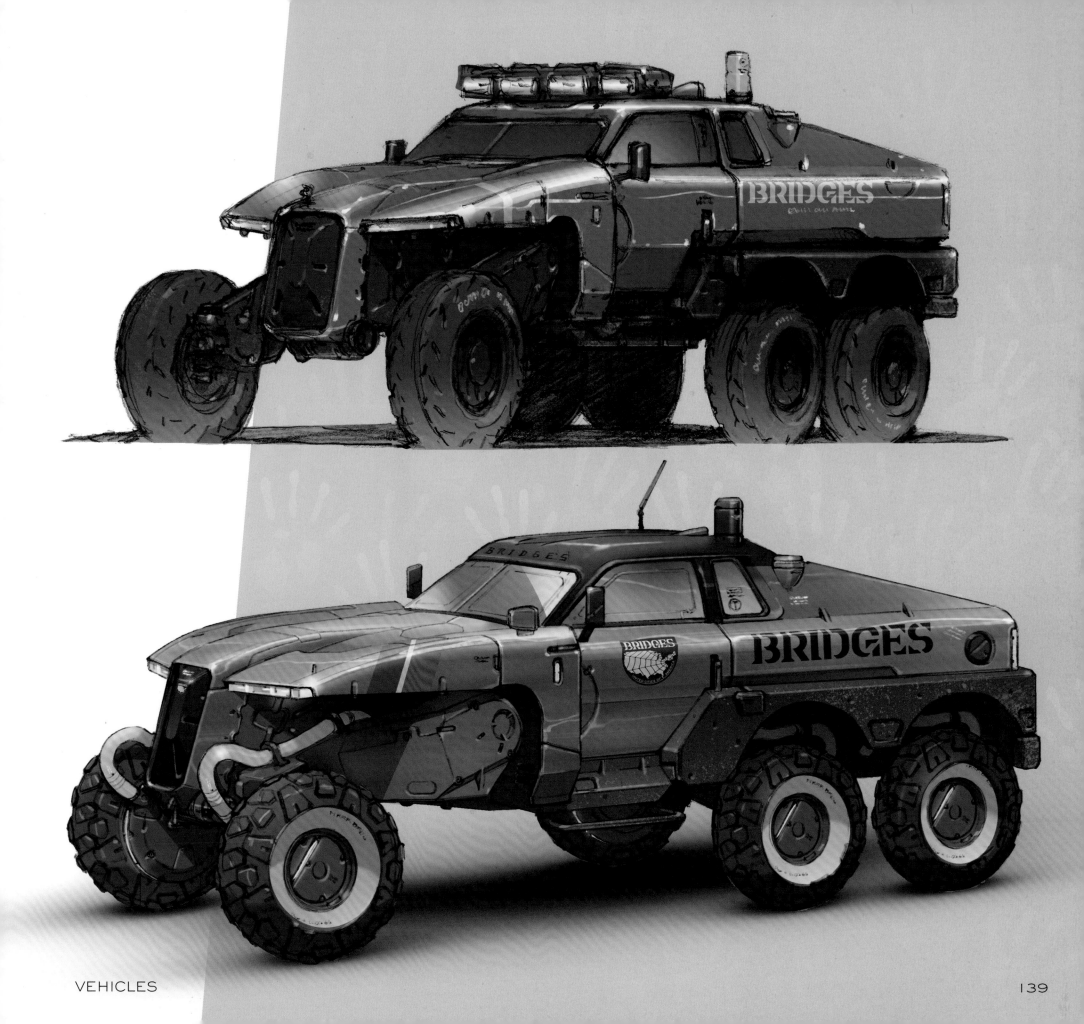

RIGHT / These three types of vehicles were originally proposed. In the end, the truck-type car (left) better fit the idea of delivering, and was used more prominently.

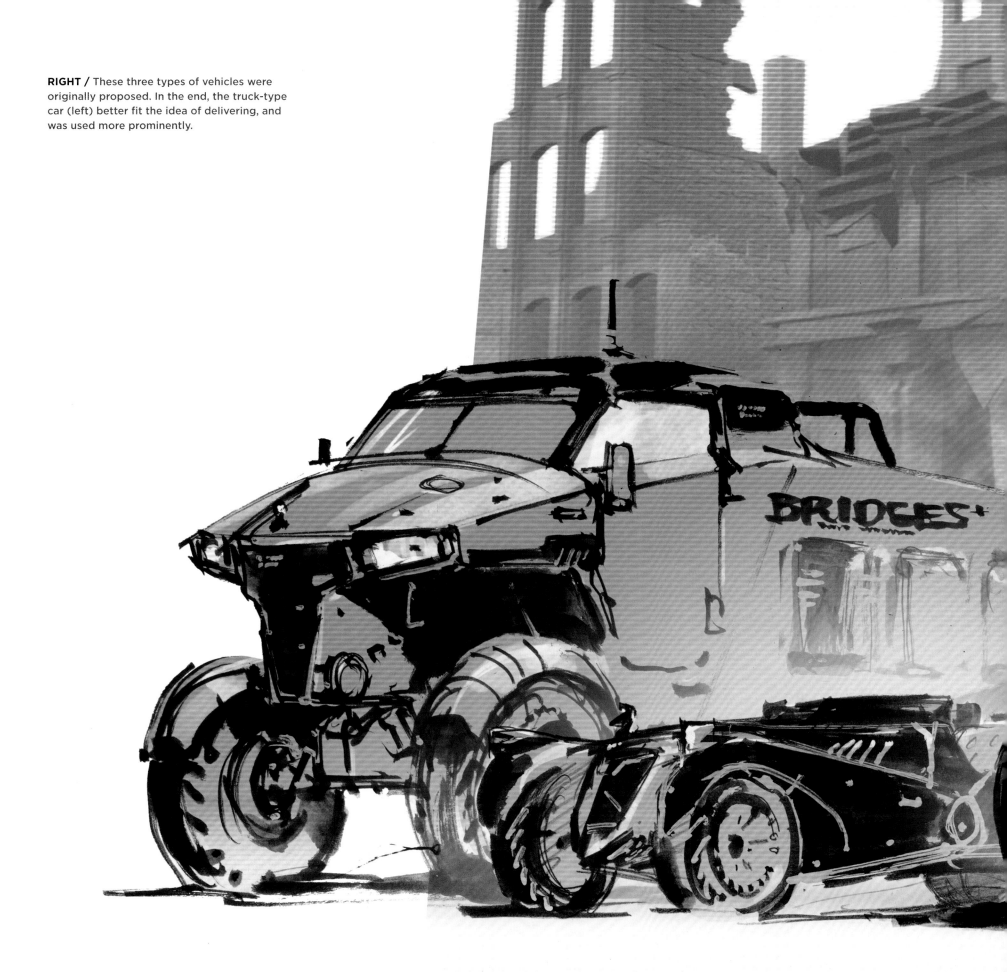

CHARACTERS

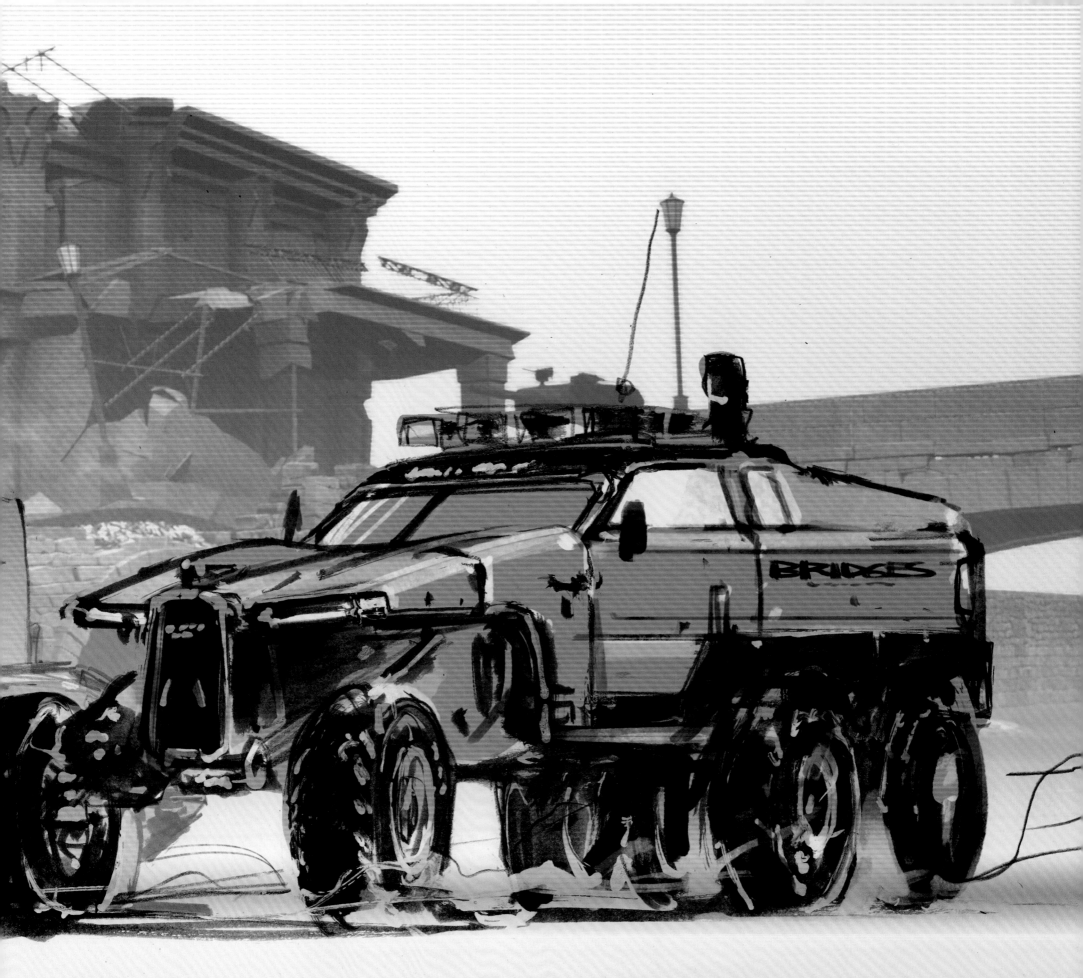

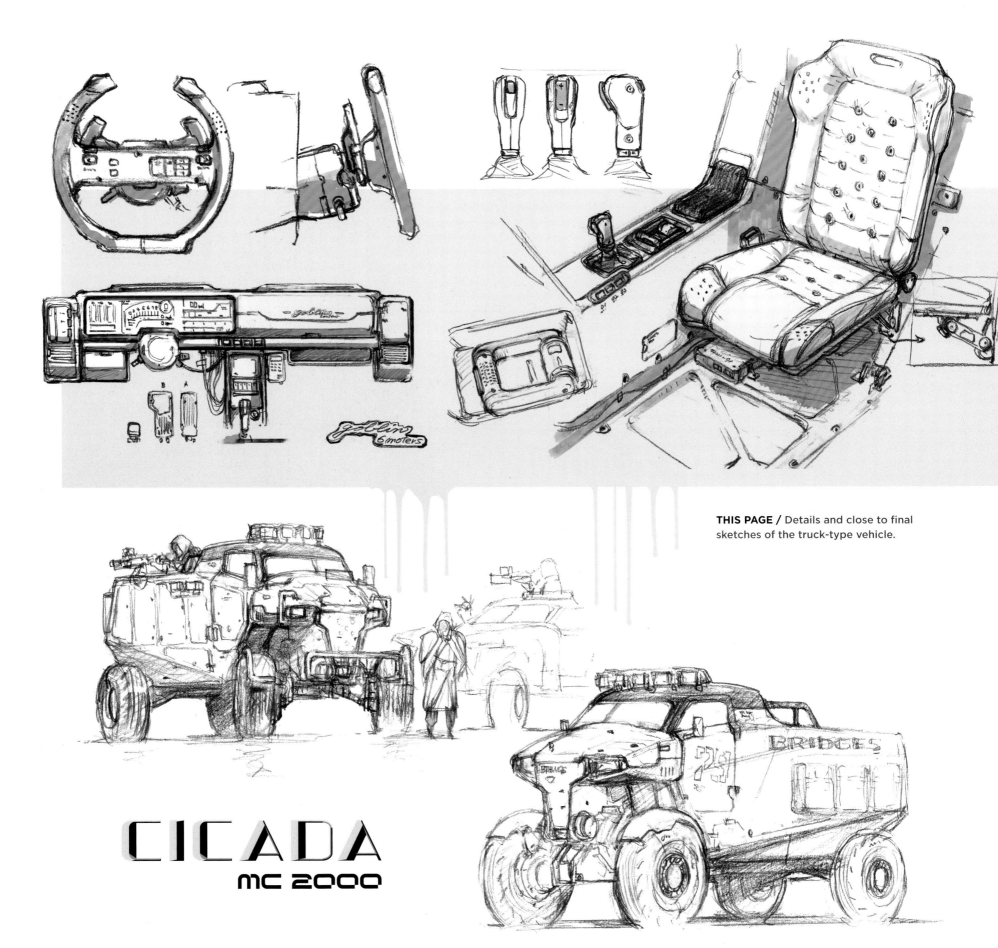

THIS PAGE / Details and close to final sketches of the truck-type vehicle.

CICADA
MC 2000

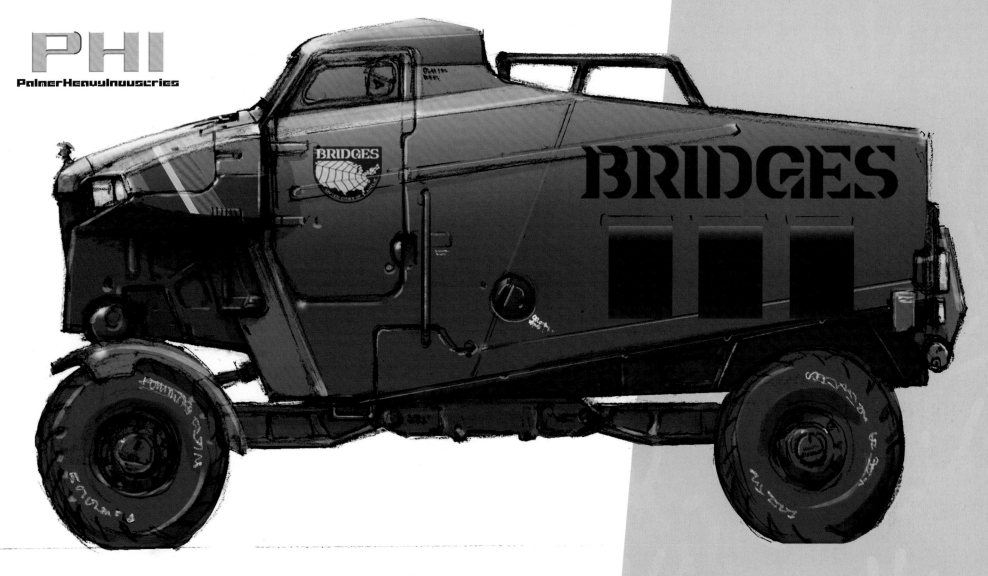

PHI
PalmerHeavyIndustries

THIS PAGE / Final concepts for the truck-type vehicle. This vehicle can modify its height through the suspension system, and excels at maneuvering on difficult terrain. The uniqueness of the suspension allows this vehicle to get out of situations where it gets stuck, which is rather common in games.

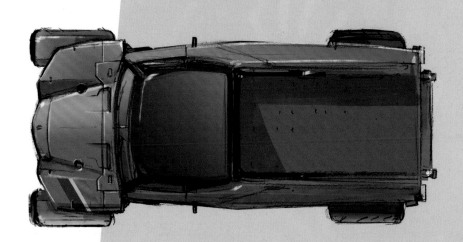

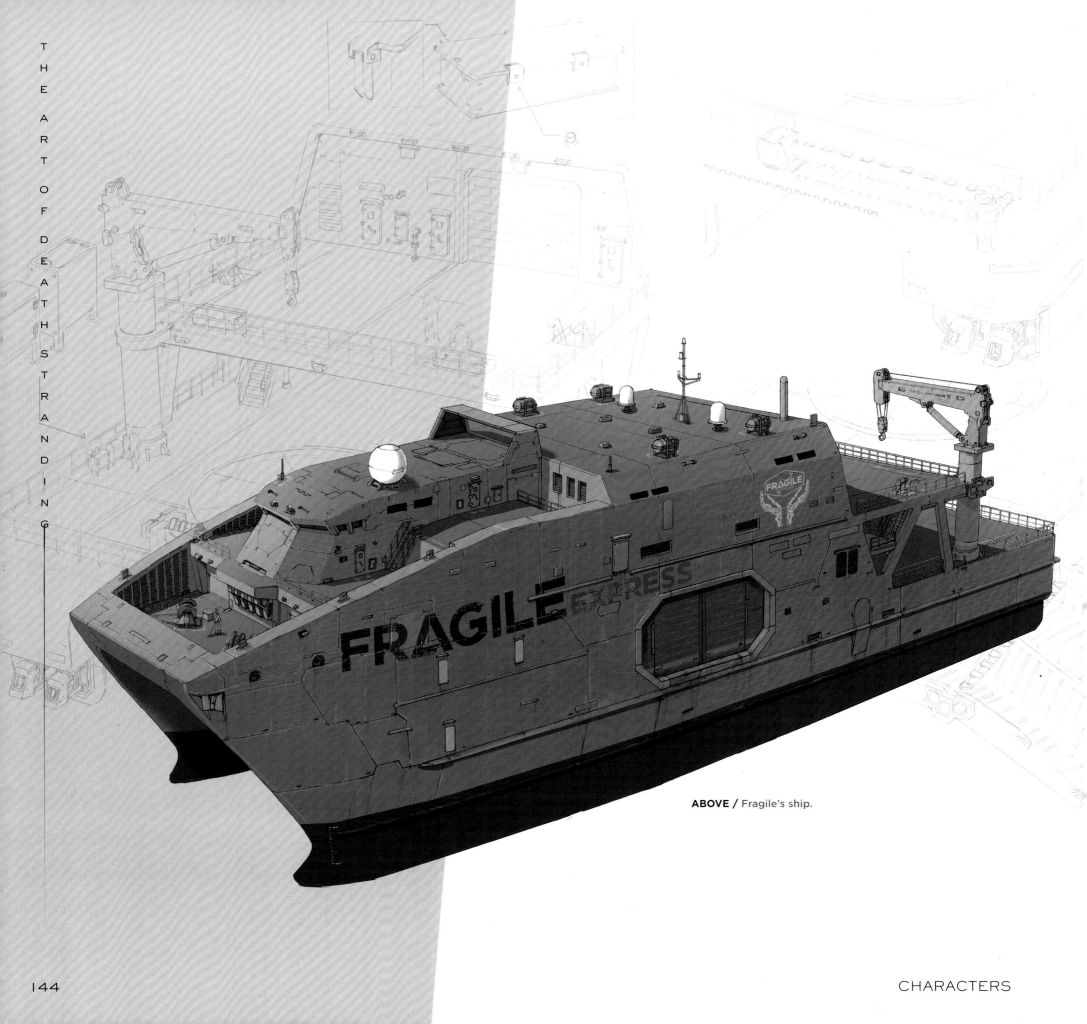

ABOVE / Fragile's ship.

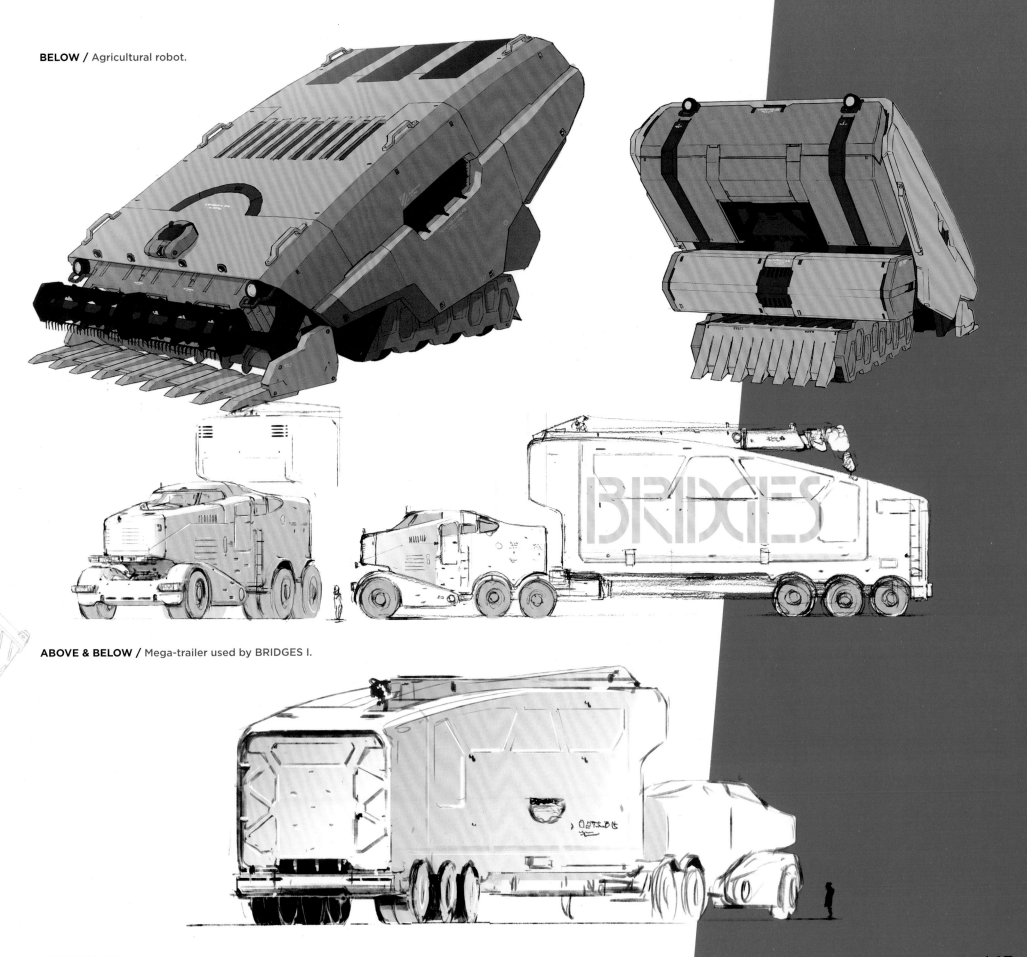

BELOW / Agricultural robot.

ABOVE & BELOW / Mega-trailer used by BRIDGES I.

WEAPONS

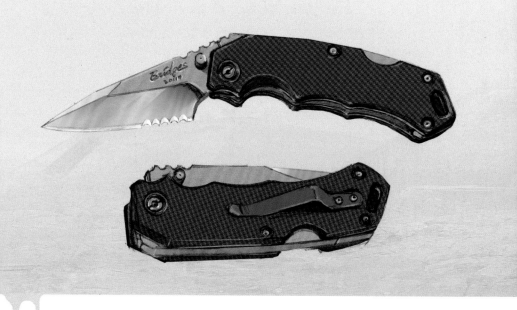

ABOVE / CDT (Corpse Disposal Team) captain's knife.

LEFT / Early weapon concepts. The attached units for blood were already considered from early stages.

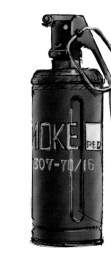

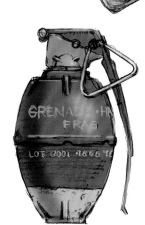

ABOVE / EX Grenades.

LEFT / Grenades used by Warriors.

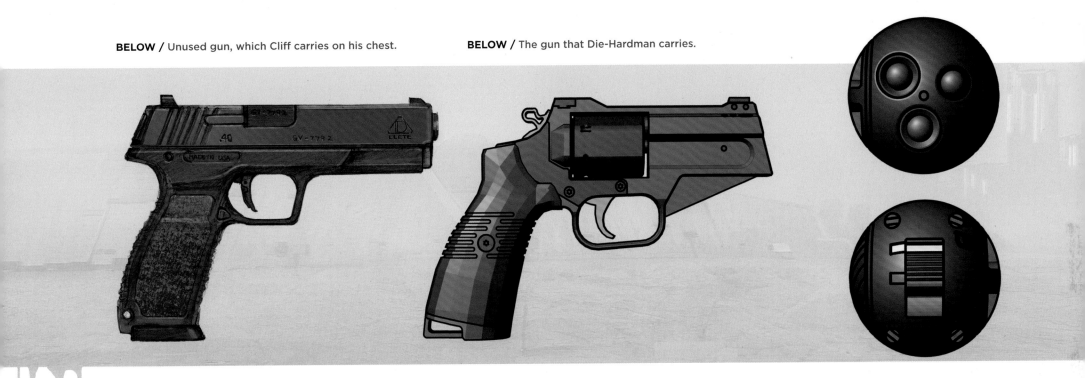

BELOW / Unused gun, which Cliff carries on his chest.

BELOW / The gun that Die-Hardman carries.

BELOW / Unused weapon. A grenade to trigger holograms.

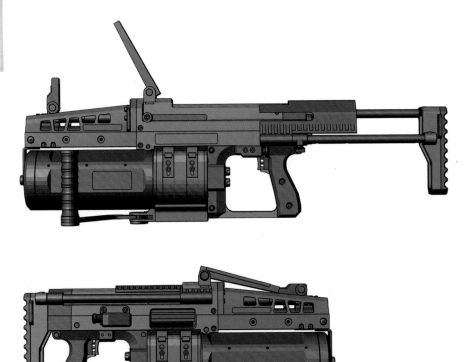

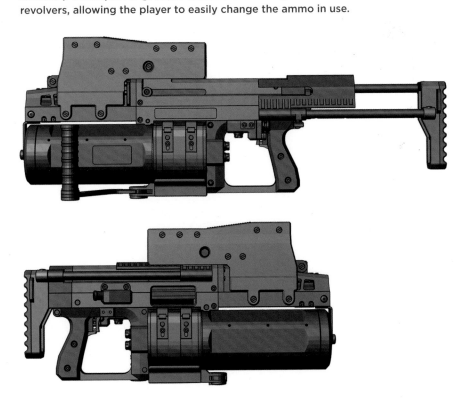

BELOW / Concepts for grenade launchers. The magazines work like those of revolvers, allowing the player to easily change the ammo in use.

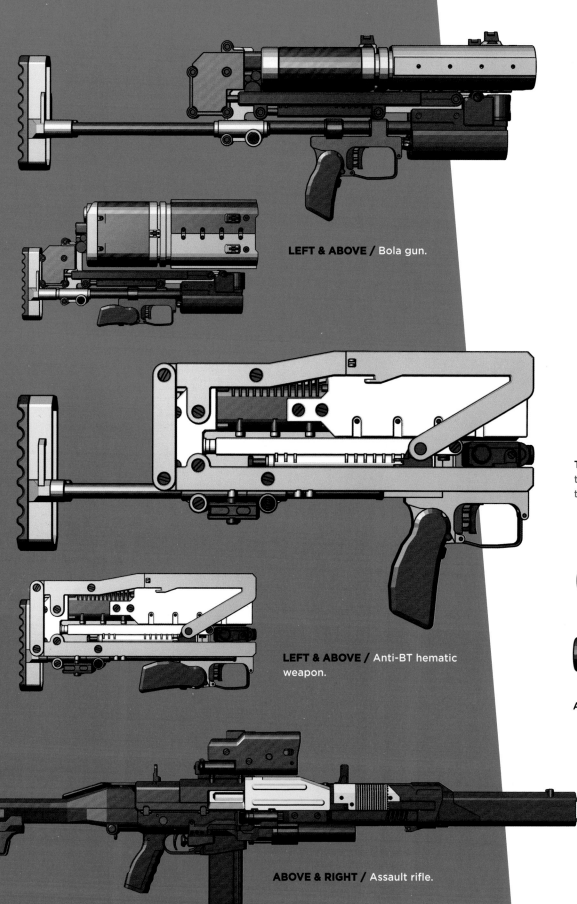

LEFT & ABOVE / Bola gun.

LEFT & ABOVE / Anti-BT hematic weapon.

THIS SPREAD / Various concepts for weapons. One general theme for the weapons was to allow them to transform so that they could fit as cargo.

ABOVE / Under-barrel grenade launcher for the assault rifle.

ABOVE & RIGHT / Assault rifle.

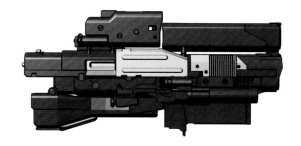

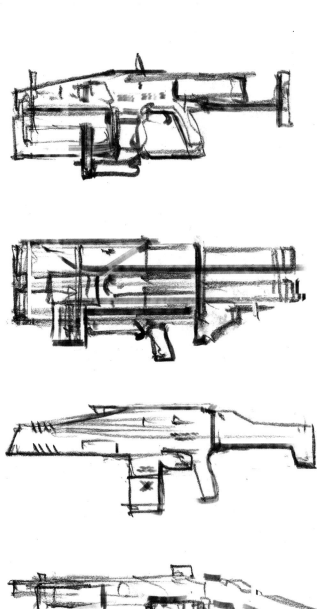

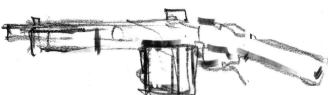

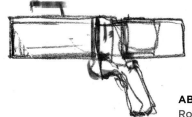

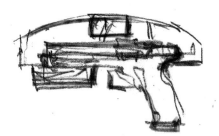

ABOVE & OPPOSITE TOP RIGHT /
Rough weapon sketches.

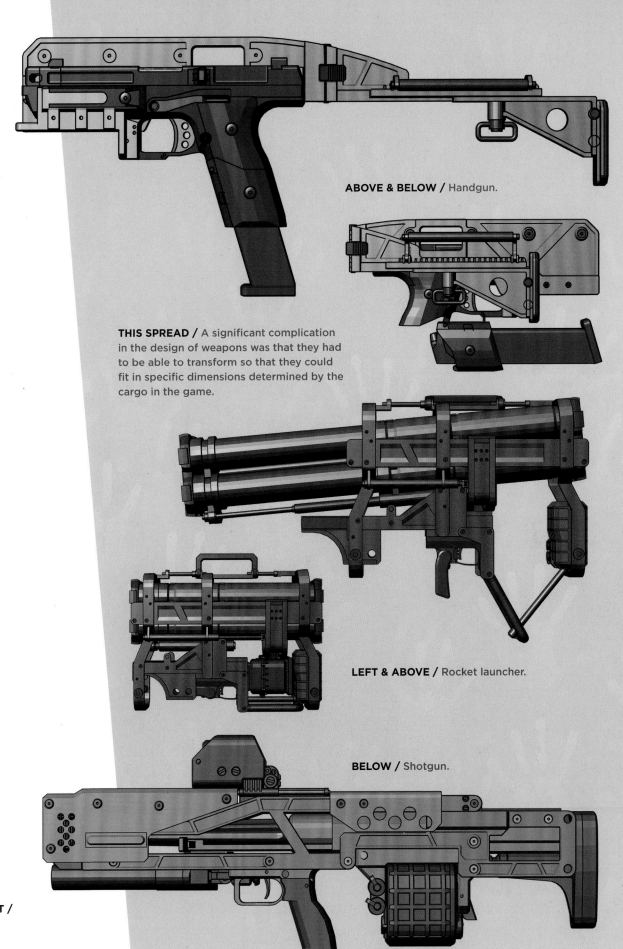

ABOVE & BELOW / Handgun.

THIS SPREAD / A significant complication in the design of weapons was that they had to be able to transform so that they could fit in specific dimensions determined by the cargo in the game.

LEFT & ABOVE / Rocket launcher.

BELOW / Shotgun.

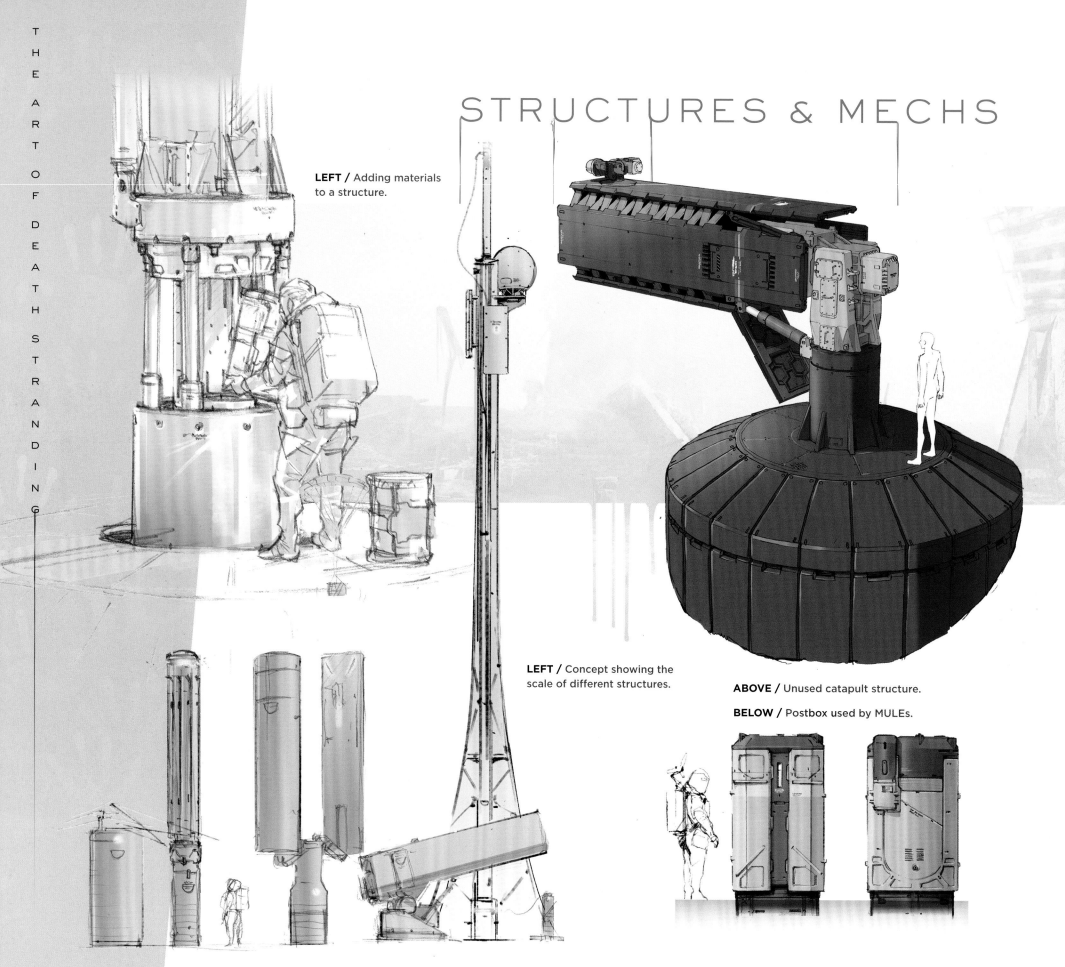

LEFT / Adding materials to a structure.

LEFT / Concept showing the scale of different structures.

ABOVE / Unused catapult structure.

BELOW / Postbox used by MULEs.

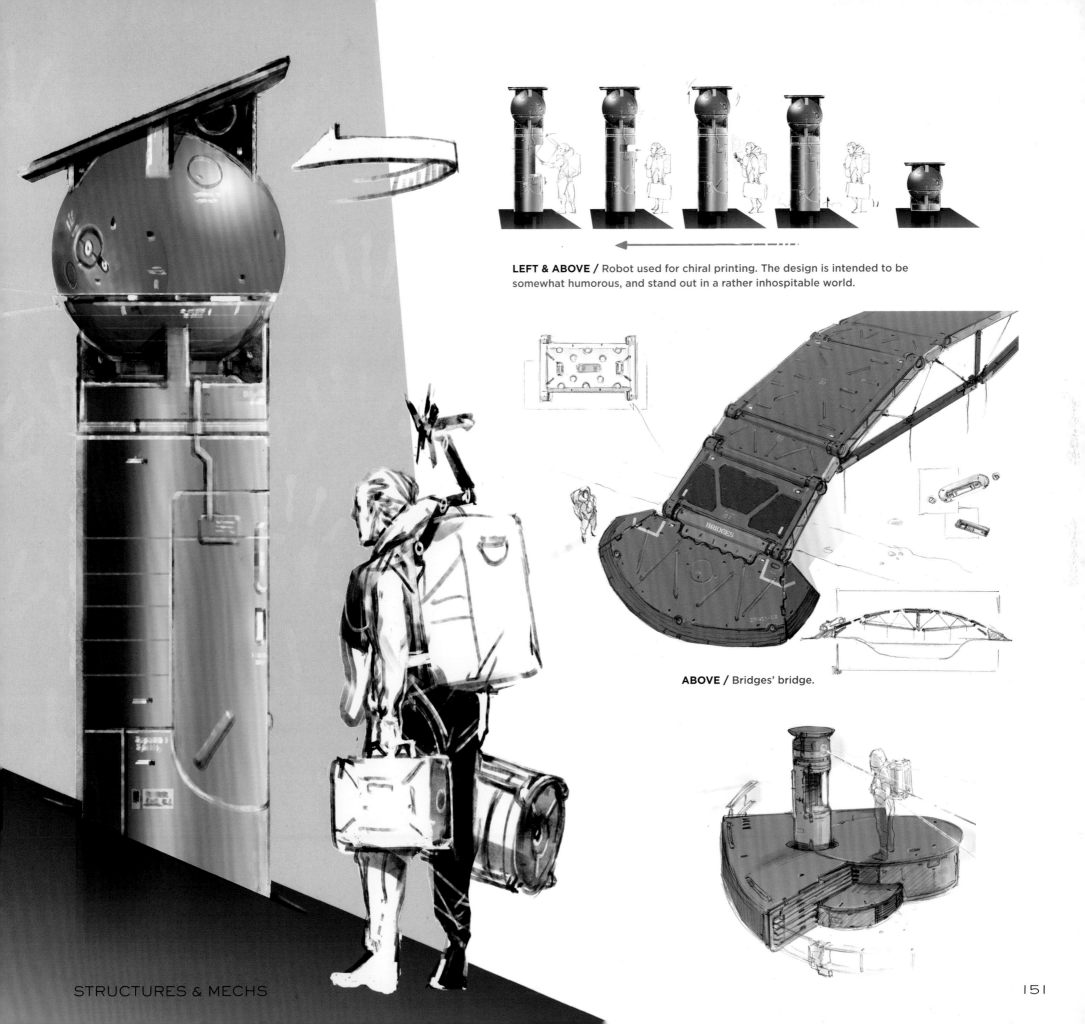

LEFT & ABOVE / Robot used for chiral printing. The design is intended to be somewhat humorous, and stand out in a rather inhospitable world.

ABOVE / Bridges' bridge.

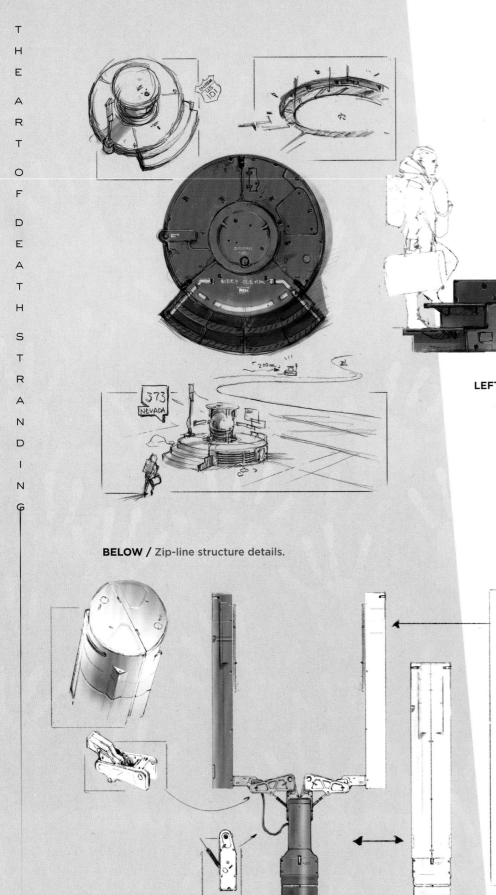

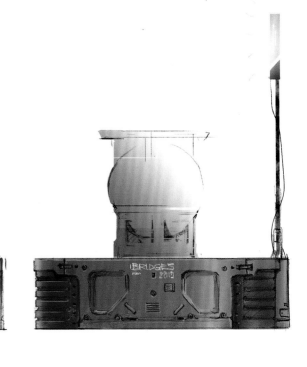

LEFT & ABOVE / Auto-Paver.

BELOW / Timefall shelter.

BELOW / Zip-line structure details.

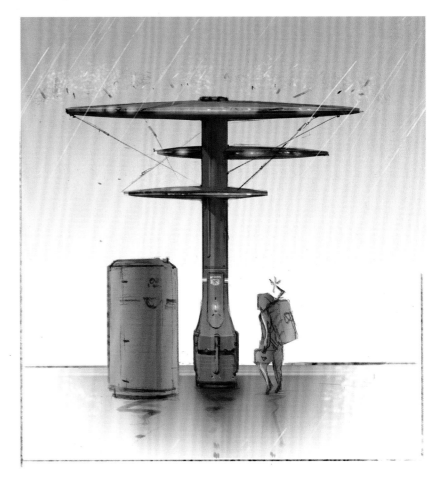

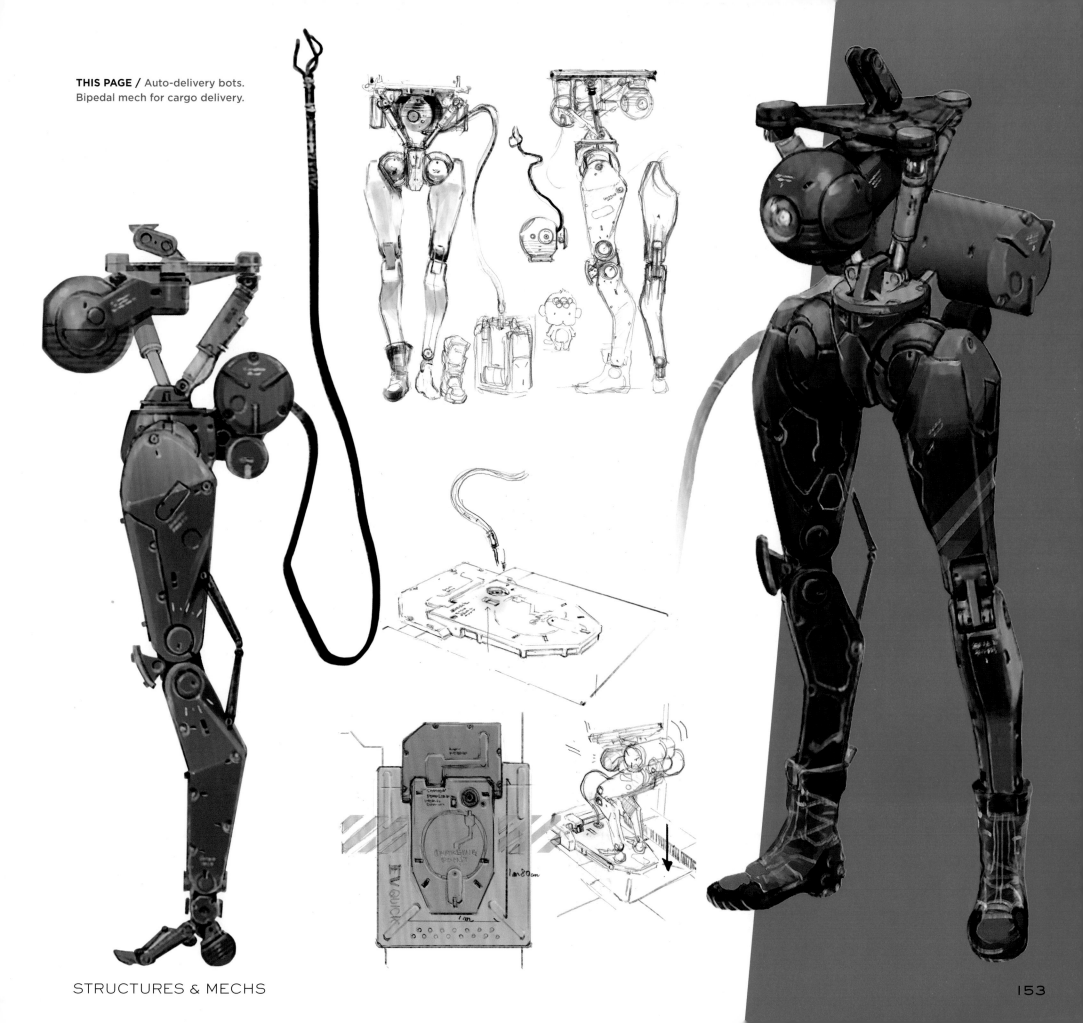

THIS PAGE / Auto-delivery bots.
Bipedal mech for cargo delivery.

STRUCTURES & MECHS

LOCATIONS

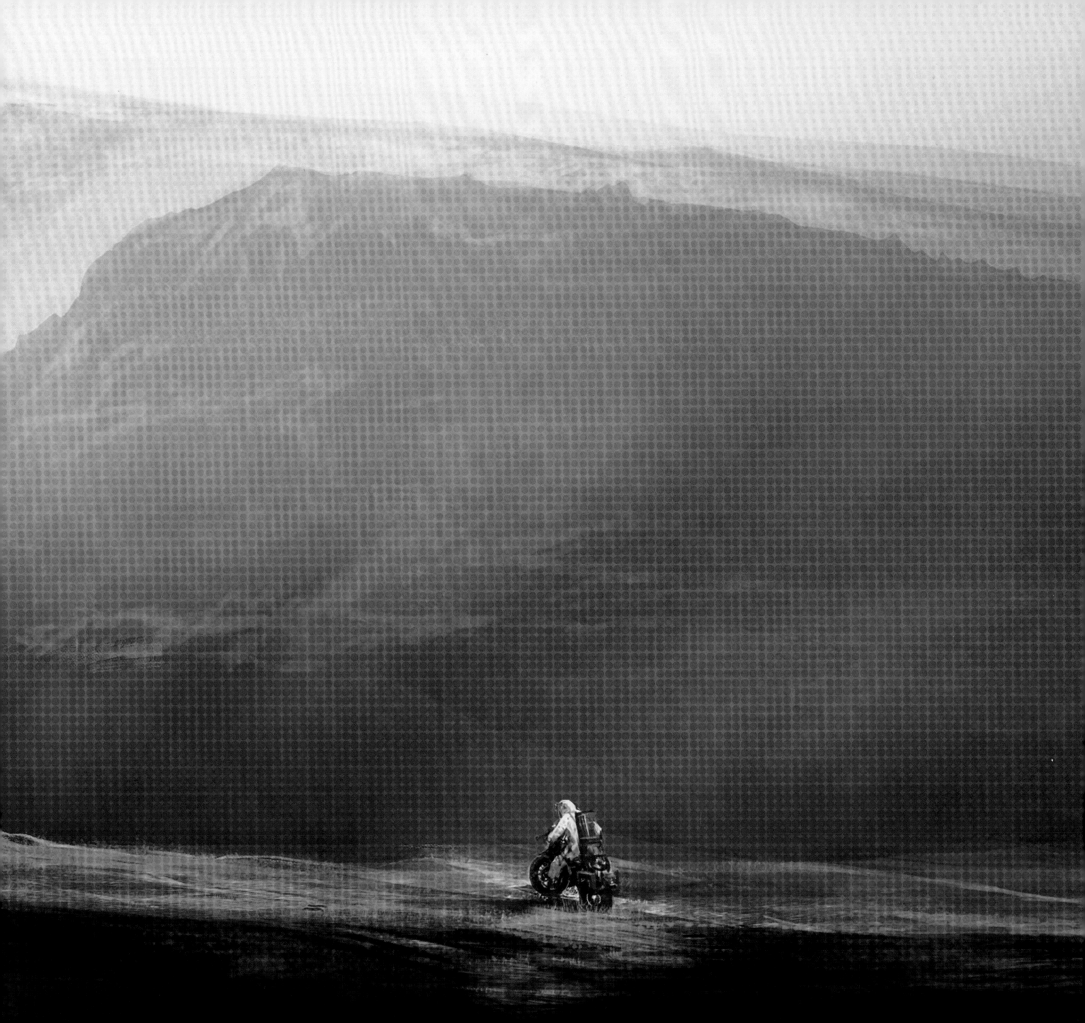

K1
CENTRAL
Knot City

UCA-01-001

CENTRAL KNOT

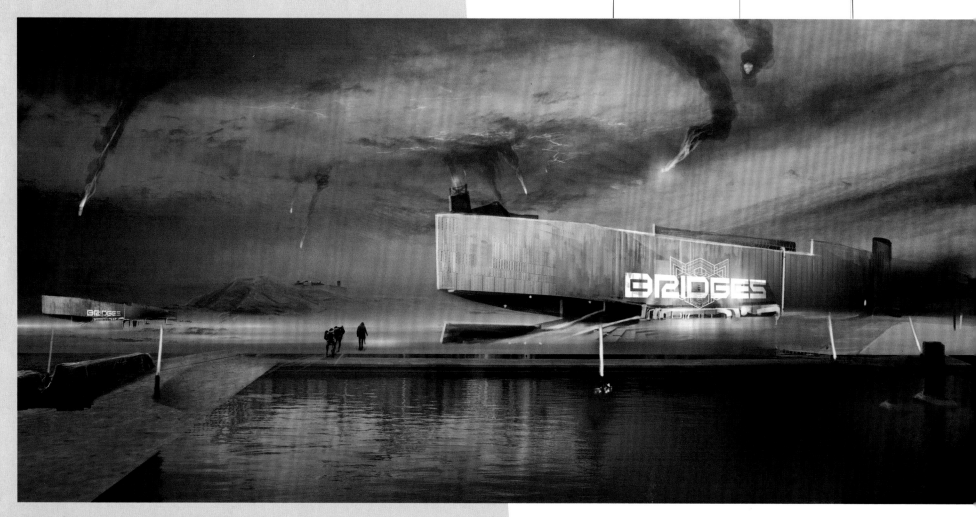

ABOVE / Early concept for distribution centers.

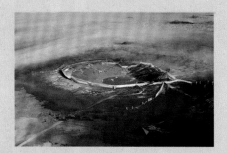
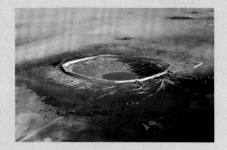
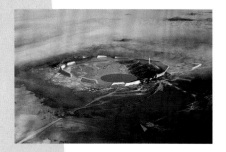
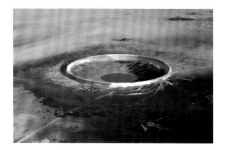

ABOVE / Ideas for the overview of the whole city.

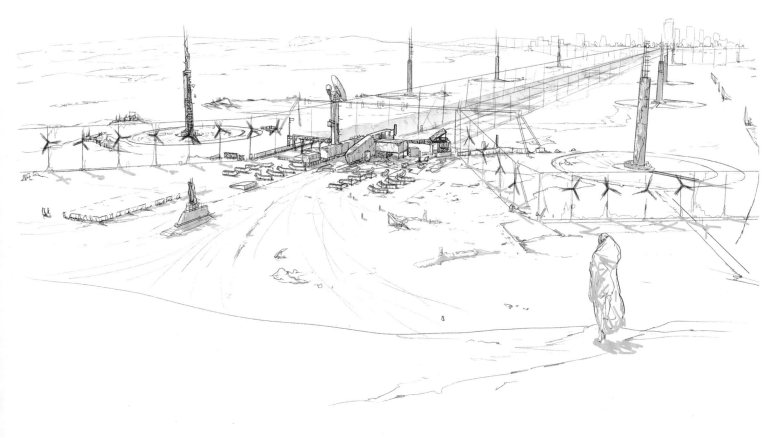

LEFT / Ideas for a road leading to the city, and the checkpoints on it.

BELOW / Concepts for the distance between the walls, the checkpoints and the actual city.

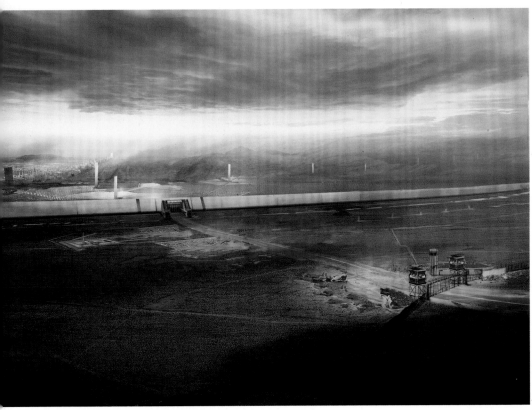

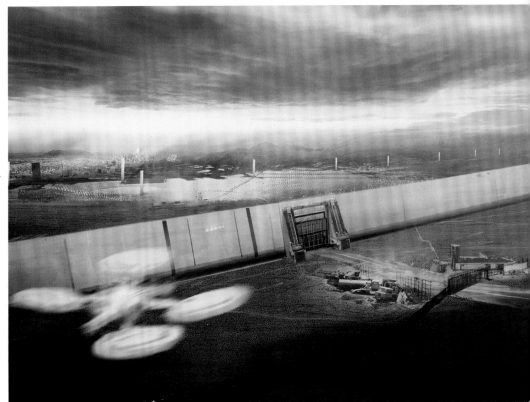

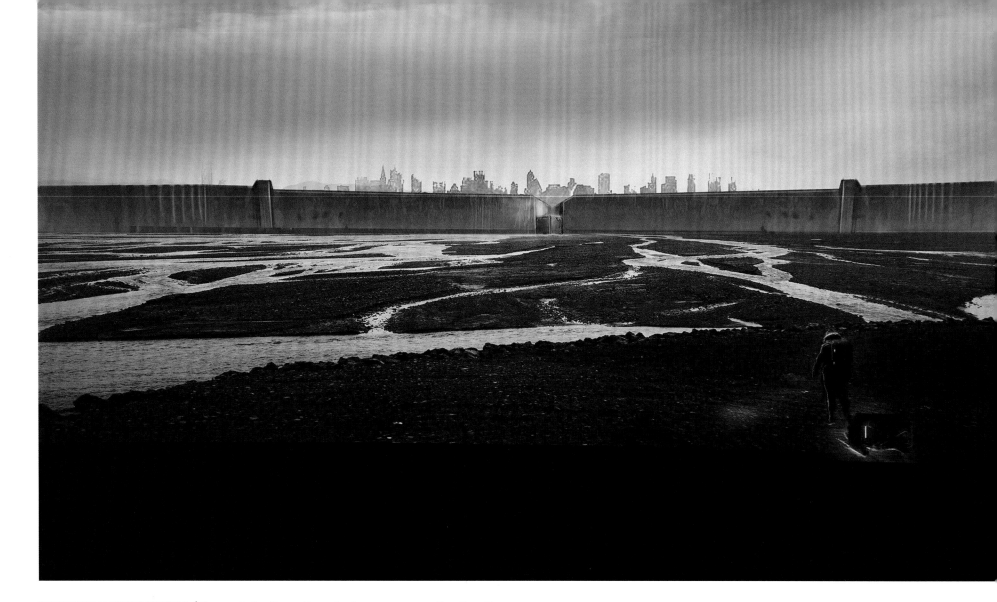

THIS PAGE & OPPOSITE TOP / Concepts for the walls and entrances surrounding the city.

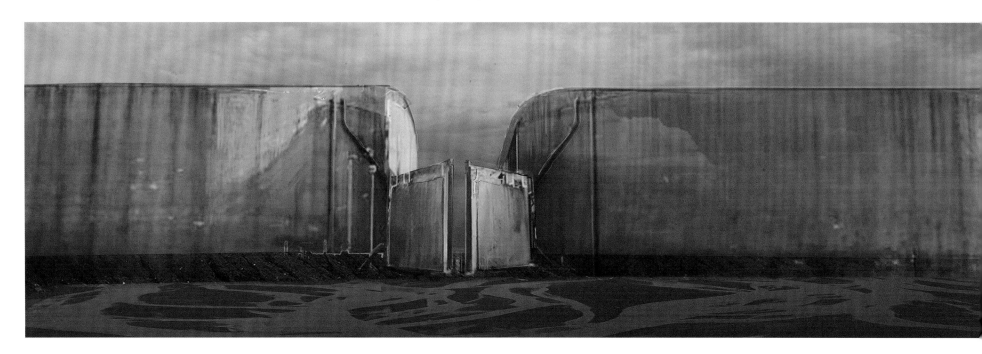

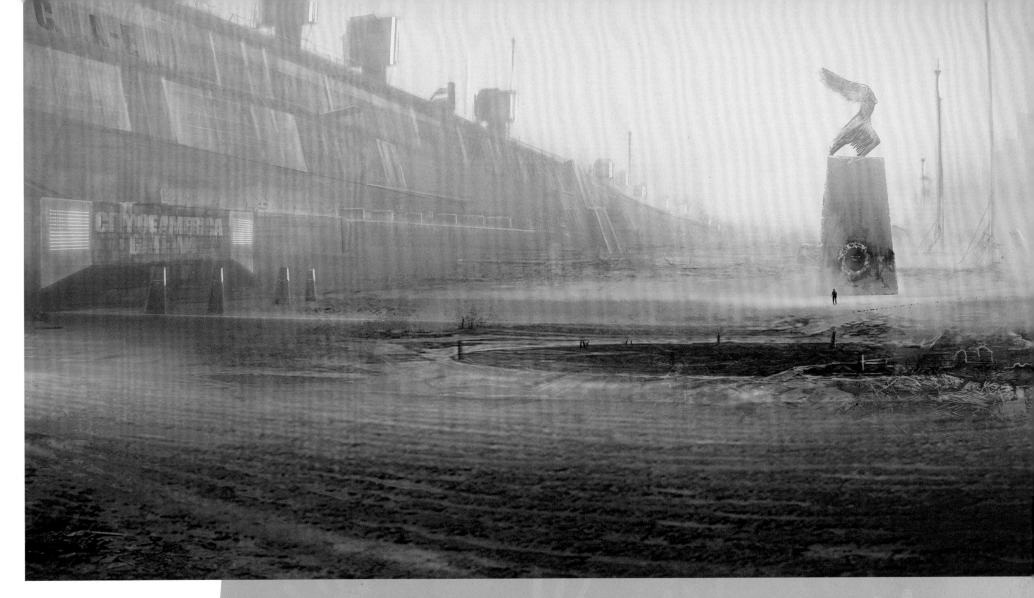

BELOW / Concepts for the crater left after the voidout in Central Knot City.

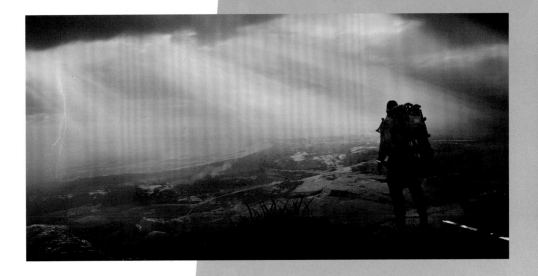

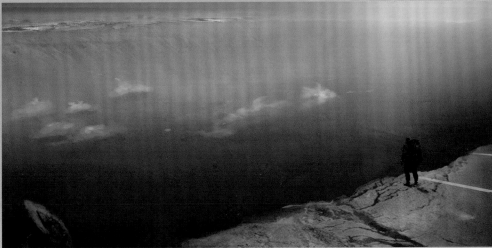

CAPITAL KNOT

K2
CAPITAL
Knot City

UCA-01-003

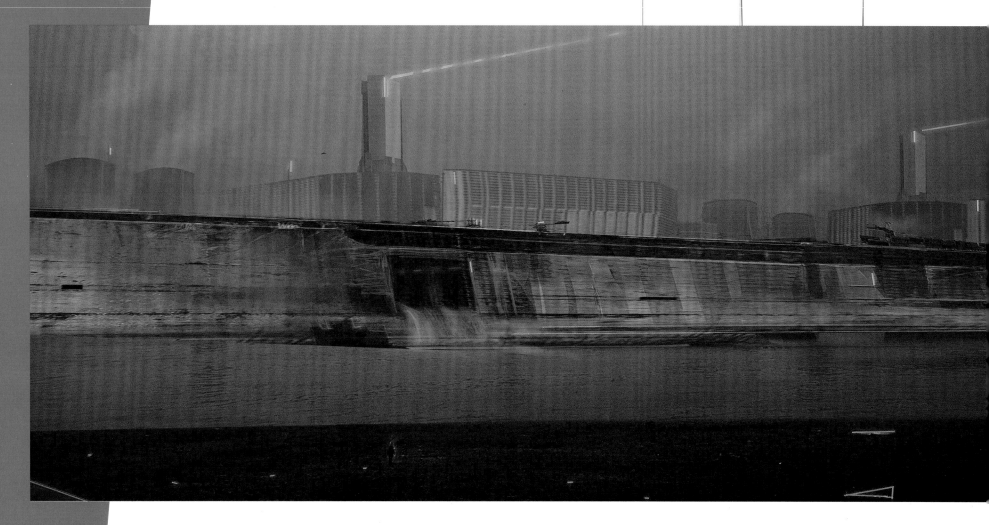

ABOVE / Some of the major difficulties when creating concepts for the cities were to figure out the scale of how big they would be and to balance how desolate they should feel. While these cities are inhabited, the people in them don't venture outside and are isolated, confined to their respective indoors.

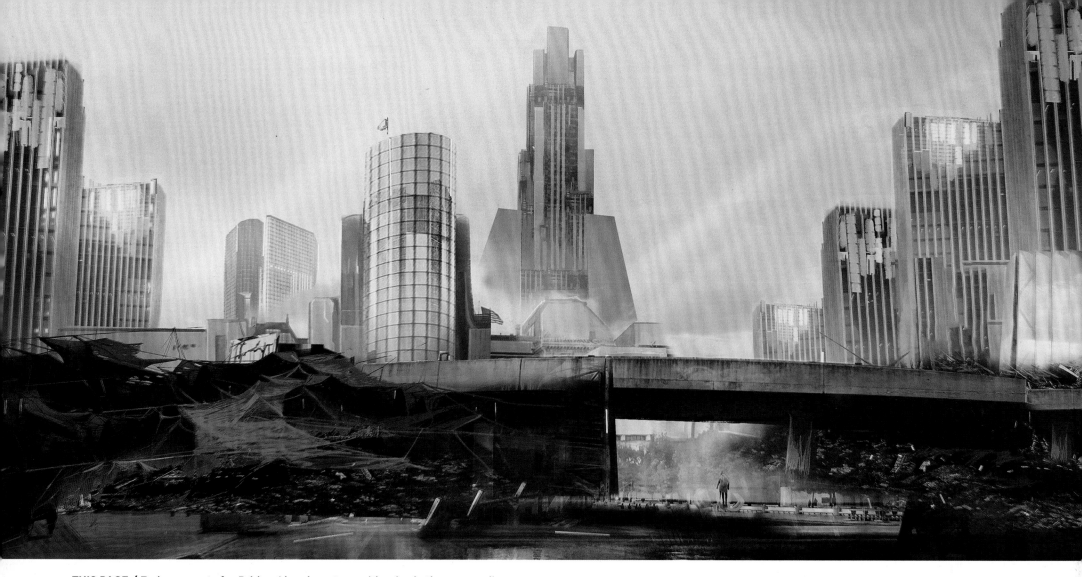

THIS PAGE / Early concepts for Bridges' headquarters, with ruins in the surrounding areas.

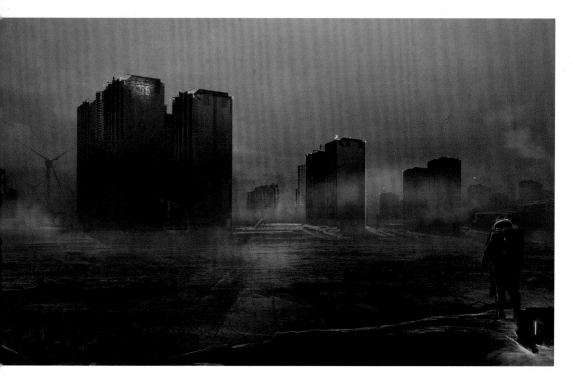

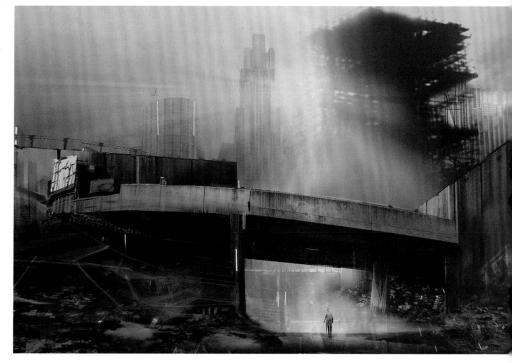

THIS SPREAD / Different concepts for walls on the outskirts of the cities, and the structures near those walls.

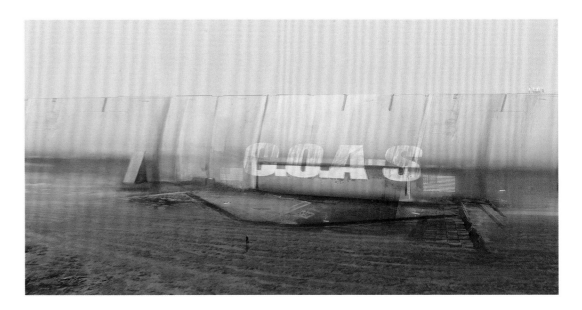

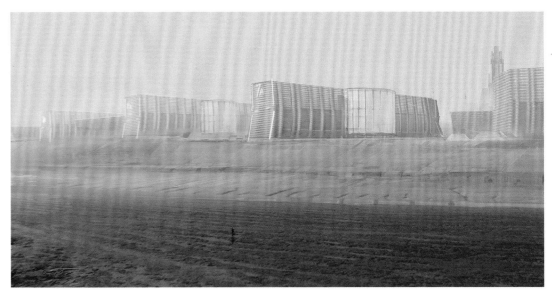

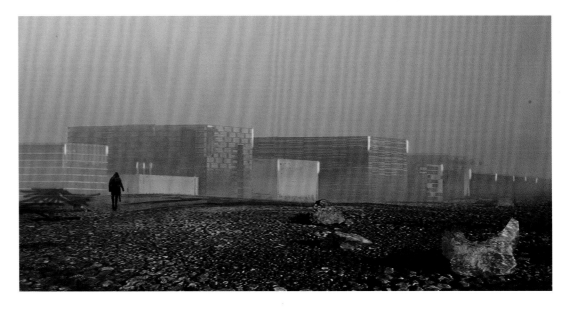

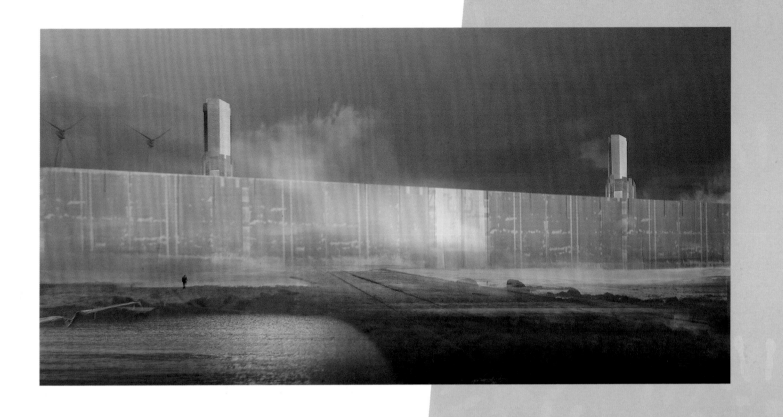
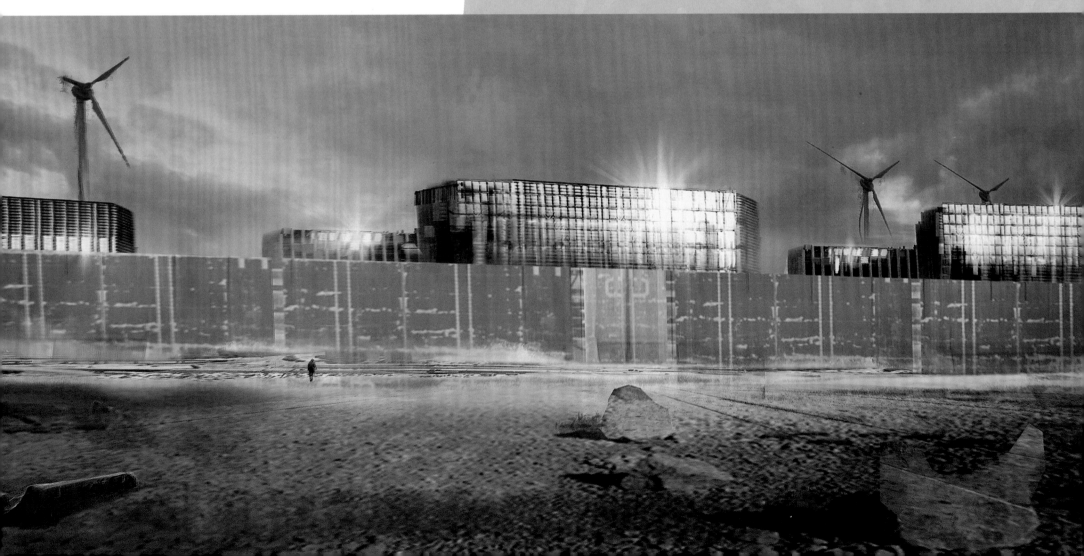

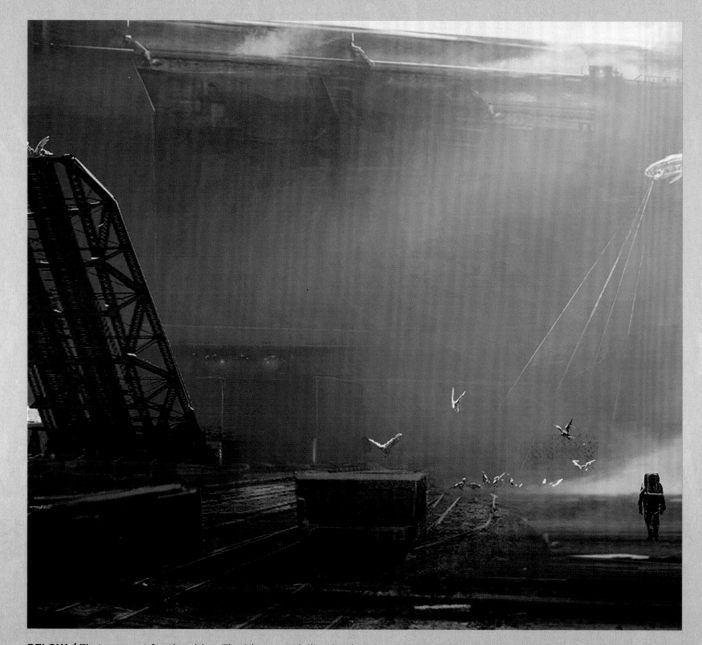

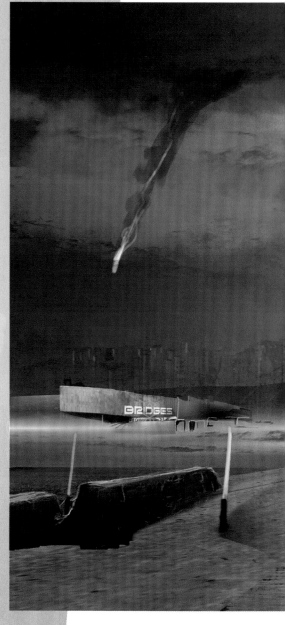

BELOW / First concept for the cities. The idea was civilization barely surviving by hanging on to remnants of the past.

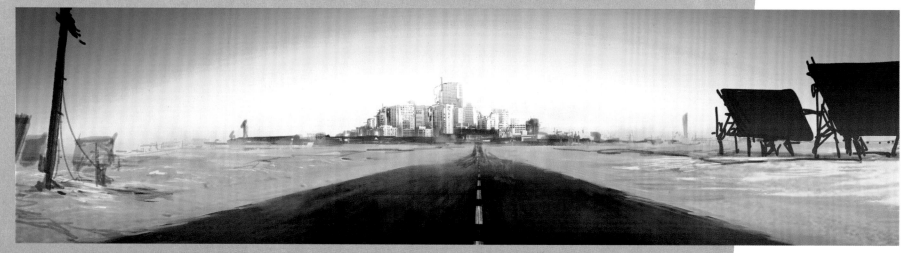

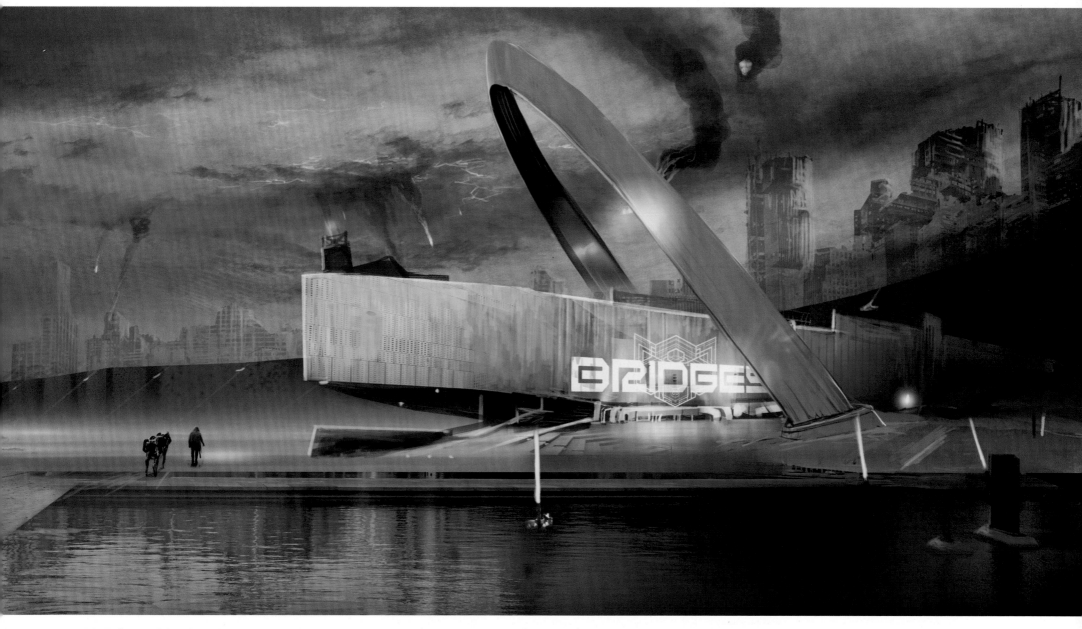

ABOVE / One of the ideas during development was for distribution centers in major cities to have monuments as part of their structure.

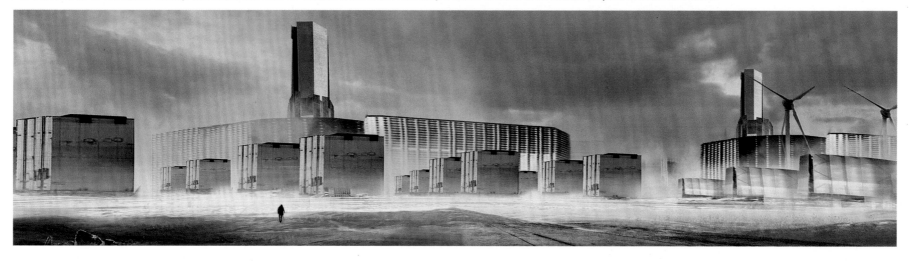

CAPITAL KNOT

K3
PORT
Knot City
UCA-0B-214

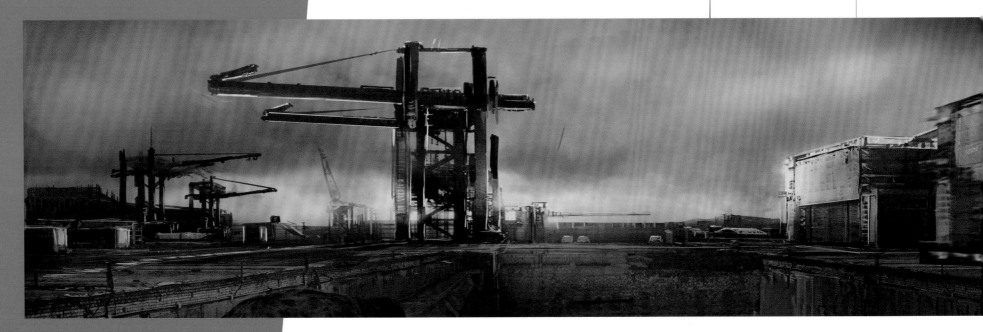

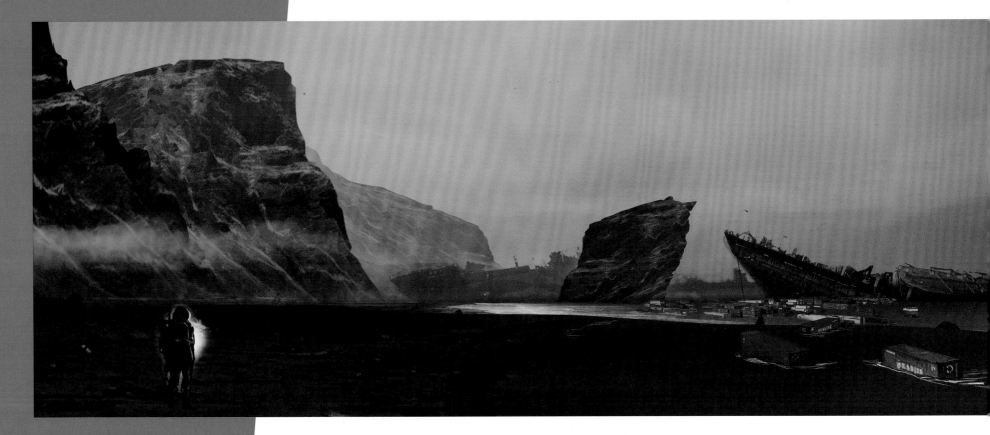

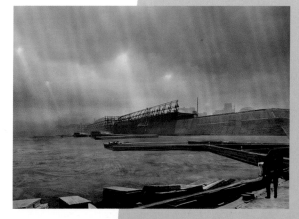

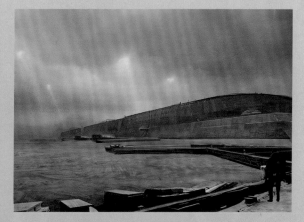

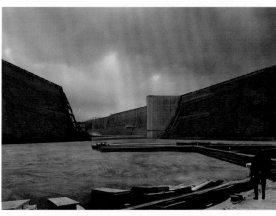

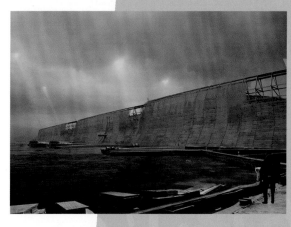

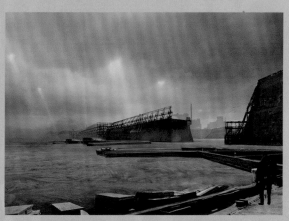

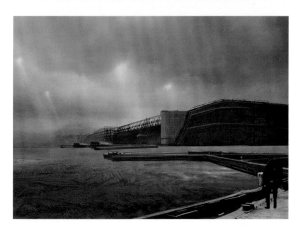

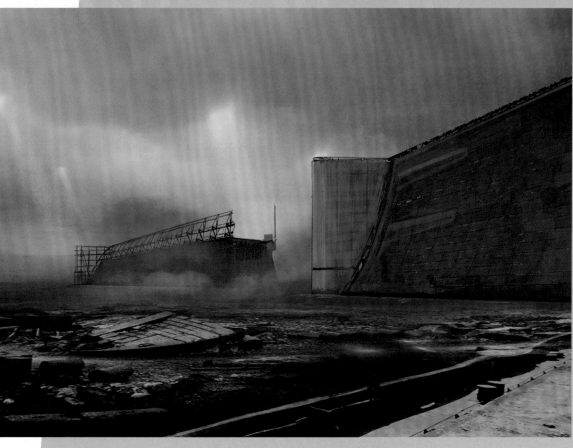

OPPOSITE / From early stages, this city featured old structures typical of a port, hinting at a time when the city flourished.

THIS PAGE / Different concepts for the walls of this city had to be considered: variations in height, length, etc.

PORT KNOT

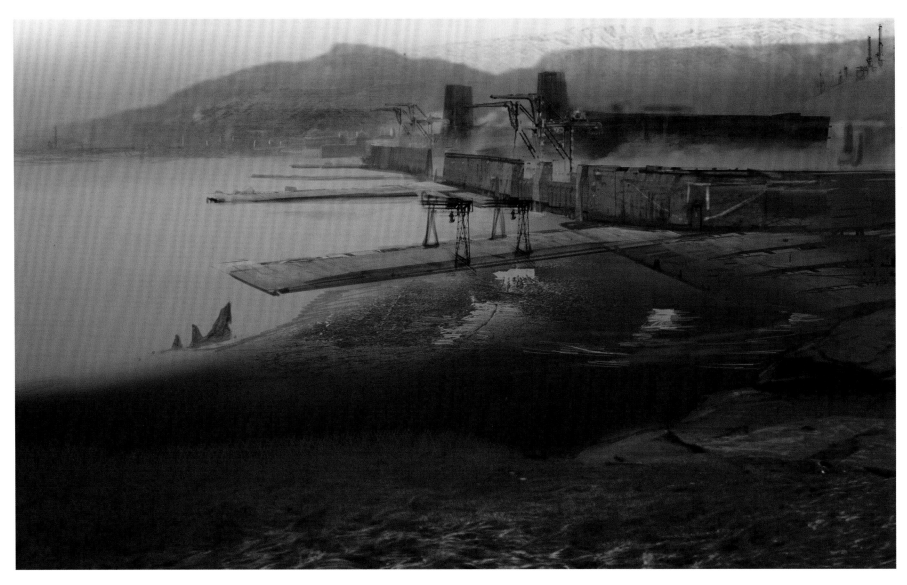

ABOVE / Final concept for Port Knot City.

BELOW / Abandoned buildings in the lake created by the crater.

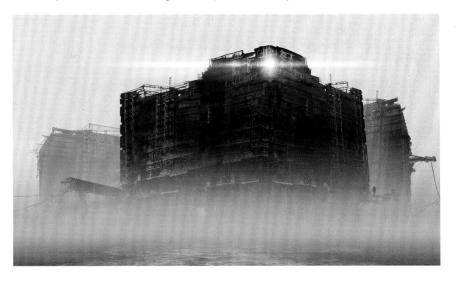

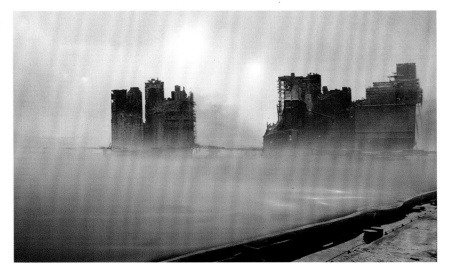

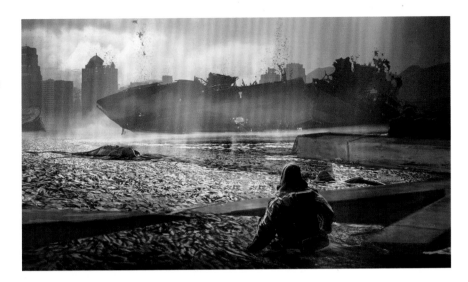 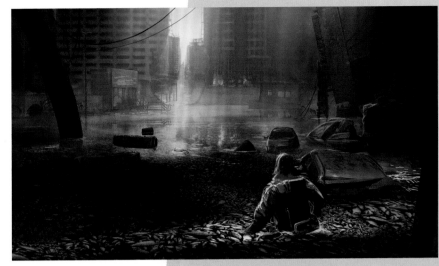

ABOVE / Ideas for a boss battle in Port Knot City.

BELOW / Early concept for MULEs using stranded tankers as their base.

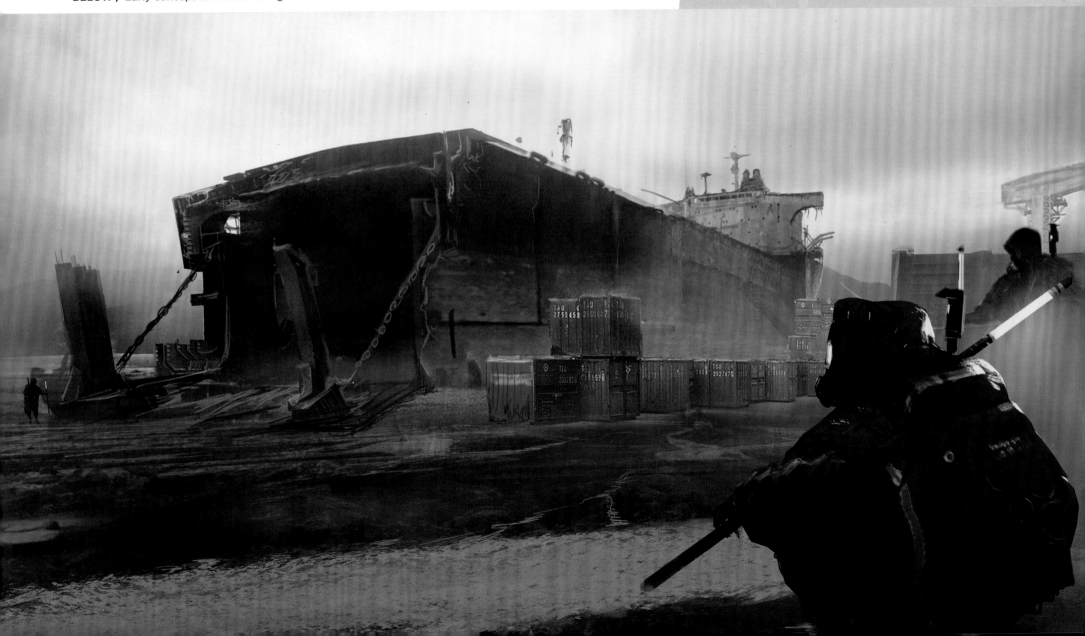

K4
LAKE
Knot City
UCA-23-105

LAKE KNOT

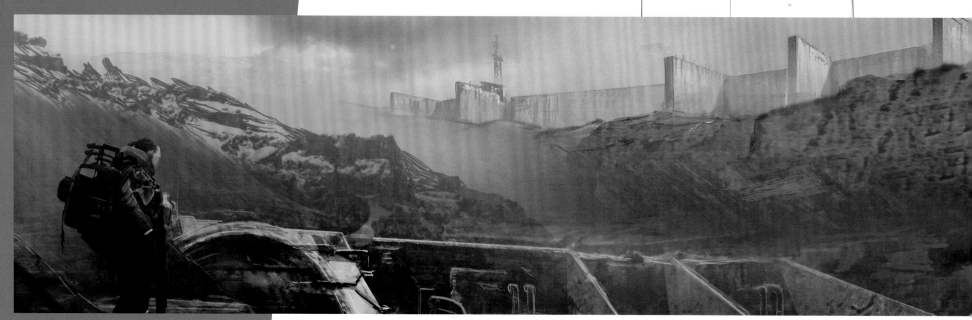

ABOVE / Final concept for Lake Knot City.

BELOW / Early concept for the outside wall of Lake Knot City.

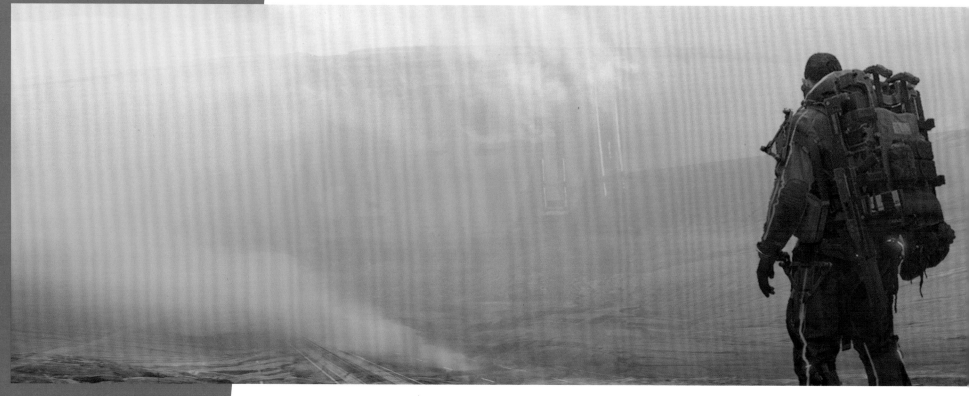

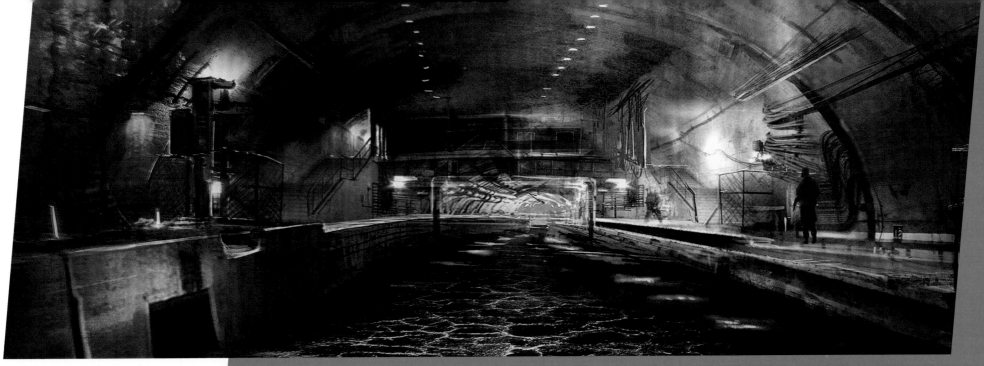

ABOVE / Port inside a tunnel, characteristic of Lake Knot City.

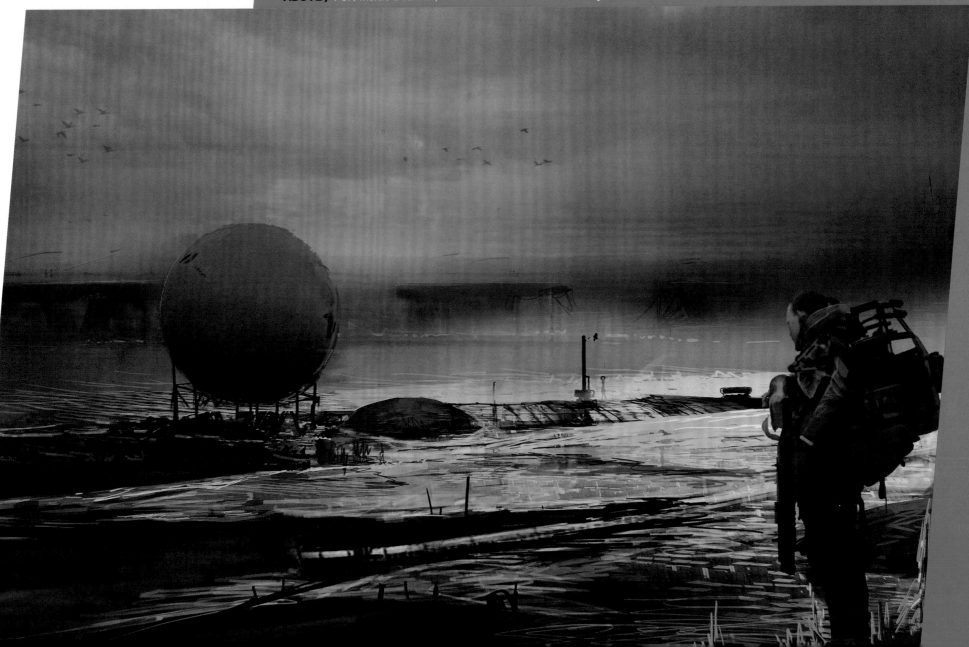

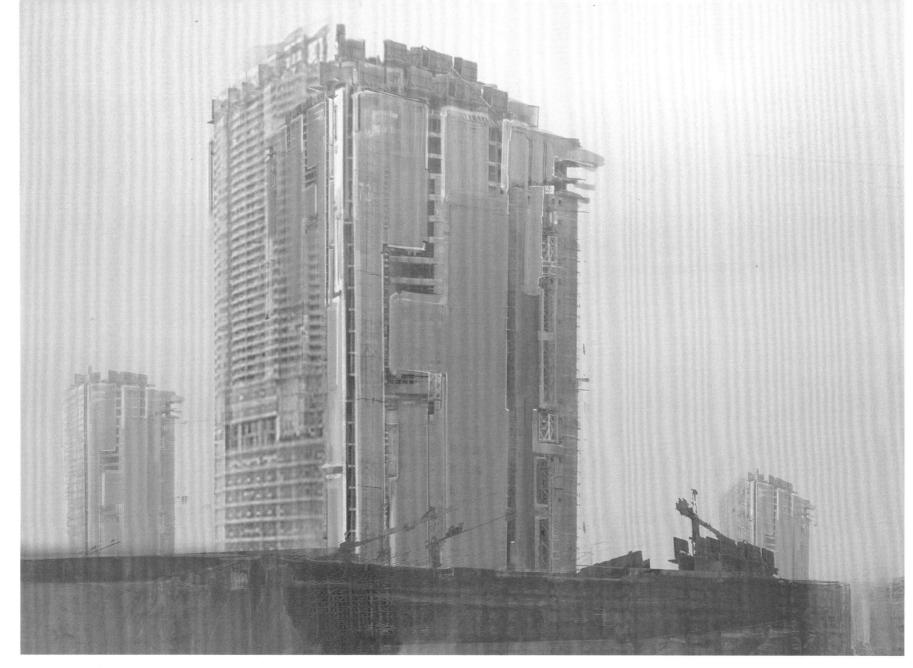

THIS SPREAD / To characterize each city, their walls featured a distinguishing color and/or textures.

BELOW / Port in the tunnel in Lake Knot City.

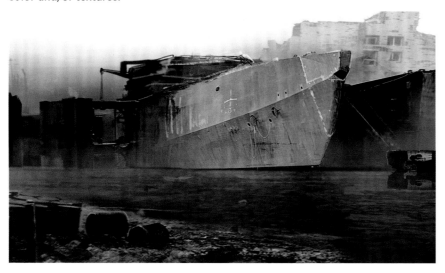

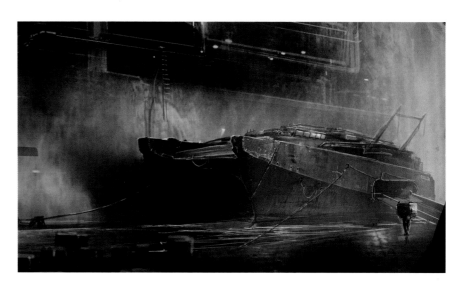

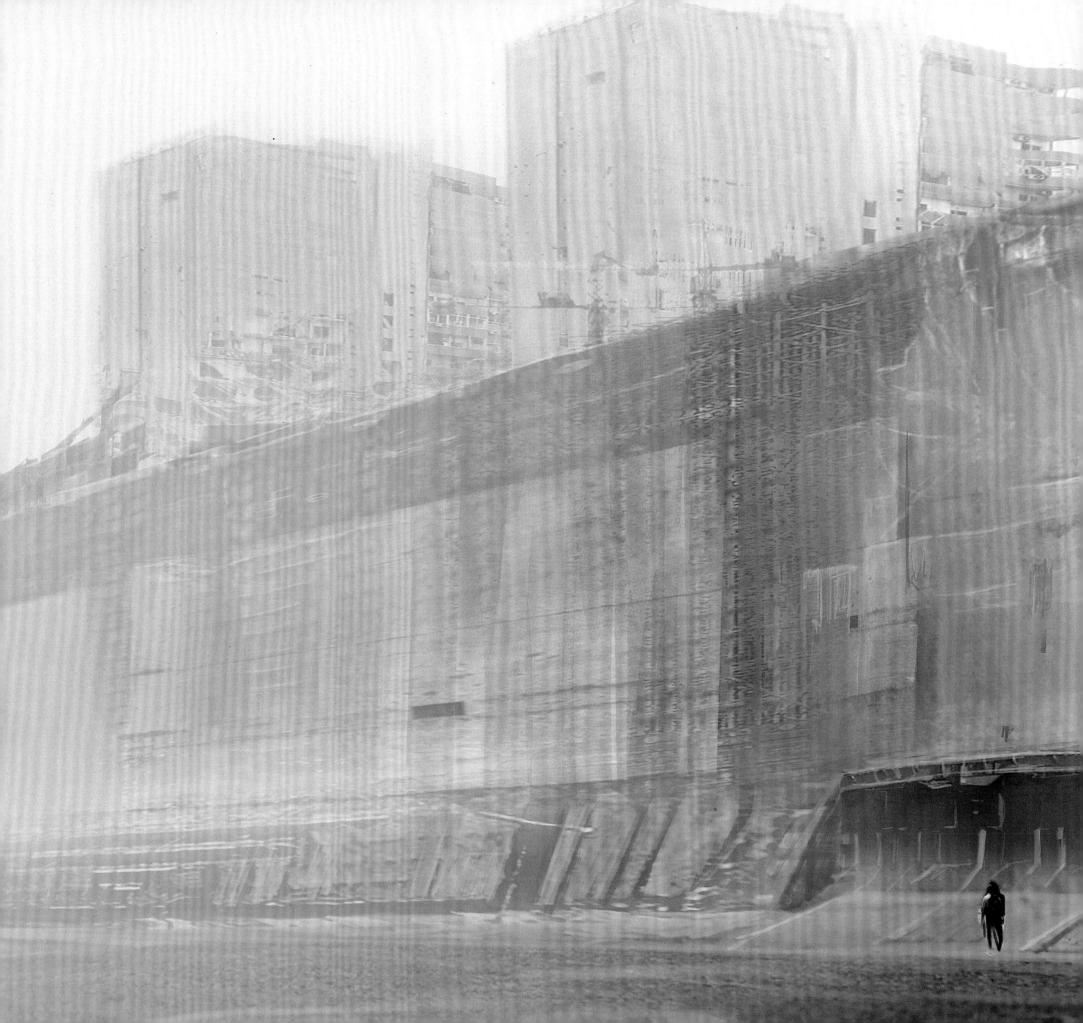

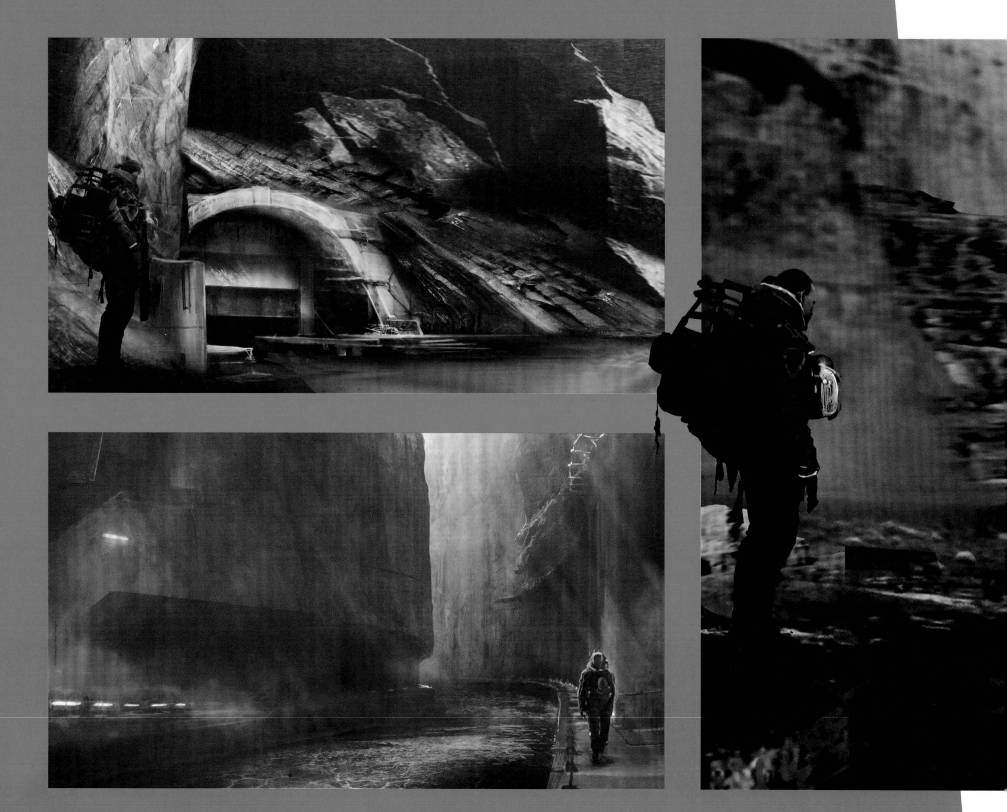

THIS SPREAD / Concepts for the entrance to the port of Lake Knot City.

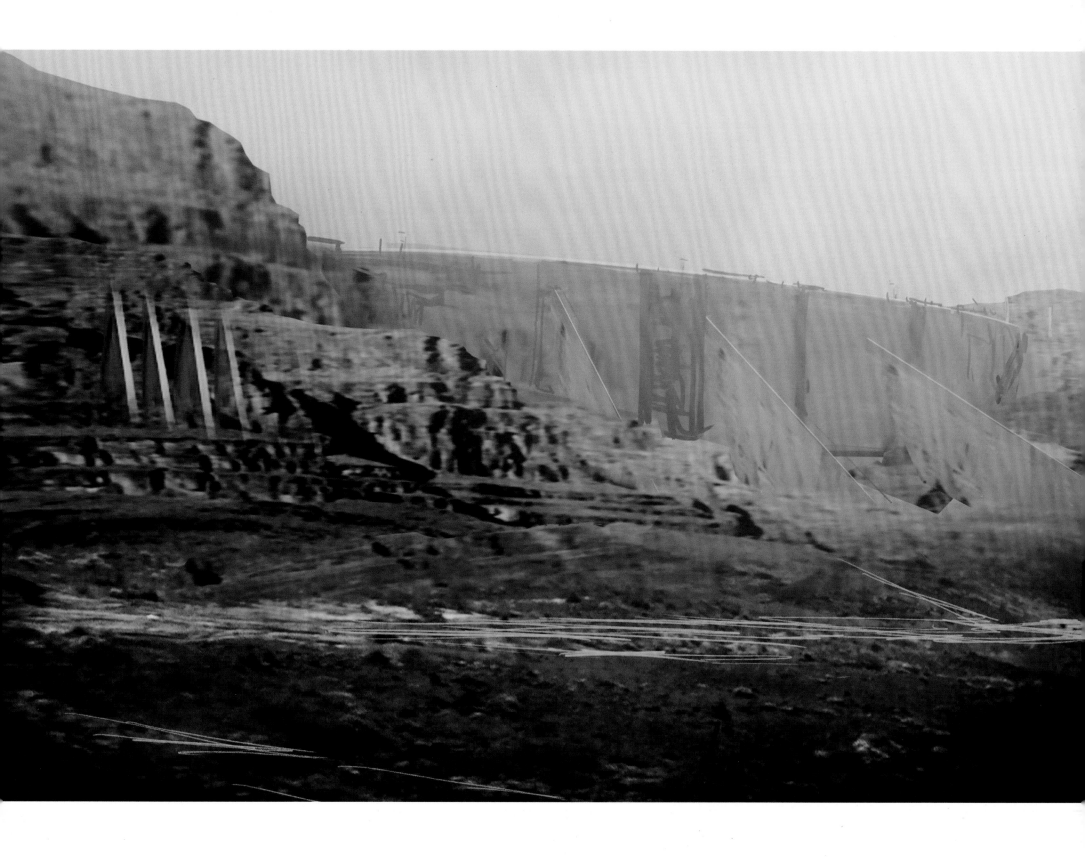

LAKE KNOT

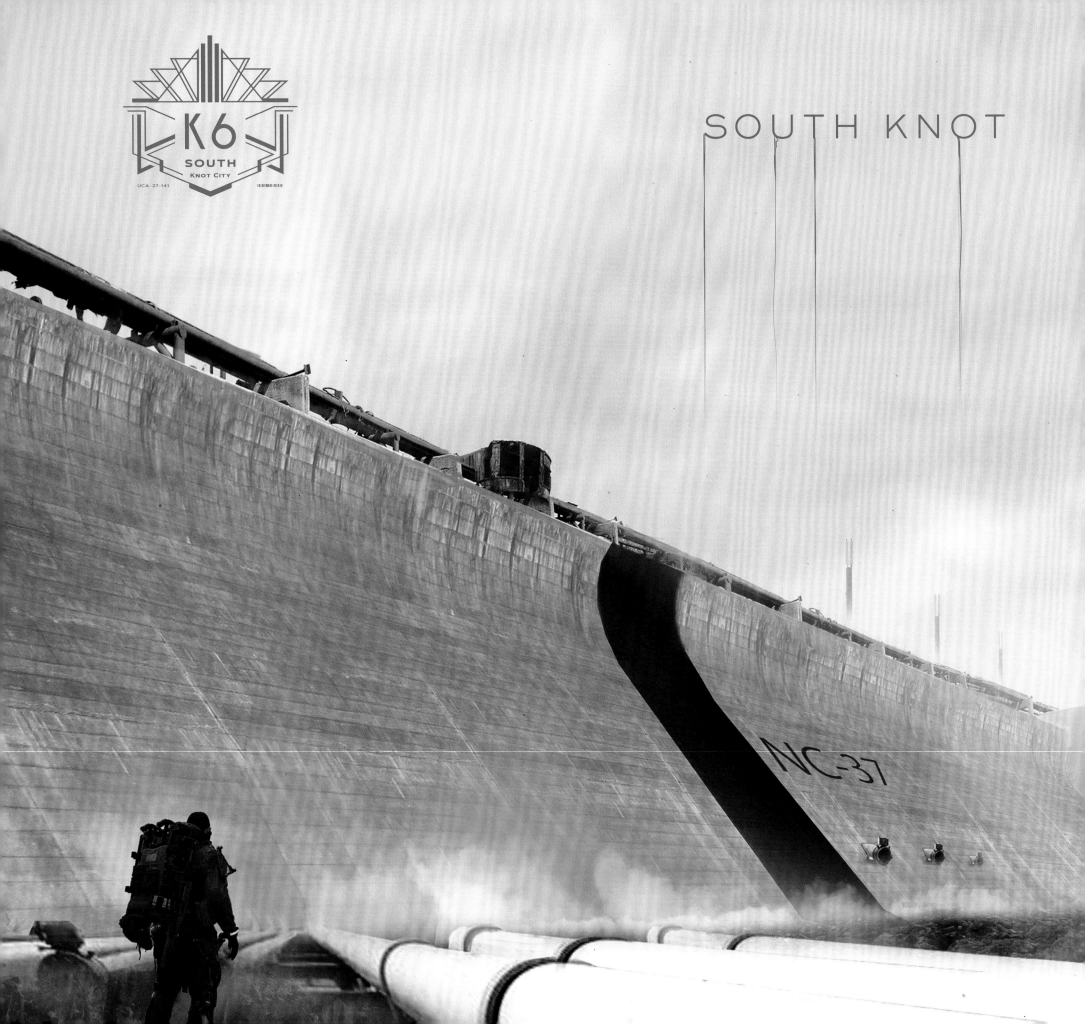

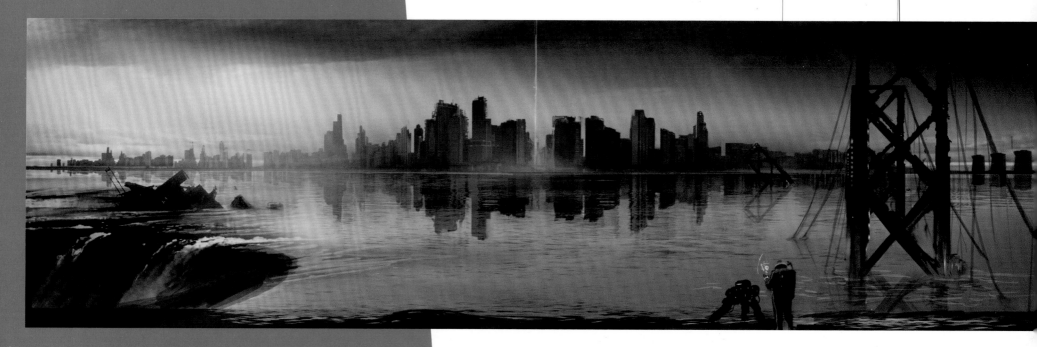

ABOVE / Landscape of Edge Knot City seen from the Tar Belt.

THIS PAGE / Early Edge Knot City concepts experimenting with the scale of the city.

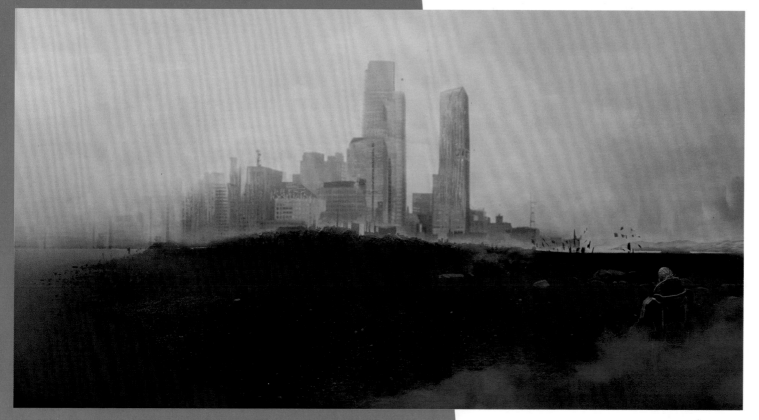

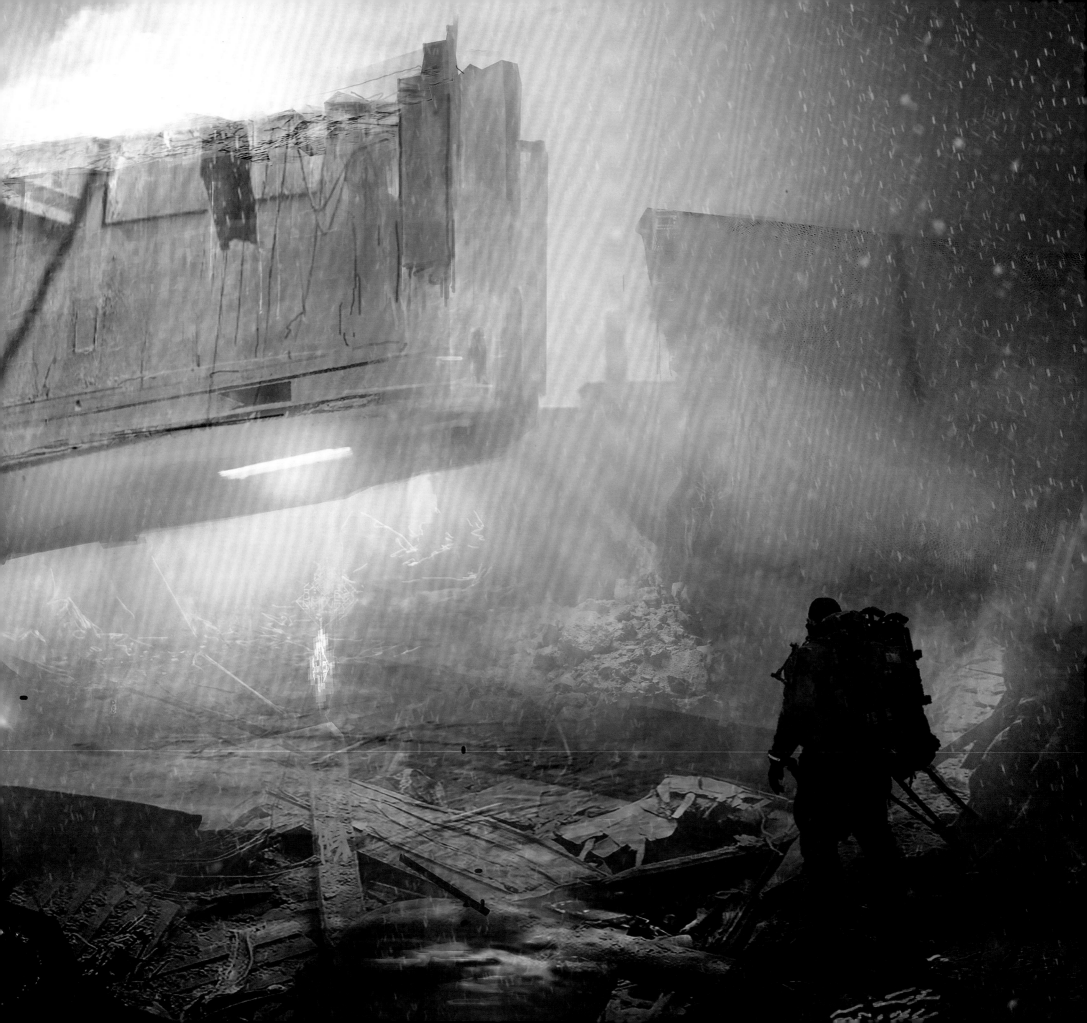

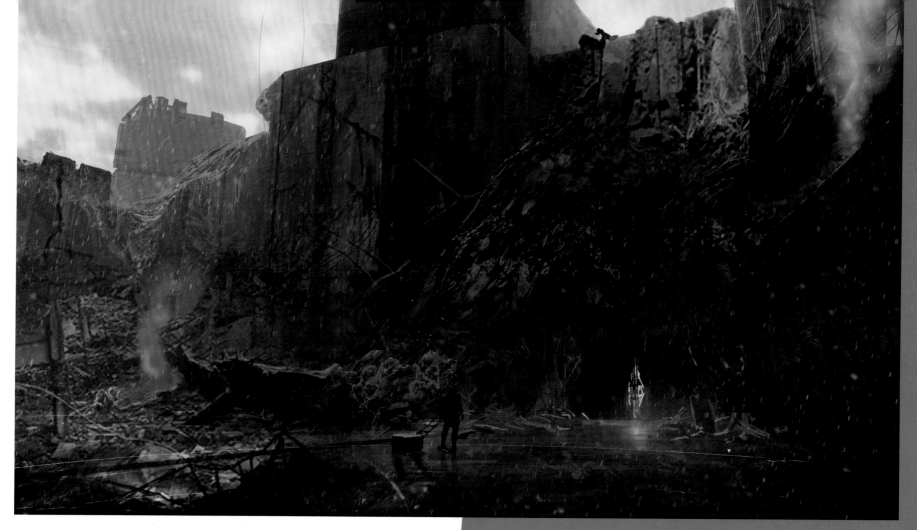

LEFT & ABOVE / Close to final concepts for the interiors of the city.

BELOW / Very early draft of Edge Knot City.

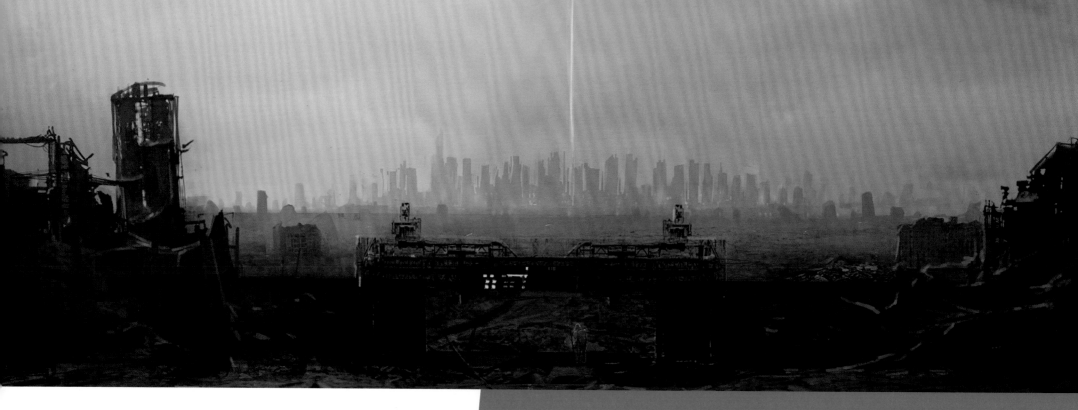

EDGE KNOT

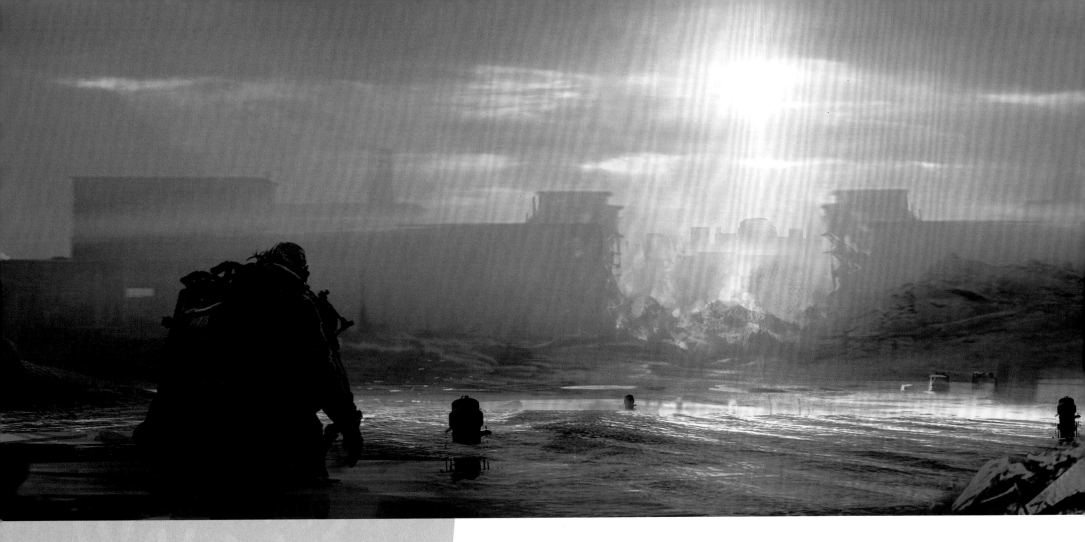

THIS PAGE / Different concepts for the entrance of Edge Knot City, with the idea being that the entrance is a broken part of the wall.

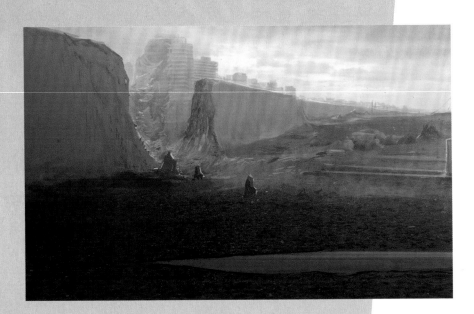

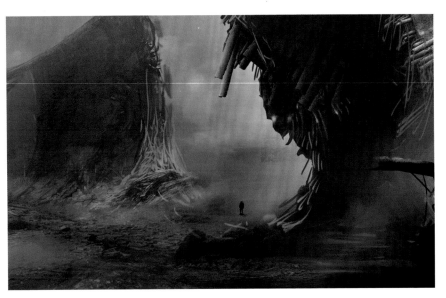

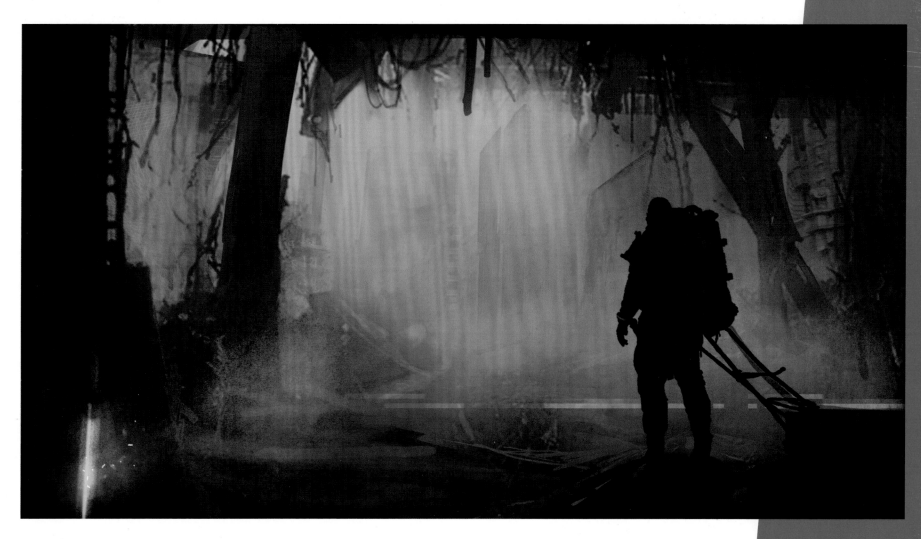

THIS PAGE / Concepts for the interior of Edge Knot City, near its entrance. The idea was a destroyed city littered with debris.

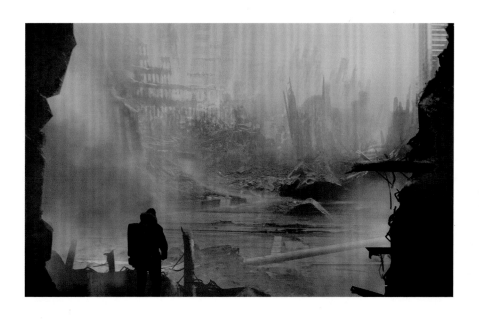

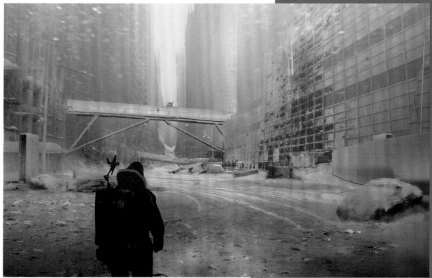

EDGE KNOT

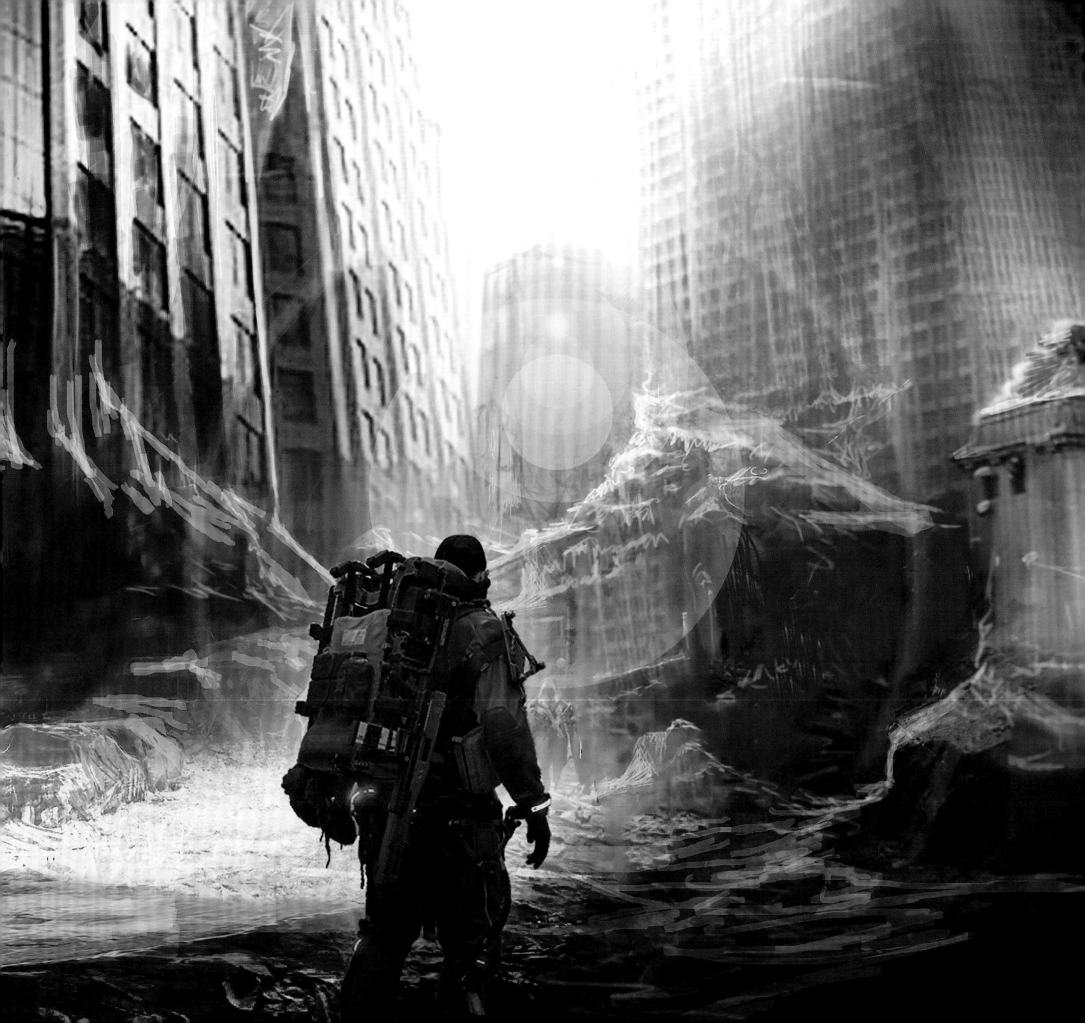

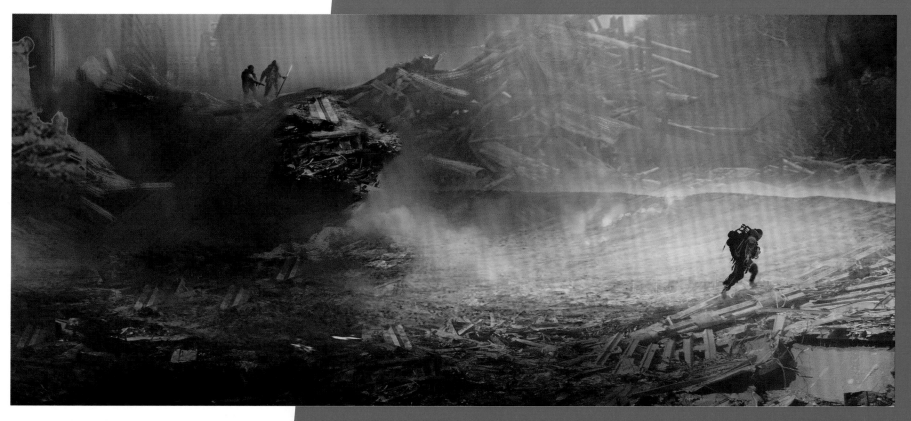

OPPOSITE & ABOVE / Interiors of Edge Knot City.

BELOW / Edge Knot City from outside. Early concepts had a sunken BRIDGES I facility near its exterior.

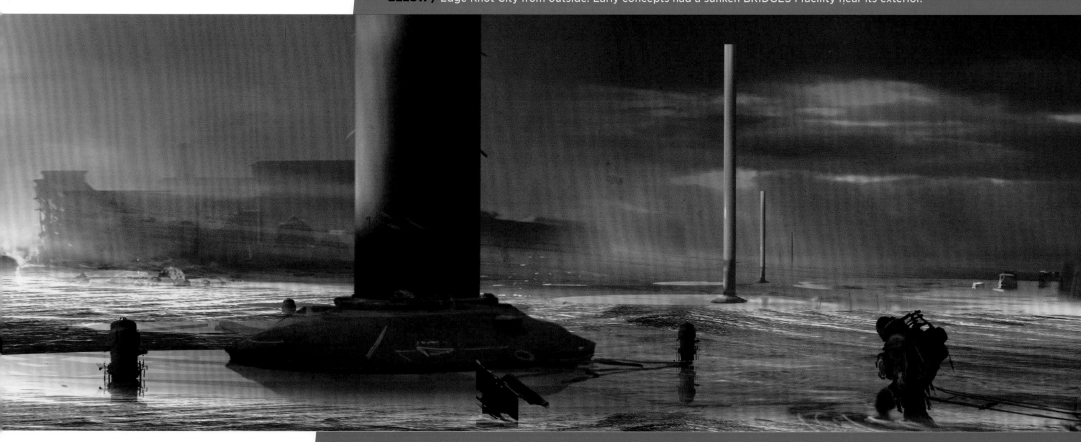

EDGE KNOT

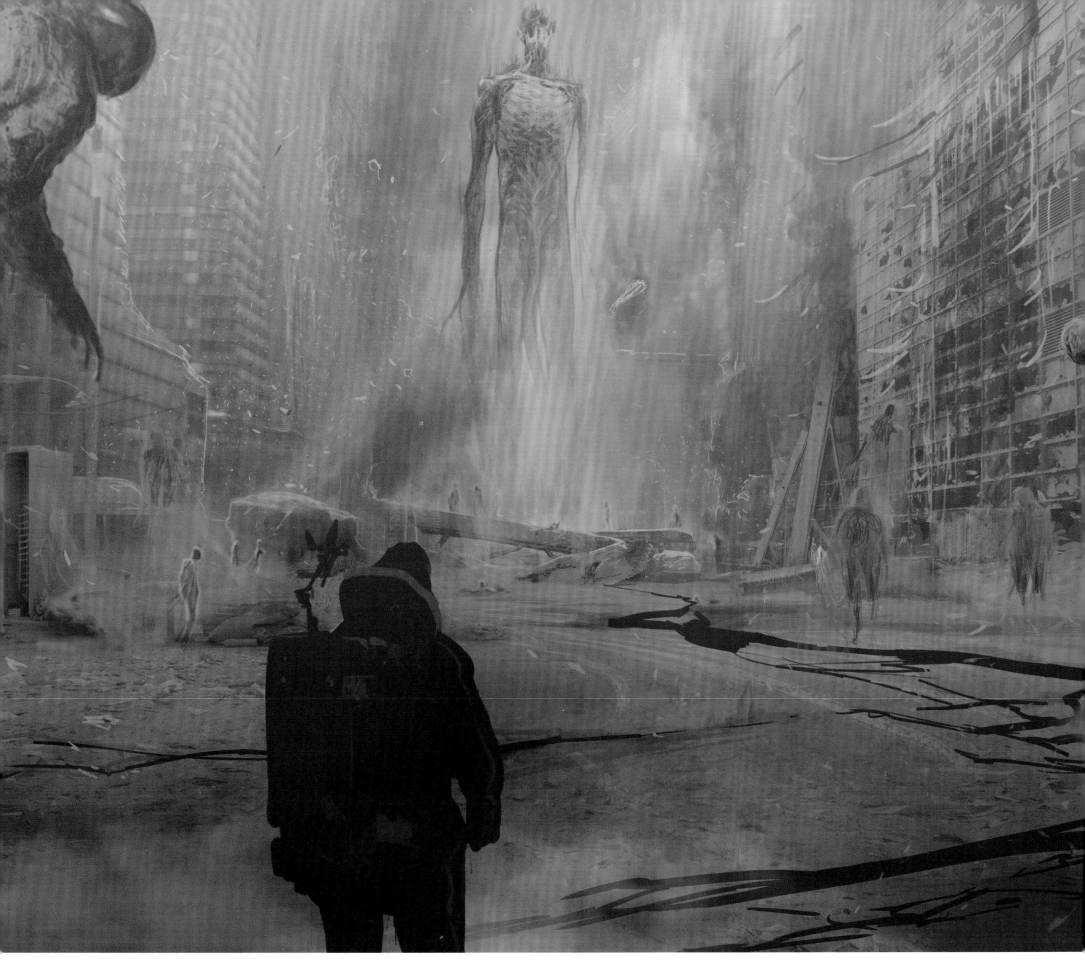

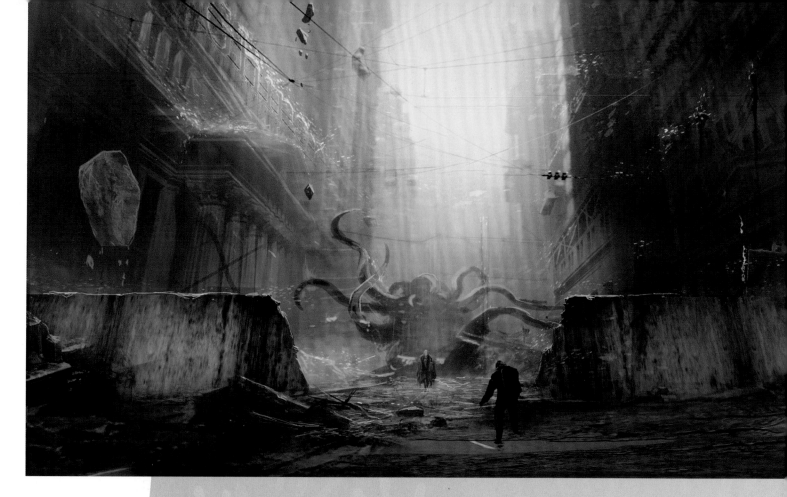

THIS SPREAD / Concepts for battles with BTs inside the city.

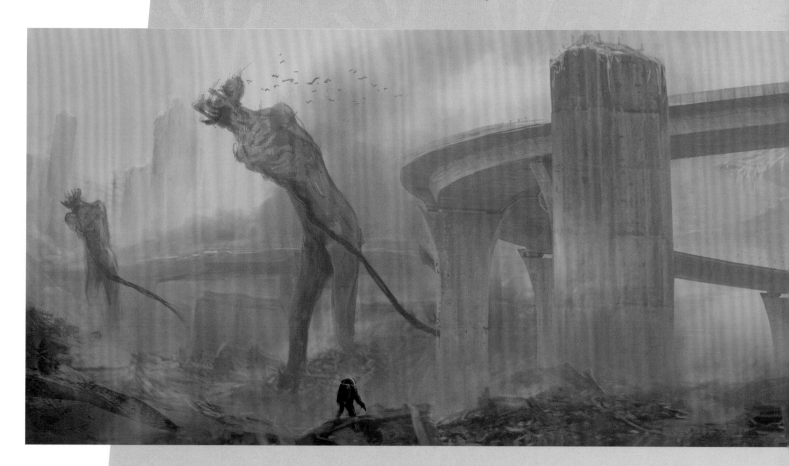

UNUSED LOCATIONS

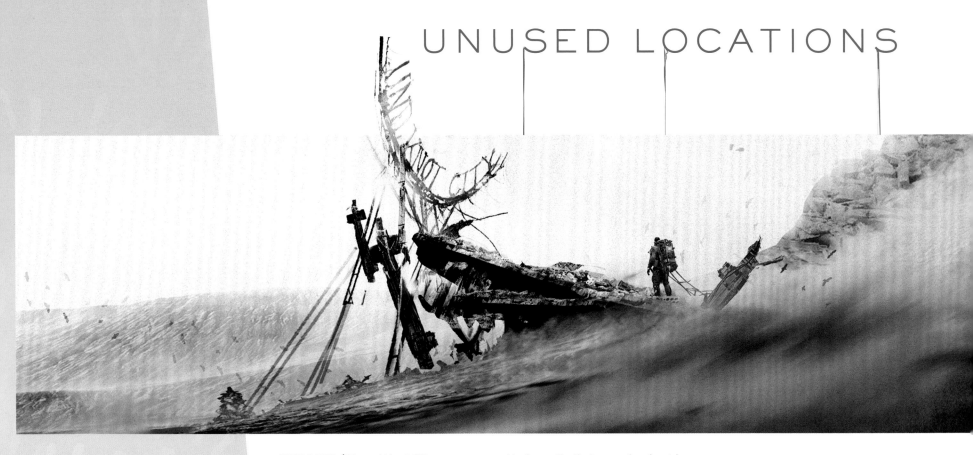

THIS PAGE / Hound Knot City was supposed to be a city that was wiped out by a voidout. Its name disappeared from the game, and its ruins were left near the old shopping mall.

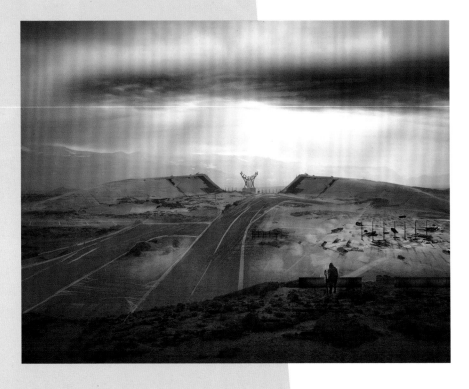

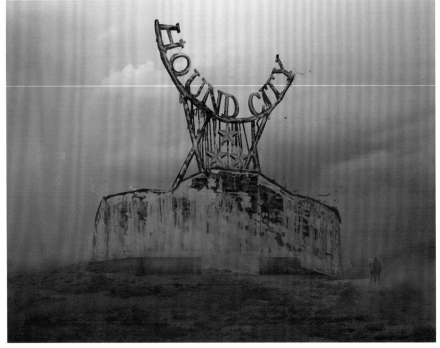

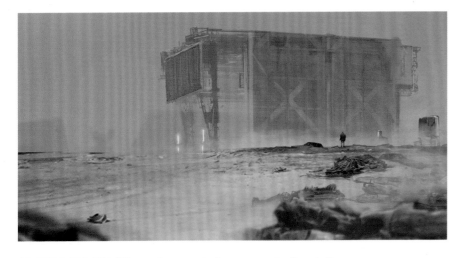
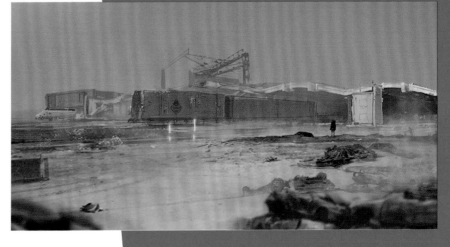

ABOVE & BELOW / Unused concepts for a mega-trailer station.

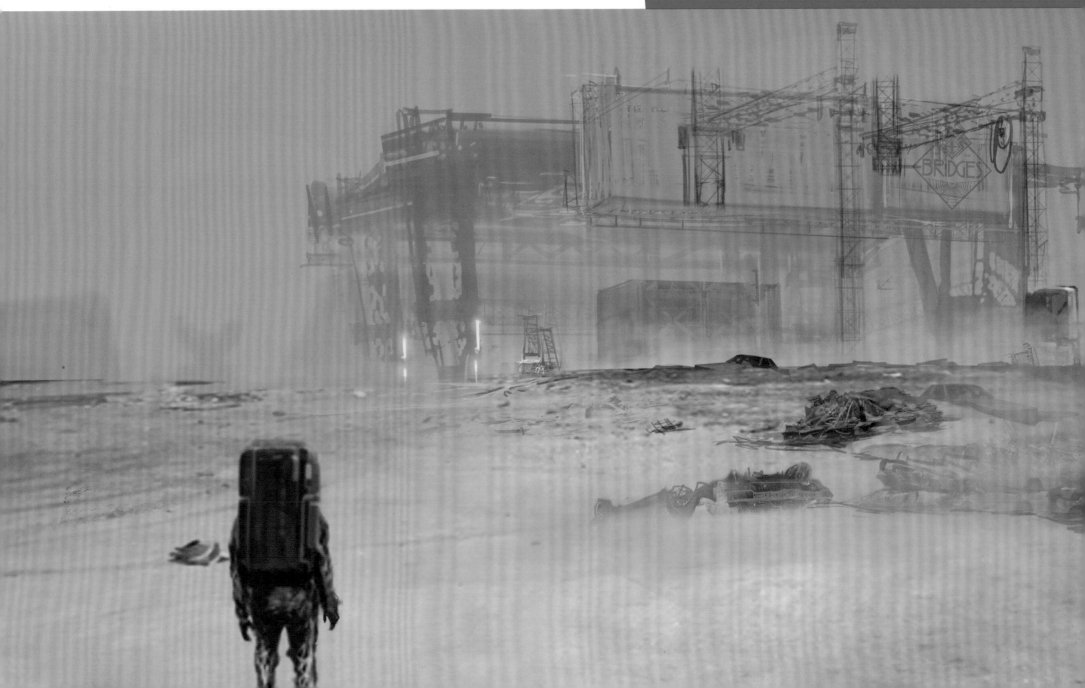

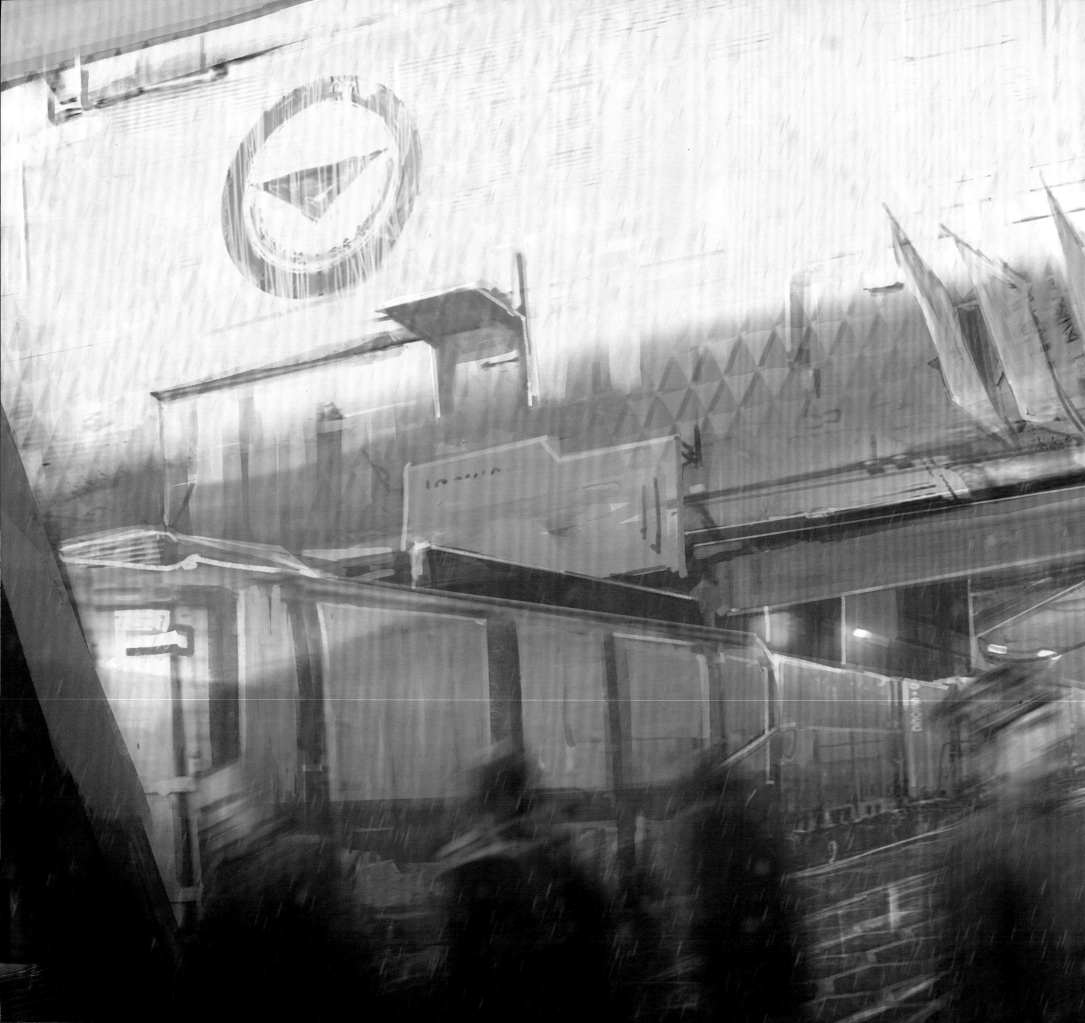

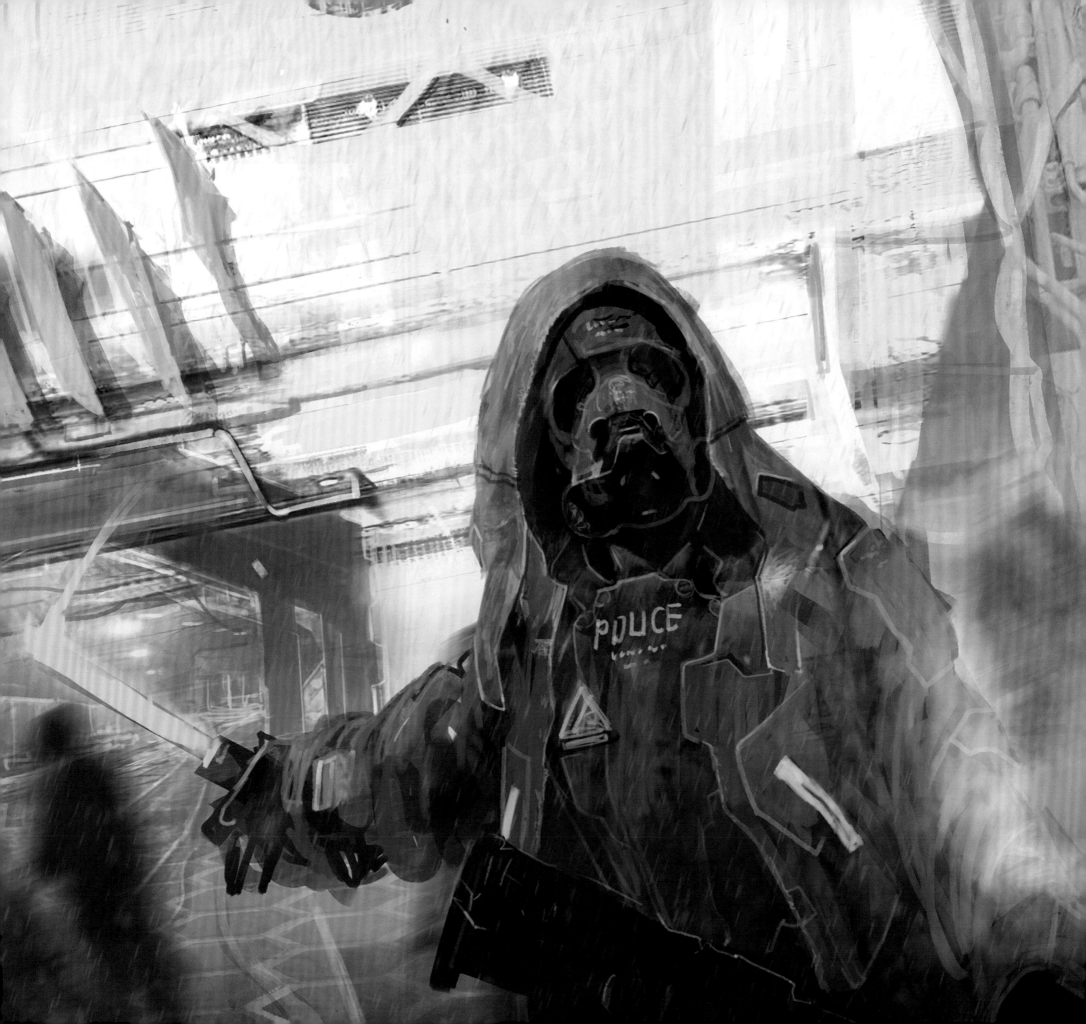

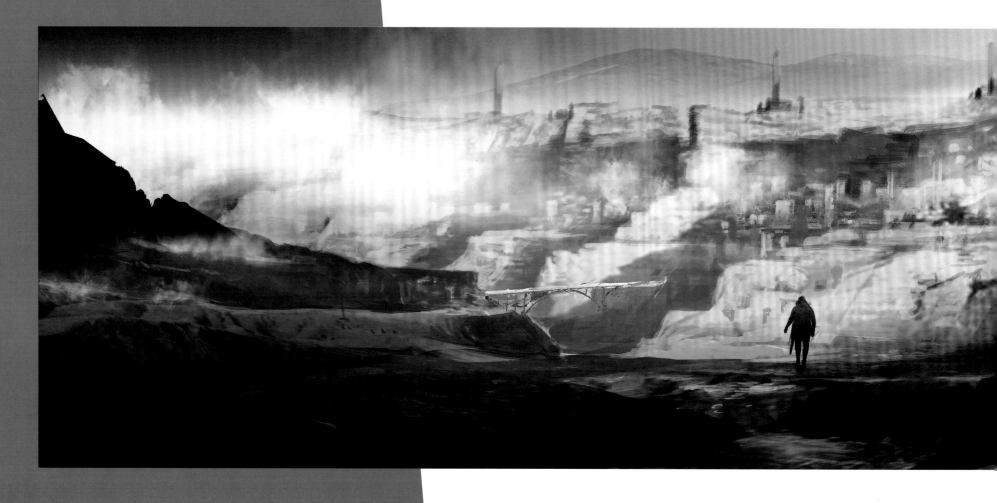

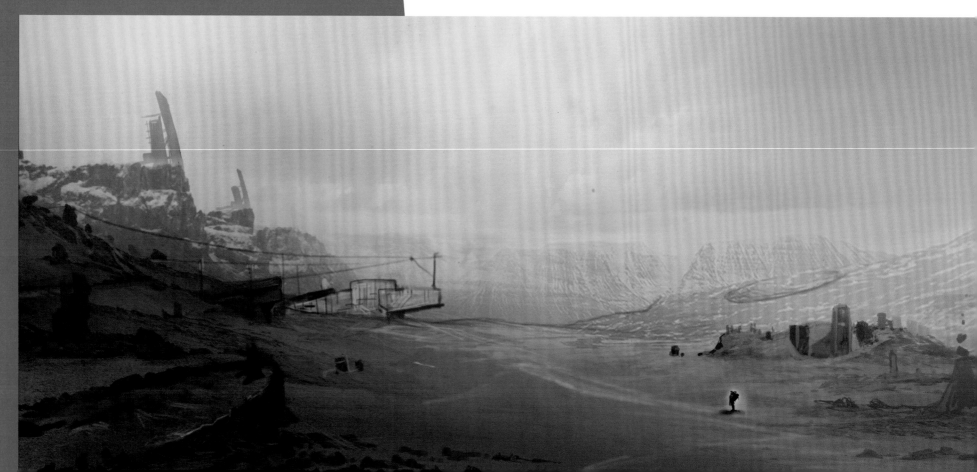

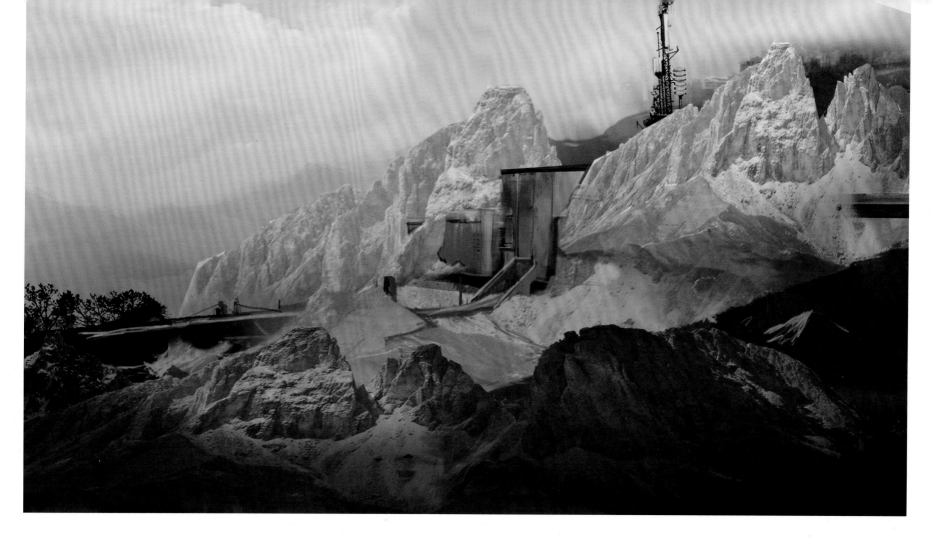

THIS SPREAD / Unused concepts for Mountain Knot City.

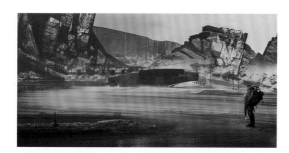

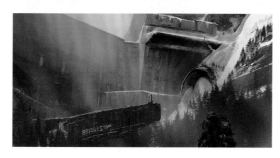

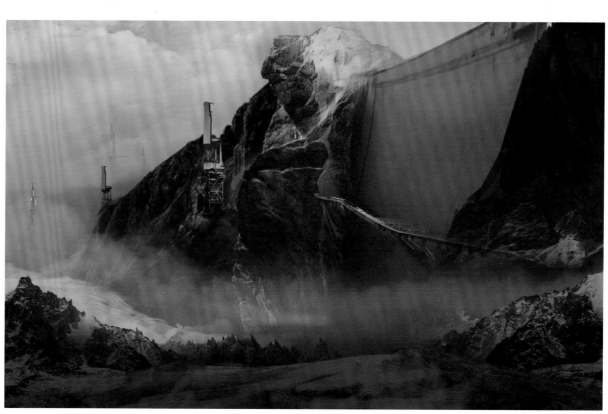

UNUSED LOCATIONS

BRIDGES CENTER

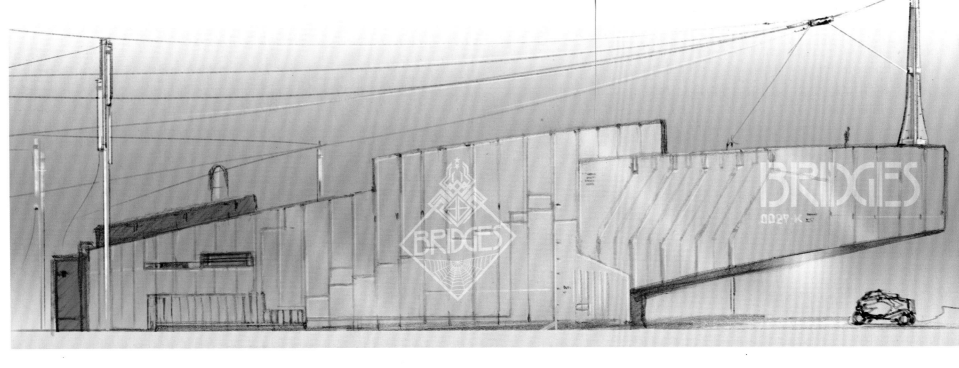

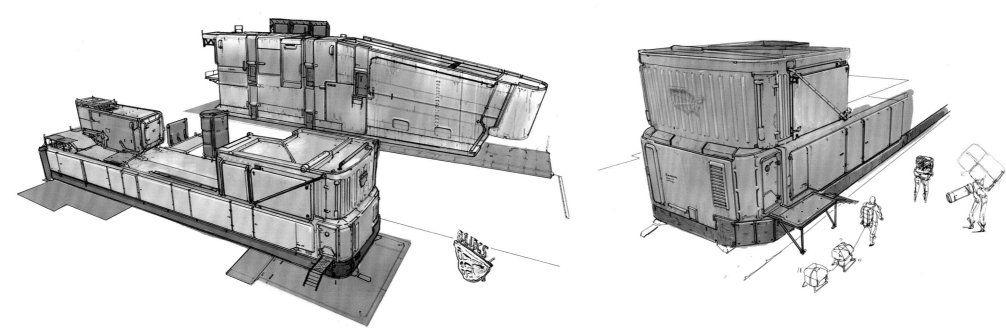

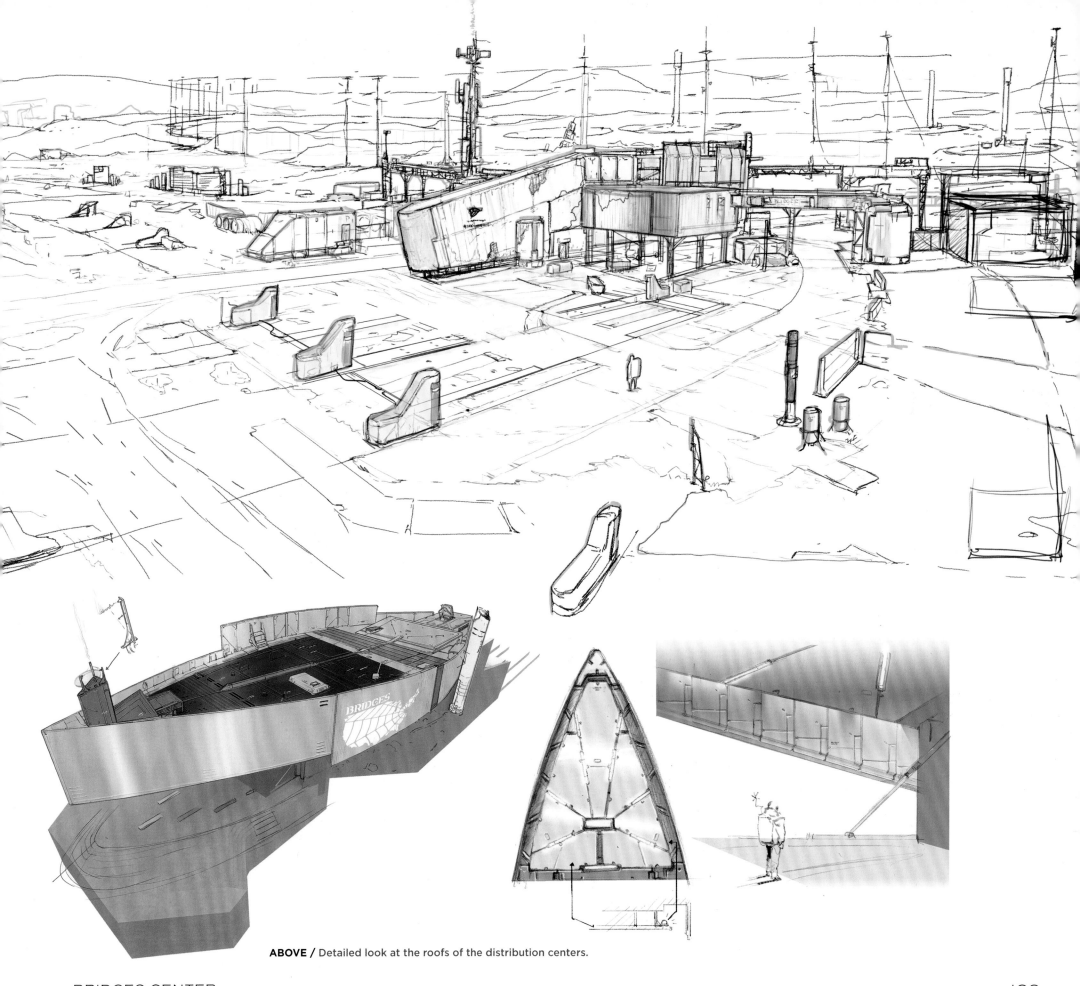

ABOVE / Detailed look at the roofs of the distribution centers.

BRIDGES CENTER

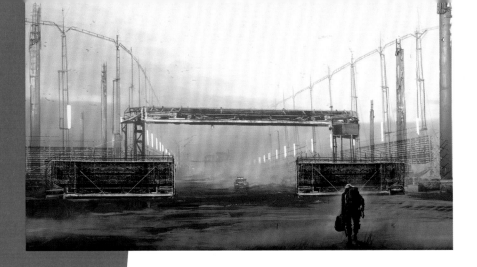

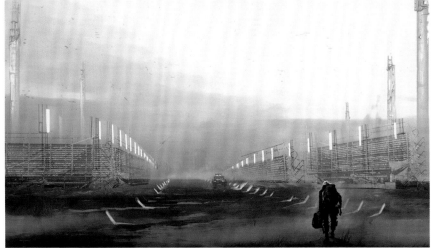

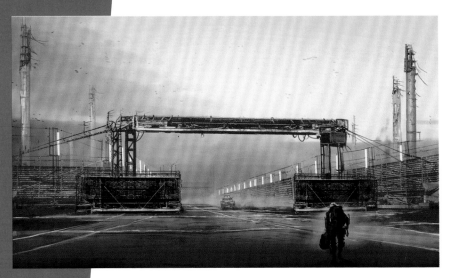

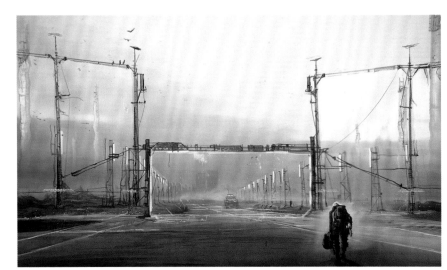

ABOVE / Concept iterations for transparent walls and how to depict them. This was the result of a request for walls that allowed visibility without using fences.

BELOW / Details and function specifications of sensor poles.

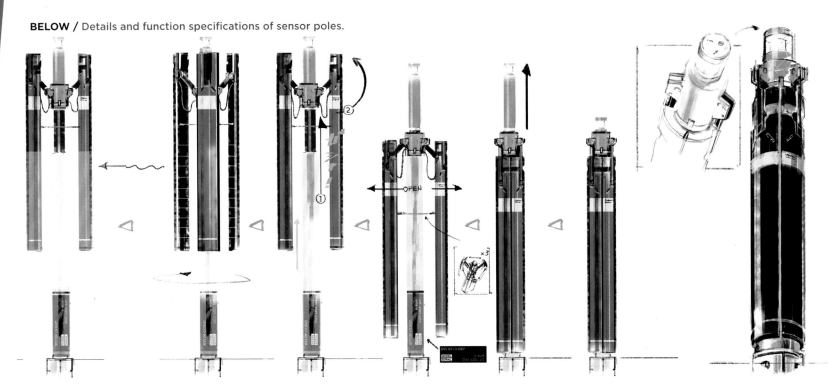

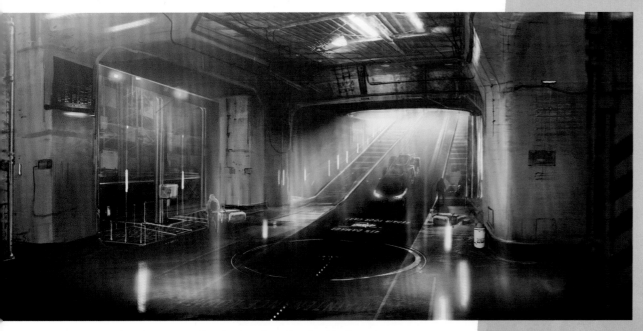

ABOVE / Early concept for the interior of a distribution center.

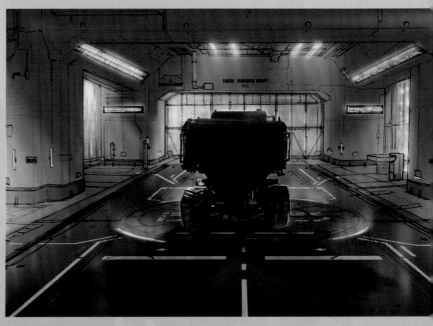

ABOVE / Final concept for the interior of a distribution center.

RIGHT / Detail of
elevator plate.

BRIDGES CENTER

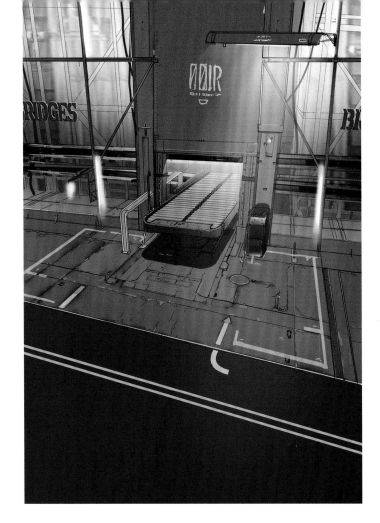

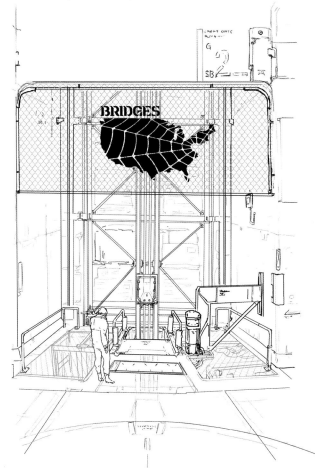

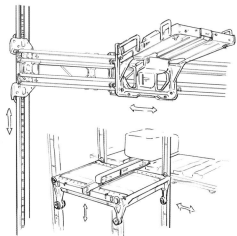

ABOVE / Concept for cargo belt conveyor system.

LEFT & BELOW / Concepts for cargo section of distribution centers.

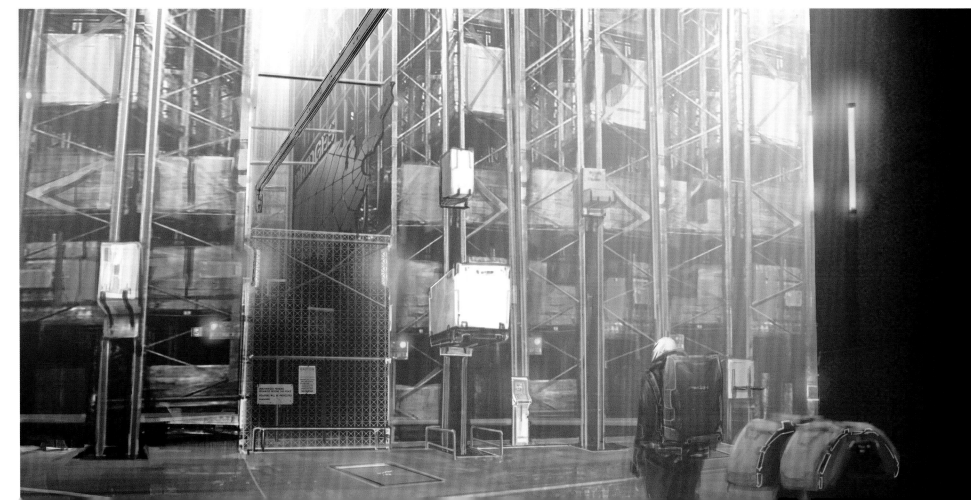

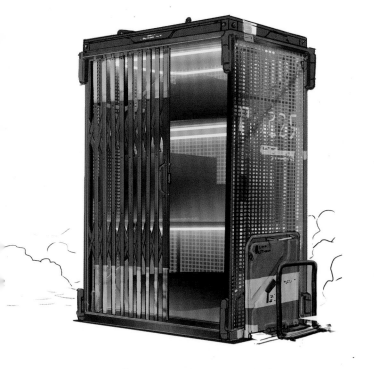
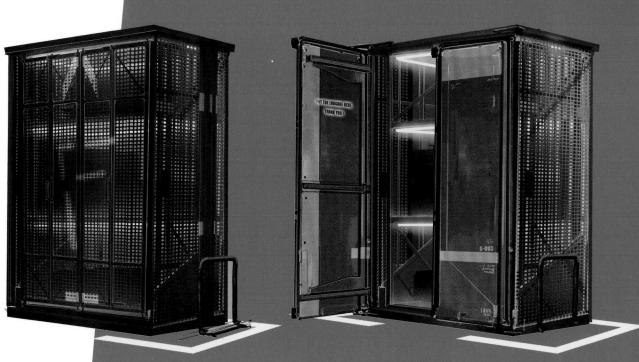

ABOVE / Unused concepts for cargo shelves for distribution centers.

BELOW / Concept for lights and how information is displayed inside distribution centers.

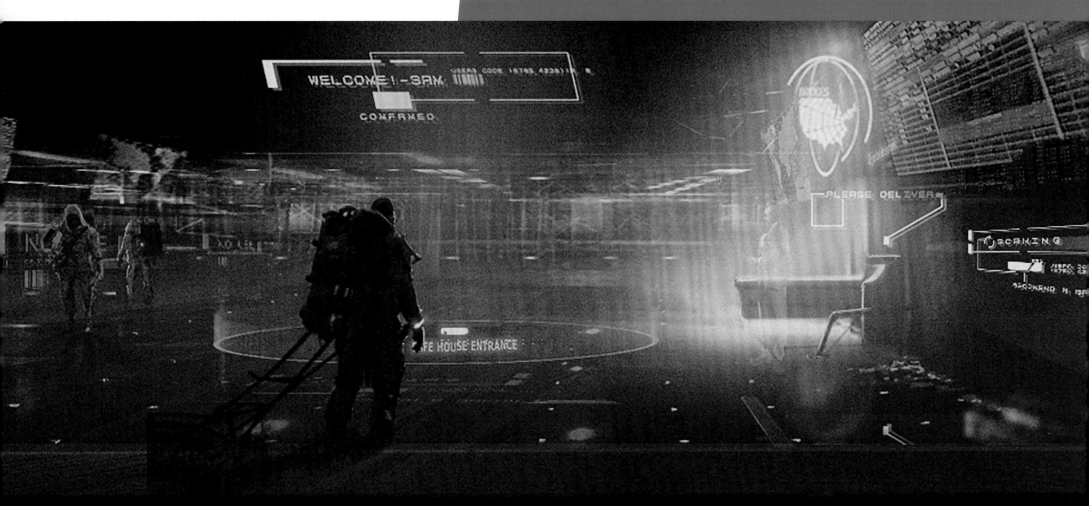

STILLMOTHERS MEDICAL FACILITY

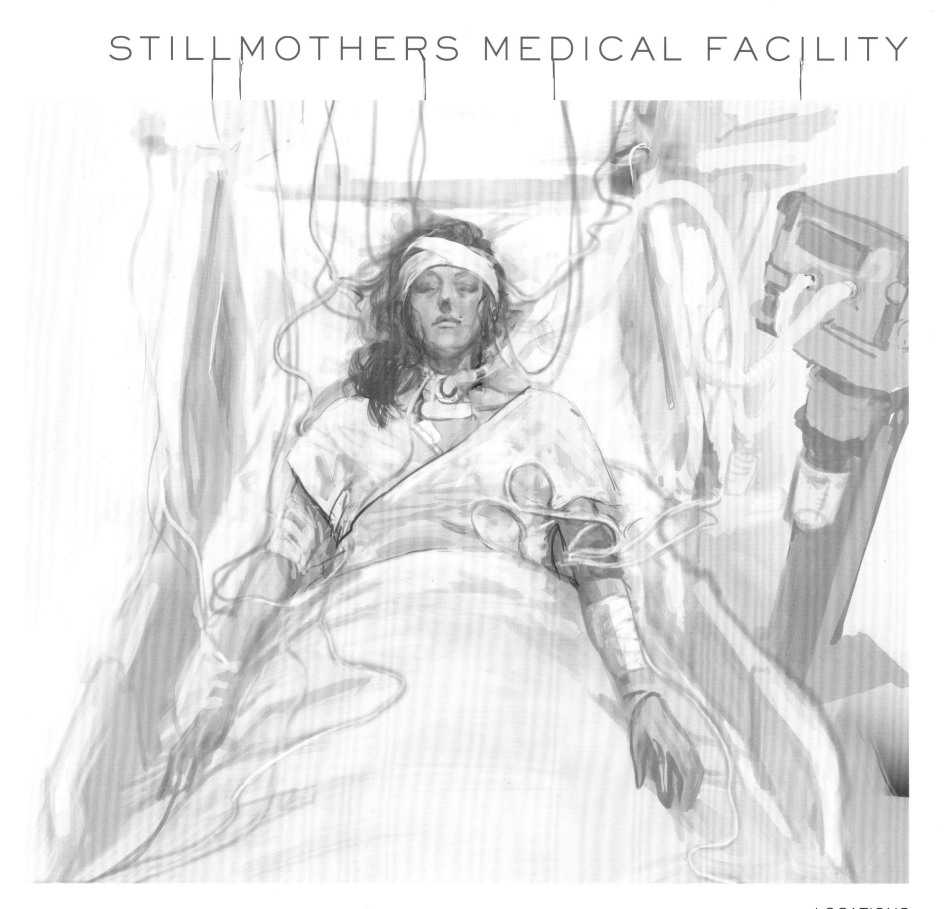

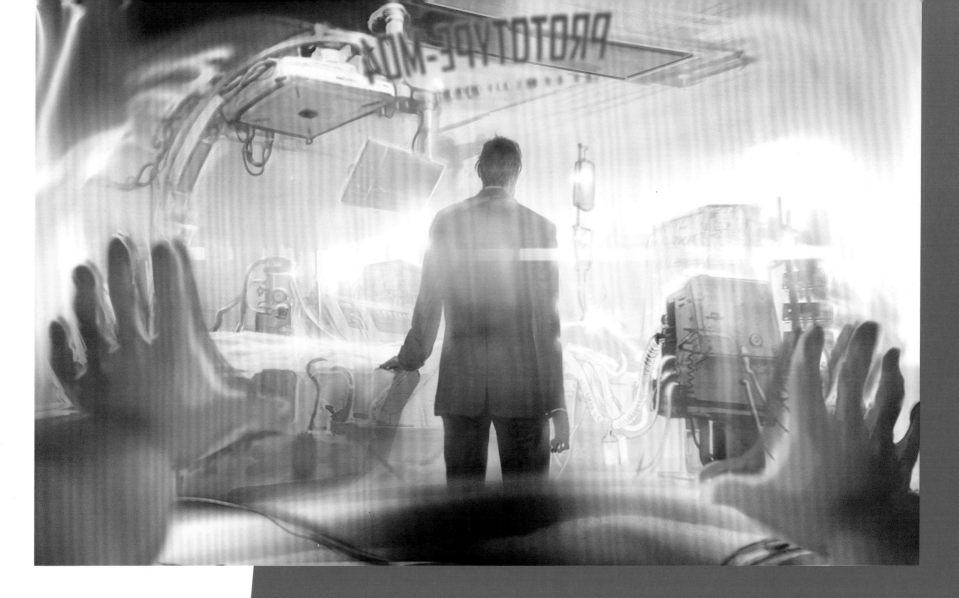

THIS SPREAD / Early concepts for Cliff and his wife.

THIS PAGE / Concepts for the angle used for flashbacks.

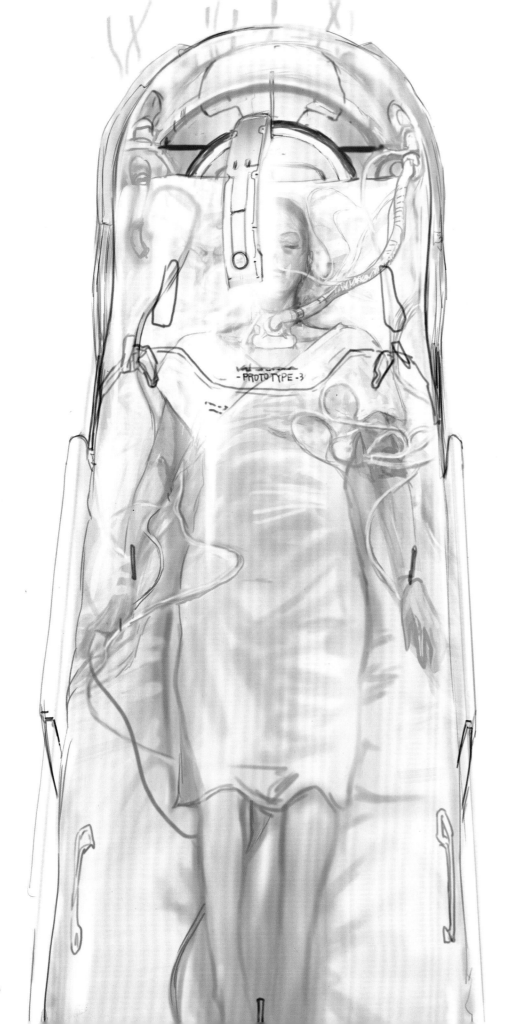

LEFT & OPPOSITE / Near-final concepts.

ABOVE / Concepts for game cutscene.

BELOW / Unused concept for stillmothers.

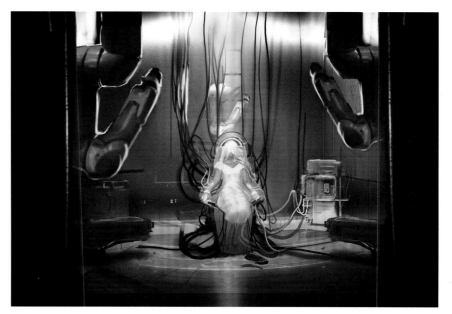

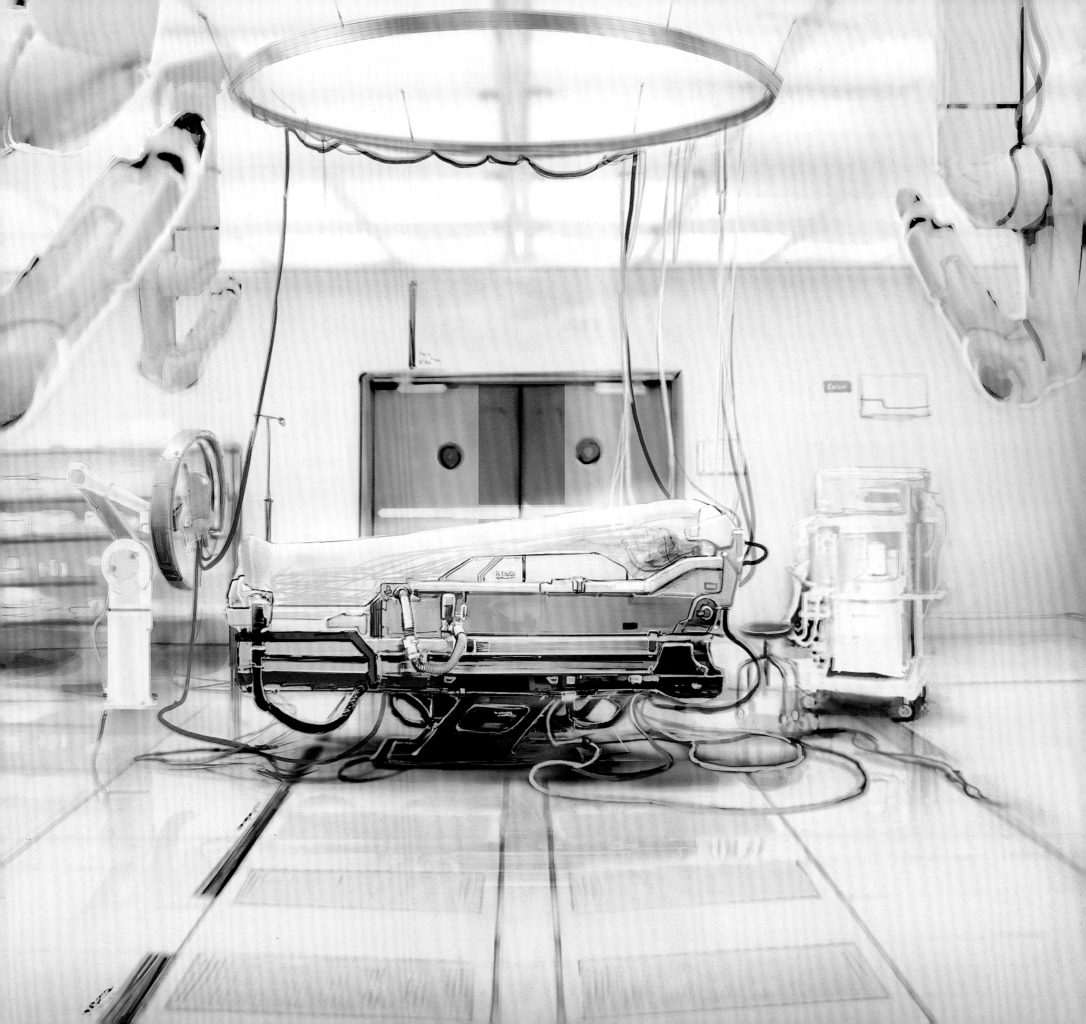

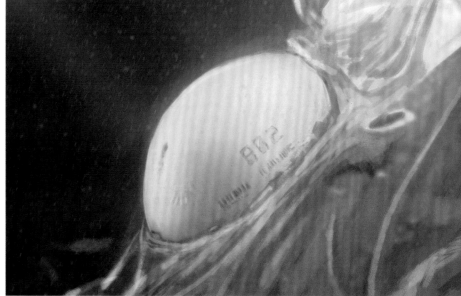

THIS PAGE / Early concepts for stillmothers.

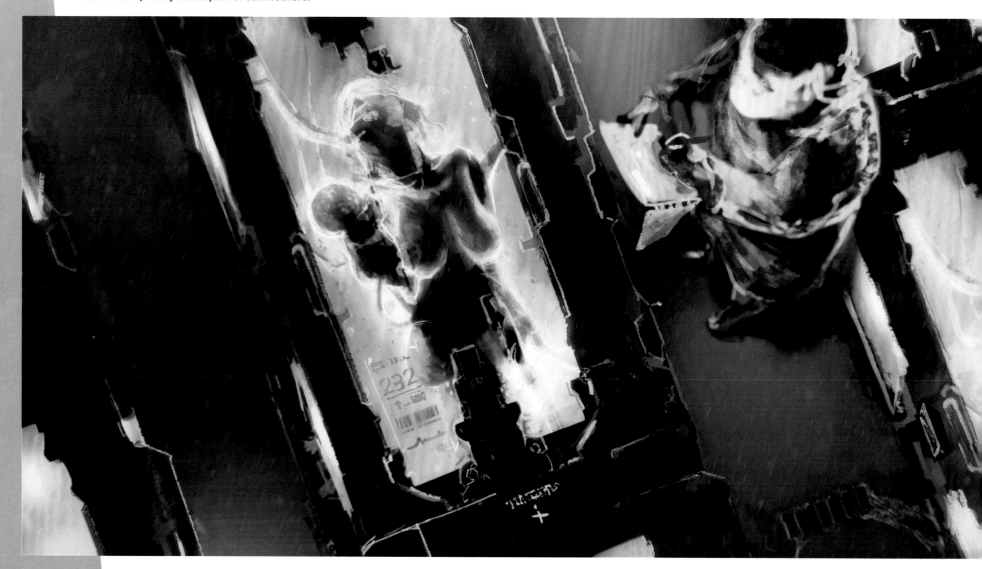

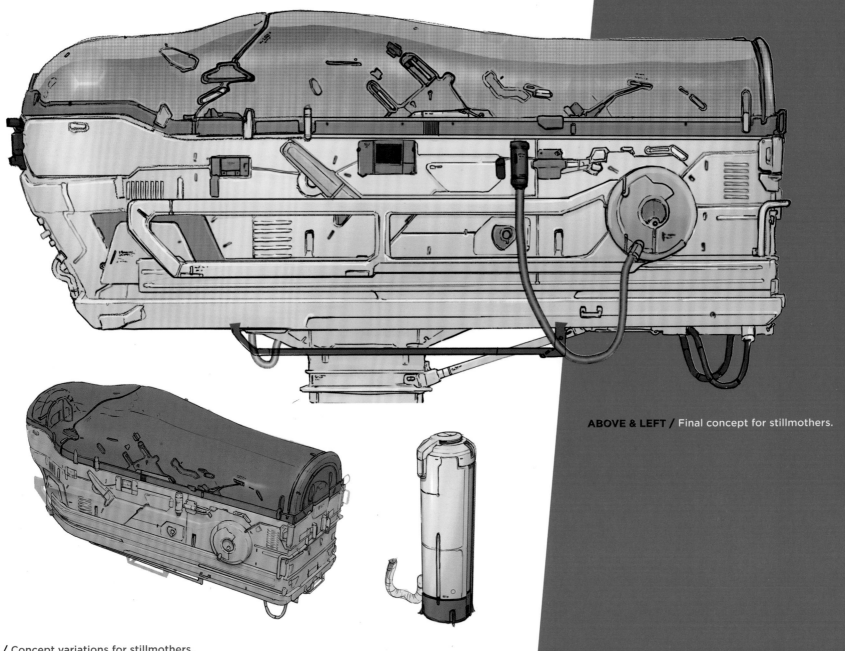

ABOVE & LEFT / Final concept for stillmothers.

BELOW / Concept variations for stillmothers.

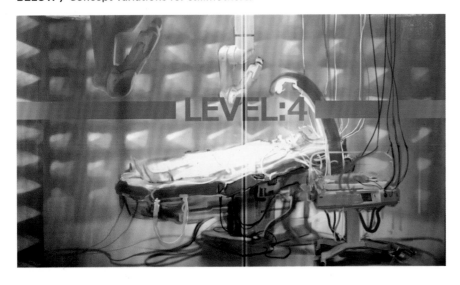

LEVEL:4

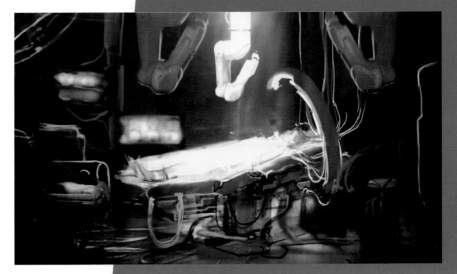

STILLMOTHERS MEDICAL FACILITY

ISOLATION WARD

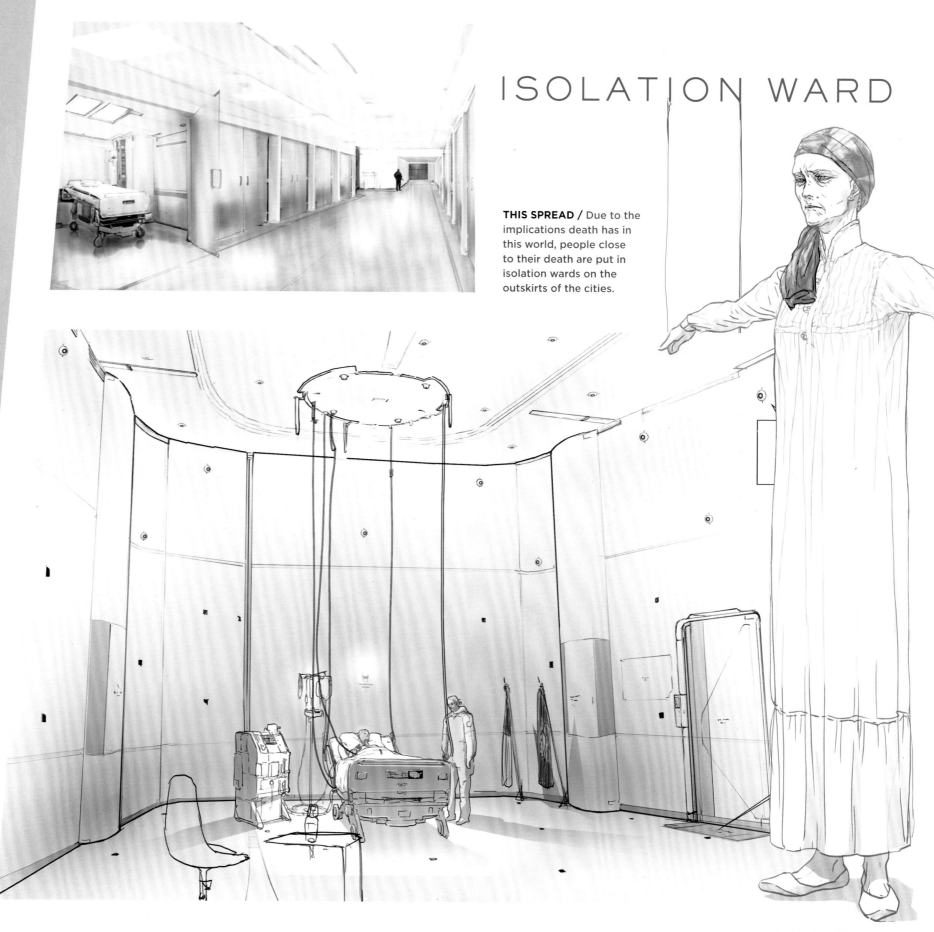

THIS SPREAD / Due to the implications death has in this world, people close to their death are put in isolation wards on the outskirts of the cities.

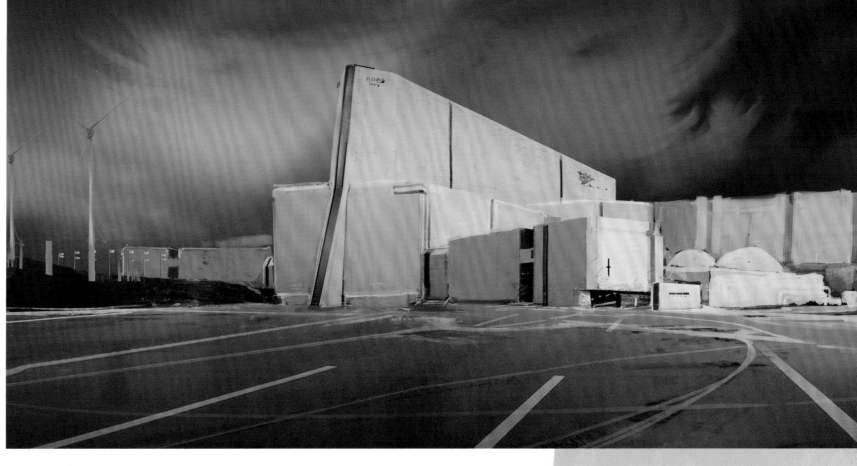

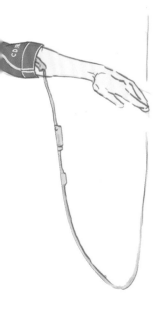

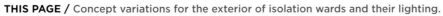

THIS PAGE / Concept variations for the exterior of isolation wards and their lighting.

ISOLATION WARD

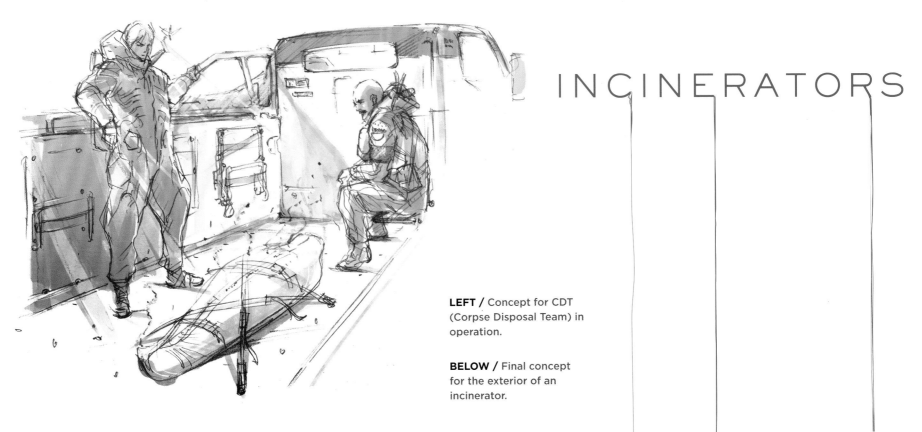

INCINERATORS

LEFT / Concept for CDT (Corpse Disposal Team) in operation.

BELOW / Final concept for the exterior of an incinerator.

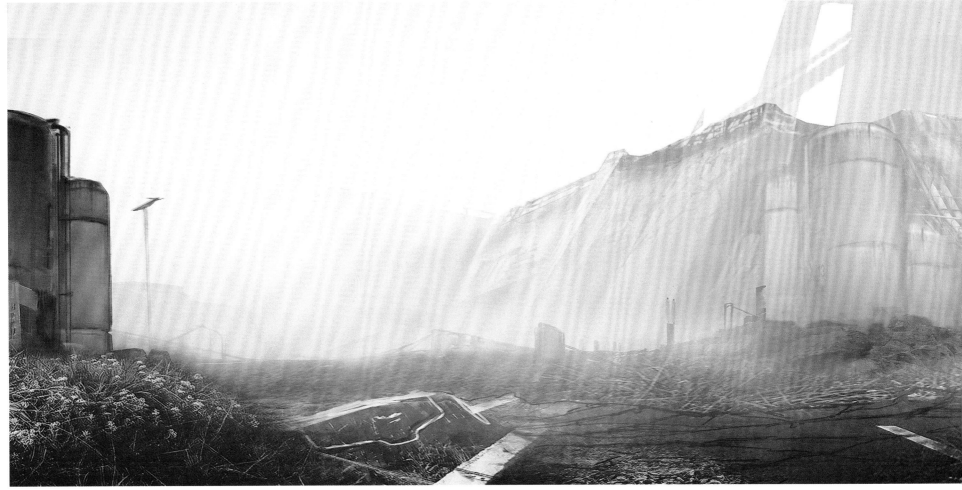

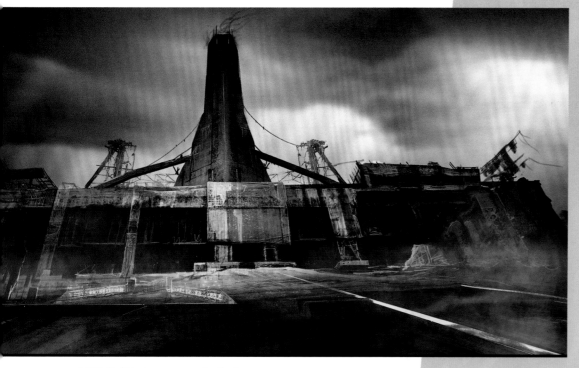

ABOVE / Early concept for incinerators.

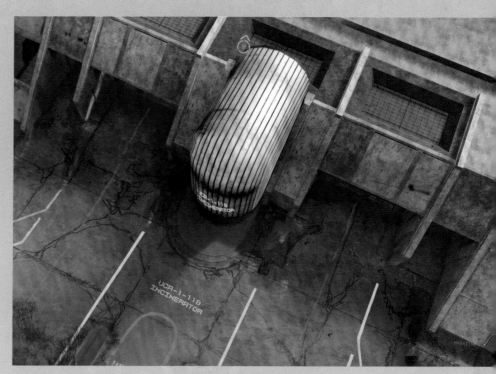

ABOVE / Detailed look at concrete floors in incinerators.

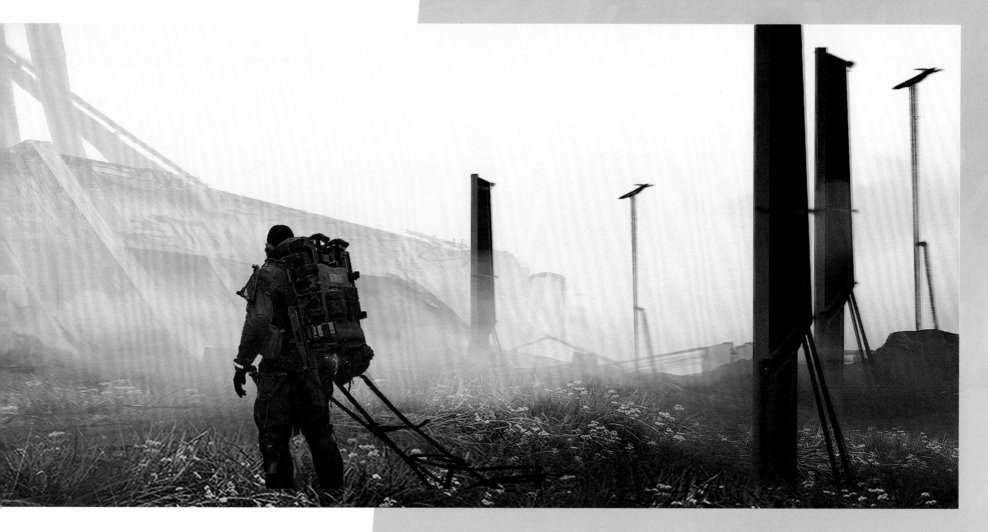

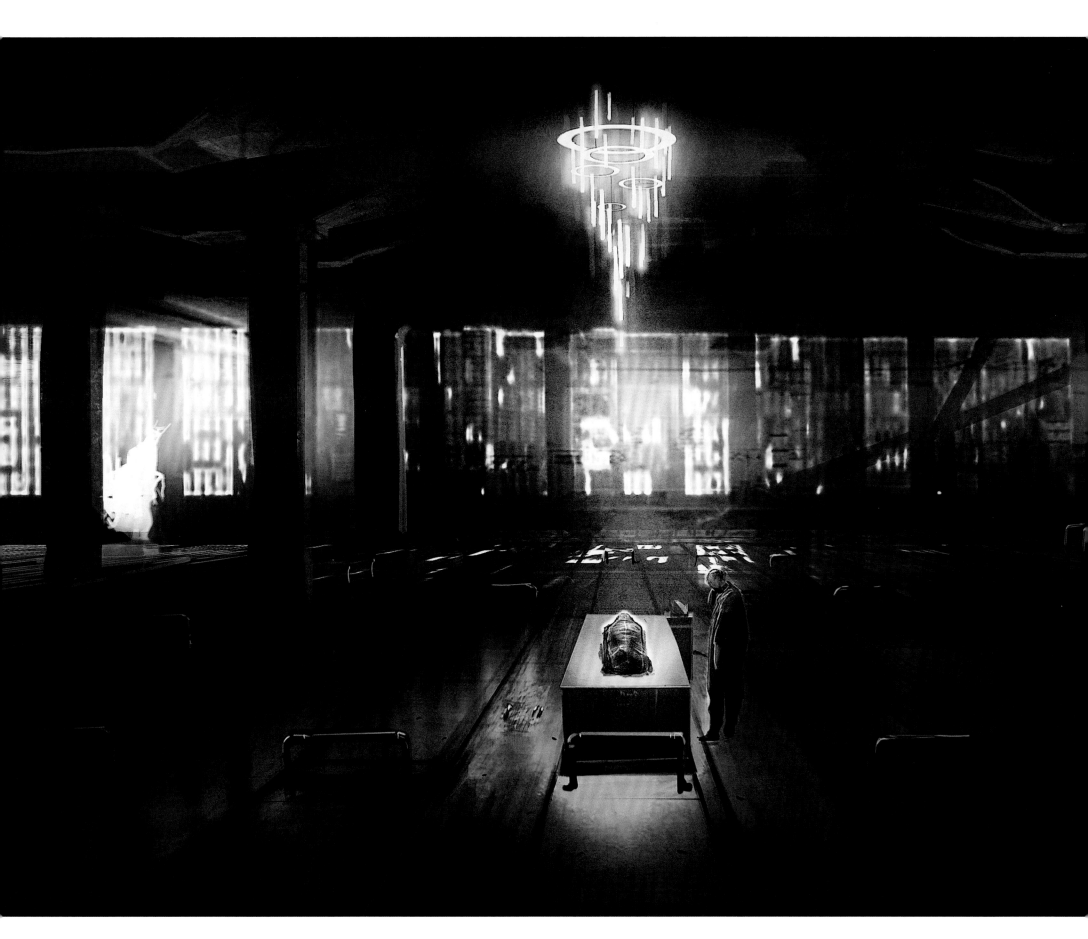

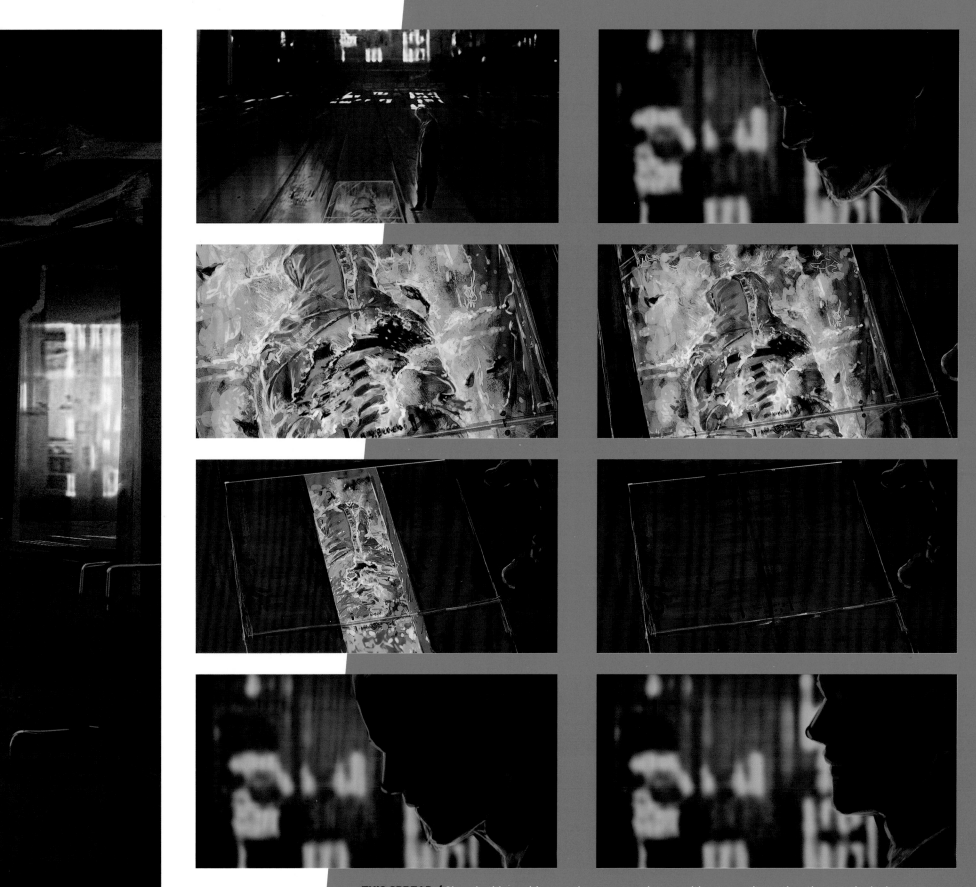

THIS SPREAD / Since in this world cremations are mandatory, without any alternative, the way the incinerator works still resembles burials, and the place itself has a solemn atmosphere.

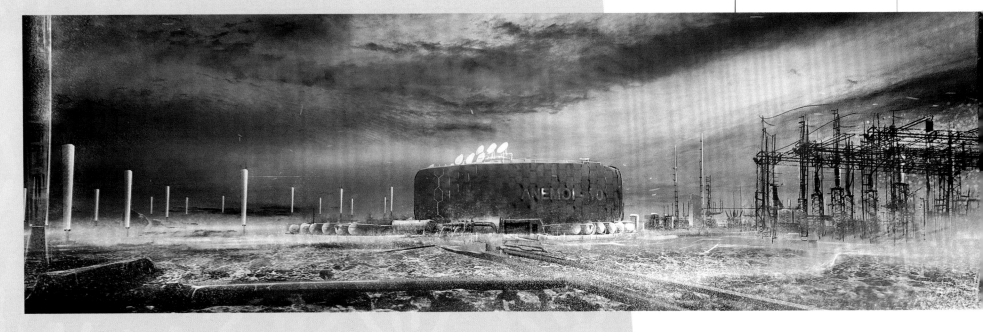

ABOVE / Early concept for wind farms.

OPPOSITE / Final concept for wind farms.

BELOW / Unused concepts for wind farms. The idea was to use wind farms as variable resources.

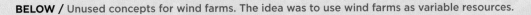

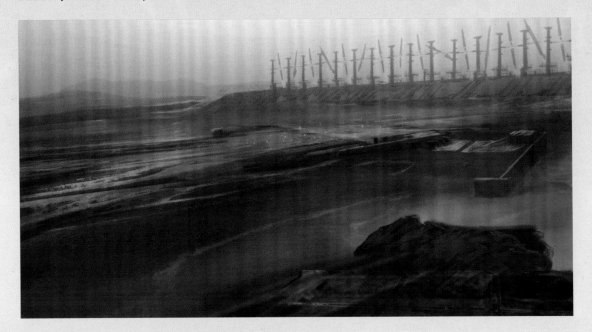

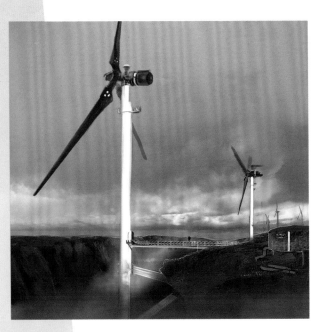

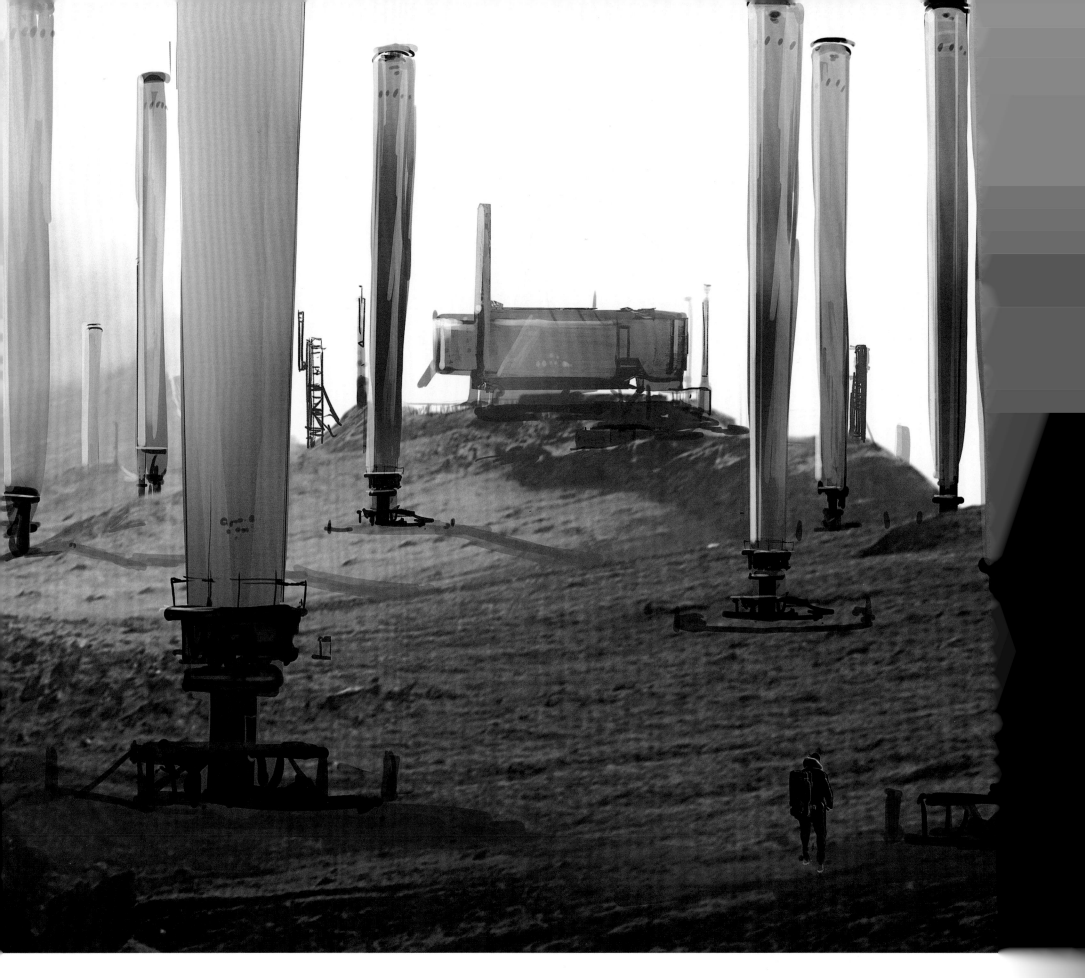

WIND FARM

MAMA'S LAB

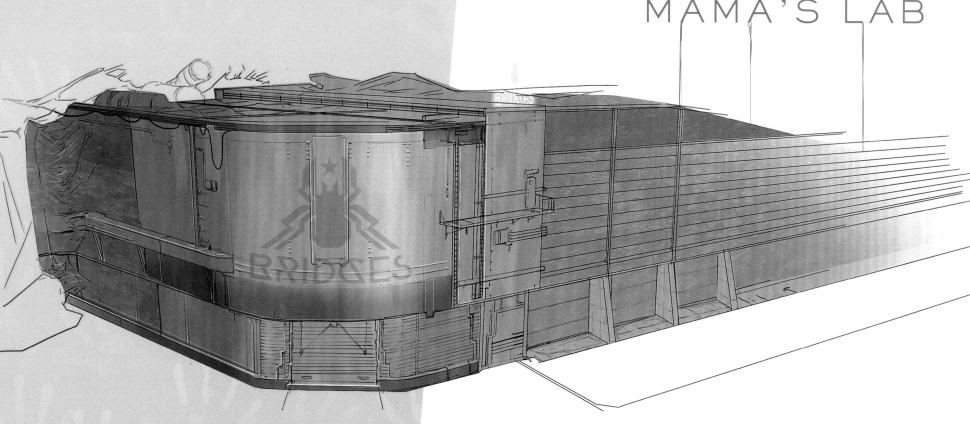

ABOVE / Early concept for Mama's lab, which features an early Bridges logo.

BELOW / Concepts for the interior of Mama's lab and the mobile for her baby.

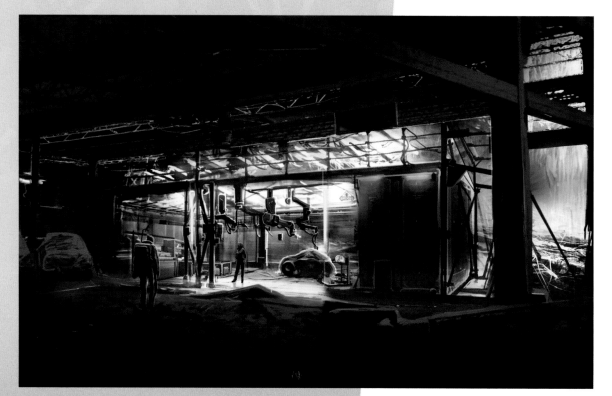

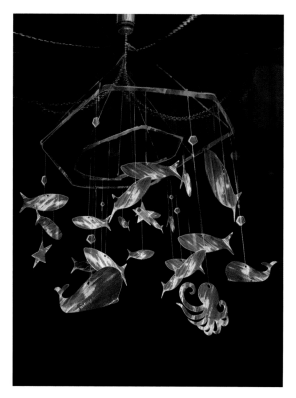

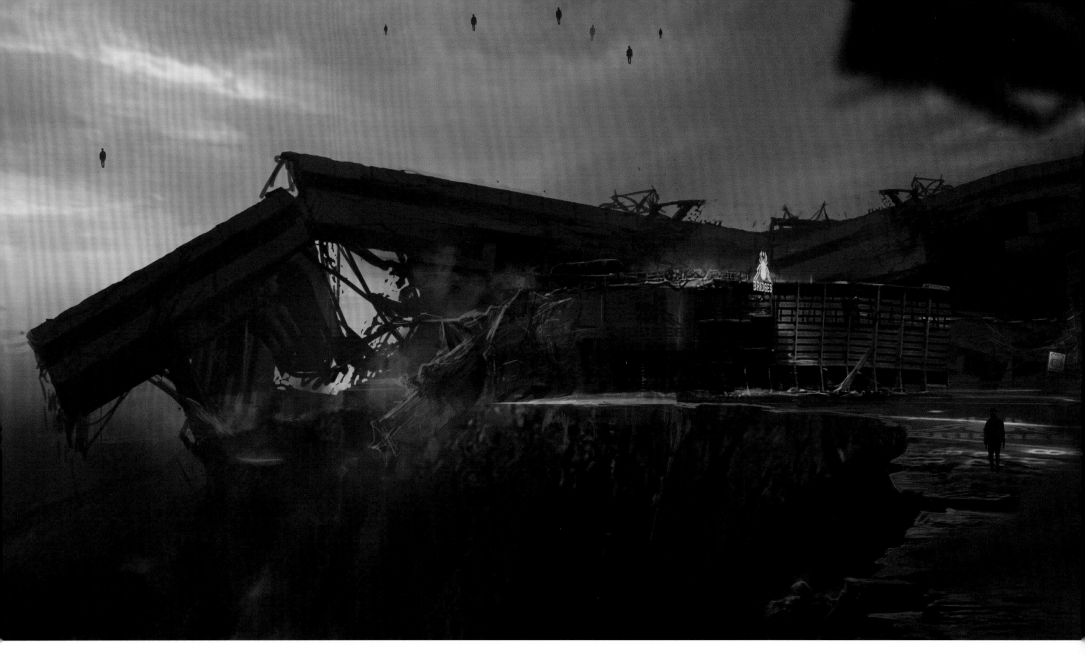

THIS PAGE / One of the concepts for Mama's lab had a crater created by a voidout next to the lab. Part of her lab was to have been destroyed by the voidout.

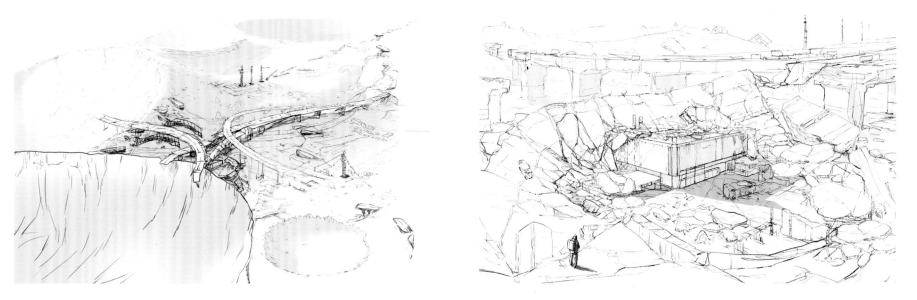

MAMA'S LAB

HEARTMAN'S LAB

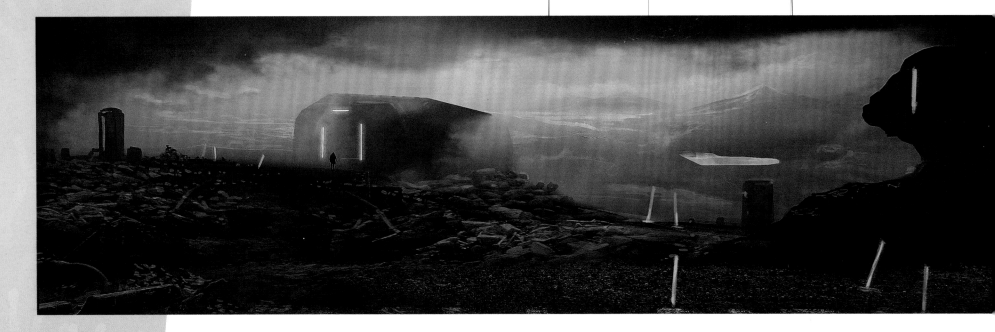

ABOVE / Early concept for the entrance to Heartman's lab.

LEFT / Early concept for the heart-shaped lake.

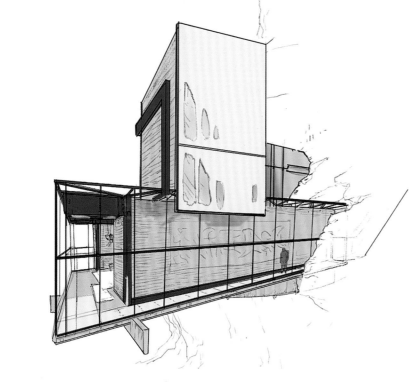

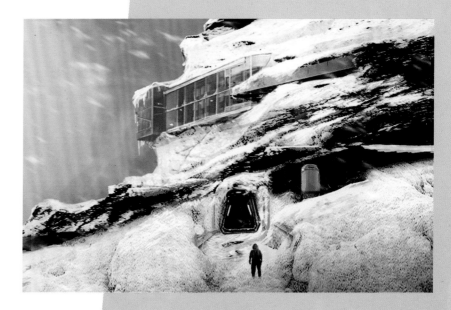

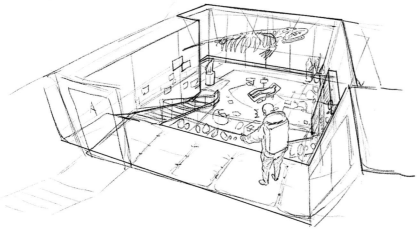

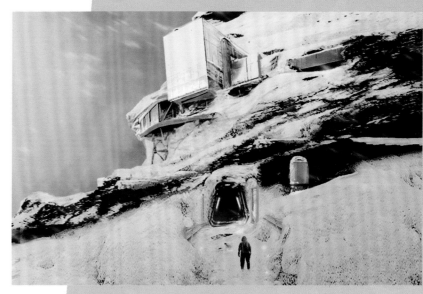

THIS PAGE / Concept variations for Heartman's lab.

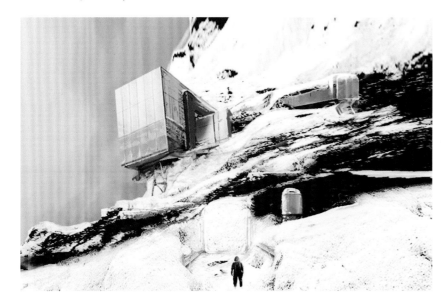

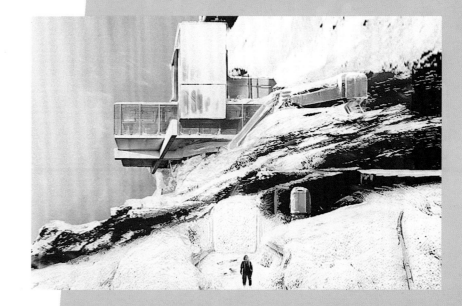

HEARTMAN'S LAB

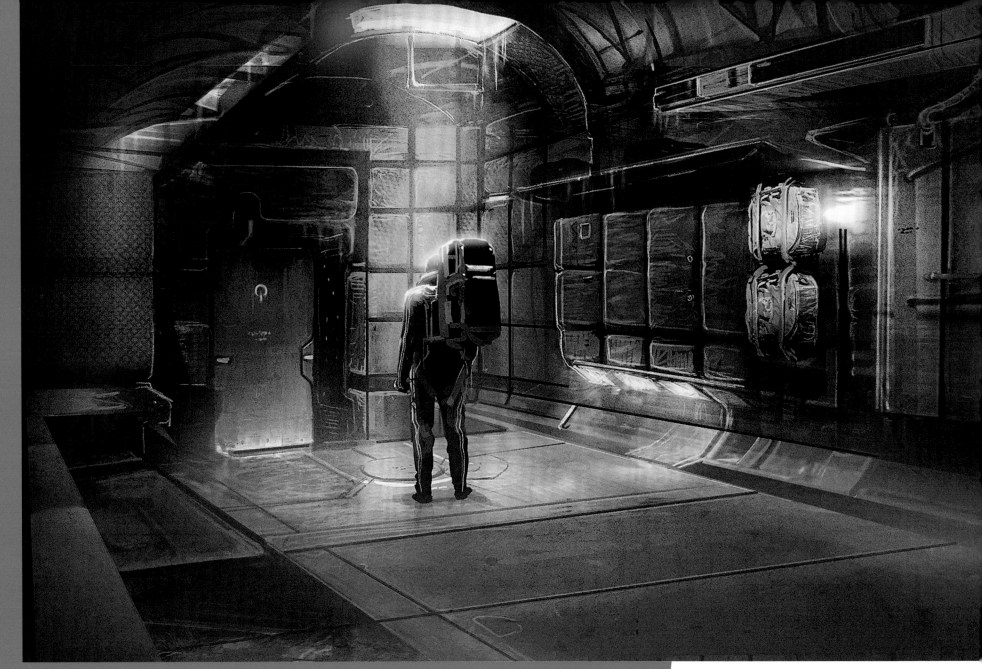

BELOW / Early concept for the interior of Heartman's lab.

BELOW / Final concept for the interior of Heartman's lab.

ABOVE / Early concept for the entrance to Heartman's lab.

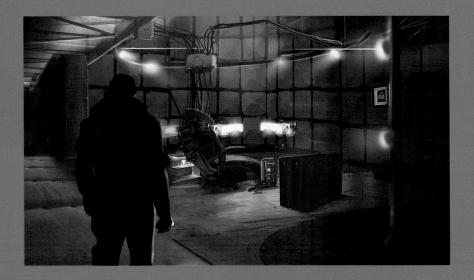

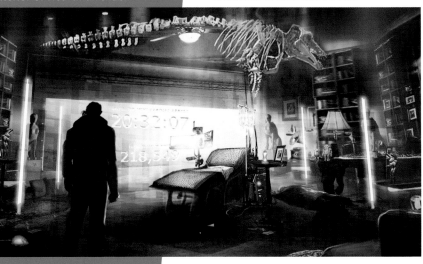

BELOW / Early concept for the heart-shaped lake. Since the lake was created by a voidout, there were some ruins around it.

ABOVE / Concept variations for the corridor in Heartman's lab.

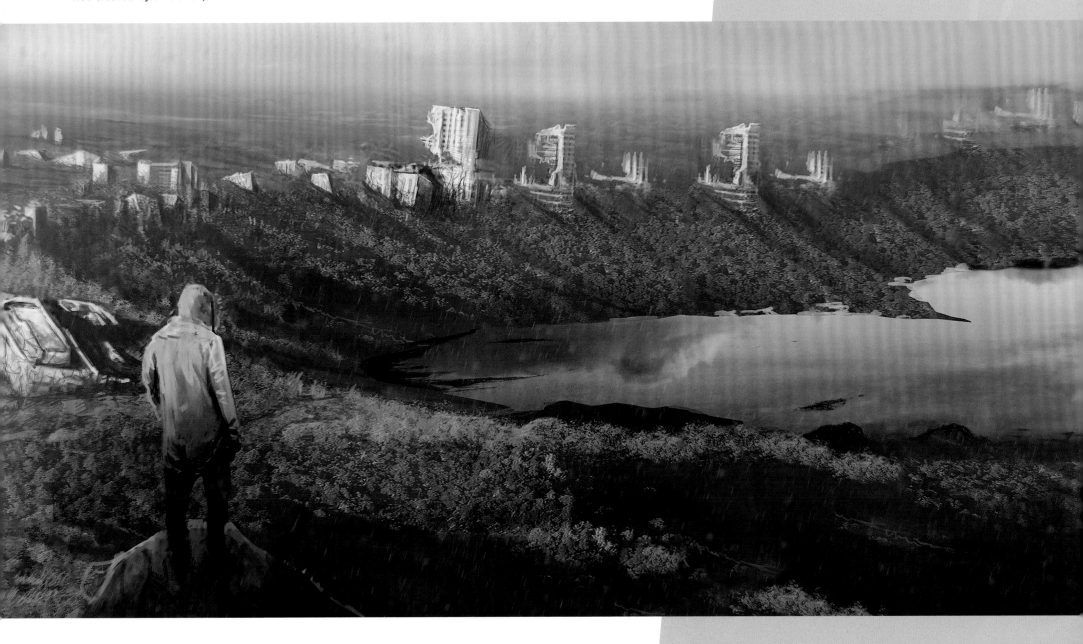

HEARTMAN'S LAB

MULE CAMPS

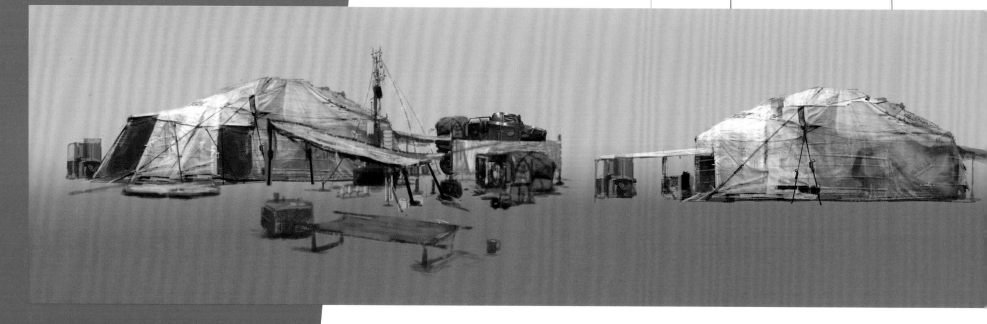

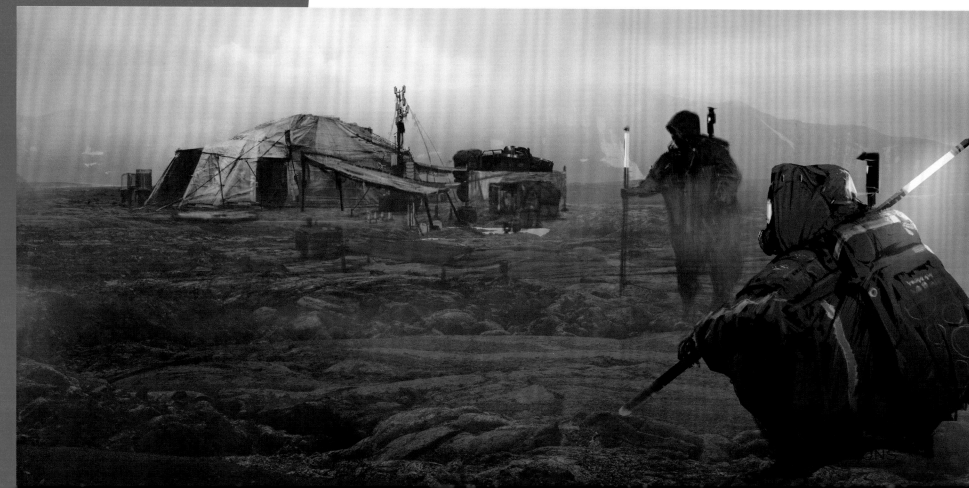

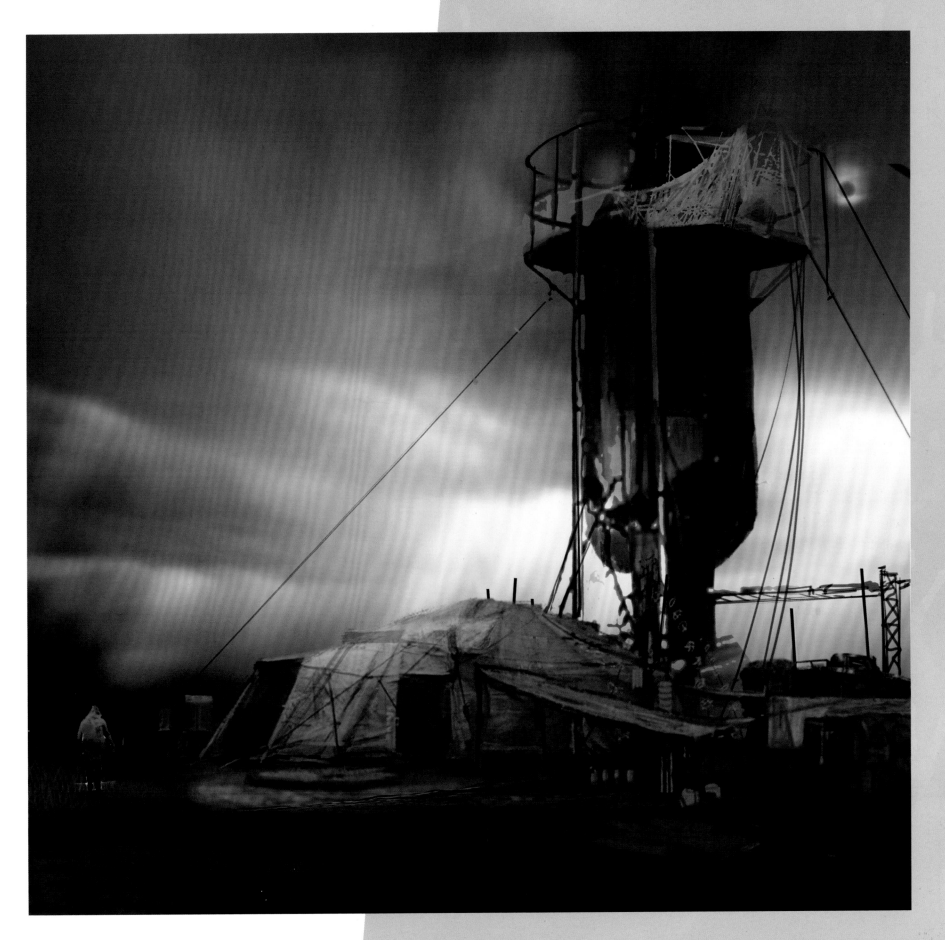

MULE CAMPS

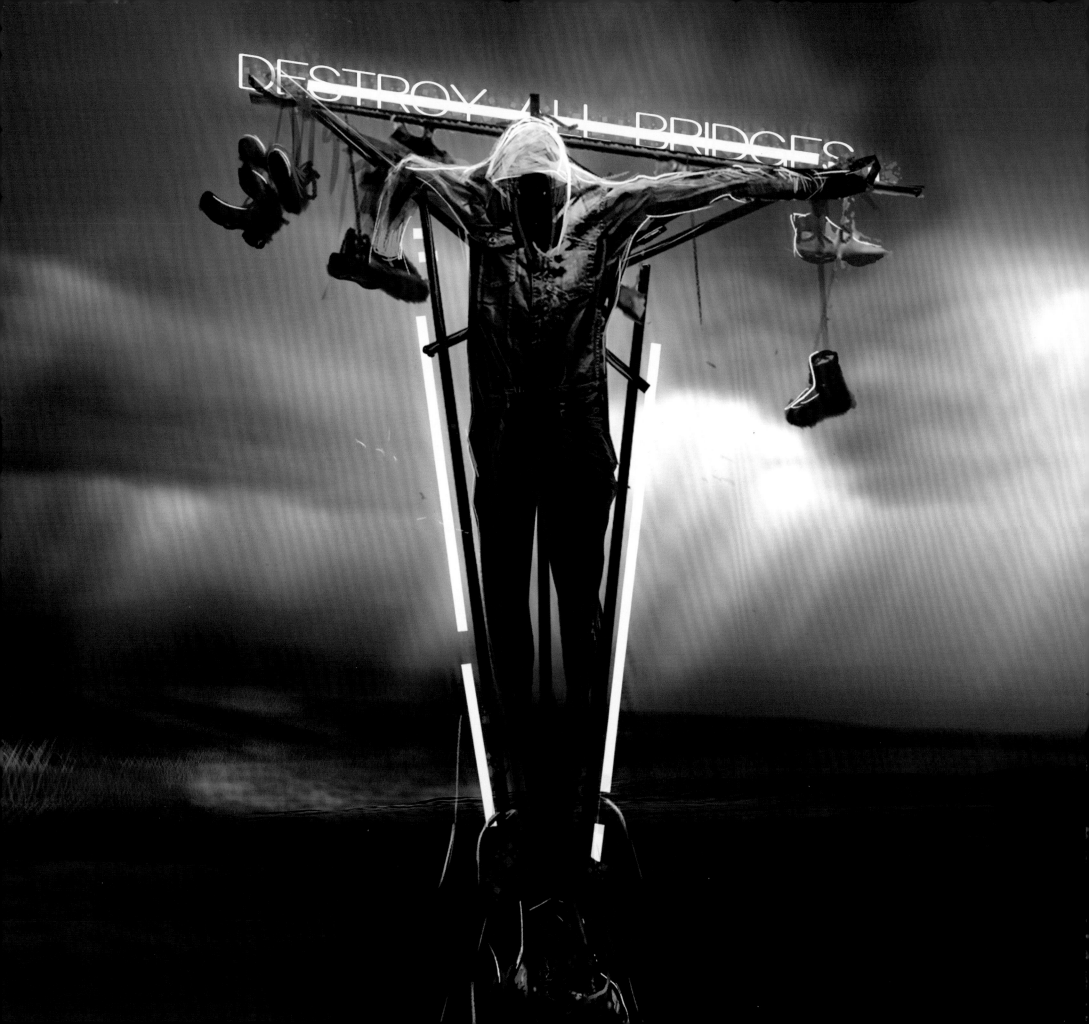

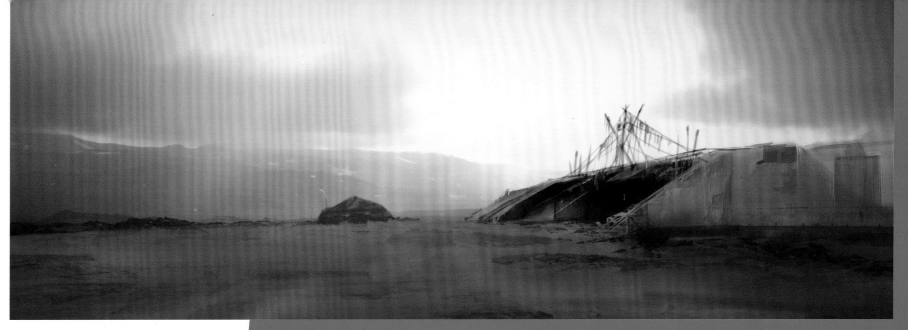

THIS PAGE / Concept variations for MULE camps.

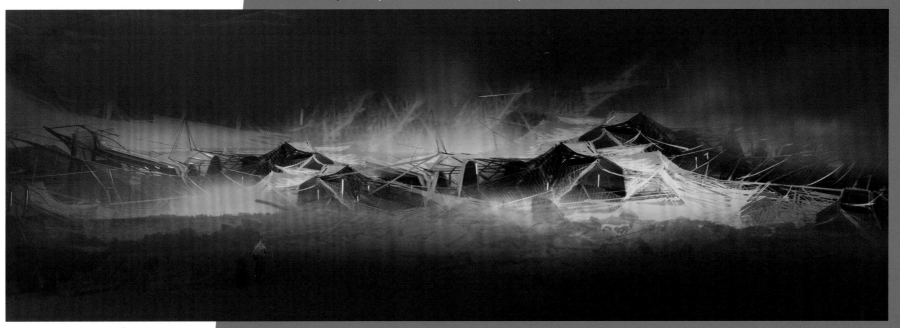

OPPOSITE / Concept to characterize the hanging shoes and Bridges clothes the MULEs take.

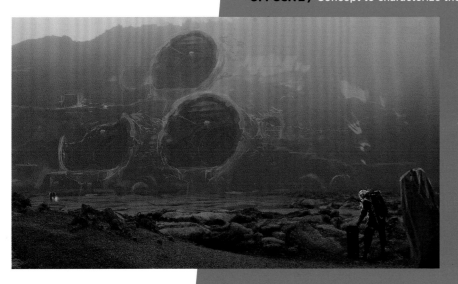

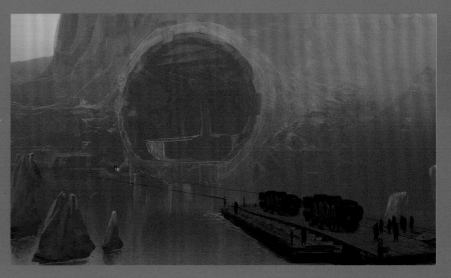

MULE CAMPS

PREPPER SETTLEMENTS

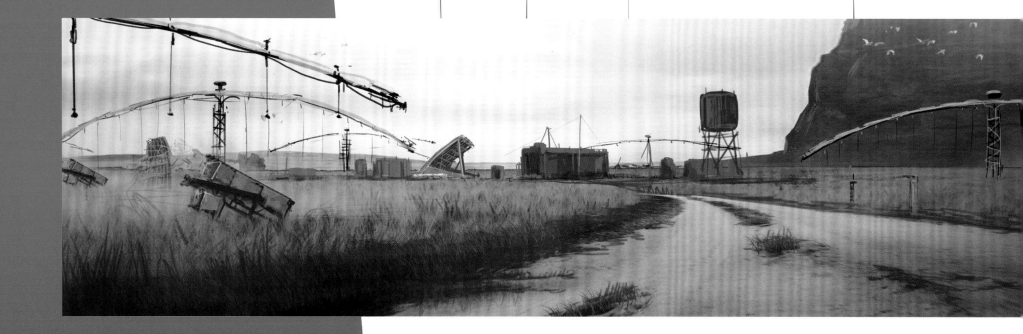

BELOW / Final concept for Prepper farms.

ABOVE & BELOW / Early concepts for Prepper farms.

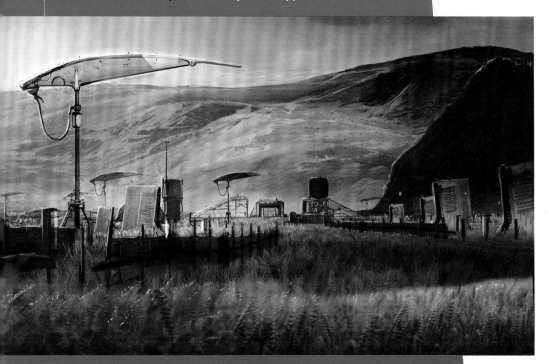

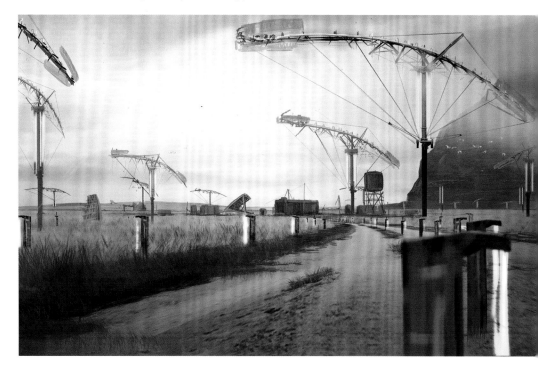

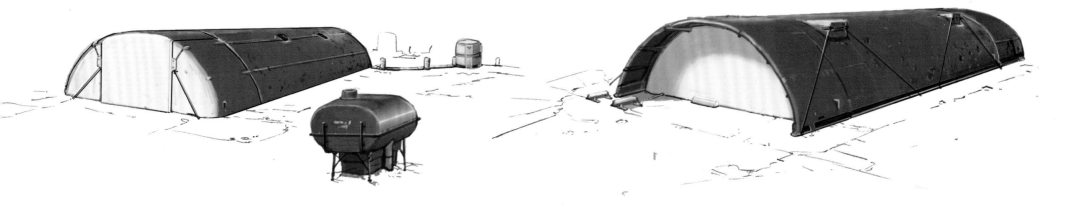

THIS PAGE / Concept variations for Prepper facilities.

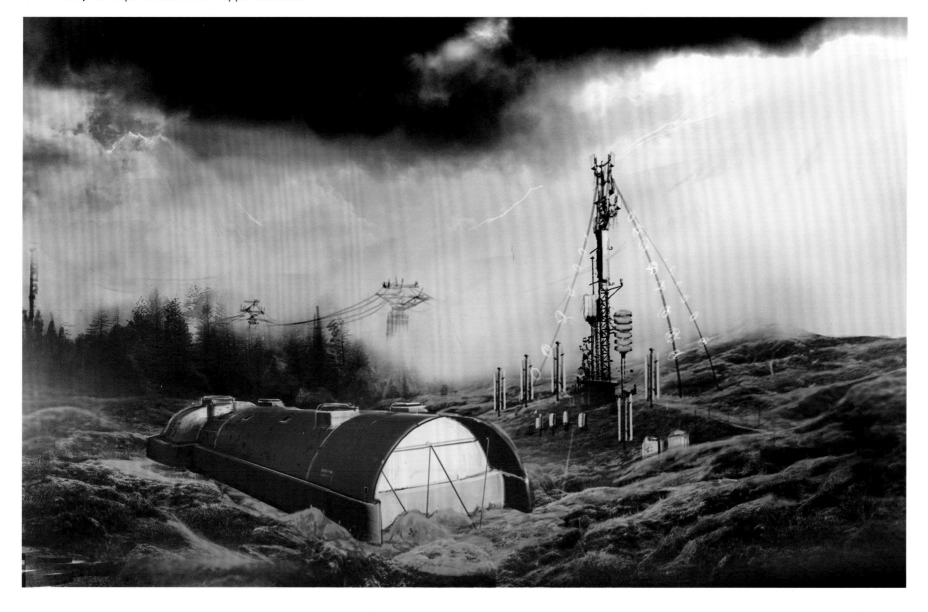

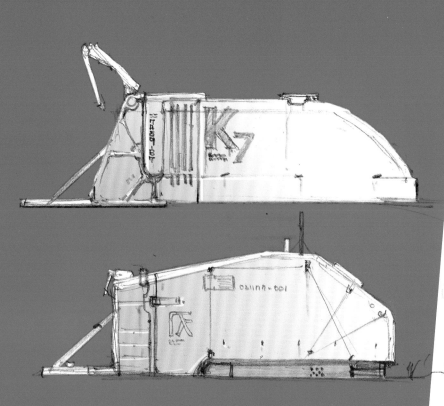

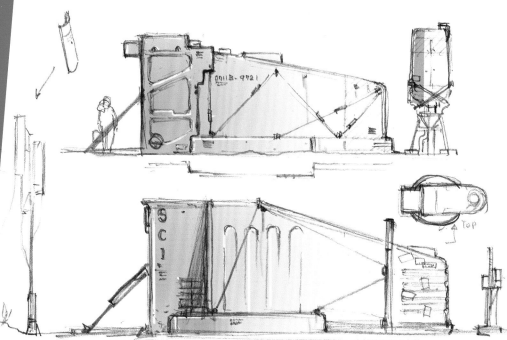

ABOVE / Ground level entrances of Prepper shelters.

BELOW / Early concept for Prepper shelters.

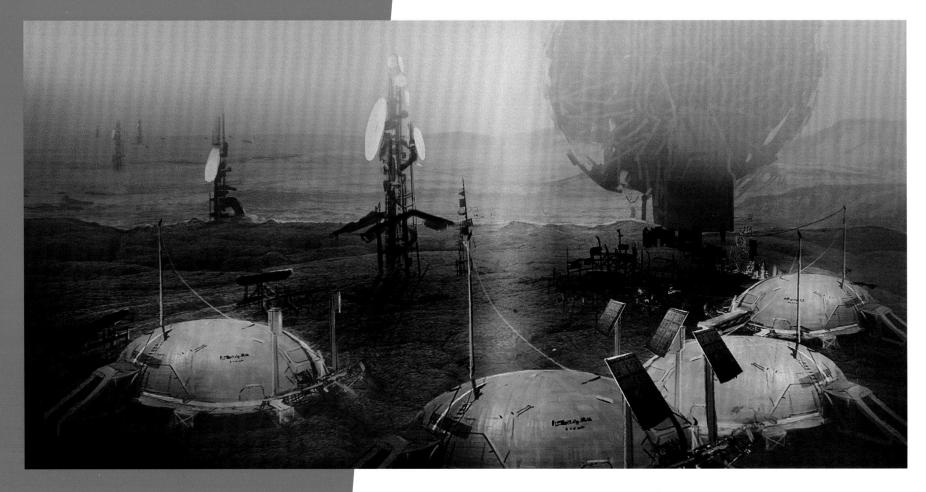

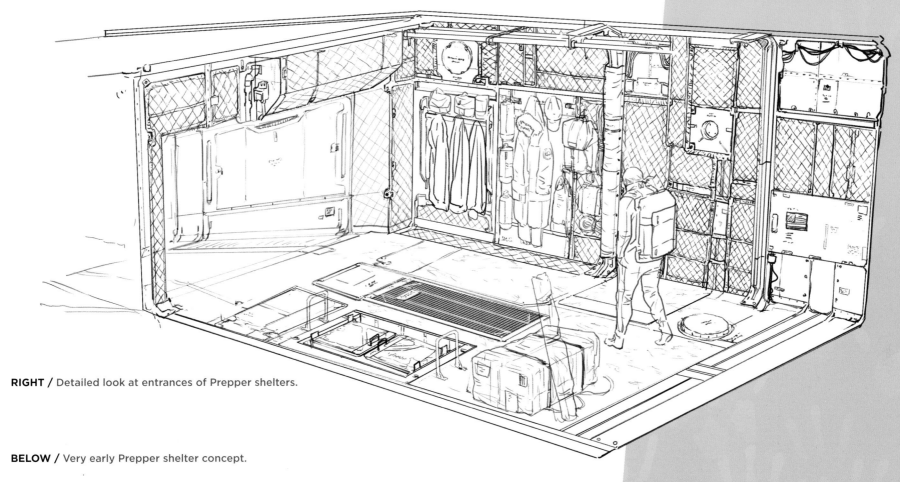

RIGHT / Detailed look at entrances of Prepper shelters.

BELOW / Very early Prepper shelter concept.

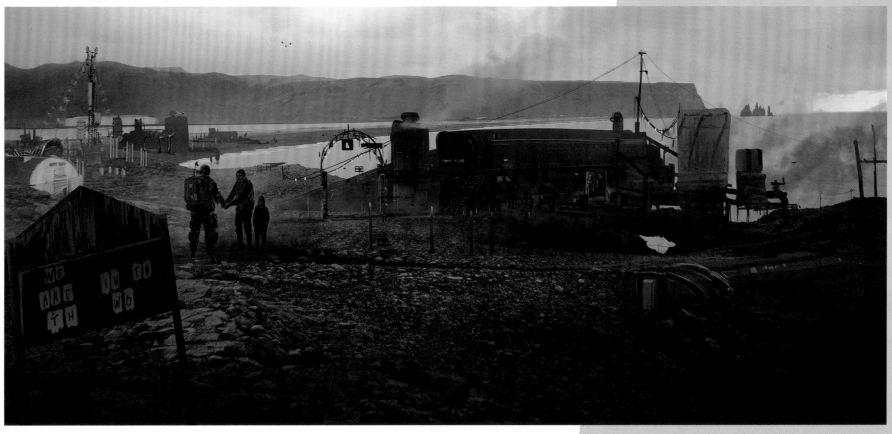

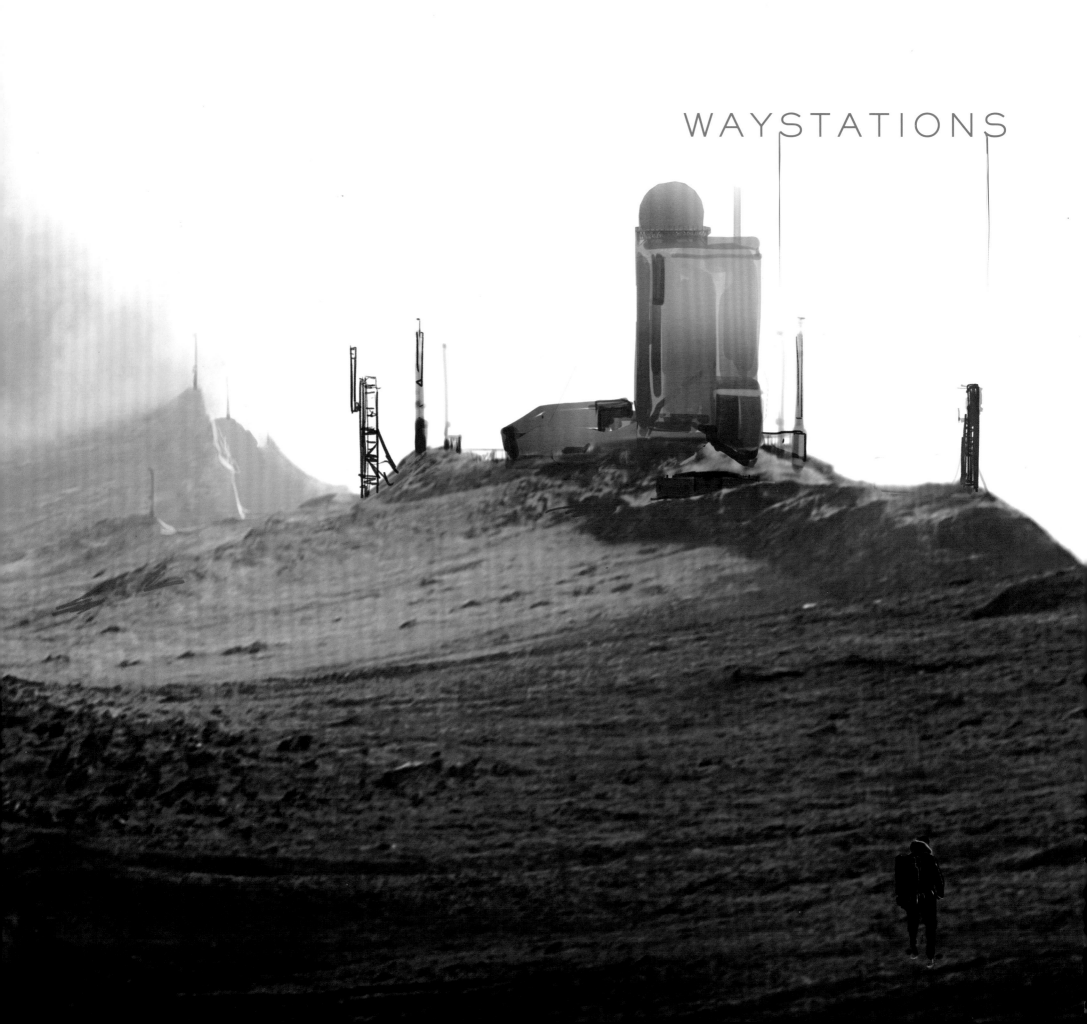

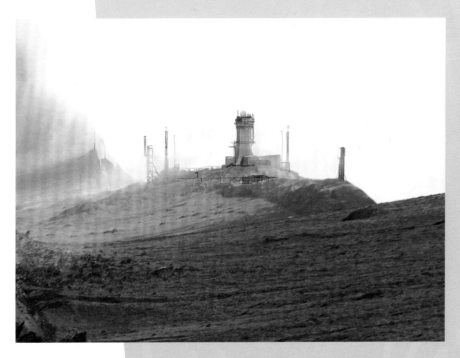

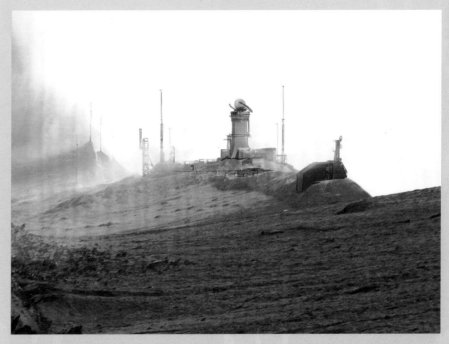

OPPOSITE / Near-final concept for waystations.

BELOW / Early concept for waystations.

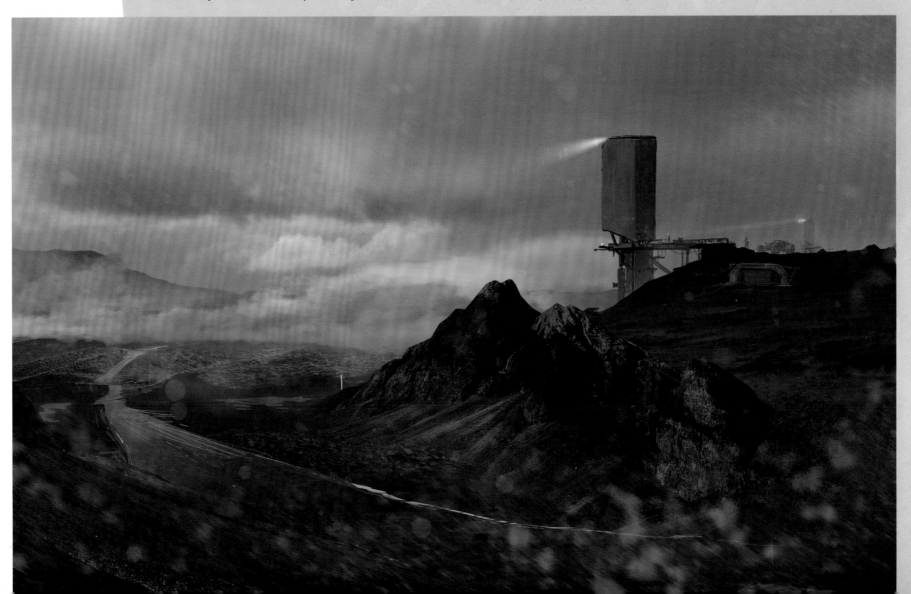

PRIVATE ROOM

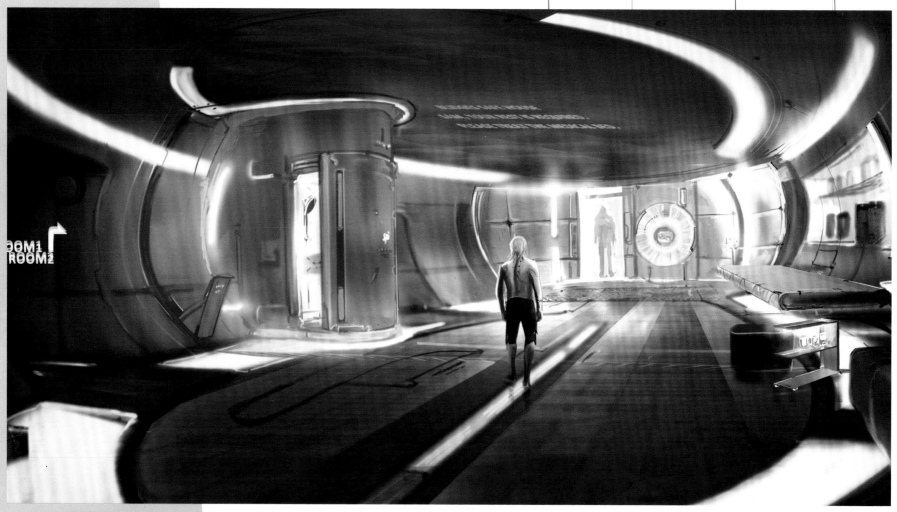

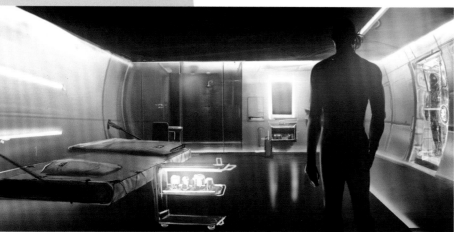

ABOVE / Near-final concept for the private room.

LEFT / Early concept for the private room.

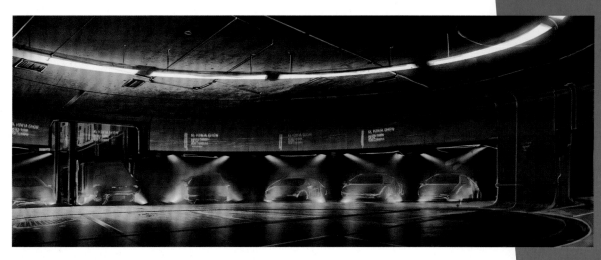

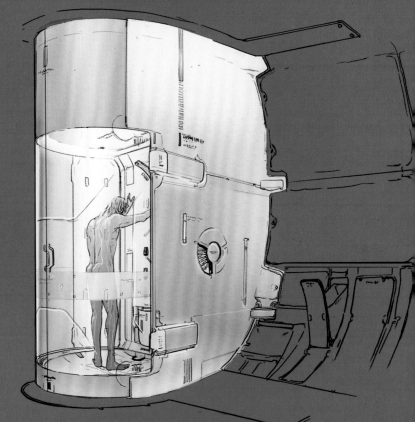

ABOVE & BELOW / Early concepts for the private room.

ABOVE / Details of the shower in the private room.

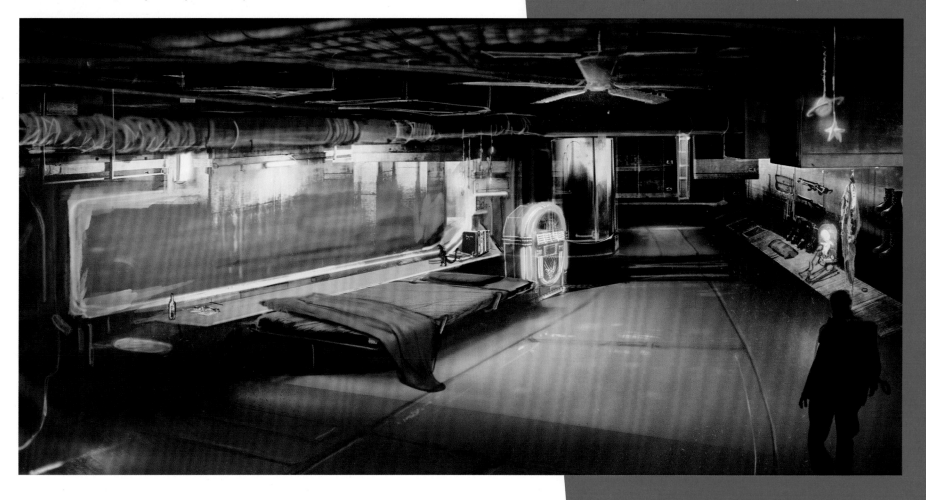

PRIVATE ROOM

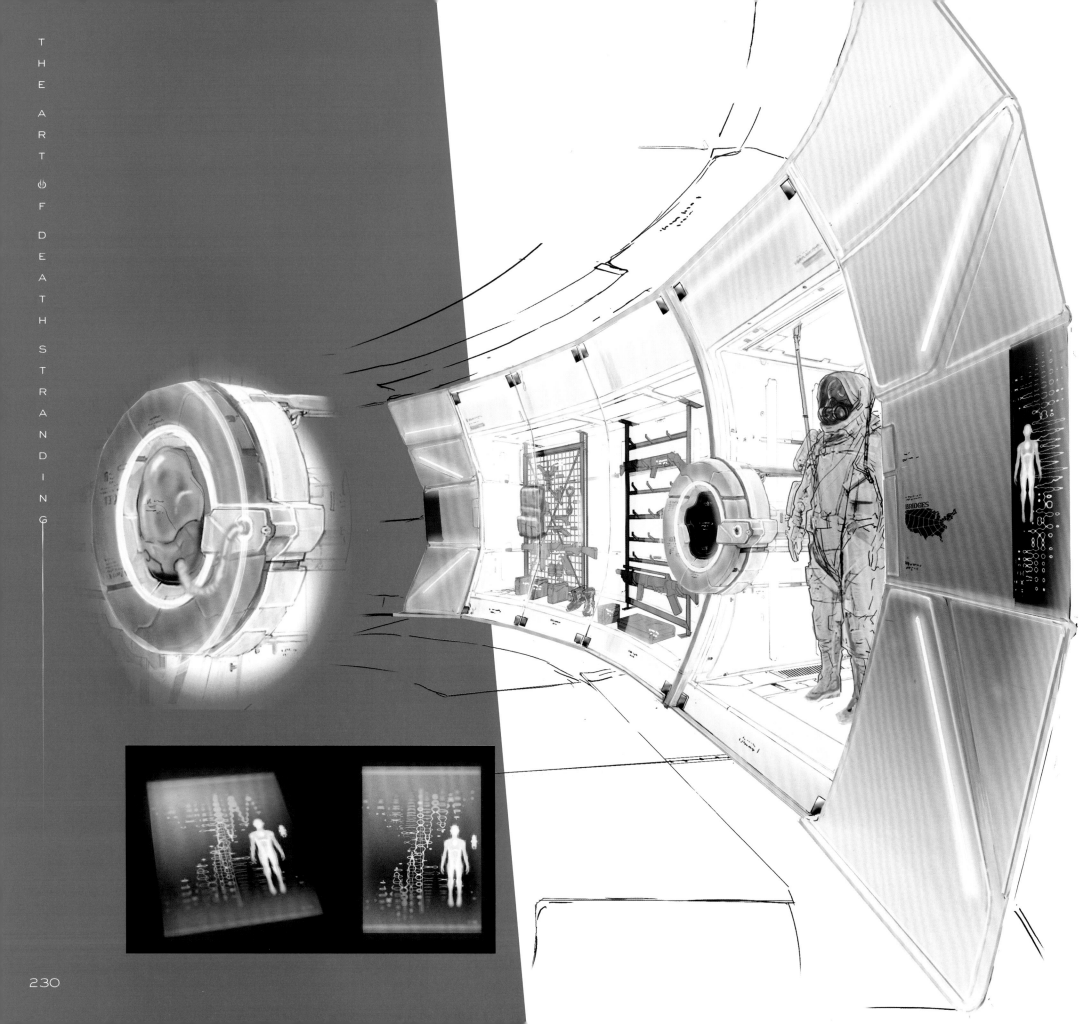

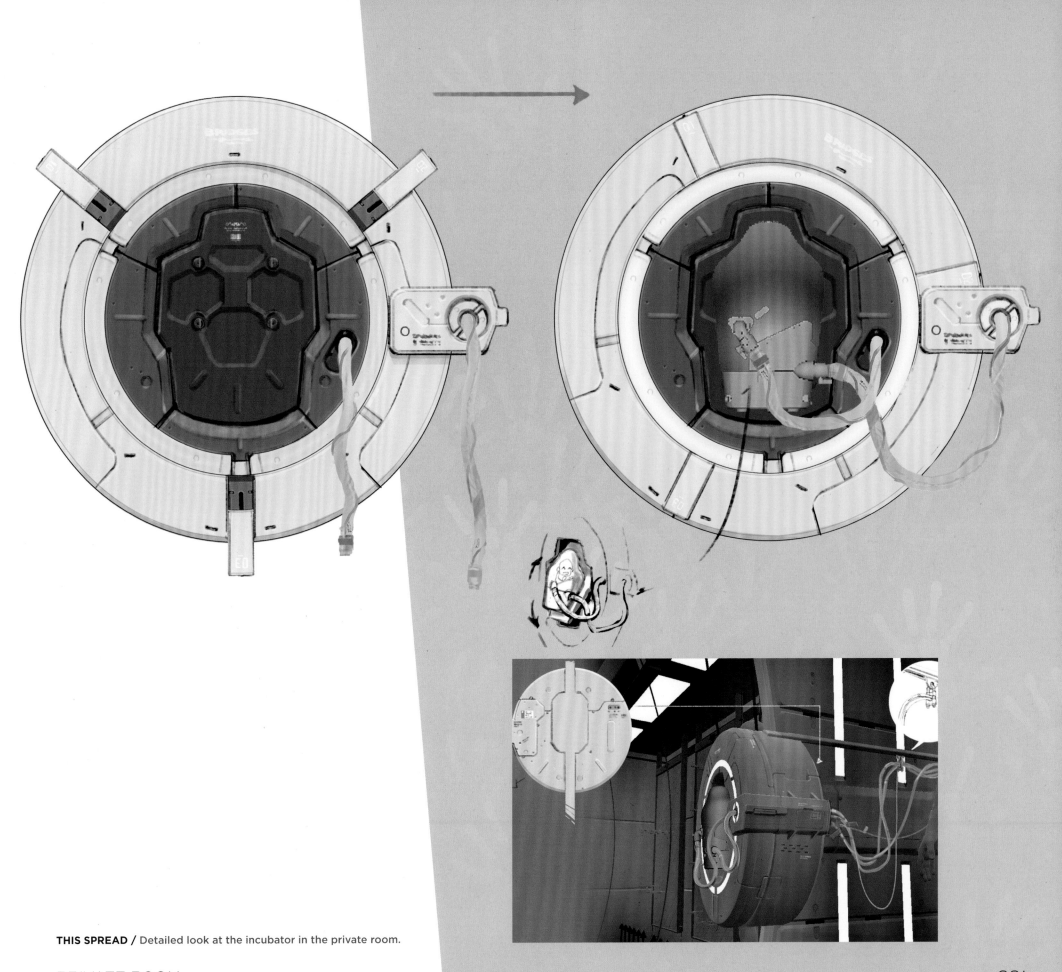

THIS SPREAD / Detailed look at the incubator in the private room.

PRIVATE ROOM

URBAN LANDSCAPES

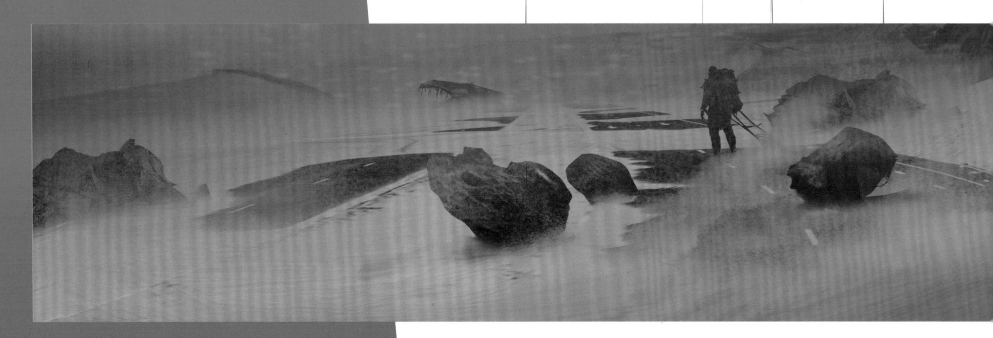

THIS SECTION / Although some of these concepts were cut, diverse situations were conceived.

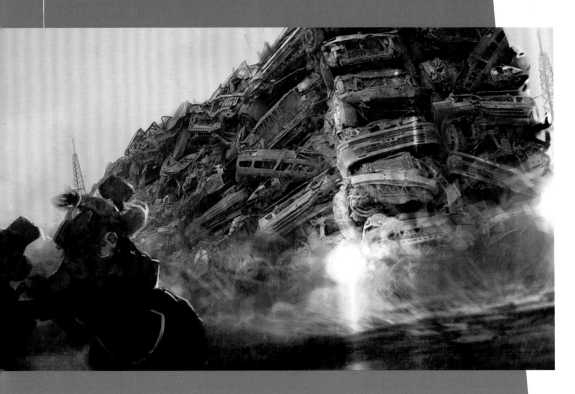

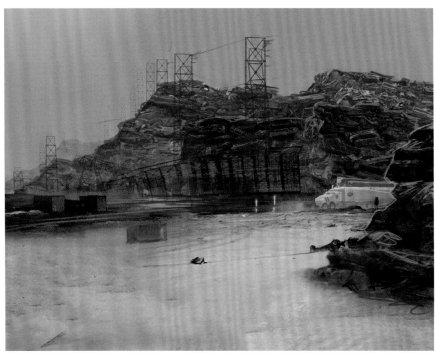

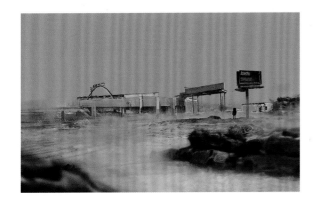
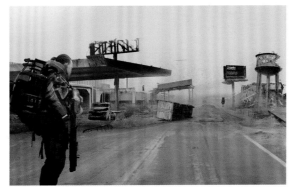
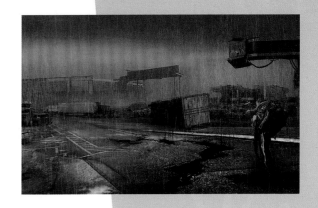
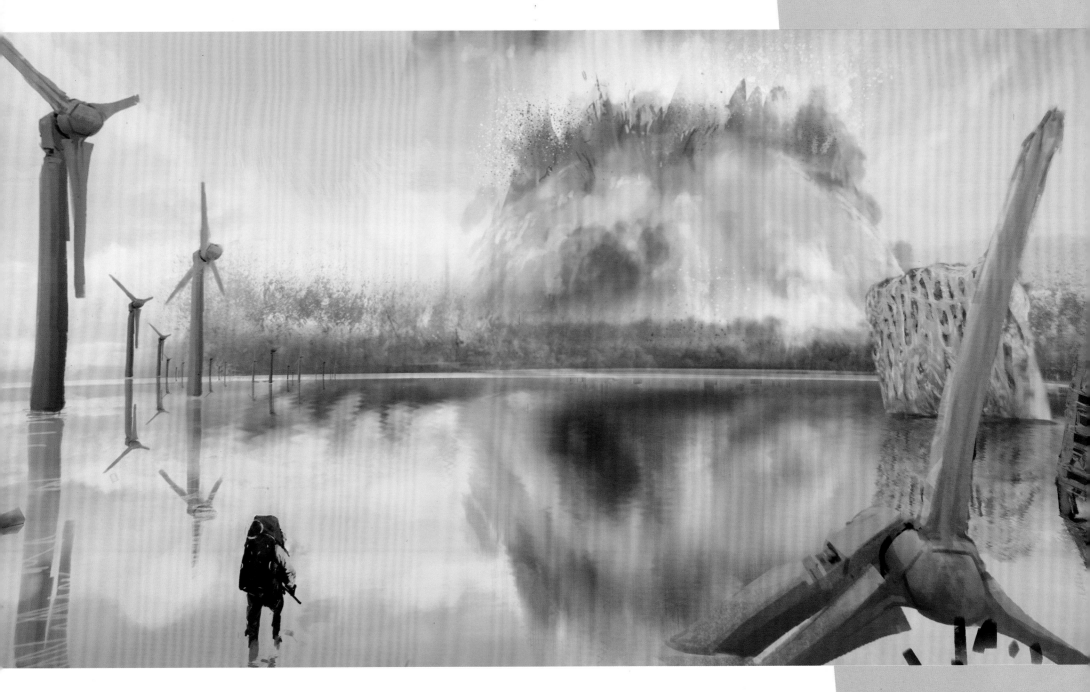

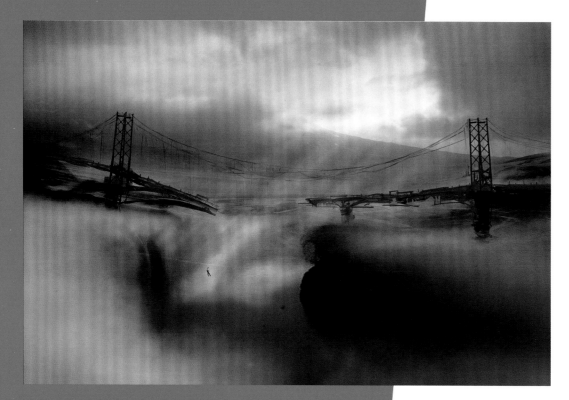

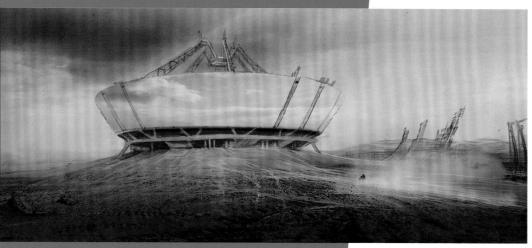

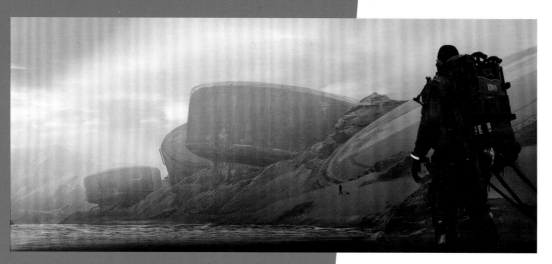

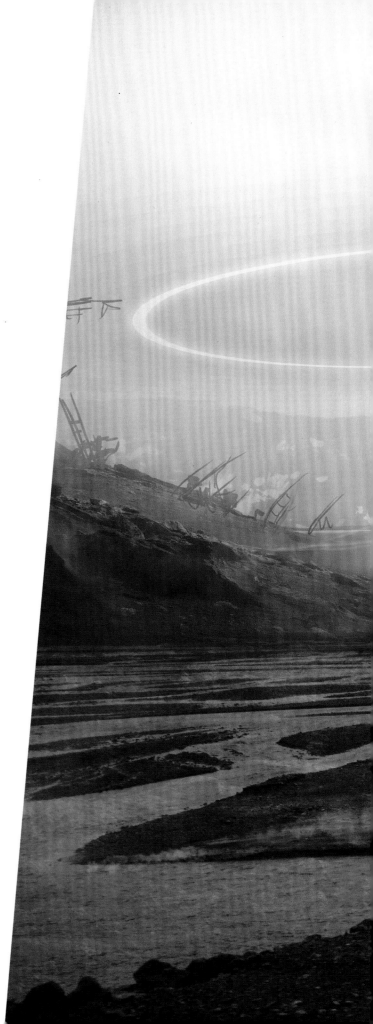

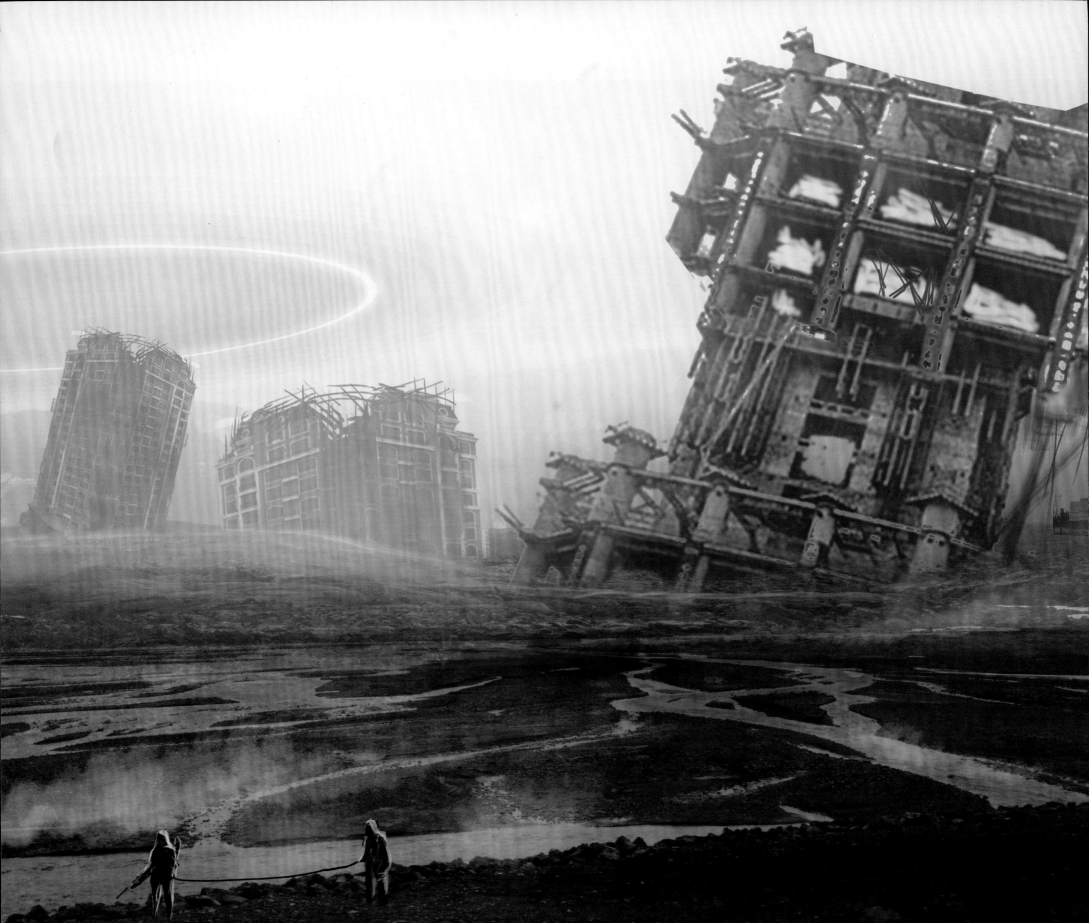

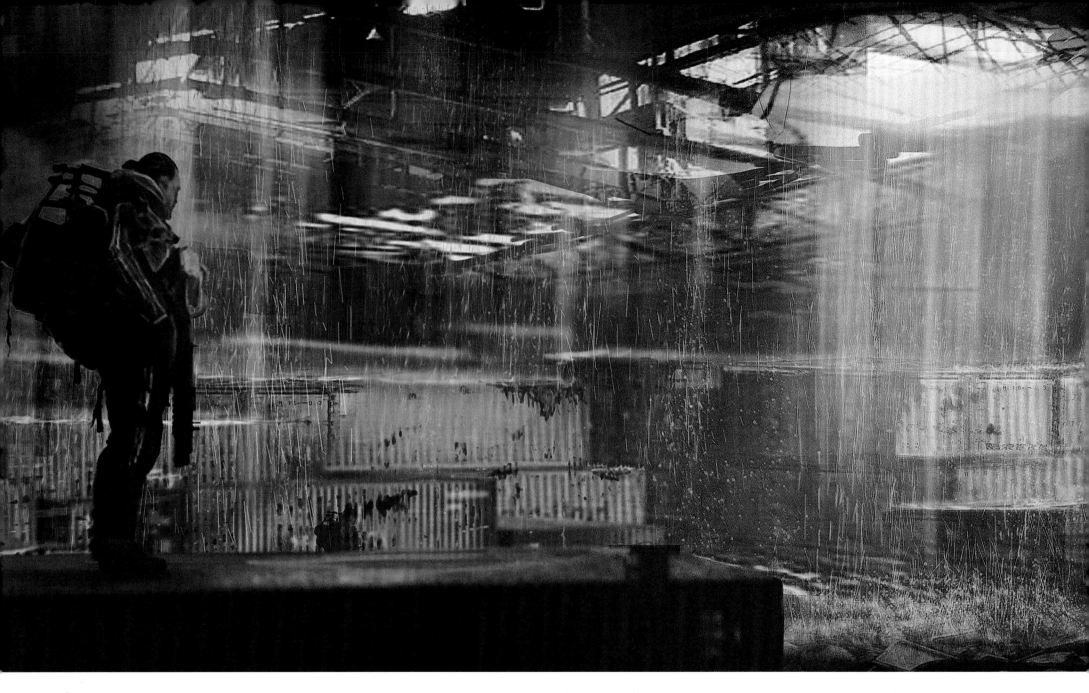

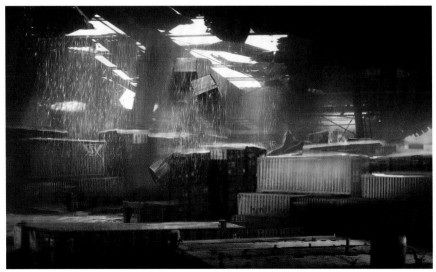

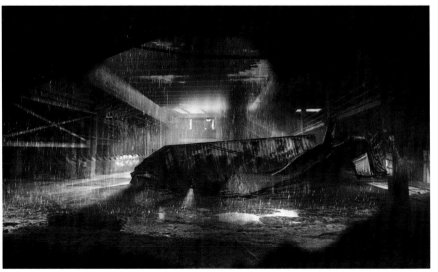

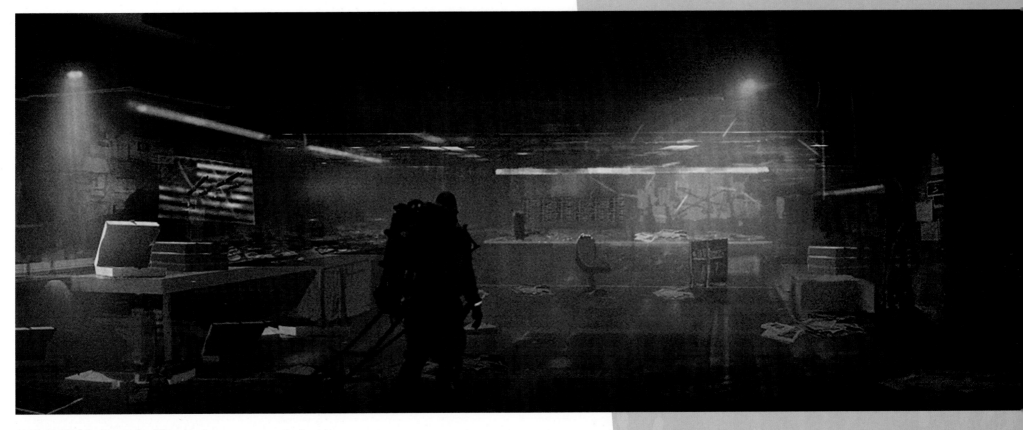

THIS PAGE / Concepts for Higgs' room.

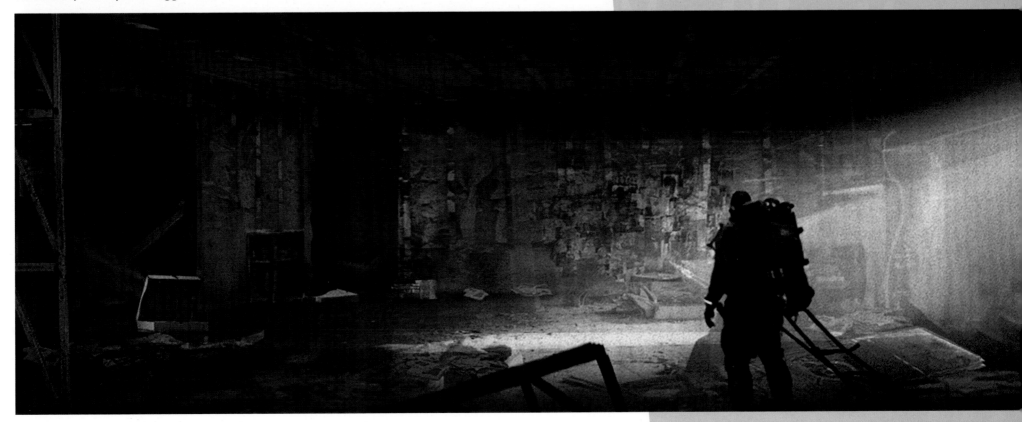

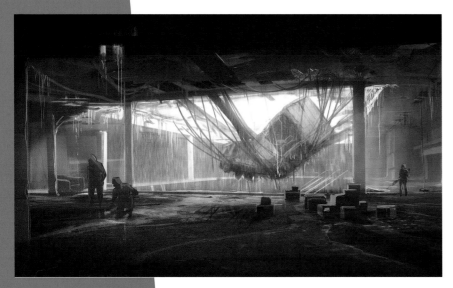

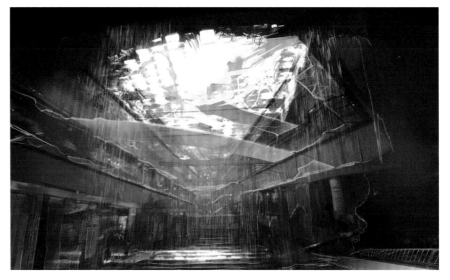

THIS PAGE / Early concepts for ruins.

THIS SPREAD / In the world of DEATH STRANDING there are no people walking around, and the ruins help emphasize the feeling of emptiness.

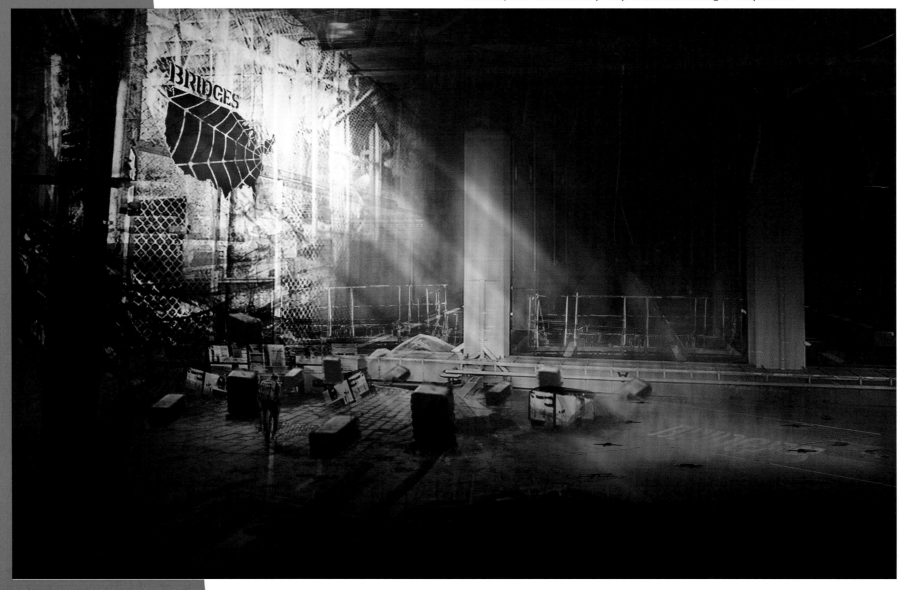

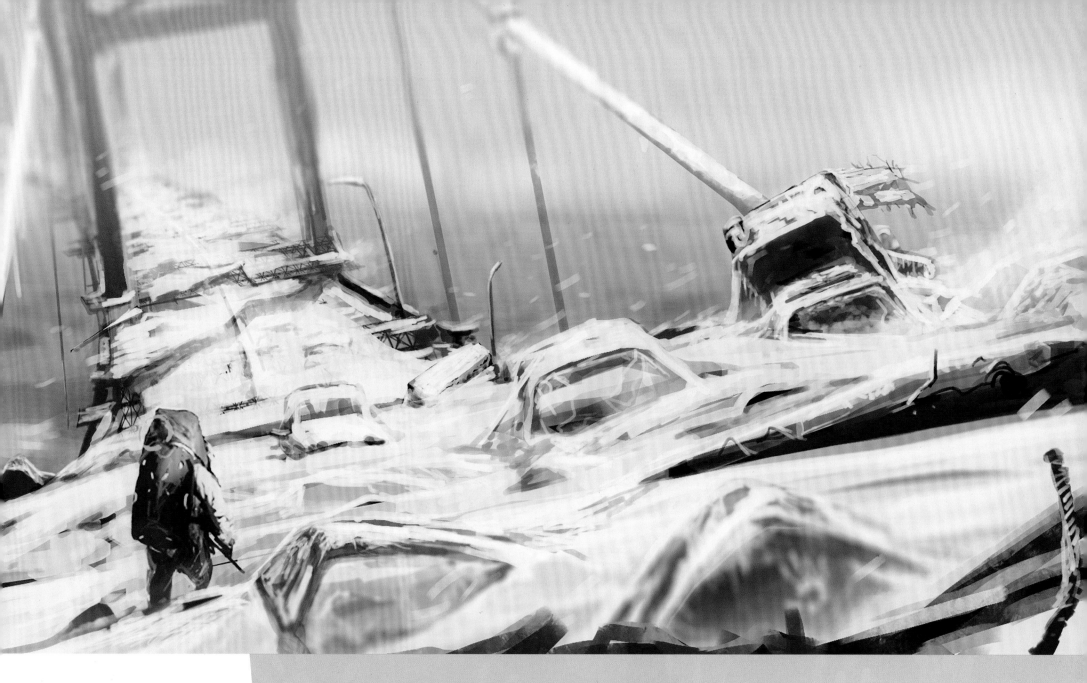

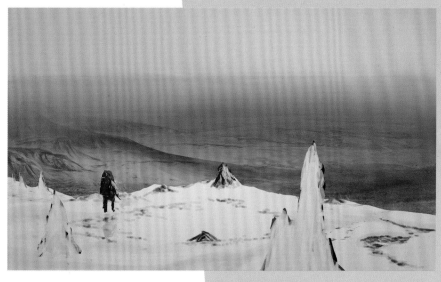

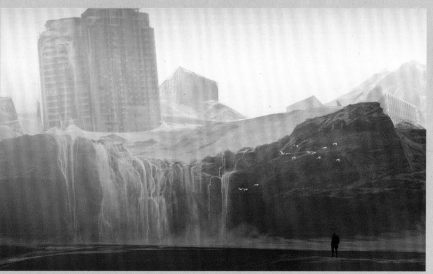

RURAL LANDSCAPES

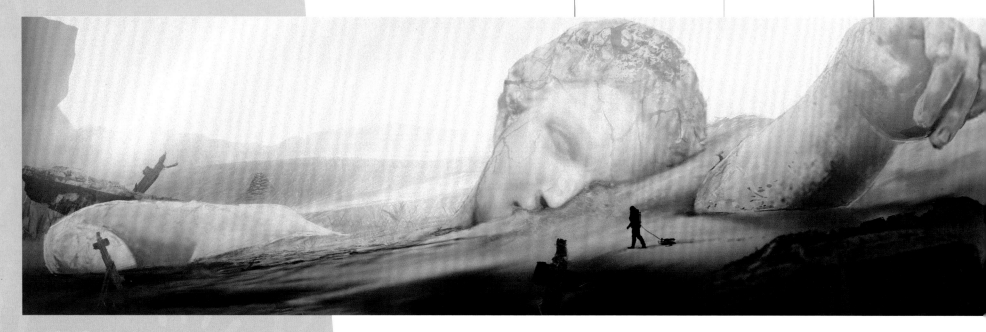

THIS SPREAD / Unused concepts, created to establish the tone of the world.

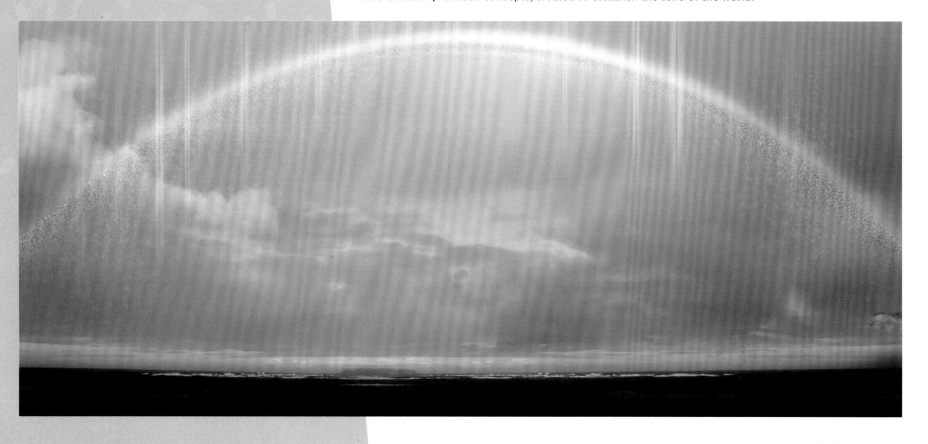

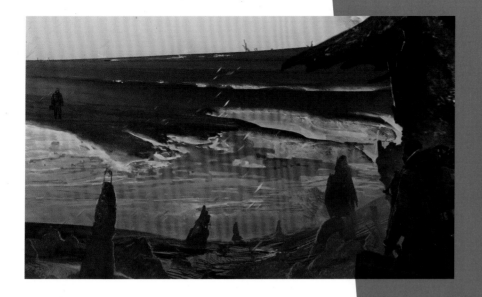

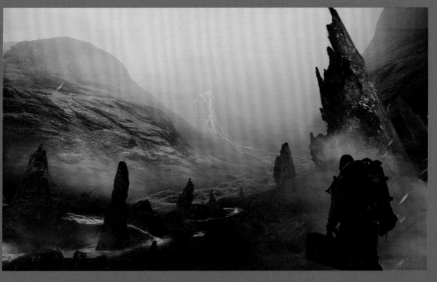

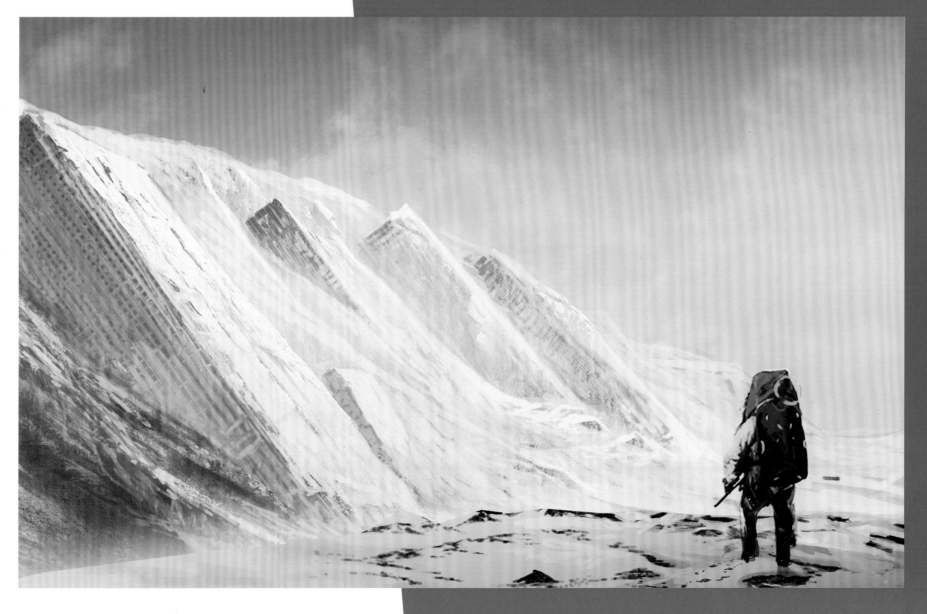

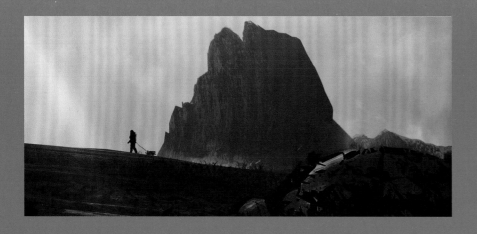

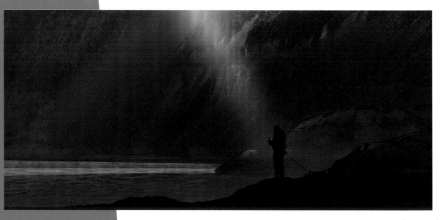

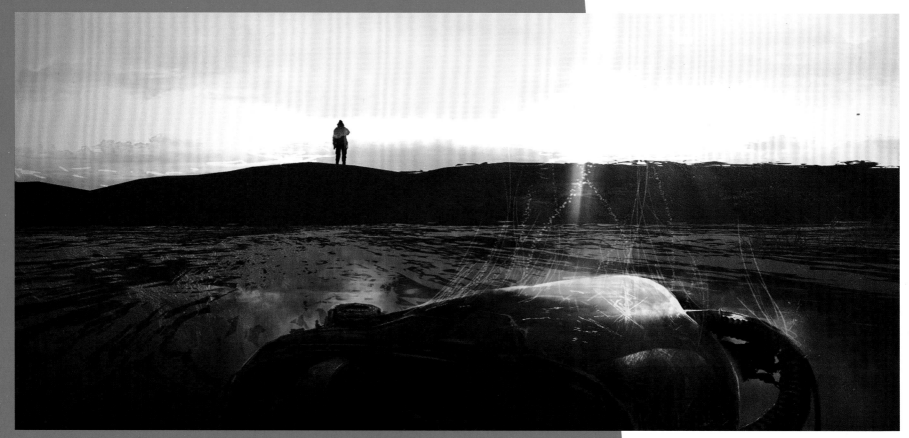

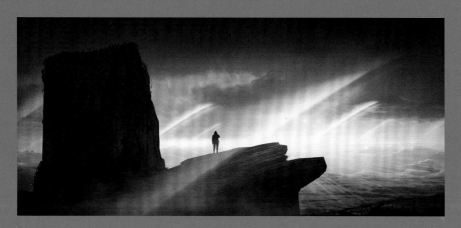

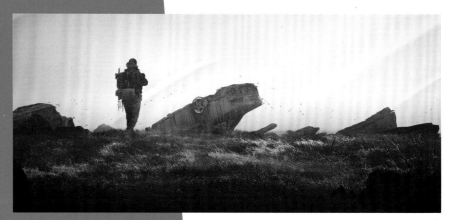

LOCATIONS

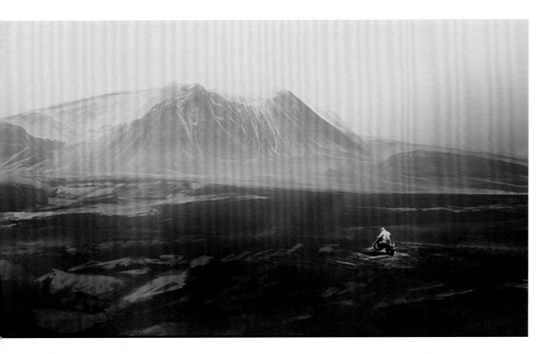 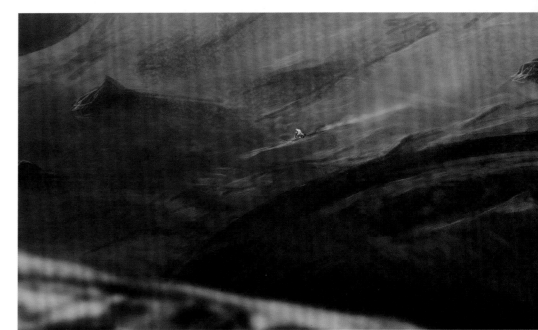

ABOVE / Concepts for the opening of the game.

BELOW / Concept for the ending of the game.

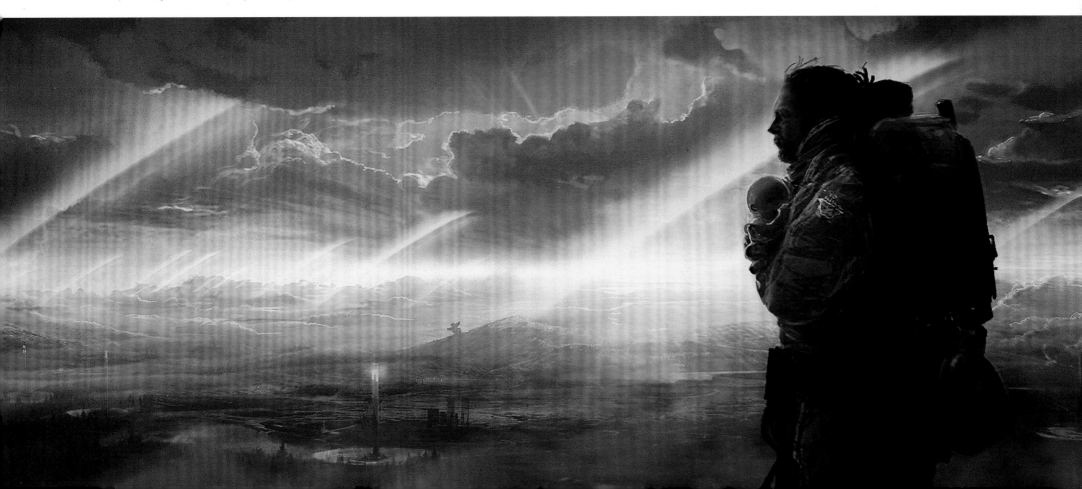

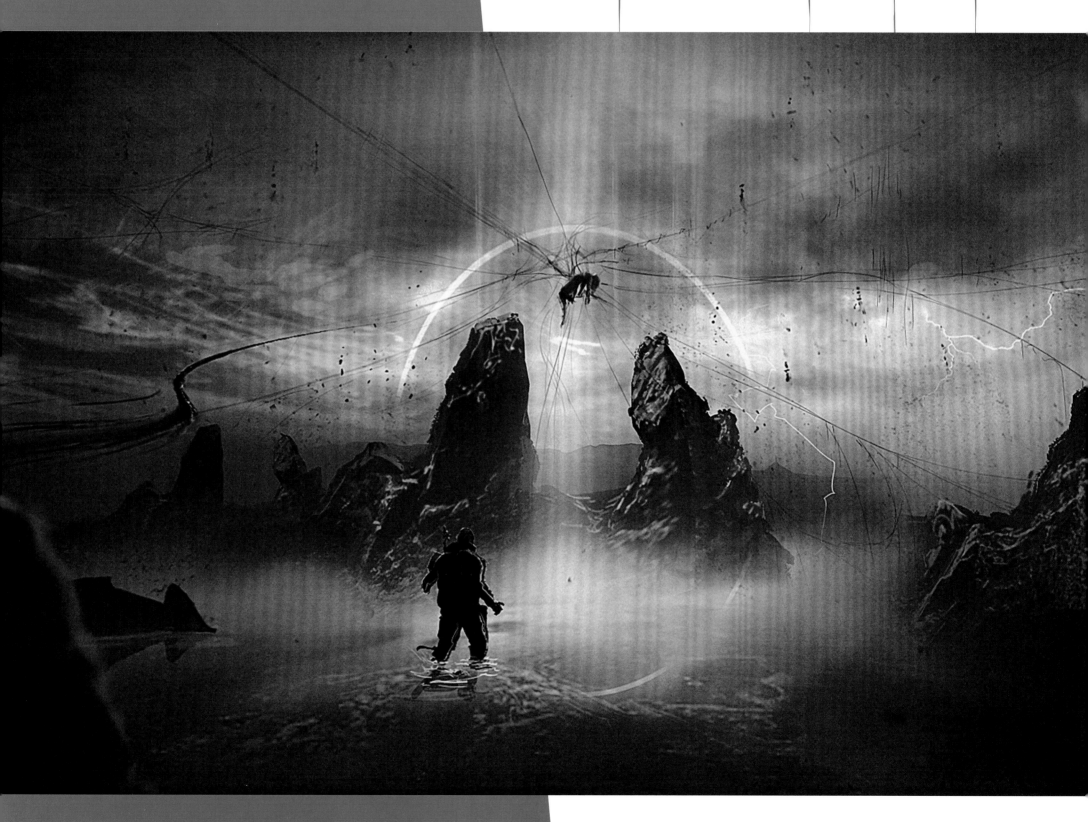

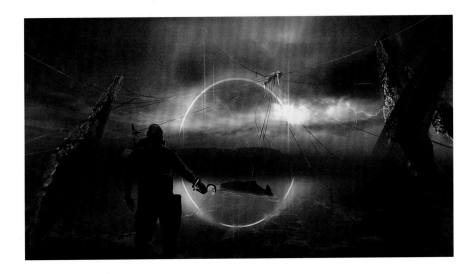

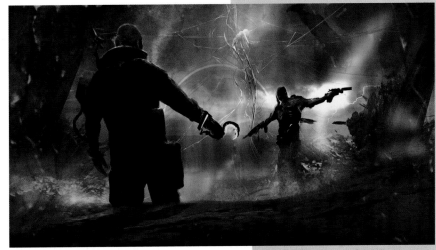

THIS SPREAD / Concepts for battles on Amelie's beach.

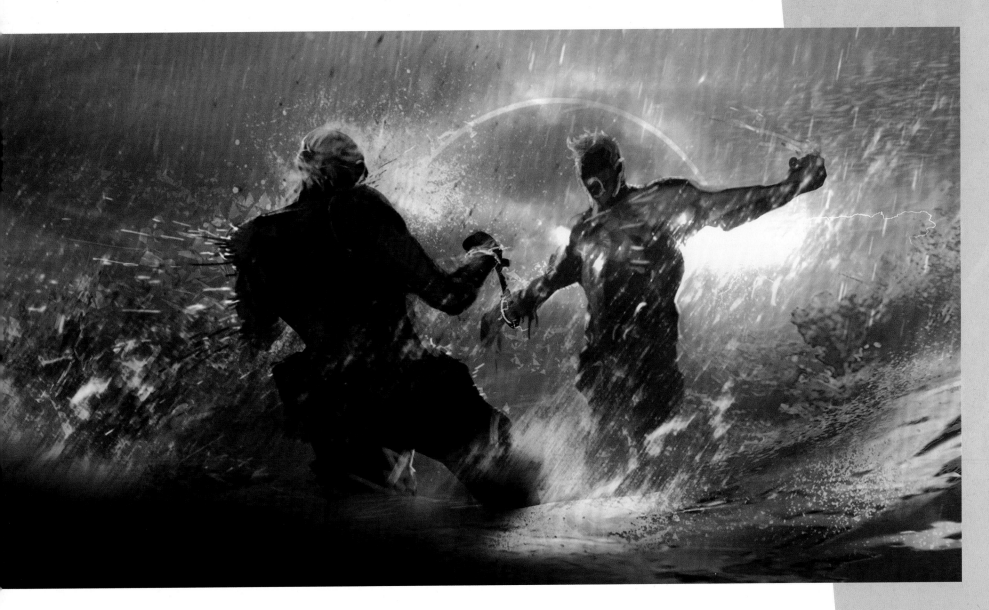

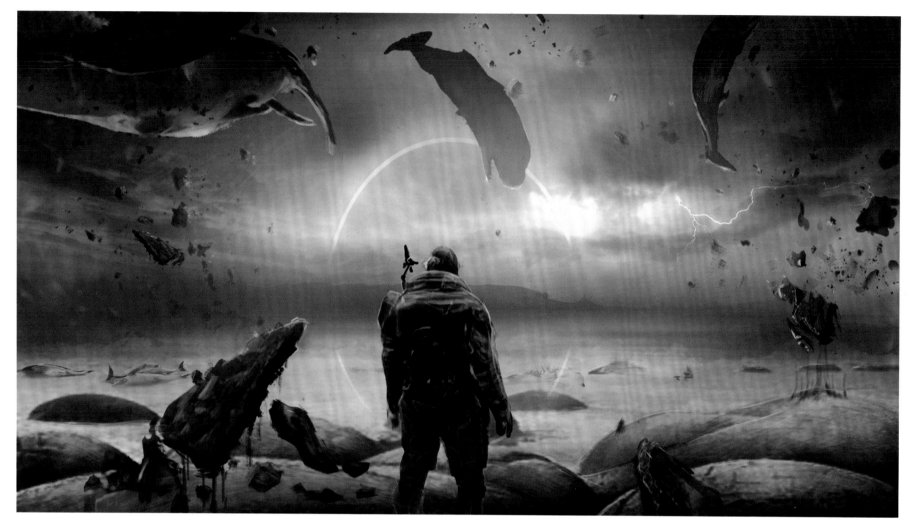

THIS PAGE / Concept variations for Amelie's beach, experimenting with whales and rainbows.

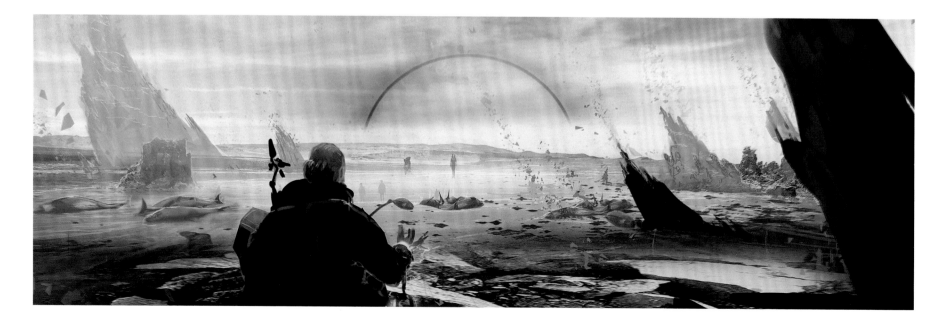

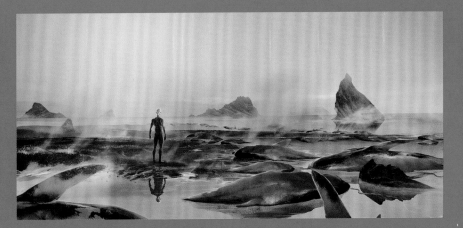

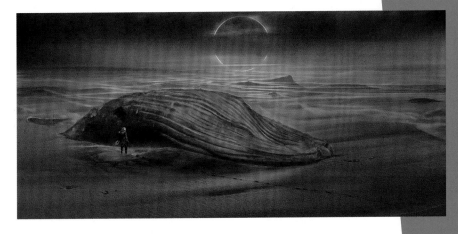

THIS PAGE / Concepts for Amelie's beach before the Last Stranding.

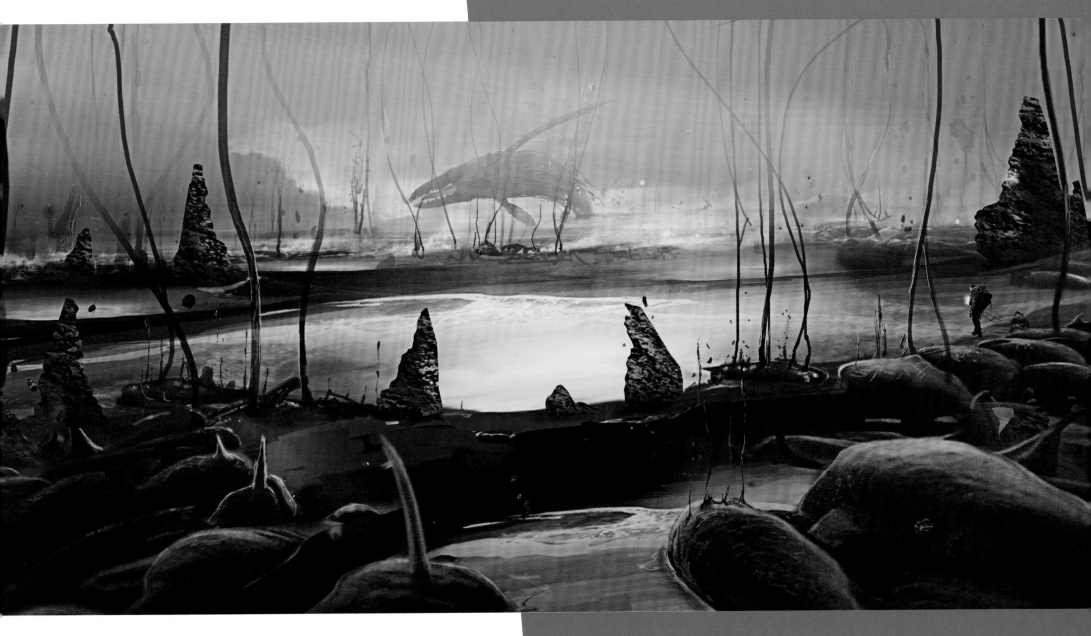

AMELIE'S BEACH

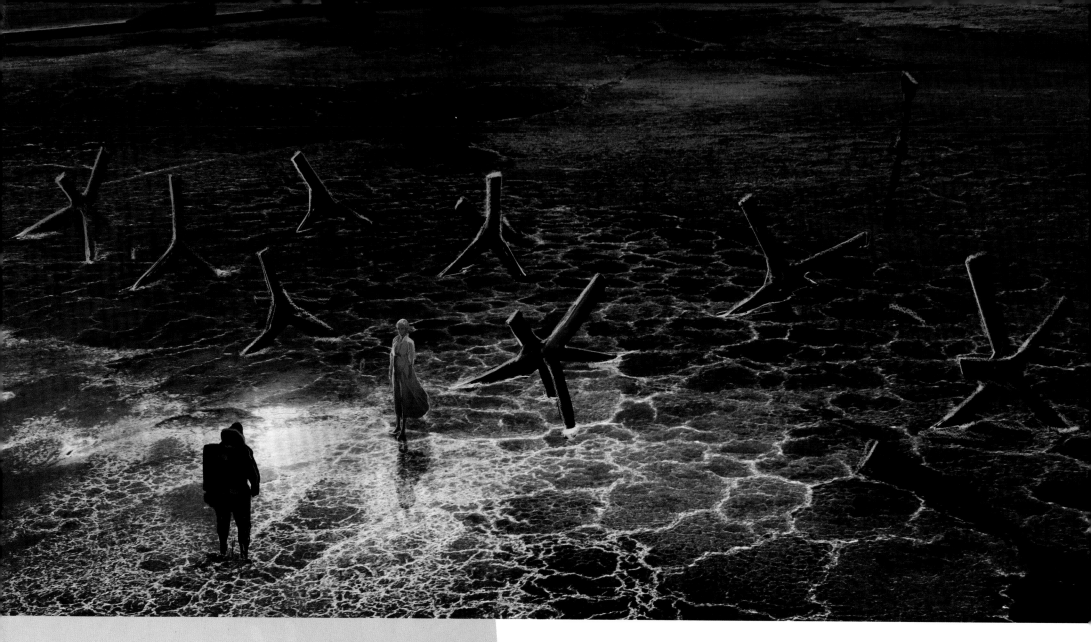

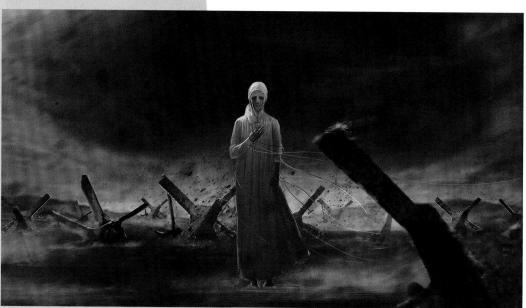

THIS SPREAD / Unused concepts for one of the last cutscenes in the game.

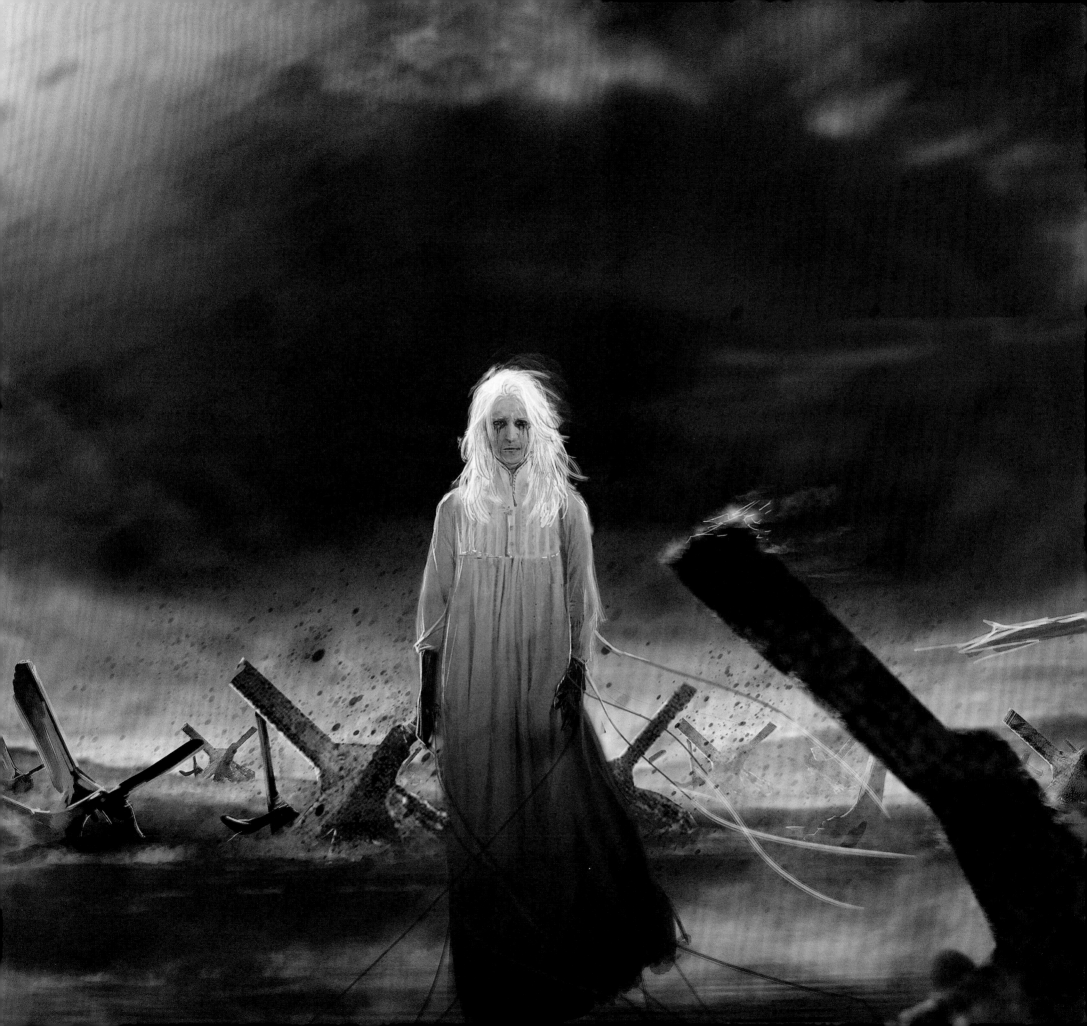

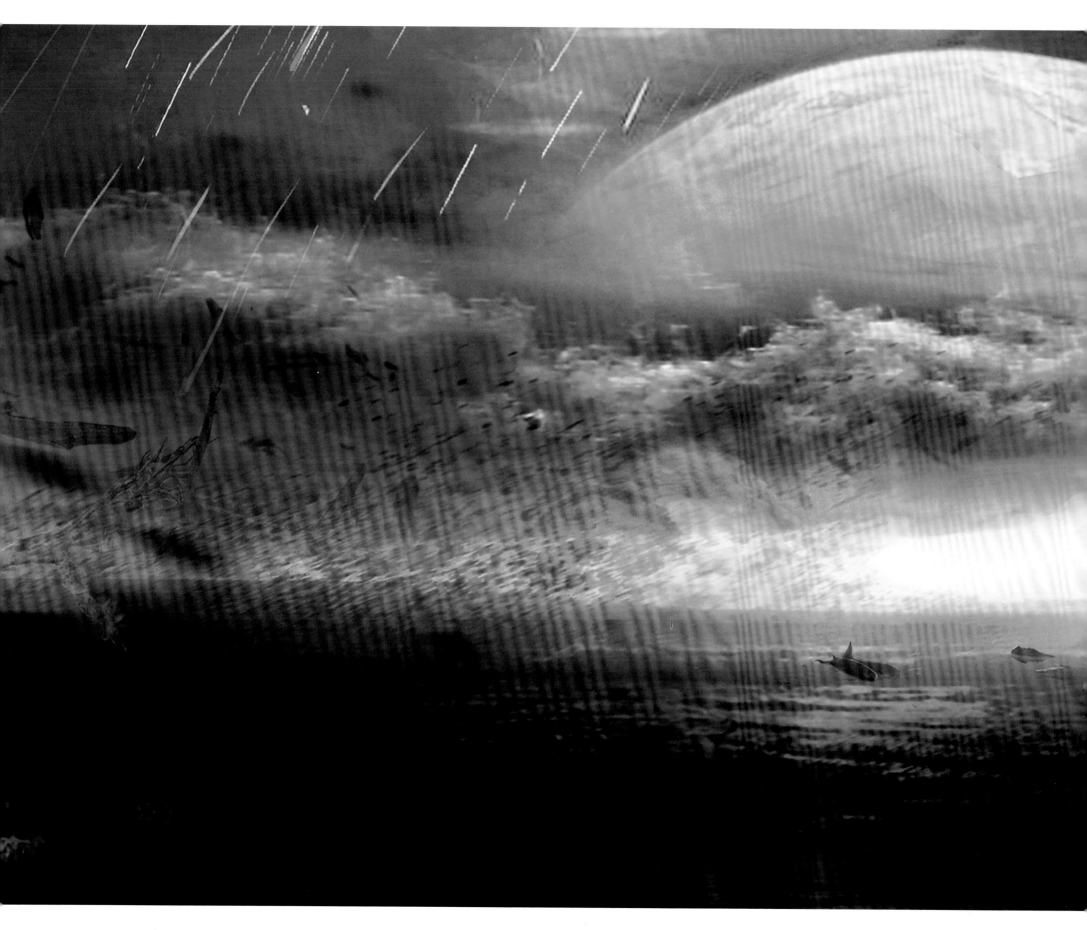

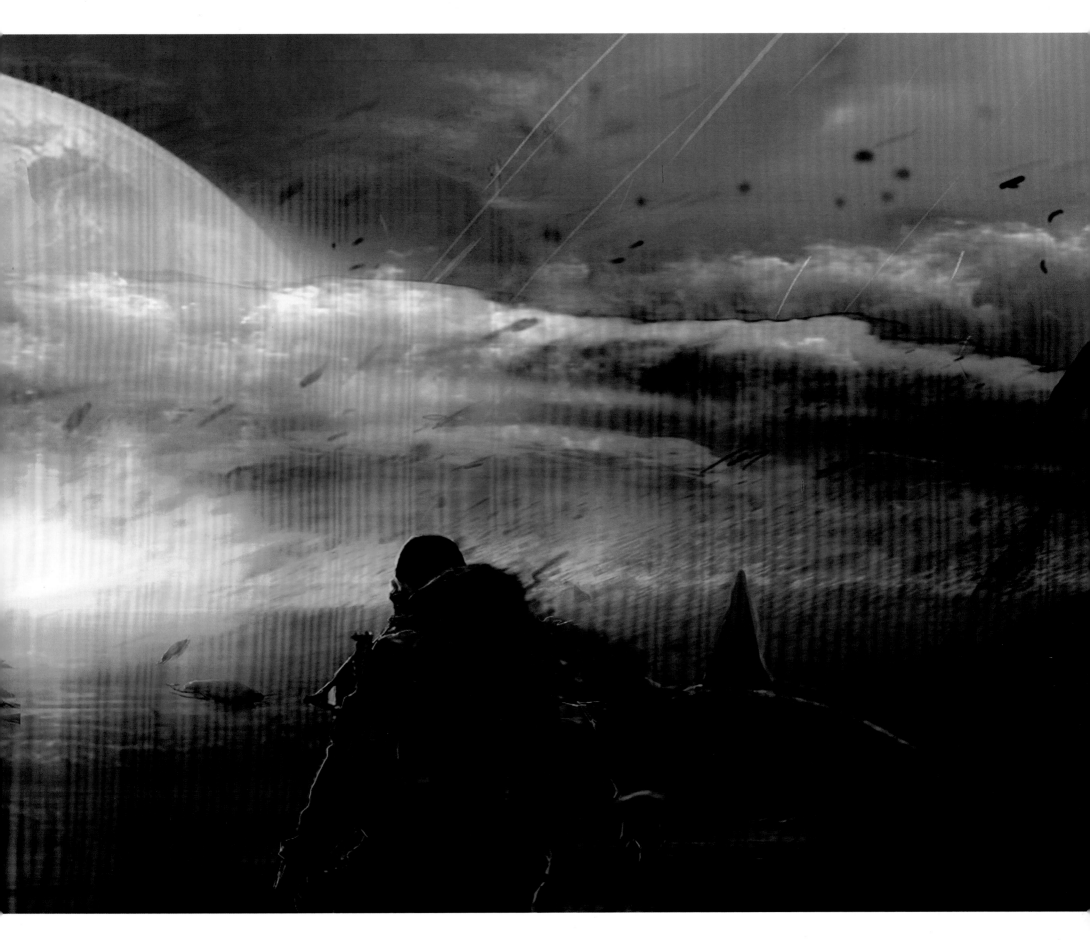

AMELIE'S BEACH

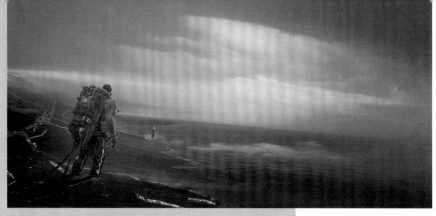

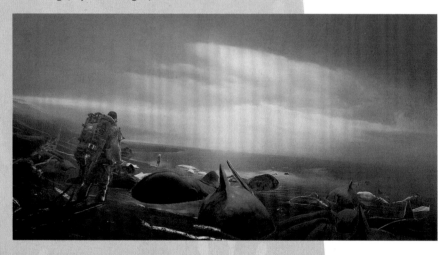

THIS PAGE / Evolution of the concepts for the Last Stranding (top left to right).

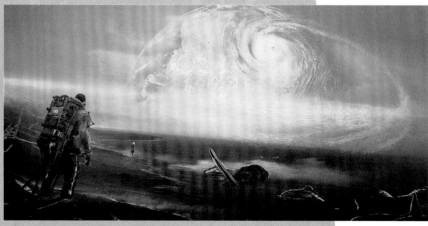

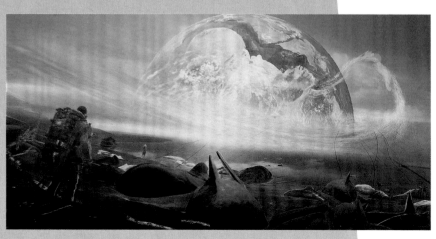

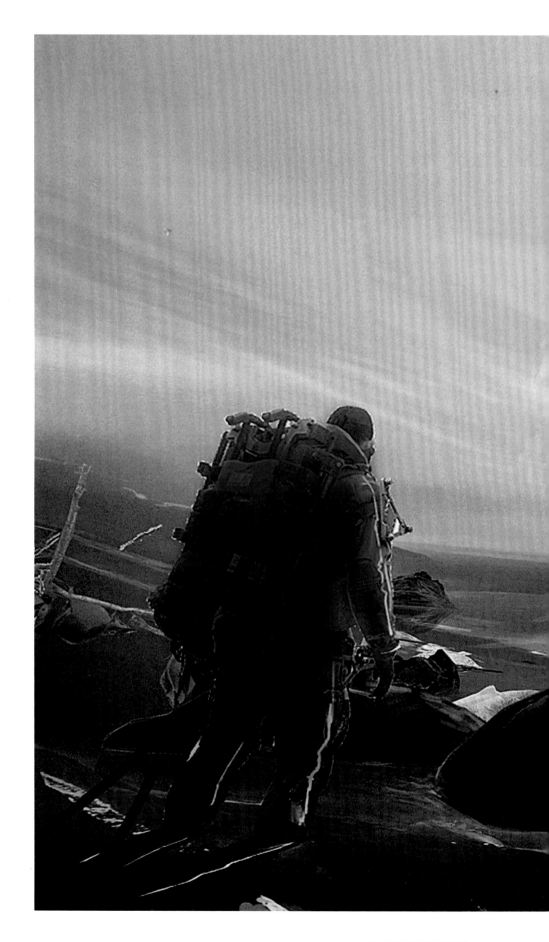

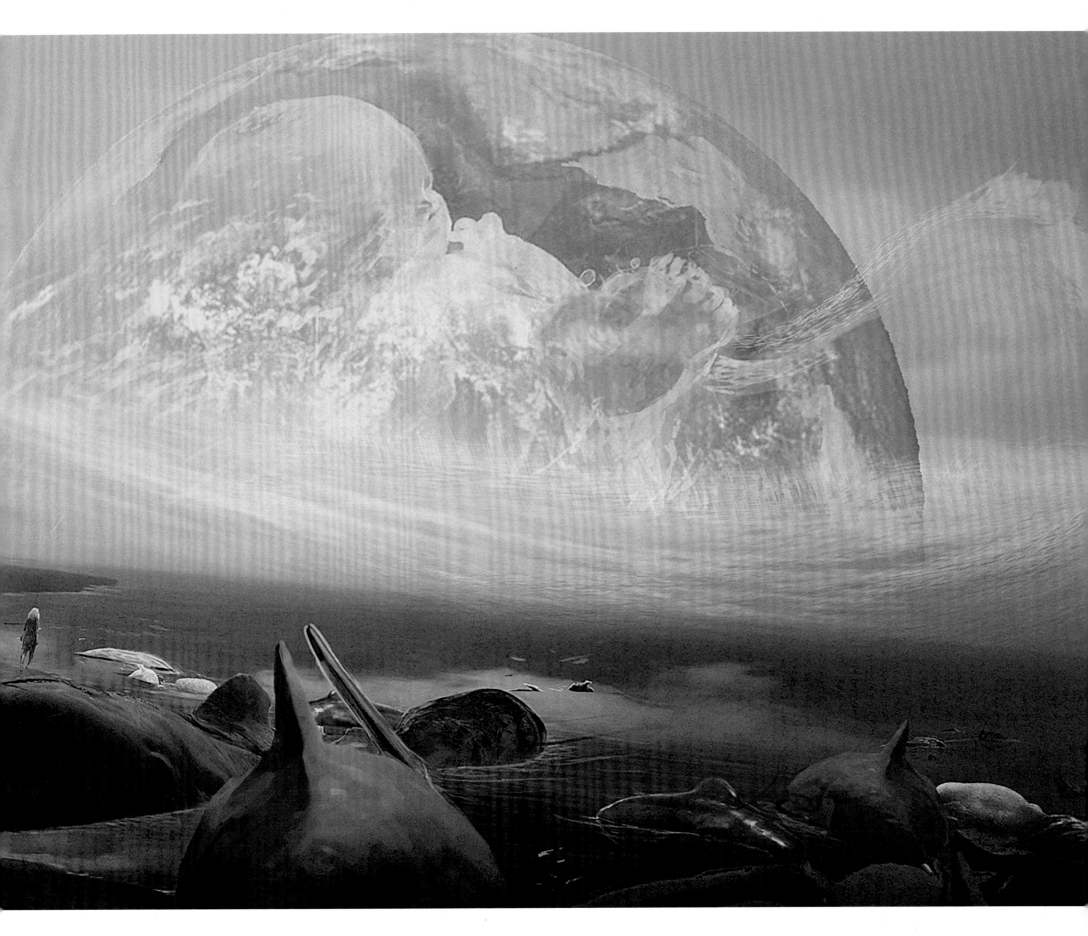

AMELIE'S BEACH

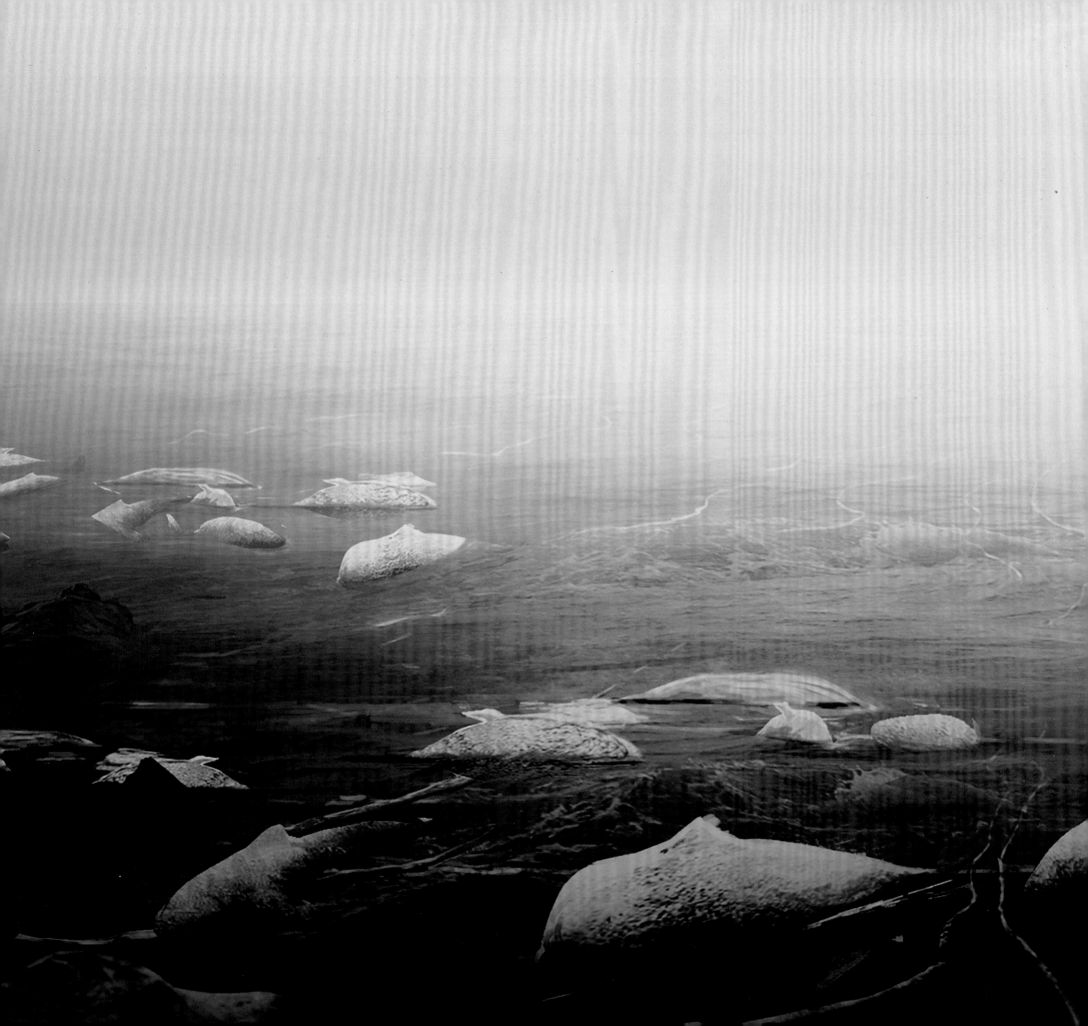